Kirkhoff

W9-ANU-662

BIRD ETCHINGS

ALSO BY CHRISTINE E. JACKSON

British Names of Birds (1968)

Bird Illustrators: Some Artists in Early Lithography (1975)

Collecting Bird Stamps (1977)

Wood Engravings of Birds (1978)

BIRD ETCHINGS

The Illustrators and Their Books,

1655–1855

Christine E. Jackson

CORNELL UNIVERSITY PRESS

ITHACA AND LONDON

Copyright © 1985 by Cornell University

All rights reserved. Except for brief quotations in a review, this book, or parts thereof, must not be reproduced in any form without permission in writing from the publisher. For information address Cornell University Press, 124 Roberts Place, Ithaca, New York 14850.

First published 1985 by Cornell University Press.
First published, Cornell Paperbacks, 1989.
International Standard Book Number 0-8014-1695-7 (cloth)
International Standard Book Number 0-8014-9684-5 (paper)
Library of Congress Catalog Card Number 84-27438

Printed in the United States of America

Librarians: Library of Congress cataloging information appears
on the last page of the book.

The paper in this book is acid-free and meets the guidelines
for permanence and durability of the Committee on Production
Guidelines for Book Longevity of the Council on Library Resources.

Of Birds. In drawing birds, begin first with the Head, and bring from under the throat, the breast-line down to the legs, where rest; then begin at the Pinion to make the wing, which being joyned to the Back is soon finished; the Eyes, Legs and Train must be the last; and be sure you make the farthest leg ever shorter, as you do in Beasts. For the feathers, take your Beginning at the head very small, and so proceed downwards greater and greater; for the true drawing of birds, you may procure some living ones.

The birds most easily to be drawn are all Sorts of waterfowl: the next are those of prey, and the hardest are those that are tame. The action of birds is flying, pruning themselves, bathing, swimming, etc.

—RICHARD BLOME, *The Gentleman's Recreation,* 1686

Contents

Illustrations

Preface

Bird Etchings covers the period of bird-book publishing in Britain from about 1655, when etching on metal as a means of reproducing illustrations was introduced, to the middle of the nineteenth century, when this method was superseded by lithography. During these two hundred years, most of the bird books published in Britain were illustrated by the authors themselves, who learned to etch their own plates from their drawings of birds. In this period hundreds of previously unknown species were discovered in all parts of the world, and these artists strove to record them all. Mark Catesby and John James Audubon illustrated an abundance of New World species in books published in England. Oriental and Ethiopian species were taken to Britain in ever-increasing numbers as British ships gained mastery of the seas in the eighteenth century, and the wealth of Australian avifauna was discovered at the end of the century. Feverish activity was required to keep pace with these discoveries over the years from 1780 to 1840, and it was during this period that the art of watercolor drawing and the crafts of etching and engraving reached their peaks. Each author, artist, and craftsman made a distinctive contribution to the literature of ornithology and advanced the knowledge of bird species. Their story is one of human endeavor with the highest aim—that of sharing their discoveries and new knowledge with others.

The efforts of these amateur naturalists, often in the face of enormous difficulties, deserve to be better known and appreciated than they have been. It is in

the same spirit of sharing newly discovered knowledge that I have written about their endeavors and achievements, for they were truly admirable men. They adapted their talents to new media, new forms of literature, new methods of collecting and preserving specimens, and a new classification system, all with a verve and energy that were symptomatic of their sheer delight in the unfolding riches of natural history and the beauty of birds. They saw the world of nature as a revelation of the wonders of creation, and they transmitted their excitement and delight along with something of their awe of its Creator.

Social historians will find clear evidence of another, perhaps hitherto unsuspected cottage industry. The Albin, Lewin, Graves, and Hayes families produced their books in their own cottages, from the gathering of the information for the text to the finished plates from which the illustrations were printed. To a lesser extent, Mark Catesby, George Edwards, Sir William Jardine, and Prideaux John Selby, who also etched their own plates at home, became part of the do-it-yourself publishing process. The relationships among these men and their clients and patrons, their colleagues, and museum proprietors throw revealing light on society in eighteenth- and nineteenth-century Britain.

The beautifully illustrated bird books they produced are a heritage that is now acknowledged to be very valuable, and one to be carefully preserved. I hope that this additional information about the creators of those bird books will reinforce this attitude, and go some way toward helping to preserve their books in entirety for the future. While an appreciation of each individual plate is to be encouraged, it must not be allowed to become the excuse for breaking up volumes for the sake of their plates. There is now an urgent need to preserve all remaining copies of bird books with hand-painted illustrations before their numbers are further reduced. Their authors planned them as surveys of the knowledge of their time and a record of the species in relation to one another. Their purpose should be respected, for the compass of our present-day knowledge is built on their collective endeavors.

In the text I have referred to birds by the names used in the bird books under review, adding a commonly used modern name in English where I thought clarification was necessary, followed by the modern scientific name of the species. For all the North American and Nearctic species I have followed the American Ornithologists' Union's *Check-list of North American Birds*, 5th edition (1957), and for the British species the British Ornithologists' Union's *Status of Birds in Britain and Ireland* (1971). Names not included in these two lists are taken from Edward S. Gruson's *Checklist of the Birds of the World* (London: Collins, 1976).

CHRISTINE E. JACKSON

Hare Street, Hertfordshire

Acknowledgments

Throughout my years of research I have been given a great deal of help by librarians, curators, archivists, and secretaries of learned societies. I am grateful to E. M. Broome and the staff of the Hertfordshire County Library; K. C. Harrison and the Westminster Public Library; P. Pagan and the Bath Municipal Libraries; A. B. Craven of the Leeds City Library; Mrs. D. Anderson of the Southall Library; G. D. R. Bridson of the library of the Linnean Society, London; J. Hermann of the Newington Public Library; the librarian of the Society of Genealogists; the staff of the Guildhall Library and its keeper of manuscripts; the librarians at the Society of Friends in Edinburgh and London; the deputy librarian at Kew Royal Botanic Gardens; Ronald Hughes, late of the Balfour Library, Department of Zoology, Downing College, Cambridge; J. W. Cockburn of the Edinburgh Public Library; W. R. Maidment of the London Borough of Camden Libraries; R. A. Fish of the Zoological Society of London Library; and Muriel McCarthy of Archbishop Marsh's Library in Dublin.

The archivists of Middlesex County Record Office and the Greater London Record Office patiently recovered their parish registers from distant vaults at my request, and the Post Office archives were similarly made available. The secretary of the Royal Literary Fund and the archivist of Canterbury Cathedral were most obliging with information on impecunious William Hayes. The Shropshire, Buckinghamshire, and Hertfordshire county record offices provided useful additional material, and Mrs. J. Craig, the archivist of the Hudson's Bay Company,

found material I had not suspected existed. To all of these people, who often went beyond the call of duty, I tender my thanks.

The names of many staff members of the British Museum, the British Library, the Public Record Office, and the General Register Office are unknown to the general public, but I thank them for the work they do.

The staff of the British Museum (Natural History) Zoology Library always make a visit to their library a pleasure and are unfailingly helpful. To be allowed to use the library at Tring I count as a special privilege. To sit in the beautifully restored nineteenth-century gentleman's library, once owned by Lord Rothschild, is an experience in gracious living and cultural standards given to few of us today.

To the conservator of the Royal College of Surgeons Museum, Edinburgh, and to the curator of the Royal Scottish Museum belong the credit for assistance with the Scottish artists and authors.

To those clergymen who have allowed me to search their parish records, I express my gratitude for the time they gave and the interest they showed: T. T. W. Peregrine of Argyle United Reformed Church, Bath; the Reverend Gordon C. Taylor, rector of St. Giles, London, and his verger and parish clerk, P. D. Wheatland; and the vicars of St. Mary Norwood and Whitford with Holywell. To Anthony Keulemans, David Lank, and all my correspondents at home and abroad, whom George Edwards and his eighteenth-century friends would have described as "Encouragers of this Work," I send my best thanks and warm regards. More particularly, I thank Dr. Gordon Greenblatt, who set the process of publication in motion. I am greatly indebted to a bibliophile nearer home who modestly wishes to remain anonymous, but who read through the manuscript and alerted me to a number of points that needed adjusting.

Finally, to my husband, Andrew, I pay a tribute of great respect and gratitude for his forbearance and assistance over the years in which I have been working on the bird illustrators, and for making it all possible.

Figures 1, 3, 50, and 62 are reproduced by courtesy of the Trustees of the British Museum, and Figures 2, 5, 9–13, 18–21, 27, 28, 31, 32, 37, 57, 59–61, 63–65, 68, and 70–76 and Plates 1–4 by courtesy of the Trustees of the British Library. The Scottish National Portrait Gallery gave permission to reproduce Figure 4; the National Library of Wales, Figure 30; the Royal Scottish Museum, Edinburgh, Figure 67. The Board of Trustees of the Victoria and Albert Museum consented to the use of the photograph of the porcelain model in Figure 25. The Zoological Society of London kindly gave permission to reproduce Figures 43–45.

I am indebted to Hugh Torrens for permission to use the photograph in Figure 42 and for help with John Walcott. Figure 36 was most generously made available to me by a private book collector in England who owns this rare item.

I thank the Master and Fellows of Emmanuel College, Cambridge, for their

kind permission to reproduce Figures 6, 8, 14–17, 22–26, 33–35, 38–41, 46–49, 51–56, 66, and 69 from books in the Graham Watson Collection. Alan C. Parker photographed these plates, in addition to three in my possession (Figures 7, 29, and 58), and I am grateful to him for his excellent work.

To all the photographers involved, most of whom worked anonymously for the various institutions named above, I express my appreciation of their work on the plates in the old bird books, for it is never an easy task to photograph them successfully.

C. E. J.

BIRD ETCHINGS

1

The Background

BIRD books that deal with many species need illustrations to provide the reader with a visual perception of the various forms. Pictures can convey at a glance information that is very difficult to express in words. The shape, form, and proportions of a bird, the exact position and shape of markings, the tone and colors of the feathers—all such features can be faithfully portrayed by a good artist or photographer with a clarity that a verbal description can hardly approach.

Apart from this utilitarian value, illustrations increase a book's attractiveness. Long before books were published, monastic scribes habitually illustrated, or illuminated, their manuscripts in order to make them beautiful as well as useful. Our earliest printed books copied these manuscripts, reproducing their illustrations as well as their texts, and so from the commencement of printing in the fifteenth century we had books illustrated for decorative purposes. Woodcuts of birds decorated the margins of some of these early books, but it was another two hundred years before the value of illustrations introduced to supplement descriptions in the text was fully realized and exploited by the author of a bird book printed in Britain.

The main reason for this long delay was that scientific interest in animals and birds came much later than the detailed study of botany. Because plants were of vital importance as both food and medicine, books about them were more numerous than zoology books up to the eighteenth century. The first major British

book about birds, William Turner's *Avium praecipuarum quarum apud Plinium et Aristotelem mentio est . . .* of 1544, was not illustrated, and for a century after this publication little interest was taken in ornithology. The second important book was Francis Willughby and John Ray's *Ornithologia,* published in 1676, which included seventy-seven uncolored engraved plates containing many figures of birds. Willughby and Ray were familiar with illustrated continental bird books, a number of which had appeared before 1660 (see Appendix A). They included many figures of birds in their *Ornithologia* because, as their text explained, they had grasped the concept that "elegant and accurate figures do much illustrate and facilitate the understanding of Descriptions."

From Ray's demonstration of the value of illustrations flowed the stream of British bird books illustrated by the hand processes—engravings on metal and wood, etching, aquatints, and finally lithographs—before the photomechanical processes took over in the late nineteenth century. Our concern here is with those artists and authors who used metal in order to reproduce the illustrations in their bird books.

THE ARTISTS

Some European textbooks published in the sixteenth and early seventeenth centuries contained pictures of the flora and fauna described in the text. The figures in these European books were the only printed bird illustrations available to the earliest British bird illustrators as models and guides, though they could also look at the birds depicted in great works of art. Paintings were frequently superior to the illustrations in early printed books. The work of seventeenth- and eighteenth-century illustrators was closely circumscribed by their materials and the conditions under which they labored.

The engraver demanded from the artist a complete composition that he could copy exactly. Thus lines had to be drawn with great care, with variation in texture and tone indicated. The artist had to show shadows and perspective accurately. The strokes of the pen had to be made in the precise manner in which the engraver would use his burin or graver on copper. This requirement allowed very little artistic freedom of expression: the artist knew that if he wanted a faithful reproduction of his original drawing, he must work within the limitations of the reproductive process. It was only when etching, a slightly freer style of reproduction, was introduced that the artist had reciprocal freedom in drawing.

In the early days of illustration, the artist used ink and a reed pen or quill. He might make his own ink from lampblack and gum (or honey or barley sugar), or he might use soot or peat, which would give a brownish tint called bister. Alternatively, he could buy ink from a street vendor. His quill was probably plucked

from a goose. Thomas Pennant said that in Lincolnshire "tame geese were plucked five times in the year; first at Lady-day for the feathers and quills" and later for the feathers only.[1]

When brushes were introduced for the application of color to monochrome drawings, they had either wooden or quill handles and were called "pencils"; this term continued to be used until the mid-nineteenth century. The size of the brush quill is still listed in art-supply catalogues today according to the size of the bird that at one time supplied the quills; the largest is swan, then goose, duck, crow, and lark. The hairs of various animals, such as the squirrel, were used for the bristles. All of these materials demanded considerable skill in their handling.

Any colors that were added to the microscopically exact drawing were largely pure earth colors made from the soil, such as ocher, raw sienna, and burnt sienna. Other sources of pigment were sap green, verdigris, litmus blue, Spanish licorice, and logwood ash for purple. An early description of these colors and suggestions for their use are found in Richard Blome's *Gentleman's Recreation* (1686), in the section "Drawing and Painting." Blome also lists colors that were to be ground (after drying in the sun) and those that were to be washed. Once separated and purified, the colors were stored on tiny saucers or shells. Thomas Bewick, in the 1820s, mentioned using "shells of colour" as a boy (and he also called his brush a pencil).[2] It was not possible to purchase ready-made colors in liquid form or as little cakes until about 1766. Occasionally the colors were reinforced with white body color, which gave an opaque quality; these paints were called gouaches.

Wenceslaus Hollar was the originator of the Dutch method of staining pen drawings with watercolors. He settled in England in 1636 and was associated with Francis Barlow, who was among the first English artists to adopt this style of drawing (see Figure 1). Most of the bird artists were to use this method for their book illustrations. Bewick was still using Indian ink for the outline and watercolors as a wash at the end of the eighteenth century. Watercolor painting, in which the colors themselves formed the picture without a black outline, was recognized as an art in its own right much later; exhibitions of water color paintings were held from 1805 by the Society of Painters in Water Colour.

As the early watercolors of birds often used a very few basic pigments, the distinct shades of green and red in birds' plumage were not reproduced exactly. One red pigment was used for all shades of red, from pink to dark wine. By the time watercolors were being used alone, not merely for staining an otherwise complete line drawing, the art of mixing colors to obtain a variety of shades was much more advanced, and the artists' suppliers Messrs. Winsor and Newton and Messrs. Reeve gradually introduced a wider range of tints.

From 1731 hand-colored bird-book illustrations were painted with watercolors in imitation of the ink outline and color washes of the early watercolorists' drawings. For a glossy finish or sheen, egg white or gum water was brushed over

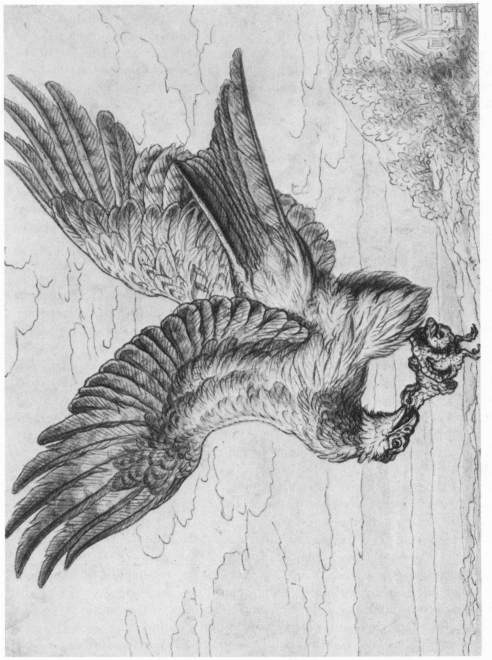

1 / Francis Barlow's drawing "An Eagle Carrying Off a Chicken," 5" by 6⅞", pen and brown ink with gray wash. The etched lines of the print in *Multae et diversae avium species* (1655) followed the strokes of the pen in this drawing.

certain parts of the feathering. These illustrations showed improvement in the veracity of the coloring of the feathers as watercolor materials and technique improved.

The quality of the coloring of the plates varied considerably. Some were carefully executed, while others show signs of hasty application of color. The plates in a few copies of these fine hand-painted folio volumes—those that have been little used and well preserved—look as fresh and glowing today as they did the day they were painted. In much-used copies, the colors have faded and the plates now appear dull.

The first colored illustrations in an English book devoted to birds appeared in Eleazar Albin's *Natural History of Birds* (1731–38), and the first full account of British birds to have hand-colored plates was Thomas Pennant's *British Zoology* (1766). These two books had etched copper plates. Audubon's aquatinted plates were also colored by hand. The last hand-colored plates were produced by lithography and published in the first half of the twentieth century. Thus, even after craftsmen discovered how to print in color in the 1830s, the hand-water-colored plate retained its popularity. Owning a hand-colored print was the next best thing to owning an original watercolor painting.

The size of the figures was determined by the size required for the plates to be made from the drawings, and varied from very small to life-sized. The tiny woodcuts in the margins or surrounded by text in sixteenth- and seventeenth-century books barely gave the artist or craftsman space in which to depict the species accurately. Small birds crowded together spoiled many of Ray and Willughby's copperplate illustrations in 1676 and Pennant's a hundred years later. On the other hand, the small etched bird figures of that excellent artist Francis Barlow are readily recognizable, so it was possible for a good artist and craftsman to execute small but accurate figures in this medium.

The few plates in Walter Charleton's *Onomasticon zoicon* of 1668 were printed on sheets of paper of a size and shape appropriate to the figure of the bird and then folded over to tuck neatly within the outline of the book they illustrated. (See Figure 2.) Thus consistency in drawing the birds to scale or adoption of a book size and format to suit the illustrations was not considered until much later. One frequently finds many species of disparate sizes reduced to the same size and crowded onto a single plate, while another plate in the same book depicts a single bird on a much larger scale.

Mark Catesby's adoption of the folio size of book enabled artists to draw many species life-size, so that problems of drawing many birds to scale were eliminated. Gradually artists who were obliged to draw for octavo- or quarto-sized plates adopted the practice of noting the scale to which they had drawn the figure at the foot of the plate. As this practice was not universally adopted until well into the nineteenth century, most earlier books do not give an accurate idea of the relative sizes of the species illustrated. Since the length of the bird was

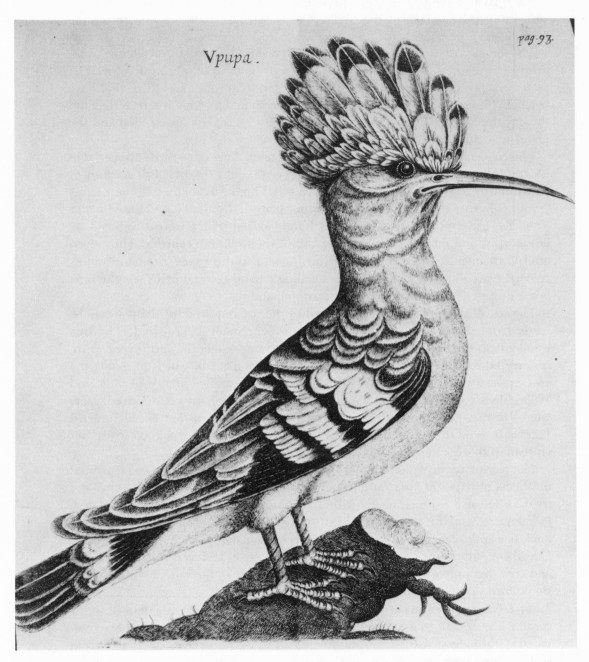

Vpupa.

pag.93.

2 / Walter Charleton's hoopoe *Upupa epops*, killed by a friend within ten miles of London. This was one of six monochrome etchings in the first real attempt to accompany a text with pictures of the birds named, so that the reader could recognize the species. The creased lines in the illustration show where the original print was folded to fit inside the book *Onomasticon zoicon*, a catalogue of British birds published in 1668.

26

almost always noted in the text, the illustrators no doubt thought drawing to scale an unnecessary restriction.

English artists had no difficulty in procuring paper for drawing and writing purposes from the beginning of the fourteenth century onward. There were no standard sizes of sheets for a very long time; the smaller drawing papers were about 16″ by 24″ and the largest sizes less than double that size. Catesby's folio plates were published in the 1730s and other eighteenth-century books were printed on folio-sized paper. At the end of the eighteenth century Messrs. Whatman produced a vellum paper that artists could use for watercolors. It was designed to receive the paint freely and to retain the colors' freshness when dry. This quality encouraged a freer, more vigorous style of painting and contributed to better work in watercolors in the nineteenth century. Machine-made paper was introduced at the beginning of the nineteenth century and was used for ordinary book production, though special de luxe editions continued to be printed on handmade paper.

At the same time that the presentation of the illustrations improved, the design of the plates became more interesting and attractive. The early woodcuts had been monochrome outlines, and so were the first copper-engraved figures of birds. The plates were extremely simple in composition, with the bird figures placed in the center and no further detail added. Ray and Willughby perched their birds on branches of trees, and from their time to the present day, pictures of the bird-and-branch kind are numerous in books about birds. The branch part of the composition is quite literally a sawn-off branch with a few twigs, leaves, and perhaps flowers, on which the bird is perched. Eleazar Albin showed more imagination with a foreground of grass, and he even added some backgrounds on occasion. Not until Mark Catesby collected birds in the southern United States and made his own records of the particular plants that formed the food of individual bird species were the bird figures accompanied by suitable foliage. Even this innovation was accidental, dictated by economics rather than artistic design. Catesby simply could not afford a separate plate for each plant and bird species, so he combined plant and bird on a single plate, sometimes appropriately and sometimes inappropriately. The idea of suitable food plants to decorate a plate designed primarily to illustrate a bird was then adopted by later artists.

Audubon's plates, issued in the 1820s and 1830s, were a revelation of what could be achieved within the confines of a single plate. He painted large vistas of scenery to fill the background of the double elephant folio plates in *Birds of America,* showing the birds in their natural habitats. The only British artist in this period who drew similarly imaginative scenes for his bird figures was George Shield (1804–80). Unfortunately, only six of the double elephant folio plates for his *Ornithologia Britannica* were published, in 1840–41, before the project was abandoned.

Further refinements included the addition of the eggs and nest of the species.

Albin first depicted eggs in *A Natural History of English Song-birds* (1737). Quite early in the history of bird illustration the female of the species had been included, though only if her plumage differed radically from the male's. The more colorful of the two, usually the male, was chosen to illustrate the species. Young and immature birds were neglected until John Gould, as late as 1840, paid a degree of attention to them. Looking back, one wonders why this most attractive phase of bird life was not exploited earlier by illustrators. The bird artists discussed in the following chapters portrayed chicks only as tiny balls of fluff occasionally added as ornaments to an otherwise satisfactory plate.

The birds from which the drawings were made were sometimes alive in aviaries and cages, but more often they were dead and either kept as skins or stuffed and set up by taxidermists. Since very few of these bird artists were also field naturalists, the accuracy of their drawings depended largely on the skill of the taxidermist. Even field naturalists did not sketch in the field, but accepted the conventional poses of the taxidermists for their own drawings. Whichever state their models were in, the results in the book illustrations were similar. Until the nineteenth century, all of the artists' work appears stiff and lifeless.

Another significant reason for the lack of vivacity in bird figures was the use of engraving and etching to reproduce the original drawings. Only when a skilled craftsman was also an artist and had a sympathetic understanding of birds were his figures lifelike, and this combination of virtues was very rare. In nearly every case the original drawing is better than the engraving or etching. In the process of preparing the copper plate, something has been lost.

Many books on birds were published only after their authors had issued successful books on flowers or insects. Alas, illustrating a bird book is not so simple as illustrating a book on flowers, insects, or even fish. Pick a flower, put it in water, and it looks much the same as it did growing in the hedgerow. Pin a dead insect to a board and it will look much the same as it did when alive. Kill a bird and you are left with a sad bundle of feathers. When it is set up it looks stuffed and its glass eye will look glassy in the drawing. If it is kept as a skin, it seems to be gripped in rigor mortis when reproduced in a drawing. The feathers on all specimens fade and the bill, cere, and legs quickly lose their color. Many of our authors and artists found out that birds are not so easy to write about, describe accurately, or illustrate as their earlier subjects had been.

In 1864, for the first time, painters were given copyright on their works. Before that date anyone could, and often did, use an artist's drawing without permission or acknowledgment. We have many instances of copying from other people's illustrations in books. Benjamin Fawcett copied Bewick's tiger, George Edwards complained that his bird etchings were used by unauthorized persons, including potters, and Barlow's etched animals in his *Aesop's Fables* suffered the same fate at the hands of the Chelsea potters. Plagiarism was rife, and few of the copiers even thought to turn the bird around to face in the opposite direction.

THE CRAFTSMEN

For two and a half centuries, bird artists had their drawings reproduced by professional woodcutters, wood engravers, copper engravers, and aquatinters, and by both professional and amateur etchers. (The processes are explained in Appendix B.) The only process that was readily learned by amateurs was etching. Most of the bird artists in this period learned to etch their own plates, among them Mark Catesby, George Edwards, William and Charles Hayes, John Latham, William and John William Lewin, James Bolton, Edward Donovan, George Graves, Prideaux John Selby, and Sir William Jardine. Some bird etchings were done by professional engravers and etchers; Thomas Pennant and John Walcott, for example, employed Peter Mazell. Eleazar Albin and George Graves both employed professional etchers, though Albin may have done some plates himself and Graves certainly did most of his own etching. John Ray employed professional engravers and the nineteenth-century engraver William Home Lizars did some engravings for bird books, but engraved bird illustrations are few in comparison with the large number of etched bird plates. Audubon employed the aquatint firm of Havell to do his illustrations, for this was a skilled operation.

Some of the earliest recognizable birds appeared in prints etched by professional craftsmen employed by Francis Barlow. He issued a series of prints (there was no text) of his paintings of birds, etched by Wenceslaus Hollar and other foreign etchers working in England in the mid-seventeenth century. Barlow drew delightful pictures of birds, all of them lively creatures shown pecking, flying, squabbling, scratching, dabbling, and preening, as in Figure 3. His excellent prints set a high standard of bird portraiture, as his birds were also accurately rendered, but unfortunately they were largely ignored by later artists. The first bird artists to etch their own plates merely copied the style of stiff bird figures done by the early engravers and failed to appreciate the greater freedom that etching would have given them.

Etching had such a great impact on bird-book illustration that we should clearly understand the difference between engraving and etching. Unfortunately, the term "copper engraving" is frequently used for both engraved and etched plates, and some title pages of bird books state that the book contains a number of "engravings" when the illustration process has clearly been etching. The reason for the ambiguity lies in the fact that the finished plate is incised in both cases. The lines of the drawing have been cut into the surface of the copper plate, and these lines hold the ink that then transfers the image to paper. An engraved plate, however, was incised by a graver, an instrument that required a great deal of skill to handle, while an etched plate was incised by acid. In the latter case the artist drew his design with an etching needle through a ground covering the copper so that the copper was exposed to the acid where the needle had passed. When the copper plate was immersed in a bath of nitric acid, the

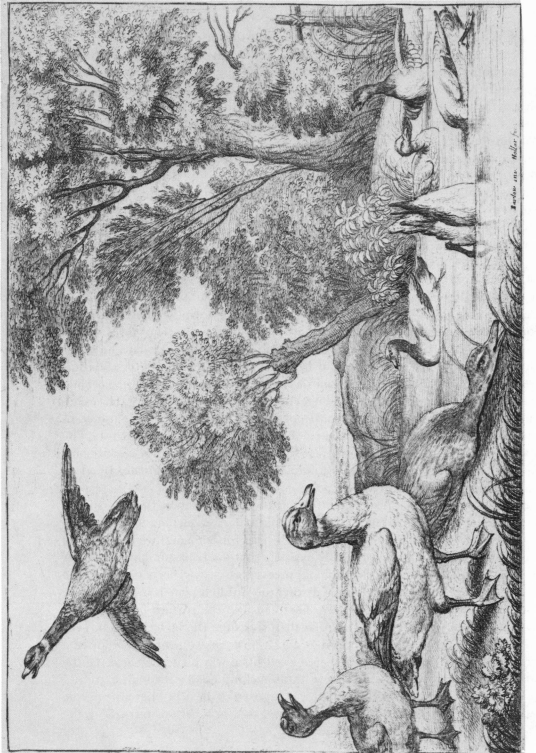

3 / This print by Francis Barlow, 8" by 6", is representative of his vivacious birds. Barlow drew these ducks, which were etched by Wenceslaus Hollar, for the second issue of his book of prints *Multae et diversae avium species* (1658).

acid cut the line into the copper. It was possible, as George Edwards explained, for an artist to learn to etch after practicing "a little while," but a seven-year apprenticeship was required to become a proficient engraver.[3]

It is not always possible, just by looking at a print, to be certain which method has been used to produce a copperplate illustration. Engravers frequently eased their task by using a preliminary etching of the subject, adding details with the graver at a later stage. A mixture of the two methods was often used from the early eighteenth century. Plates mentioned in the following pages as being engraved were basically or wholly engraved, but may have had some etching added. Plates that are stated to be etched were etched in the main, perhaps reinforced with some engraving; sometimes other processes, such as stipple and aquatint, were used for special effects.

The first major book illustrated with engravings was Willughby and Ray's *Ornithologia* of 1676. The engravers whom Ray employed were eminent craftsmen but not naturalists. Their attempts to reproduce the drawings of birds that Ray sent to them disappointed him greatly. He wrote about some of the drawbacks involved in using engravings in his preface. There were three main disadvantages: the author faced the heavy expense of employing a skilled engraver; the artist lost control over the quality of the finished print; and the majority of engravers could not be expected to have a knowledge of ornithology and the ability to engrave lively figures of birds. Bird-book authors and artists learned from Ray's experience, and after *Ornithologia* few bird illustrations were engraved until the work of Lizars appeared in the nineteenth century.

After Ray, etchings were preferred. In the eighteenth century the professional etcher Peter Mazell produced nearly six hundred plates while working in London, from about 1761 to 1797. He etched the illustrations in Pennant's Arctic, British, and Indian zoologies and figures of British species for John Walcott. Some of Mazell's prints were exhibited at the annual shows of the Society of Artists of Great Britain in London, but he was described in their catalogues as a flower painter by profession. His engravings of landscapes were distinguished by their crispness and extreme neatness, characteristics that are also evident in his etchings of natural history subjects.

The first artists who etched their own plates etched the bird very thoroughly; they delineated, for example, all the fine feather markings and the scales on the birds' legs. Later artists realized that a light etching, merely a sketched outline and a few important features such as the eyes and the contours of the wings, was adequate as a basic print. The details were then painted in with watercolors for a much lighter and more natural effect. An outline printed in a soft brown or grayish ink was readily submerged under the paint and the resulting print was like a watercolor painting. Of course, if the etcher planned to sell his book with plain or colored plates, according to the purchasers' choice, then he had to make a more thorough job of the etched figures for the sake of those who wanted their plates uncolored. Selby's book could be purchased plain or hand-colored, and

his etchings are so thorough that it is debatable whether the colored plates have anything more to offer than the monochrome versions.

The Edinburgh firm of Lizars (father and son) was responsible for printing some of the most important illustrations in books about birds in the first half of the nineteenth century. The founder of the firm, Daniel Lizars, was succeeded at his early death in 1812 by his son William Home Lizars, (Figure 4), whom he had taught to engrave and etch. William Lizars was a very good artist and would have preferred a career as a painter. He had been trained in the Trustees' Academy in Edinburgh and his talent was of value to a number of bird artists and authors. When Audubon went to him in 1826 to get his drawings engraved, Lizars had already been at work for some time on Prideaux John Selby's *Illustrations of British Ornithology,* printing Selby's etchings and adding finishing touches to them when necessary. Sir William Jardine naturally turned to Lizars, his brother-in-law, for help with his joint publication with Selby, *Illustrations of Ornithology,* and the even larger task of reproducing more than a thousand plates for his Naturalist's Library series. Lizars used steel for these small illustrations, which had extremely fine details. Lizars also printed twenty bird plates for James Wilson's *Illustrations of Zoology* in 1831. Lizars produced some rather stiff figures from Wilson's drawings, which were then colored by hand. Given good drawings, Lizars made good prints, but even this artist-craftsman could not put life into poor drawings.

Lizars also did some plates for periodicals. A few etched and engraved plates signed by him were included in Jardine's *Contributions to Ornithology* (1848–53), but most of the illustrations were lithographed and some were produced by papyrography. By the time the work on this bird book was completed, lithography had almost completely superseded copper engraving as a medium for book and periodical illustration. When Lizars died, in 1859, the greatest of the bird illustration engravers passed away, and the use of metal to produce those illustrations died with him.

THE AUTHORS

The typical early author published only one bird book; the prevailing fashion in the seventeenth and eighteenth centuries was to be recognized as a good all-round naturalist rather than as an expert on any one subject. Our authors may therefore be considered to be aspiring naturalists. This is probably the only factor they have in common. Otherwise, they were as diverse as any random cross section of the educated British public could produce. Their number included members of the gentry (Willughby, Pennant, Walcott, Jardine, and Selby), artisans (Graves), scholars who had been fortunate enough to be supported at a university (Ray), men with less learning but brought up as gentlemen (Hayes

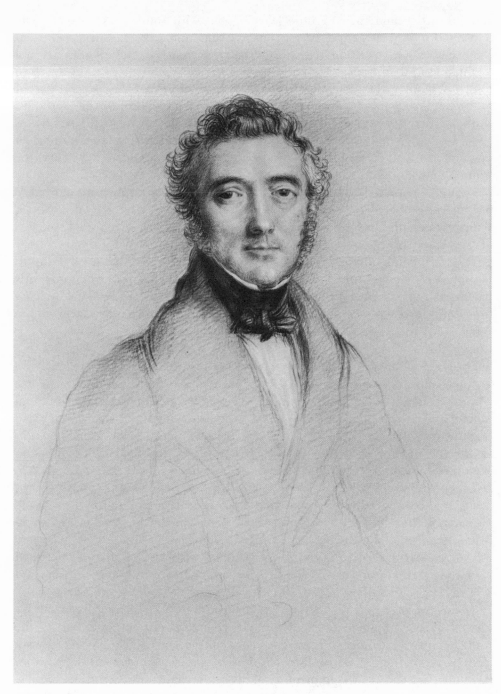

4 / John Flaxman's portrait of William Home Lizars (1815), now in the Scottish National Portrait Gallery. Lizars, an Edinburgh engraver, was responsible for some of the best illustrations in the first half of the nineteenth century. Besides being a very good engraver and etcher, he was an artist of some merit and was elected a fellow of the Scottish Academy at its founding in 1826.

and Edwards), and men of little learning but with some artistic ability who depended to a great degree on patronage (Albin and J. W. Lewin).

Since they were writing scientific texts, their religion and politics are not mentioned in their books. We know that most were members of the Church of England, that Graves was a member of the Society of Friends in the early part of his life, and that John Walcott gave his allegiance to a schism of the Methodist church. Their writings express their wonder and excitement as further truths about God's creation were revealed. Edwards, who dealt with a large number of new and exotic species, expressed his delight and awe by dedicating "to God" the volume he considered to be his finest achievement.

Though our period covers some of the most momentous upheavals in English history—the Civil War, the plague and fire of London, the arrival of Dutch William and German George, the Agrarian and Industrial revolutions, the loss of the American colonies—little of this history intrudes. We are sure of the political affiliation only of Pennant, Jardine, and Selby. Pennant, recalling his meeting with Samuel Johnson, the lexicographer, says that Johnson apparently received an utterly wrong impression of him. Johnson said of Pennant, "He's a whig, Sir, a sad dog!"[4] Pennant was in fact a moderate Tory. Selby was certainly a Whig, but his close friend and co-author, Sir William Jardine, was a Conservative.

The greatest impact on the lives and work of the authors and artists came from the mechanization of the printing trade and the speeding of communications. Monthly issues of books and periodicals were carried to all parts of the kingdom by road and rail. The exploration of new countries brought particular benefits to English ornithologists because so much of the exploration done in the eighteenth and nineteenth centuries was carried out by the British. Traders and explorers took back to England many species new to science. Though Englishmen had been much slower than European zoologists to produce bird books, in the hundred years after ornithology was made popular by Pennant at the end of the eighteenth century, more books on birds were produced in Britain than in all the European countries together.

The reasons that these authors wrote books on birds are diverse. Some of them state their reasons in prefaces or advertisements for their books. Albin and William Hayes published in order to provide some income for their large families. George Graves was brought up as a colorer of natural history plates and his whole background was connected with books and publishing. Members of the landed gentry were more interested in science for its own sake and the establishment of reputations as naturalists than in the financial returns on their books. Ray published *Ornithologia* in memory of his dead friend and patron, Willughby. Edwards, Hayes, Lewin, and Bolton were all painters of natural history objects for aristocratic clients and had a collection of paintings done over the years. Later in life they wrote short texts to complement their pictures and published books.

The authors could fill out the knowledge they lacked by copying paragraphs or whole chapters from other books without compunction or acknowledgment—until 1710. In 1709 the Copyright Act was passed, and for the first time British authors and publishers were given statutory protection. Books already in print were given a copyright of twenty-one years from 10 April 1710. New books had a copyright of fourteen years; if the author were still living at the end of that time, copyright was renewed for a further fourteen years. Painters and engravers then began to agitate for copyright protection for their works, and in 1735 the bill that became known as Hogarth's Act was passed, but it was never so effective as the legislation establishing copyright for authors and publishers. Foreign books were still considered legitimate sources and copied by English authors during the nineteenth century.

Publishing a book was a very expensive undertaking, and some bird books would never have appeared in print had their authors not had wealthy patrons. Some authors published their own books, in parts, and financed the later parts from the subscriptions collected from the earlier parts. Wealthy authors financed their own publications, and one, Edward Donovan, was ruined by his publishing ventures.

It was a precarious way to earn a living, as Graves and Hayes found to their cost. Because publishing was such an expensive business, a large percentage of our authors were their own artists and etchers, some also their own publishers. Even such wealthy men as Selby and Jardine drew their own illustrations and made the plates from which the illustrations were printed. None, however, could manage to issue a book without a great deal of help from friends and colleagues. Since it was necessary to describe and draw many specimens, a wide circle of friends was the only way to ensure access to sufficient material for a book. These same people were counted on to buy enough copies of the book to avert a financial loss.

THE PATRONS

The purchasers of the bird books from the sixteenth to the nineteenth century belonged to an elite class of educated and wealthy men and women. But by the second half of the nineteenth century, a much wider public was being reached by Sir William Jardine, who set out to produce inexpensive illustrated works on natural history which the middle classes could afford. Before the 1830s, when Jardine issued the small six-shilling volumes of his Naturalist's Library, only a very small section of the community could afford to pay one or two guineas for each part of a large illustrated volume.

The first English bookshops opened in the eighteenth century. Their stock consisted of books on gardening, law, politics, religion, and natural history, bought either from wholesalers or directly from authors who had their own books printed. Such authors counted heavily on private subscriptions by friends,

patrons, and acquaintances in scientific societies. Among our bird authors only Donovan's relations with the booksellers are well known; he contracted to share the profit equally with his bookseller but was cheated out of most of his half. Gilbert White's brother, Benjamin White, was a bookseller in London, and his shop sold bird books during the last quarter of the eighteenth century and the early nineteenth century.

Other authors and members of scientific societies purchased bird books, and we have some letters between bird-book authors in which they arranged to exchange their publications with one another. These arrangements made good economic sense and had an additional advantage: since the books were nearly always published in parts, a letter from a fellow ornithologist acknowledging receipt of a recently issued part often also conveyed additional information on the species described in it and corrections to be made, with offers of specimens and information for future issues. Such institutions as the Royal Society Library also subscribed, as did foreign authors and institutions. The first books published in England were in Latin, the universal language of educated people all over Europe. In the eighteenth century, English bird books frequently also included a French text, which widened their market considerably. The authors were voluminous letter writers and had correspondents in many parts of the world, so selling abroad was no problem.

Patronage took two forms, either financial aid and encouragement or the granting of free access to collections of drawings and specimens. The patrons were wealthy aristocrats and landed gentry, such as the Duke and Duchess of Portland, Sir Hans Sloane, and Sir Joseph Banks. These people were keenly interested in science and helped to promote voyages of discovery, more often than not purchasing the natural history items brought back from such expeditions. They were influential members of the learned and scientific societies and gave financial backing to those societies' projects and to the naturalists whom the societies employed to collect specimens abroad. Mark Catesby's expedition to North America was made possible by this kind of support.

The patrons had excellent libraries and subscribed to at least one copy of a client's bird book, sometimes several copies. They frequently collected original watercolor drawings of natural history objects, and a number of our bird artists drew for aristocratic clients as a means of livelihood. To a large extent aviaries, menageries, and museums were privately owned until the nineteenth century, and since such a collection might well contain a unique specimen of a bird—unique, that is, to England or even to Europe—the author and artist had to obtain permission from its owner to use it. Some specimens of new species remained hidden in collections for many years and were discovered only when the collections were visited by an ornithologist or sold. To their great credit, many owners of large collections were extremely liberal in allowing naturalists to use the contents of their museums and aviaries.

Those authors who were supported by many patrons before their bird books

were published, such as Albin, Catesby, Edwards, and Lewin, covered their costs and may have made a profit. An author who had little or no patronage found it very difficult to obtain sufficient subscribers to make publishing profitable. Audubon had difficulty in selling his book, while Hayes lost his patrons through untimely deaths and so had insufficient patronage while he was publishing.

Some authors had no need of financial support, but because they chose to write about foreign bird species, usually rare or newly discovered, they had to rely heavily on the owners of bird skins. Jardine and Selby paid their own collectors in Africa and elsewhere, but also sought the cooperation of many museum curators and private owners of specimens. The value and importance of these collections as sources of bird specimens cannot be overestimated.

THE SPECIMENS

Obtaining the bird model, alive or dead, presented difficulties we can hardly imagine nowadays. Bird skins were not collected until the seventeenth century; it was not possible to keep skins for any length of time before that date, as the methods of preserving them had not then been discovered. Nehemiah Grew's catalogue of the Royal Society museum, published in 1685, contains an early reference to the first method of preserving bird specimens. On page 58 Grew listed "a young LINET, which being first embowel'd hath been preserved sound and entire, in rectified spirit of wine, for the space of 17 years. Given by the Honourable Mr. [Robert] Boyl. Who, so far as I know, was the first that made trial of preserving animals this way." James Petiver (1663–1718) dried skins in an oven. Until Boyle and Petiver made known the results of their experiments, few attempts were made to keep bird specimens, and collections of birds were rare until the early nineteenth century.

Once it was found that a skin could be kept in good condition so that it could be used as a model for artists over a number of years, the interest in the importation of foreign specimens grew. Catesby used two methods of preparing bird skins for shipment from America to England: some were dried and some immersed in alcohol. These methods were crude and the stiff portraits drawn from such specimens show them to be in the grip of rigor mortis, with the skin stretched out so that the bird was elongated. The soft parts, including the eyes, were removed. Unless a note of the colors of the eyes, bill, and legs had been made while the bird was alive or freshly killed, the artist would not know what color to give them. One reason for the faulty coloring of early bird plates can be traced to careless note taking when the specimen was killed. A large number of bird portraits have wrongly colored eyes until well after our period ends.

With the growing interest in natural history collections at the beginning of the nineteenth century, the prices of rare birds and eggs rose sharply, providing an incentive to sportsmen to obtain specimens. (See Fig. 5.) Every one of our bird

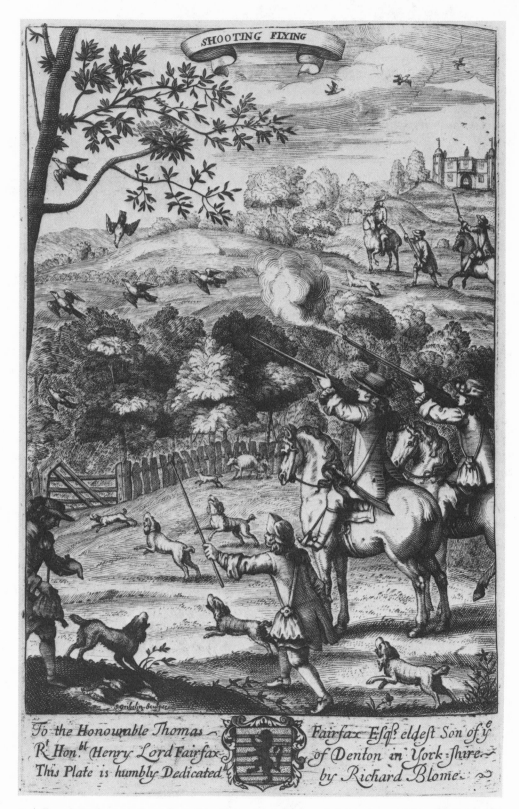

SHOOTING FLYING

To the Honourable Thomas Fairfax Esq.ᵗ eldeſt Son of yᵉ Rᵗ Honᵇˡ Henry Lord Fairfax of Denton in York-ſhire This Plate is humbly Dedicated by Richard Blome.

5 / Francis Barlow was the author of the first print depicting wing shooting, or "shooting flying," as he called it in 1686 (in Richard Blome's *Gentleman's Recreation*, pt. 2, p. 125). At this stage and for many years to come, the gun was almost as dangerous to the shooter as to pheasants and ducks.

authors and illustrators mention having received specimens from friends and sportsmen, and some obtained their own specimens. A great deal of interest was then taken in where the specimen had been shot, and the many references scattered through the literature of the period later formed the basis for the compilation of British county avifaunal records.

The more colorful male was usually the specimen to be taken when there was a choice. Not until Audubon made strenous efforts to obtain the pair of each species was this more logical manner of collecting birds established. Before Audubon's time, the male and female, if of different plumage, were frequently thought to be entirely different species. Unless the birds were caught and dissected in the breeding season, it was most difficult to pair them (birds' sexual organs diminish after breeding and remain shrunken until the next breeding season). There was much confusion over male and female members of the species, and even greater confusion between a bird in spring plumage and the same bird in autumn/winter plumage. "Red godwits," for example, abound in eighteenth-century bird books, all of them thought to be quite different species from the black and bar-tailed godwits, (*Limosa limosa* and *Limosa lapponica*). Chicks were not collected, but as eggs were easily stored, they received some attention.

About a third of the British bird authors and artists worked from foreign bird specimens. During the hundred years from 1670 to 1770 naturalists had to be content with the descriptions of any animals and birds that sailors had shot or clubbed to death, mainly for fresh meat, during the course of a voyage. Naturalists began to take an interest in these strange creatures, and the vagueness of the descriptions in the published journals of the voyages whetted their curiosity. It was tantalizing to have just enough information about a bird to know it had never been described before but insufficient detail to classify, describe, or name it for science. The references in books by William Dampier in the 1660s are of this nature.

Sailors gradually became aware that if they brought whole skins back with them, or a foot or a beak, they could sell them for handsome prices. The earliest natural history collections boasted ownership of the only foot belonging to a bird species in the whole of the United Kingdom. Bringing back live specimens proved more difficult, for they not only had to be housed in an already overcrowded ship but supplied with suitable food, sometimes for months, until the ship reached its home port. The price that aristocrats were willing to pay for colorful parrots and such exotics as the "laurey" shown in Figure 6 made the trouble worthwhile, but there must have been many casualties on board. It is surprising how many live birds reached England, even in the seventeenth century, but they were mainly seed eaters. With the advent of the steamship, the length of voyages was cut and it became easier to transport live specimens.

Naturalists recognized that haphazard collecting by sailors was unsatisfactory and that they must go to foreign countries themselves and collect on a more

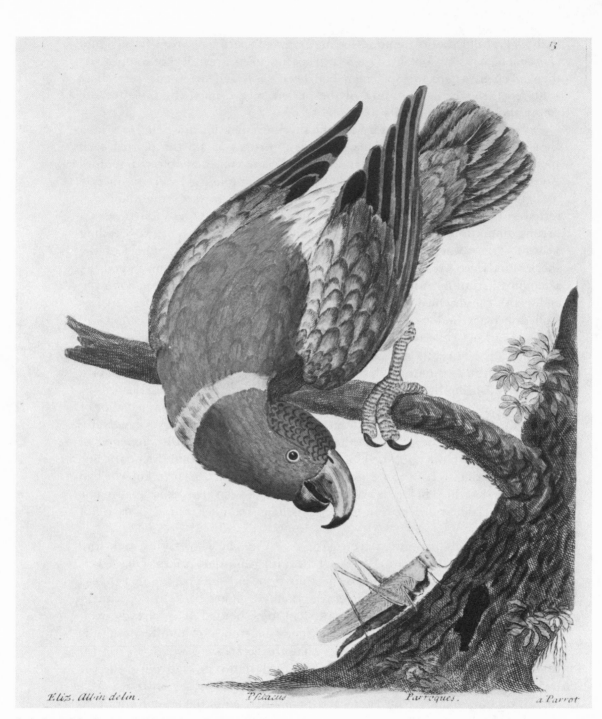

/ One of the live exotic birds imported into England in the early eighteenth century. Eleazar Albin's daughter drew this "Laurey from the Brasils," a very articulate bird, for Plate 13 in vol. 1 of his *Natural History of Birds* (1738). Albin said that "Mr Bland at the Tyger on Tower Hill sold one for 20gns. He had a great collection of foreign birds." Albin's picture represents no known species, though it approximates more closely a yellow-bibbed lory (*Lorius chlorocercus*) in its coloration than any other lory. The gold collar of the yellow-bibbed lory, however, is under its chin, not around the back of the neck.

systematic basis. It became the practice, therefore, for a botanist and a zoologist to accompany a voyage, though often the ship's surgeon would double as botanist, since he had some knowledge of herbs and plants. An artist was sent too, mainly to record the natives and landscapes of new regions, but he also drew the flora and fauna. When it was still difficult to transport bulky specimens, the advantages of drawing a new species are obvious. The custom of sending scientists and artists on expeditions started when Sir Joseph Banks accompanied Captain James Cook on his voyage around the world in 1768–71. Banks later sent other naturalists on voyages, and in his capacity as president of the Royal Society used his influence to persuade the society to sponsor naturalists to accompany voyages of discovery. Among the beneficiaries of Banks's efforts was Robert Brown, who accompanied Captain Matthew Flinders in H. M. S. *Investigator* in 1801 and sent back some of the earliest specimens of Australian birds. The Linnean Society also encouraged explorers. It was not until 1831, however, that the British government took a direct interest in accounts of the wildlife encountered on such expeditions. In that year the government granted £1,000 toward the cost of publishing lithographs and wood engravings after drawings by William Swainson, depicting the products of the North American fur countries, in a book titled *Fauna Boreali-Americana*.

In 1839 *The Zoology of Captain Beechey's Voyage to the Pacific in the Blossom during the Years 1825 to 1828* was published. The birds, among them several new species, were described by Nicholas Aylward Vigors, and Edward Lear drew the designs for the twelve hand-colored copper plates executed by John Christian Zeitter. The Lords Commissioners of the Admiralty, under whose auspices the *Zoology* was published, lent its active support to numerous expeditions thereafter. The illustrated account of the specimens collected is a far cry from the incidental comments on birds and crude woodcuts in William Dampier's account of his voyage around the world, published in 1697. The method of preserving specimens, however, had changed hardly at all since Catesby's expedition to Carolina in 1722–26. In 1839 Joseph Dalton Hooker recorded: "We had rum as preservative from the ship's store."[5] No wonder the sailors sometimes resented the presence of naturalists on board!

In the nineteenth century the collections brought back were usually kept together and handed over to competent naturalists, often at the British Museum or the Zoological Society. Before that time the collections were frequently split up and sold to individual collectors, who might be interested in the specimens only as curiosities. Many valuable specimens lay undescribed for years in the museums of Sir Ashton Lever and William Bullock. The catalogue of the sale of their museums describes many lots as "non-descripts" and "species unknown."

Other foreign specimens came from governors of colonies who sent out native collectors and sometimes also employed native artists to draw the local flora and fauna; missionaries who were interested in natural history; tea merchants and other traders, many of whom traded with the East India Company and some in

the north with the Hudson's Bay Company; soldiers with these companies; and captains and ships' personnel.

The earliest natural history collections were made by two men who went on voyages themselves and so acquired a taste for foreign rarities. They brought back a nucleus collection to which they added in later years. John Tradescant took home some skins of birds from his Russian journey of 1618, including a "Gorara bird or Colymbus bird" (a diving bird of some kind) listed in *Musaeum Tradescantianum*. There were also some "Virginia birds" in this first museum of natural history in England, and until about 1691 a stock of living birds in the gardens at Lambeth, the home of the Tradescant family. These were the descendants of birds taken to England by John Tradescant, Jr., from one of his three visits to Virginia in 1637, 1642, and 1654. From this wide-ranging collection our earliest pictures of cassowaries, emus, hummingbirds, ostriches, tropic birds, and birds of paradise were drawn.

Another notable collector was Sir Hans Sloane, who had traveled in Jamaica, Barbados, Madeira, and St. Christopher–Nevis. His account of his fifteen-month stay briefly described eighty-two birds and gave their measurements and other features of special interest. Sir Hans Sloane's collection was used by Ray and Edwards.

The third great collector of the seventeenth century was James Petiver, who maintained a museum from about 1693 to 1718, when it was bought by Sloane. Petiver helped Ray with some birds for his *Synopsis methodica avium* (completed about 1696). Petiver had an extensive acquaintance among seafaring men and with their help established an almost worldwide correspondence with people interested in natural history. Unlike Sloane's collection, Petiver's was disorganized, and after his death it took months to sort out the heaps of rare specimens and skins.

In the eighteenth century the numbers of private museums with natural history objects increased rapidly. Marmaduke Tunstall's museum was a source of birds for many artists and authors, including Peter Brown, Thomas Bewick, and Thomas Pennant. Sir Ashton Lever's museum was of vital importance to W. F. Martyn, John Latham, John Walcott, William Lewin, and Edward Donovan.

Many authors of bird books had their own specimens and skins. Some collections were modest but others became famous. Latham's museum, in Kent, attracted many visitors, and was especially useful to William Lewin, a near neighbor. The northern artists Selby and Jardine had good collections of their own, though they also borrowed many specimens, and comments by Bolton, Lewin, and Graves indicate that they had some skins in their possession.

Two trading companies established their own museums. The Hudson's Bay Company's museum of stuffed birds in Fenchurch Street, London, included objects from "Rupert's Land," and Oriental species in the museum of the East India Company were used by Jardine and Selby.

The birds in the museums of the scientific societies were available to their

members. The Royal Society had a valuable collection that included the leg of a dodo, a puffin, many small unnamed birds, pelicans, toucans' heads, birds of paradise, and a treasured flamingo. We do not know which species they were, for the catalogue is vague. Charles II frequently exhorted the East India Company's merchants to bring back waterfowl for his ponds in St. James's Park. Ray and Barlow used the living birds in Charles's collection as subjects for their drawings. Charles was patron of the Royal Society and no doubt took an interest in its museum. This collection increased until 1779, when the British Museum took it over. Artists and authors who were members of the Royal Society and had access to its collections were Ray and Willughby, Catesby, Edwards, Pennant, and Latham.

When it was founded in 1789, the Linnean Society started collecting specimens, but its collections were never properly organized. It had a number of birds in its museum from 1789 to 1863, when it ceased to compete with the British Museum. Latham, Lewin, Graves, Selby, and Jardine were members of the Linnean Society.

The resources of the Zoological Society Museum chiefly benefited the lithographers of the nineteenth century, though Sir William Jardine found it a useful source for specimens, particularly while John Gould was a member of the museum staff, from 1827 to 1837. In 1855 this collection was dispersed, and many of the birds eventually found their way to the British Museum. Thomas Eyton and other ornithologists bought some of them in 1855 and then left the specimens to the British Museum when they died.

The universities had some good collections; Edinburgh University was outstanding in its early formation of a natural history museum. Jardine and Selby were given permission to use it, and William MacGillivray, an assistant curator who was himself an author, befriended Audubon.

The specimens in these many collections formed the subjects in the bird books published from 1660 onward. With the opening up of new trade routes and the exploration of new countries at the end of the eighteenth century, the trickle of newly discovered birds turned into a flood. To keep pace with these new species, the authors had recourse to many forms of literature.

THE BOOKS

Bird books were nearly always issued in a series of parts consisting of five or more plates and accompanying text. The subscriber had these sheets bound in a style to suit his own taste and to conform with other bindings in his private library. Authors sought their own subscribers and delivered sheets directly to them, since publishers and booksellers were not numerous until the nineteenth century. (A detailed description of the arrangements for issuing books is given in my earlier book *Bird Illustrators: Some Artists in Early Lithography* [1975].)

Books varied in coverage from broad surveys to detailed treatments of small groups of birds. At the beginning of our period, authors attempted to be comprehensive and wrote dictionaries and encyclopedias of natural history. W. F. Martyn's *New Dictionary of Natural History*, an early example of this type, claimed to be a "complete universal display of nature." Its two volumes, published in 1785, contained 344 figures of birds in 100 hand-colored plates. The drawings were based on specimens in the Lever Museum. Though Lever's was the finest zoological collection in Britain, its ornithological section was not comprehensive, and neither was Martyn's dictionary. The first dictionary devoted entirely to birds was compiled by Colonel George Montagu and published in 1802. The frontispiece of *Ornithological Dictionary* was a hand-colored steel engraving/etching of the cirl bunting (*Emberiza cirlus*). A supplement, issued in 1813, included twenty-four plates; the second edition of 1831, by James Rennie, was illustrated with some poor wood engravings by Eliza Dorville.

As naturalists found it increasingly difficult to cover the whole of natural history, they concentrated on specialized groups. Early accounts of a county's geology, natural history, and antiquities, such as Richard Carew's *Survey of Cornwall*, published in 1602, gave way to publications restricted to the natural history of an area. The earliest of these books were by Robert Plot, who as the first keeper of the Ashmolean Museum at Oxford was in an ideal position to write *The Natural History of Oxfordshire* in 1677, with sixteen plates by the artist and engraver Michael Burghers. This volume was followed in 1686 by his *Natural History of Staffordshire*, with thirty-seven plates engraved by Burghers from Joseph Browne's drawings. Not until 1809 did a book dealing solely with the birds of one county appear. Andrew Tucker of Ashburton, in Devon, called his excellent book *Ornithologia Danmonensis*, but unfortunately failed to complete his work. Seven plates were published, four of them signed "W. R. Jordan delin. I. Warner sculp." The birds shown were a male and female sparrowhawk (*Accipiter nisus*), a red-backed shrike (*Lanius collurio*), a woodlark (*Lullula arborea*), a green woodpecker (*Picus viridis*), a yellow wagtail (*Motacilla flava*), and a young hen harrier (*Circus cyaneus*). The foreground was aquatinted, and the birds also had some aquatinting and stipple in addition to line engraving. The book was planned to be sold either monochrome or hand-colored. Later county avifaunas failed to emulate this fine example, and few were well illustrated.

Among the scientific books, arranged systematically and giving full physical descriptions of the species, were three outstanding illustrated textbooks on British ornithology: Ray and Willughby's *Ornithologia* in the seventeenth century, Pennant's *British Zoology* in the eighteenth century, and William Yarrell's *History of British Birds* in the nineteenth century. The texts of the first two were illustrated with metal-plate figures, but Yarrell chose wood engravings. The outstanding book about the British avifauna in the nineteenth century illustrated with metal-plate etchings was Selby's *Illustrations of British Ornithology*. Selby's separately printed text, however, did not match the meticulously high standard

of Yarrell. Willughby and Ray had attempted to include all known bird species; Pennant confined himself to British species and was emulated by later authors.

It was not until the nineteenth century that separately published monographs on bird families were attempted, and very few were illustrated with line engravings, as lithography had superseded metal engraving by the time they were published. The volumes of Jardine's Naturalist's Library which dealt with a single family, such as parrots, hummingbirds, or flycatchers, had steel etchings and engravings, such as the one shown in Figure 7. A volume on parrots in the rival Miscellany of Natural History by Sir Thomas Lauder and Captain Thomas Brown had thirty-five hand-colored engravings. These are among the very few line engravings in bird monographs.

The keeping of birds in captivity has always appealed to the British. In the eighteenth century this taste was catered to by Eleazar Albin and James Bolton, who wrote about songbirds and how to look after them. Patrick Syme, Robert Sweet, and John Cotton continued this tradition in the nineteenth century. Patrick Syme, of Edinburgh, was a drawing master and colorer of natural history plates. His *Treatise on British Song-birds*, published in 1823, had fifteen hand-colored plates by Robert Scott. The text is an unusually well-written account of thirty-three species. Edwin Dalton Smith was the artist for Robert Sweet's *British Warblers*, published from 1823 to 1832. Sweet kept most of the *Sylviidae* in captivity at one time or another. The original issue had six plates, another had twelve plates, and a later edition was expanded to include sixteen plates. The care with which Smith and Sweet designed the plates and provided appropriate plants in the background made this a most attractive book. The coloring of the life-size figures in John Cotton's *Resident Song Birds of Great Britain* was not nearly so good. All issues of this book should have thirty-three colored plates, published in two parts, but copies vary in the number of plates present. Such books gave instructions on how to maintain birds in a healthy condition, how to feed them, provide for their nesting requirements, and treat the young. Some of these books were links in the long chain of development of bird illustration and so deserve to be mentioned, especially as British wild birds were often the occupants of the cages. The books were short, and dealt with a few species among the warblers, thrush family, larks, and buntings, and the favorite songbird, the nightingale (*Luscinia megarhynchos*).

A few authors abandoned their publishing activities for various reasons. Some may have failed to attract the necessary subscribers, others to find sufficient material. Among those who published only part of their projected titles were George Shield, who issued six double elephant folio plates in 1840–41; H. Whiteley, who about 1846 managed to issue three parts of a work on tits and finches, each part with seven hand-colored octavo etchings of birds and one of eggs; William Weston Young, who was working on octavo plates around 1804; and Charlotte Perrot, who issued one part consisting of five plates in 1835 but died the following year.

SPECTACLE TODY

7 / One of William Home Lizars' etched steel plates for Sir William Jardine's Naturalist's Library series. The spectacle tody (*Platysteira cyanea*) from West Africa was drawn by William Swainson to illustrate his monograph *Flycatchers*, published in 1838 (Ornithology, vol. 10, Plate 22). The original size of this plate was 4″ by 7″. Here it is enlarged to show the extremely fine detail that Lizars achieved by working on steel.

The use of journals and magazines is the most significant development in our period. Many of the books that might have contained notices of new species took years to complete, whereas it was possible to get an article published in a journal in a matter of months or even weeks. (These publications, too numerous to mention here, are listed in Appendix C.) Ornithological journals flourished during the time when many new species were being discovered abroad and much new information about the native British birds was being recorded. The value of magazines as vehicles for the speedy dissemination of such knowledge was quickly recognized and exploited by imaginative authors and artists.

In the following chapters the work of some very good artists and craftsmen is reviewed. Their books were published in Britain through two centuries, from 1676 to 1853. Among them John James Audubon was outstanding, and Prideaux John Selby was among the best English artists of the period. The outstanding craftsmen were William Home Lizars and Robert Havell. When the two came together—Audubon and Havell, Selby and Lizars—the results were superb. Their books are the highlights in bird illustrations made with metal plates. Though the other artists may not be in the same high category, their work was good, often very good, and each had his own contribution to make toward the development of bird-book illustration.

2

Francis Willughby
(1635–1672)
and
John Ray
(1627–1705)

"OUR main design was to illustrate the History of Birds," wrote John Ray in the preface to the first systematic treatise on birds, which formed the foundation of British ornithology. Ray and Willughby's *Ornithologia libri tres,* written in Latin and published in London in 1676, was the first illustrated comprehensive guide to birds to be published in Britain. The illustrations were engraved on copper or brass and the prints left uncolored. Two years later an English translation was issued under a very lengthy title, which explained that all the birds so far known had been accurately described by a method suitable to their natures and illustrated "by most elegant figures, nearly resembling the live birds." The title claimed more than we should allow nowadays, but this first British illustrated guide to birds was a remarkable achievement at the time of its publication.

John Ray and Francis Willughby had become acquainted at Cambridge University. Willughby, a fellow commoner at Trinity College, was said to be such an

ardent student that he "did much weaken his body and impair his health."[1] He entered Trinity in 1653 and received a B.A. degree in 1655/56, then an M.A. in 1659. Ray, who had been at Cambridge since 1644, was elected a minor fellow of Trinity in 1649. In the same year he established his reputation as a naturalist with the publication of a catalogue of the plants to be found growing around Cambridge. In 1661 Ray resigned his fellowship rather than subscribe to the Act of Conformity. Thereafter he was provided for by Willughby, who became, in effect, his patron as well as his friend. Ray earned additional income from his books and articles.

In background the two were quite dissimilar. Ray was baptized at Black Notley, near Braintree in Essex, on 6 December 1627. His father, John Wray, was the village blacksmith. Willughby was born at Middleton Hall, one of his family's homes, near Tamworth, Warwickshire, in 1635. He succeeded to the Middleton estate and to the family seat at Wollaton, in Nottingham, in 1665.

Ray formed the habit of making extensive botanical tours in the summer months, and Willughby joined him in 1662. They traveled through the north midland counties and Wales, and then Willughby left Ray in Gloucestershire. Willughby collected specimens for the museum he was building up while Ray made notes of the journey and botanized. We know that among the many birds they saw were gulls, cormorants (*Phalacrocorax carbo*), puffins (*Fratercula arctica*), razorbills (*Alca torda*), guillemots (probably the common murre, *Uria aalge*), terns, and near Padstow in Cornwall "great flocks of Cornish choughs" (*Pyrrhocorax pyrrhocorax*).[2]

Willughby's name appeared among those of the original founders of the Royal Society on its incorporation 1663/64, but Ray was not numbered among its fellows until 1667. At the Royal Society they met such famous people as John Evelyn, Sir Christopher Wren, and Christopher Merrett, the ornithologist who made the first attempt to list all known British birds, in 1666. Another fellow member, Samuel Pepys, was presented with a beautifully bound copy of the 1678 edition of *Ornithology*, with all the plates most carefully hand-colored. Emma Willughby, Francis' wife, distributed the small colored edition. Pepys's copy is now preserved in the McGill University Library, Montreal.

In the spring of 1663 Willughby and Ray ventured farther afield. They spent that year and part of the next two years journeying through Europe, in company with two students, Nathaniel Bacon and Philip Skippon. Their object was to collect as much material as possible for inclusion in a publication that would provide a systematic account of the animal and plant kingdoms. They divided the labor according to their interests, "and forasmuch as Mr Willughby's genius lay chiefly to animals, therefore he undertook the birds, beasts, fishes and insects, as Mr Ray did the vegetables."[3] They kept detailed journals, but after traveling through the Netherlands, Germany, Switzerland, and Italy they had to hurry home through France because that country was at war, and they lost some of their valuable records.

WILLOUGHBY

[signature]

Engraved for the Naturalist's Library

8 / Francis Willughby and John Ray in portraits engraved by William Home Lizars for Sir William Jardine's Naturalist's Library series. Lizars based his engravings on H. Meyer's engraving after a portrait of Ray in the British Museum and on an oil painting of Willughby at Wollaton.

JOHN RAY.

At Cologne they saw hoopoes (*Upupa epops*) on the last day of June 1663. One of the party shot a golden oriole (*Oriolus oriolus*) near Frankfurt, and they discovered hawfinches (*Coccothraustes coccothraustes*) to be quite common there. Less common, but no doubt as exciting to them as any new bird is to us, was a black stork (*Ciconia nigra*). They visited markets wherever they went, for a new species might well be found on the poultry stall or confined in a cage. In Ratisbone market, in Bavaria, they picked up a great black woodpecker (*Dryocopus martius*), and they found that the live-bird shops in Vienna offered them close views of serins (*Serinus serinus*), citril finches (*Serinus citrinella*), and crested larks (*Galerida cristata*). At the Modena market, which they visited in February 1664, they came across a great bustard (*Otis tarda*) hanging up. In Venice, that city of waterways, their discoveries were mostly waterbirds: ruff (*Philomachus pugnax*), avocet (*Recurvirostra avosetta*), water rail (*Rallus aquaticus*), little egret (*Egretta garzetta*), a sea eagle (*Haliaetus albicilla*), goldeneye (*Bucephala clangula*), and tufted ducks (*Aythya fuligula*), as well as bramblings (*Fringilla montifringilla;* Figure 9) in profusion. In Rome they enjoyed the sight of a little owl (*Athene noctua*) and made the acquaintance of the learned Sir Thomas Browne, who was to prove helpful with their

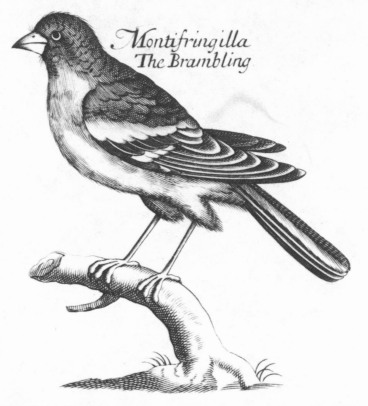

9 / Frederick Hendrick van Hove's engraving of a brambling (*Fringilla montifringilla*), one of six birds in Plate 45 of Willughby and Ray's *Ornithology* (1678).

book by sending Ray drawings, specimens, and observations from that time on. Sir Thomas made colored drawings and sketches of many species himself. He had had drawing lessons as a student at Winchester College and was a competent artist.

Willughby bought the materials they collected. At Strasbourg he purchased a number of pictures of birds, together with descriptions of them, from a book by Fischer Leonhard Baldner, which included among its plates fifty-six colored illustrations of birds. Baldner, a fowler and fisherman, had employed an artist to draw and paint figures of birds, fishes, and insects of the Rhine. Some of the figures were later copied for the *Ornithologia* to illustrate the birds said to inhabit the Rhine Valley.

It appears that Ray and Willughby owned few dried skins of birds themselves, but they took every opportunity to examine specimens wherever they went. In Bologna in 1664 they visited the collection of the naturalist Ulisse Aldrovandi, and Ray remarked that "among many natural and artificial rarities therein preserved, we took more especial notice of the ten volumes of the pictures of plants, and six of birds, beasts and fishes drawn exactly in colours by hand."[4]

Willughby was recalled to England by the death of his father in December 1665. He was kept at Middleton Hall during most of 1666 attending to the affairs of the estate, but on 22 July, in company with other members of the Royal Society, he was in London to observe the eclipse of the sun through Robert Boyle's sixty-foot telescope. Ray joined Willughby back in Warwickshire that autumn and spent the winter there helping Willughby to put his collections in order.

The year 1667 followed a similar pattern, with a summer excursion in the west country and the winter at Middleton Hall, when the two friends sorted the materials they had collected. The following year this routine was disrupted. Ray went to Yorkshire and Westmorland by himself to collect some plants and animals, and Willughby married Emma Barnard, the second daughter and joint heiress of Sir Henry Barnard. Ray seems to have occupied himself with his plants for some time, for his *Catalogue of English Plants* was published in 1670; Willughby continued to work on his museum specimens and lived a family life. During the course of the next four years Emma bore two sons, Francis and Thomas, and a daughter, Cassandra.

At the close of 1671 Willughby was seriously contemplating a journey to north America in order to increase his knowledge of the history of animals for their projected book. His health was not robust, however, and he did not feel physically capable of the expedition. He was taken ill in the summer of 1672 and died on the third of July. Ray returned from a botanizing trip shortly afterward and was stunned by the news that his friend and patron had died. Willughby had not only arranged for a generous annuity for Ray but demonstrated his faith in his scholarly companion by entrusting his two sons' education to him. As this charge curtailed Ray's freedom to go off on botanical tours, he set to work on the publishing ventures they had planned together. First, however, he published

Nomenclator classicus (1672), a book he had composed for the boys' instruction, listing the names of natural objects.

Soon after Willughby's death, Ray lost another close friend when Bishop John Wilkins died, in November 1672. Ray found consolation and companionship again, however, when he married Margaret Oakely, daughter of John Oakely of Launton, Oxfordshire, a member of the Willughby household at Middleton. They were married in Middleton Church on 5 June 1673 and his wife "gave him important assistance in educating the Willughby boys and was attentive and affectionate so helping him when he became the victim of a protracted disease."[5] They stayed at Middleton Hall until 1675, when the two boys were removed from his charge. After a short period in Sutton Cofield and Falborne Hall in Essex, the Rays finally went to live in Black Notley, John's birthplace, where he resolved to remain for the rest of his days.

When Ray determined to complete Willughby's work on birds and issue an *Ornithologia,* in Latin, he turned to his many friends and associates at the Royal Society for help and encouragement. Dr. Martin Lister, a fellow of both the Royal Society and the College of Physicians, was one of Ray's most intimate friends and correspondents. On 29 November 1673 Ray wrote to him, "I am going on as fast as I can with the Ornithology. That the work may not be defective, I intend to take in all the kinds I find in books which Mr Willughby described not, and to have a figure for all the descriptions I can procure them for. I have sent this week to Mr Martin to begin to get some figures engraved."[6] Ray chose John Martin, the Royal Society's London printer, to produce the *Ornithologia* because Martin was known to be an efficient workman. His shop was at The Bell in St. Paul's Churchyard.

Ray was procuring specimens and dried skins from correspondents in other parts of the country. Dr. Ralph Johnson of Brignall, near Greta Bridge, Yorkshire, sent a black tern (*Chlidonias niger*). Peter Dent, another friend and member of Trinity College, on 15 February 1674 sent Ray "put up in a box some water-fowl viz a Pocker, a Smew, three Sheldins, a Widgeon and a Whewer; which last two are male and female of the same bird."[7] These four ducks were pochard (*Aythya ferina*), smew (*Mergus albellus*), shelducks (*Tadorna tadorna*), and European widgeon (*Anas penelope*).

Ray evidently gave Francis Jessop of Yorkshire strict instructions for packing and sending the specimens, for Jessop wrote in November 1668 to say, "I have done for the most part of that you enjoined me. I have stuffed the skins of a Moor-cock and Moorhen. I have gotten a black-legged Linnet. . . . I have procured the skin of a great bird, which he that gave it me called a Scarfe."[8] The moorcock and hen were red grouse or willow ptarmigan (*Lagopus lagopus scoticus*) and the scarfe either a shag or cormorant (*Phalacrocorax aristotelis* or *P. carbo*). A little bird that Ray was to include in the *Ornithologia* (Bk. 2, chap. 2, sec. 5) as a "Titlark that sings like a Grasshopper, Locustella, D. Johnson" came from Dr. Ralph Johnson as a skin in 1672, accompanied by a lot of muddled information.

This specimen of a grasshopper warbler (*Locustella naevia*) certainly was not the "regulus non-cristatus" Ray had requested, and though Dr. Johnson referred to it as "she," the singing bird would be a male. Dr. Johnson wrote, "I have sent you the little bird you called Regulus non-cristatus, what bird it is I know not; but we have great store of them each morning about sunrise and many times a day; besides she mounts the highest branch in the bush, and there, with bill erect, and wing hovering, she sends forth a sibilous noise like that of the grasshopper, but much shriller."[9] Ray often had to sort out similar miscellaneous and often conflicting notes attached to specimens.

Ray paid tribute to the famous ornithologist Sir Thomas Browne, now back home from his trip to Europe and practicing medicine in Norwich, Norfolk. Ray tells us that Sir Thomas, "a Professor of Physick . . . frankly communicated the Draughts of several rare birds, with some brief notes and descriptions of them."[10] These colored drawings and sketches included the Manx shearwater (*Puffinus puffinus;* Figure 10), little auk or dovekie (*Plautus alle*), a stork (probably *Ciconia ciconia*), and the common scoter (*Oidemia nigra*). Browne also sent a drawing of a "sea dotterel" which Ray and later ornithologists knew as a turnstone (*Arenaria interpres,* the ruddy turnstone of North America). Browne never got these drawings back from Ray, despite assurances from both Ray and Sir Philip Skippon, their mutual friend, that they would be returned. Many years later George Edwards saw one of Browne's sketches of a shearwater at the British Museum, so perhaps Browne took the precaution of making more than one drawing. Sir Thomas was also unfortunate in having his bird specimens destroyed. In a letter to Christopher Merrett he explained, "I had about fortie hanging up in my howse, wch the plague being at next doores the person intrusted in my howse, burnt or threw away."[11]

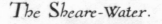

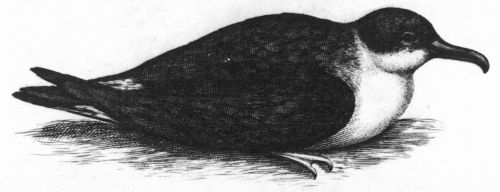

10 / A Manx shearwater (*Puffinus puffinus*) drawn by Sir Thomas Browne, engraved for Plate 78 of Willughby and Ray's *Ornithology.*

During a visit to London, Ray visited the Royal Society's repository and took a description of a dried specimen of a tropic bird (*Phaethon spp.*). He also used the museum of James Petiver, who had collected objects of natural history from all over the known world and had developed his own technique of drying specimens to preserve them. Ray consulted Sir Hans Sloane's collection, which was the most famous at the end of the seventeenth century and which included Petiver's accumulations after 1718. He also visited Tradescant's collection at Lambeth to inspect its dodo (*Raphus cucullatus;* Figure 11) and penguin (that is, the great auk, *Pinguinnis impennis*).

During the sixteen months of the *Ornithologia's* production, Ray set to work on another book that Willughby had planned. In a letter to Dr. Martin Lister dated 19 December 1674 he wrote, "Having finished the History of Birds, I am now beginning that of Fishes, wherein I crave your assistance."[12] At the same time he was checking the proofs of the *Ornithologia* and attempting to keep some control over the engraving of its seventy-seven plates.

The engraving, paid for by Emma Willughby, was done by William Faithorne, William Sherwin, and Frederick van Hove for the printer John Martin. In the

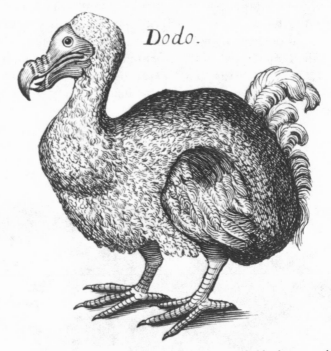

11 / John Tradescant's dodo (*Raphus cucullatus*), probably the one exhibited alive in London in 1638, from Plate 27 of Ray and Willughby's *Ornithology*. Tradescant's catalogue of his museum contents listed a "Dodar from the Island Mauritius; it is not able to flie being so big."

preface Ray apologized for their work on the plates and complained that "the Gravers we employed, though they were very good Workmen, yet in many Sculps they have not satisfied us. For I being at a great distance from London, and advices and directions necessarily passing by Letter, sometimes through haste mistook in my directions, sometimes through weariness and impatience of long writing sent no so clear and full instructions as was requisite; and they as often neglected them or mistook my meaning." William Derham commented, "Considering how well the engravers were paid for their labours it is a great pity that they have not had some able person in London to have supervised them."[13] It must be admitted that only a small number of these engravings are anything like the birds they purport to represent.

The figures are often grouped four or more to the quarto page, as in Figure 12, and are rather small in consequence. The birds' shapes are not accurate, and apart from a very large or imposing bird that was assigned a whole plate, no attempt was made to indicate the relative sizes of the figures. The engravers depicted the birds in the stiff pose of rigor mortis, with no background and few foreground details other than a tree branch. As Ray said in the preface, "by mistake some species appear twice." Some figures, such as the "Red-leg'd Patridge, Swallow, Swift, Blackbird, House Dove, Royston Crow, Witwall and Dottrel," were so poorly executed that Ray made the engravers do the work again.[14] These birds are now known as, respectively, *Alectoris rufa*, barn swallow (*Hirundo rustica*), *Apus apus*, *Turdus merula*, rock dove (*Columba livia*), hooded crow (*Corvus corone cornix*), great spotted woodpecker (*Dendrocopos major*), and *Eudromias morinellus*.

It is impossible to agree with Ray's summing up: "Notwithstanding the Figures, such as they are, take them all together, they are the best and truest; that is most like live Birds, of any hitherto engraven in Brass."[15] Walter Charleton's of 1668 were better proportioned, and Francis Barlow's, though etched rather than engraved, were certainly more "like live birds." We must remember, however, that the *Ornithologia* was the first real attempt to provide a large number of bird illustrations for identification purposes in a book published in Britain. Though Ray and Willughby had little in the way of earlier publications on which to build, they provided good descriptions. Thus the value of this first scholarly scientific book about birds lies in its text rather than in its illustrations.

The English edition of 1678 had an additional plate. The expense of the plates on this occasion was borne by Bishop John Fell and some of the fellows of the Royal Society. The work was printed at Oxford University Press. The bishop was the Dr. Fell about whom a student of Christ College, Oxford, wrote:

> I do not like thee, Dr. Fell,
> The reason why I cannot tell;
> But this I know, I know full well,
> I do not like thee, Dr. Fell.

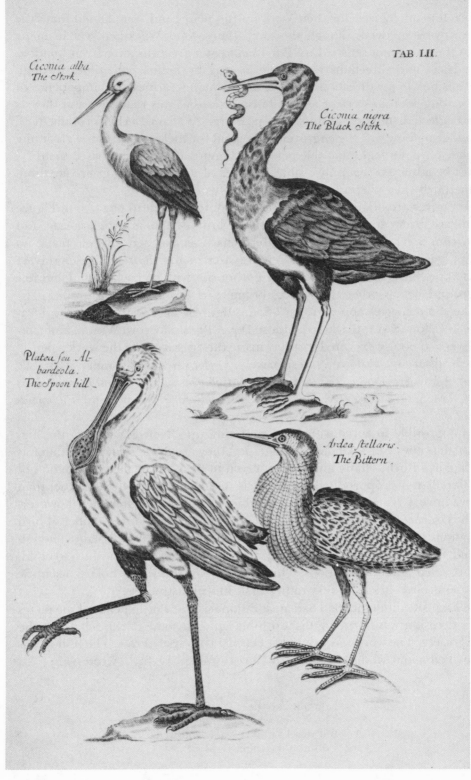

Ciconia alba
The Stork.

Ciconia nigra
The Black Stork.

Platea seu Albardeola.
The Spoon bill.

Ardea stellaris.
The Bittern.

TAB. LII.

12 / Plate 52 of Ray and Willughby's *Ornithology,* overcrowded with four large species: stork (*Ciconia ciconia*), black stork (*Ciconia nigra*), spoonbill (*Platalea leucorodia*), and bittern (*Botaurus stellaris*).

The three engravers who occasioned such criticism from Ray and opprobrium from Derham were all eminent engravers of their day. William Faithorne was born in London in 1616 and apprenticed to Robert Peake, to whom he dedicated his publication *Art of Graveing and Etching* in 1662. He established himself as an engraver and print seller "at his shop next ye Signe of ye Drake, without Temple Bar," in 1650.[16] He did some work for booksellers, including John Martin, who was his brother-in-law. Faithorne, also an artist, executed a portrait of John Ray in crayons. Engravings made from this picture by William Elder and George Vertue were prefixed to some copies of Ray's various publications.

The engraver William Sherwin worked from about 1670 to 1711. Only a few of his plates, mainly portraits, are to be found today. He was the first professional English mezzotinter.

Frederick van Hove moved from The Hague to London and was employed by booksellers there. His prints, dating from 1648 to 1692, were also mainly portraits (one was of Sir Thomas Browne) but he did some engravings for a book on botany.

Ray maintained his interest in birds and issued some lists of species in various forms in order to record birds discovered after the *Ornithology* was published. He sent a synopsis of birds and fishes to the printers, but it was not published until eight years after his death. William Derham finally edited and published it under the title *Synopsis methodica avium et piscium* in 1713.

Another short list compiled by Ray was the earliest attempt to enumerate the birds of any part of the British possessions in India. James Petiver issued a catalogue of his collections, *Musei Petiveriani,* in 1695 with an appendix by Ray listing about two dozen birds sent by Edward Buckley from Fort St. George (Madras) to Petiver. Buckley was a surgeon at the fort. Two unsigned plates of Indian birds seen at Fort St. George were engraved for this museum catalogue.

When Ray died, in 1705, leaving four daughters as well as his widow, his collections passed to one of the friends of his later life, Samuel Dale. Ray's herbarium eventually came into the possession of the Society of Apothecaries, which transferred it to the British Museum in 1862. His library of 1,500 volumes was sold at auction in 1707.

Francis Willughby's instruments, library, and natural history collections were kept for many years at Wollaton Hall. After the naturalist's death, his elder son, Francis, was created a baronet in infancy on 7 April 1677 in recognition of his father's service to science. Sir Francis Willughby died in 1688. His brother, Thomas, succeeded him to the baronetcy and was later created Baron Middleton in 1711. Wollaton Hall and park were purchased by Nottingham Corporation in 1925 from the eleventh baron Middleton, who transferred the manuscripts and books to his other seat, Birdsall House, Malton. Wollaton Hall is now Nottingham's Natural History Museum, so part of Francis Willughby's estate is still a repository of the natural history objects that inspired him and his friend John Ray three centuries ago.

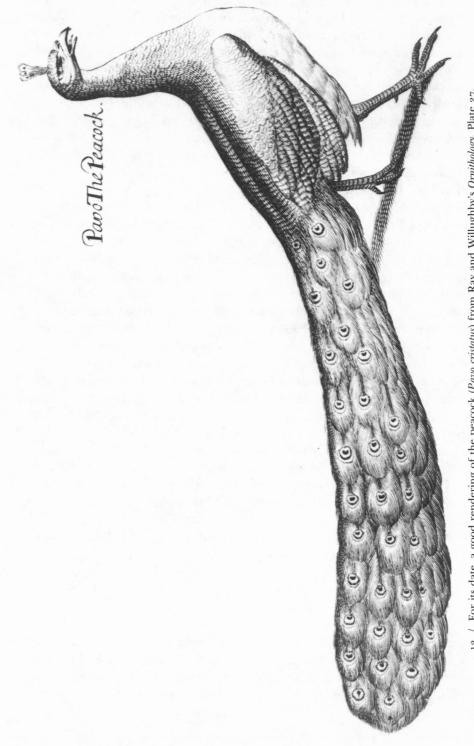

Pavo The Peacock.

13 / For its date, a good rendering of the peacock (*Pavo cristatus*) from Ray and Willughby's *Ornithology*, Plate 27.

Ray's first love had always been plants; it was Willughby's inspiration and collection of materials that prepared the ground for the *Ornithology*. Ray's scholarship and discipline shaped Willughby's collections and notes into order, and his friendship and respect for Willughby's memory brought the work on the *Ornithology* to completion. This earliest English systematic textbook on ornithology is a fitting monument to the memory of both men and has been appreciated in that capacity ever since its publication. Posterity, however, has been far less appreciative of Ray's very early recognition of the fact that "elegant and accurate figures do much illustrate and facilitate the understanding of descriptions."[17]

Francis Willughby and John Ray's Illustrated Bird Books

Willughby, Francis. *Ornithologia libri tres: In quibus aves omnes hactenus cognitae in methodum naturis suis convenientem redactae accurate describuntur, descriptiones iconibus elegantissimis et vivarum avium simillimis aeri incisis illustrantur.* Totum opus recognovit, digessit, supplevit Joannes Rajus. Sumptus in chalcographos fecit Emma Willughby vidua. 1676. 77 plates.
 Artists: Sir Philip Skippon, Sir Thomas Browne, F. L. Baldner, and others. (Drawings and printed sources other than those mentioned in the text above are listed in Appendix A.)
 Engravers: William Faithorne, Frederick Hendrick van Hove, William Sherwin.
————. *The Ornithology of Francis Willughby of Middleton in the County of Warwick, Esq. . . . in three books wherein all the birds hitherto known being reduced into a method suitable to their natures, are accurately described. The descriptions illustrated by most elegant figures, nearly resembling the live birds. Engraven in LXXVIII copper plates. Translated into English, and enlarged with many additions throughout the whole work. To which are added, three considerable discourses. I. Of the art of fowling: with a description of several nets in two large copper plates. II. Of the ordering of singing birds. III. Of falconry. By John Ray, Fellow of the Royal Society.* 1678. 80 plates.
 Artists and engravers. See 1676 edition.

3

Eleazar Albin

(d. 1741/42)

Eleazar Albin was a professional watercolor painter who also taught drawing and painting. He is reputed to have painted a picture called *Rich man and Lazarus* in the art gallery at Kassel, West Germany, but this is the only known painting by him. As an artist he is remembered today only for his book illustrations. In the introduction to his *Natural History of Birds,* Albin said that his occupation as a professional artist led to his interest in natural history and that he was first attracted to insects, flowers, and birds because of their beautiful coloring. He wrote illustrated books on insects, spiders, fish, and birds from 1714 onward.

Few details of Albin's life are known, but an engraving of his portrait was included in his treatise on spiders in 1736. It shows him seated on a white horse, surrounded by mites, scorpions, and other insects. Albin is dressed in a green coat and black hat and he looks solemn and apprehensive—not surprising in the circumstances, for he has drawn the insects larger than himself. The portrait plate is signed by Albin (as the artist?) and by J. Scotin as the engraver.

The earliest known reference to Eleazar Albin is in the parish registers of St. James, Piccadilly, London. His daughter Elizabeth was baptized at the church on 21 June 1708, having been born on 30 May. This daughter, who was named after her mother, was a favorite of Eleazar's, for she assisted him with his illustrations. Seven more Albin baptisms are recorded in this register, the last on 4 June

1721. Eleazar attended St. James's Church while he resided in Golden Square, Soho, "next ye Green Man near Maggots Brew House."[1] It was the church to which the ladies of the court and attendant courtiers went; no doubt Albin's social aspirations led him to this particular parish church.

Albin's earliest preserved drawings, now in the British Museum Manuscript Room, are dated 1711. He copied some drawings of "plants observed and fig-ured in Italy, by Mr Jesreel Jones's Collection of some productions of nature by him observed and drawn in Barbary."[2] These "productions" include a butterfly, a cucumber, fish, and shells. Jezreel Jones first visited Barbary (North Africa) under the patronage of the Royal Society in 1698, with £100 voted by the council to enable him to make an expedition of discovery. He visited there a second time in 1701, and sent Sloane and Petiver many valuable specimens. The butterfly that Albin copied is inscribed by him (in his usual odd spelling) "Boath sides of a Butterfly caught at Martin the beginning of Aug 1701. Albin fecit from Mr Jones's Coppay: 1711."[3] Petiver refers to Albin in a document also dated 1711, and was apparently his patron. Albin wrote to Petiver on 5 January of that year about a drawing of a lizard he was making for him, and another letter later that month stated, "i am a gitting some curious paintings of buirds in watter. If the man & I can agree for them at a reasonable price for you."[4] Albin's signature here is very similar to that in Figure 14.

Albin was acquainted with a number of natural history collectors by this date. He had discovered that the patrons of science in the first two decades of the eighteenth century were particularly interested in insects, and his ability to draw them had earned him patronage as well as a source of income. His first book, *A Natural History of English Insects,* commenced publication in 1714. In the preface Albin wrote that Joseph Dandridge "employed me in painting caterpillars for him." Dandridge, a keen entomologist, had a large natural history collection that included stuffed birds and birds' eggs. Dandridge was a kind and constant friend to Albin, who learned much from him about insects. He also recommended Albin to another of his patrons, the widow of Dr. George Howe, who had been one of the fellows of the College of Physicians and had died prematurely in 1710. For Mrs. Howe Albin painted butterflies and moths. One of the Howes probably introduced Albin to Sir Hans Sloane, who was president of the College of Physicians from 1719 to 1735 and a fellow for many years before that. Sir Hans had several of his own natural history objects painted by Albin, and when Albin began to publish, Sir Hans encouraged him and subscribed to his books.

Following his work for Sloane, Albin was introduced to Mary Somerset, Dowa-ger Duchess of Beaufort (c. 1630–1714), who employed him for a similar pur-pose. She suggested that Albin write a book on insects, and she did much to obtain subscribers for him among her wealthy acquaintances. She and the Duke of Beaufort were liberal contributors to botanical expeditions and to James Petiver's splendid museum. The duchess remained a keen naturalist after the

MITES.

J. Scotin Sculp.

E Albin

14 / This portrait of Eleazar Albin, engraved by J. Scotin, formed the frontispiece of his *Natural History of Spiders*, published in 1736. The copy from which this photograph was taken, in the Graham Watson collection, Emmanuel College, Cambridge, bears Albin's signature in ink in the lower right corner. If he is the artist of this plate, his understanding of human anatomy leaves even more to be desired than his understanding of equine anatomy.

duke's death in 1699/1700, and her connection with the botanists and with Sir Hans Sloane (to whom she left her twelve-volume herbarium) helped to forward Albin's interests.

Unfortunately, the duchess died in 1714, before Albin's *English Insects* was much advanced, and he had some difficulty in obtaining additional subscriptions in order to finish the work. He finally procured about 170 subscribers. When the work commenced publication, six years later, he said that he needed to make a profit from it because he then had a "great family."[5] The book was illustrated with 100 plates "curiously engraved from the life; and (for those who desire it) exactly coloured by the author."

Other naturalists of importance to Albin were Dr. Richard Richardson, an apothecary in Aldersgate Street, and his friend and correspondent William Sherard. Richardson also collected birds, and Albin noted seeing a "China dove" (*Streptopelia chinensis?*) at his house, and was allowed to draw it in 1737.[6] Sir Hans Sloane and William Sherard, both fellows of the Royal Society, were eager promoters of scientific exploration, and their financial aid enabled many aspiring young naturalists to visit distant countries. On 20 September 1720 William Sherard mentioned Albin in a letter to Richardson. It seems that Albin had "proposals of going to Carolina, to paint there in the summer months, and in winter to paint in the Caribbe ilands."[7] This project never materialized, perhaps because of Albin's family commitments, but the record is interesting in view of the Royal Society's approval of a very similar proposition two years later, when Mark Catesby (a bachelor) was sent to study the natural history of the same areas. As Catesby proved to be the better artist, it is as well that it was he and not Albin that set sail for Charles Town.

Albin moved from the neighborhood of the Soho brewery to St. Pancras sometime between June 1721 and March 1722. His last two children were baptized at St. Pancras Church, James in 1722 and Judith in April 1725. In 1730 we have two references to Albin as a resident of St. Pancras. The first occurs when his daughter Elizabeth, aged twenty-two, was married at St. Giles' Church on 28 March. A license was necessary because both she and her husband, James Jones, were then residents of St. Pancras parish. The second, as we shall see, places Eleazar's home near the Dog and Duck, an inn in Tottenham Court Road, almost surrounded by fields in those days. There he prepared the text and plates for his first book about birds.

The three volumes of *A Natural History of Birds* were issued in 1731, 1734, and 1738. Albin's patrons helped to cover the cost of publication, particularly Dr. Richard Mead, who was physician in ordinary to George II and a member of the College of Physicians of London. Dr. Mead earned a great deal of money as a fashionable physician and used his wealth in the interests of natural history. The third volume of Albin's bird book was dedicated to him.

A Natural History of Birds was illustrated with 306 copperplate etchings. For the most part, Albin delineated one bird on a plate, as in Figure 15, occasionally two

15 / Eleazar Albin's plate of the bittern (*Botaurus stellaris*), made from his own drawing and published in his *Natural History of Birds* (1731), vol. 1, Plate 68. The sketchy background scene is most unusual in plates of this early date.

when the birds were small, such as the wren (*Troglodytes troglodytes*) and goldcrest (*Regulus regulus*) or two blue tits (*Parus caeruleus*). The birds are placed on a branch or on the ground, each part colored. This was the first British bird book to have colored plates, which must have appeared to be an enormous extravagence at the time. The proportions of the birds were a distinct improvement on those in Willughby and Ray's *Ornithology,* but they are not always accurate. The coloring was done with a limited range of colors, the cardinal (*Richmondena cardinalis*) and the breast of the bullfinch (*Pyrrhula pyrrhula*) for example, are the same red. Albin prepared his paints in a rather strange manner, according to Petiver's account. For his reds he washed and dried vermilion pigment in four waters and then proceeded to "grind it in boys urine three times, yn [then] gum it and grind it in Brandy wine."[8] Whatever his methods and however singular the contribution by his sons, this very first effort at coloring plates depicting birds is highly commendable and the results were gratifying, for the book was popular.

The first two volumes were concerned mainly with British birds; more foreign species appeared in the third volume. Many of the birds that Albin included are of interest either because they were not previously recognized as native British species or because he provided the first evidence that a foreign species, such as the golden pheasant (*Chrysolophus pictus*) was present in Britain. Albin was the first author to record as British the "red pole" (*Acanthis flammea*), in 1738; the greenshank (*Tringa nebularia*), as a "green-legg'd horseman," in 1734; and the tree pipit (*Anthus trivialis*), as the "lesser lark," in 1731.

Perhaps the most interesting British bird in this book is the bearded tit (*Panurus biarmicus;* Figure 16), for this was the first time this bird was depicted. The plate was issued under the title "bearded titmouse," a name devised for it by Albin. The bird was first discovered in Britain by Sir Thomas Browne, of Norwich, who sent a picture of it to Ray. For some reason Ray did not use the drawing, but noted the bird in his *Collection of English Words Not Generally Met With,* published in 1674. He said it was "a little Bird of a tawny colour on the back and a blew head, yellow bill, black legs, shot in an Osier yard, called by Sr Tho. for Distinction sake silerella." Albin presented it with the label "Beard Manica from Juteland, or bearded titmouse," but stated that he had the information from Sir Robert Abdy that it was found in the salt marshes of Essex, and from others that it likewise occurred in the fens of Lincolnshire. The idea that it came from "Juteland" arose when "the Countess of Albemarle brought a cage of these birds from Denmark" (according to William Hayes in 1799).[9]

Sir Robert Abdy, a London merchant and the owner of a stately home at Albyns, Essex, was another of Albin's patrons and a subscriber to his books. He provided Albin with a number of birds to draw, among them the bearded tit and a brown gull (an immature bird of *Catharacta skua*). The first two volumes of *A Natural History of Birds* were dedicated to him. Sir Robert was a member of Parliament for Essex and a "man of deep knowledge in antiquity and natural

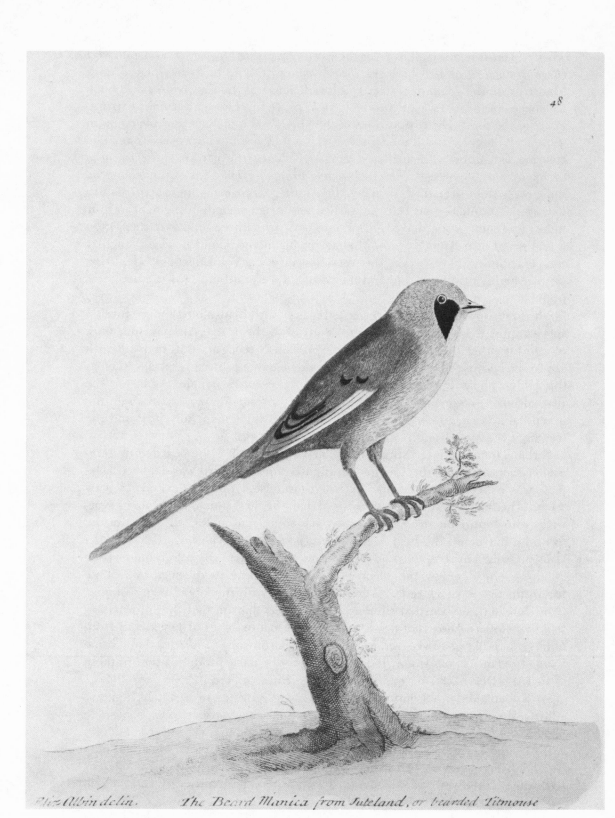

Eliz Albin delin. The Beard Manica from Juteland, or bearded Titmouse

16 / Elizabeth Albin's drawing for the first published picture of a beard manica, or bearded titmouse (*Panurus biar-micus*), in her father's *Natural History of Birds,* vol. 1, Plate 48.

history . . . a true patriot, and a person of unshaken integrity and remarkable humanity."[10] Because he was Albin's special patron, one wonders if, when Albin anglicized his German name of Weiss, he was influenced by Abdy's seat, Albyns or Albins. A more normal translation would have been White.

Albin mentions Willughby and Ray's *Ornithology* as being helpful to him in writing his own book, and added that he had also used "Mr Ray's Improvements thereof in his *Synopsis Methodica Avium* published by Dr Derham." Albin took his names of birds from these books, "only to some of the Non Descripts I was forced to impose Names, or take such as the London Bird-Catchers, or others called them by." William Derham contributed notes for Albin's histories of birds and insects over the years 1724–31. Derham was greatly esteemed by Ray and the other naturalists of the period and was responsible for many notes on the history of birds, some of which he recognized as British for the first time. His notes were incorporated in publications of the early eighteenth century, though he did not publish a book on birds himself. He made a collection of bird skins, however, and it was these specimens that first led him to suspect that there was some difference between the two species we now call willow warbler (*Phylloscopus trochilus*) and chiffchaff (*Phylloscopus collybita*). His surmise was confirmed exactly fifty years later, in 1768, by Gilbert White. Derham provided notes for the second edition of Albin's *Natural History of Birds,* published in 1738–40. This edition was also published in French, at The Hague, in 1750.

William Swainson's stricture that Albin was "without much knowledge of natural history and a very indifferent artist" is partly true.[11] Albin's birds are recognizable portraits and reasonably true to life, but he knew little about the birds' habits, and the information he gave in the short text concerning each species included nothing new, nor was it as good as that contained in Willughby and Ray's *Ornithology.*

The forty-eight plates in volume 1 which were drawn by Eleazar are signed either "E. Albin delin." or "Eleazar Albin delin." There are twelve unsigned plates, and a further forty-one are signed by Albin's daughter Elizabeth as the artist. Albin included his daughter among his pupils and proudly referred to her in his lengthy title, part of which reads, "Published by the author and carefully colour'd by his daughter and self, from the originals, drawn from the live birds." In the second volume the plates are unsigned; the plates in the third volume are signed by Eleazar, with one interesting exception. The plate depicting the "Red Linnet cock" (*Acanthis cannabina*) bears the signature, in quite different handwriting, "F. Albin delin 1737." Though Eleazar makes no mention of this artist, Fortin Albin is known to have drawn three fishes (chub, haddock, and whiting, all dated 1740) published posthumously in 1794 in Albin's *Esculent Fishes.* Eleazar's son Fortin was born 18 September 1719 and baptized twelve days later as Fortinalus Albin, at St. James's, Piccadilly. Albin chose some strange names for his children, with a bias toward Roman forms—Roberta, Augustus Innys (partly after his printer William Innys?), Caesar—so that Fortinalus was less farfetched

than it seems. Some of his other children, by contrast, had very plain names: John, Jane, Ann, James, Judith.

There is no evidence as to who etched most of the plates, but one etcher was Henry Fletcher, who had executed six of the twelve plates in Charles Collins' *Icones Avium . . .* in 1736. He was an excellent etcher of flowers, fruit, and birds, and worked in London from about 1710 to 1750. The "Red Linnet Hen" in volume 2, dated 1737, was inscribed "H. Fletcher sculp." The only other signature, which occurs once, was appended to Elizabeth's charming little quail, "G. Thornton sculp." (Figure 17). Nothing is known of this craftsman. Eleazar signed the delightful picture of the Eurasian kestrel (*Falco tinnunculus*) with the caption "E. Albin fecit 1737 The Cock Windhover," but he may have done the drawing rather than the etching.

Albin ingeniously tapped a source of supply of bird specimens by advertising his requirements in early parts of *A Natural History of Birds*. "I shall be very thankful," he wrote, "to any Gentleman that will be pleased to send any curious bird (which shall be drawn and graved for the second Volume, and their names shall be mentioned as Encouragers of the Work) to Eleazar Albin near the Dog & Duck in Tottenham-court Road." (This inn, at the southern end of the road, survived until 1827.)

Albin stressed the point that he had "drawn from the life," and the phrase was invariably copied by later authors. Some of his birds were alive when he drew them, but others were dead specimens. Again he claimed, "I have done those with all the accuracy I could from the very Birds themselves which I had always by me at the time." Nowadays we take such claims to mean that an artist has sketched in the field and then done his final drawing from those sketches, perhaps also referring to a museum specimen as an added source for complete accuracy in the number of feathers, placement of color marks, and the like. Albin, and those artists who followed him up to Audubon's time, meant something quite different. "From the life" in their terminology meant from a specimen, more often dead than alive, and drawn in their own or other people's homes, not sketched in the field.

One specimen was a rare species of pigeon. Tunstall's museum displayed a vulture-like pigeon from Nicobar (*Columba nicobarica*), an inhabitant of the Indo-Australasian region. Some of these birds were taken to England in 1737 and Albin bought a pair and presented them to Sir Hans Sloane at Lord Petre's order. A supply of rice in the husk had to be brought with them in order to keep them alive. Albin acted as emissary to Robert James, Lord Petre, who was a keen naturalist and whose death from smallpox at the early age of twenty-nine, in 1742, was much lamented by his friends. Plates 47 and 48 of Albin's third volume show both the male and female of the Nicobar pigeon. Other non-British species illustrated were parrots, including "parroquets," from the East Indies and Angola and some American birds. Three North American species were the "Virginia grosbeak," now the northern cardinal (*Richmondena cardinalis*); a "New

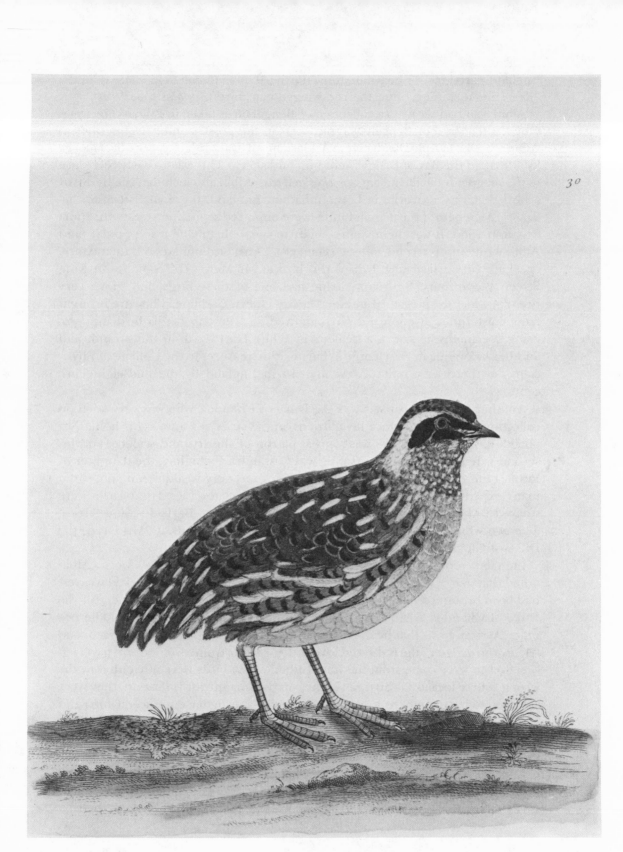

17 / The quail (*Coturnix coturnix*) that Elizabeth Albin drew for Plate 30 of Eleazar Albin's *Natural History of Birds*.

England partridge" or bobwhite, now northern quail (*Colinus virginianus*); and a "Red-wing'd starling," now the red-winged blackbird (*Agelaius phoeniceus*).

Albin also had access to a collection of Bengal birds taken to England in 1734. One, "a dial bird of Bengal, Magpie," was in the possession of a subscriber to Albin's book, Joseph Dandridge. (A kinsman of Dandridge at Fort St. George [Madras], in the Bay of Bengal, sent him bird skins.) This was an early reference to the magpie robin of India (*Copsychus saularis*). Albin also included the figure of a bird that was a favorite in both India and England, the mynah (*Gracula religiosa*). Members of the mynah family were imported soon after trade with India began in 1600. It was the mynah's ability to speak that made it so popular, and Albin wrote in his second volume (Plate 38), "This bird imitates a human voice, speaking very articulately. I drew this bird at Mr Mere's coffee-house in King Street, Bloomsbury. Sir Hans Sloane had one of these birds that spoke very prettily, which he presented to Her Majesty Queen Caroline. They are brought from East India." George Edwards figured and described this bird in 1740, using specimens he saw at a dealer's in White Hart Yard, in the Strand, and another belonging to Dr. George Wharton, the treasurer to the College of Physicians, so there were quite a few mynahs in England by the mid-eighteenth century.

Another of Albin's patrons was the Duke of Chandos, who was very keen on collecting live birds to grace his gardens and aviaries at Canons, his home just outside London. The duke was a great patron of the arts and science, and his second wife shared his interests. She was Cassandra Willughby, the daughter of Francis the naturalist. The Duke of Chandos was very wealthy and sponsored many expeditions to collect plants, seeds, and other novelties. His aviaries were stocked with European species and birds from Virginia, Barbados, and Africa. The two white storks (*Ciconia ciconia*) that Albin says he saw at "His Grace the Duke of Chandos's" had come from Rotterdam.

Linnaeus took three descriptions of African birds from Albin's work. Albin noted that one of these birds, "*Ploceus melanocephalus*," the yellow-backed weaver, had been brought from "Gamboa" (perhaps Gambia?) as a live specimen for the Duke of Chandos. Albin's drawing of this bird is barely recognizable. The two other African birds that he drew were "*Turacus persa*," the Guinea touraco, and "*Agapornis pullaria*," the red-faced lovebird, the latter from a live specimen wrongly stated to have come from the East Indies. Many birds were attributed to the wrong source locality at this time. If they arrived on an East Indiaman, they were assumed to have come from "the East Indies"—a term that embraced China and India as well as the East Indies proper. The East Indiamen, however, called at ports along the African coast en route to England, and many species picked up there were attributed to "the East Indies" when they were unloaded.

Encouraged by the success of his earlier book, Albin embarked on a second book about birds, *A Natural History of English Song-birds*. This volume was very small in format (see Figure 18, reproduced in the original size) and had an

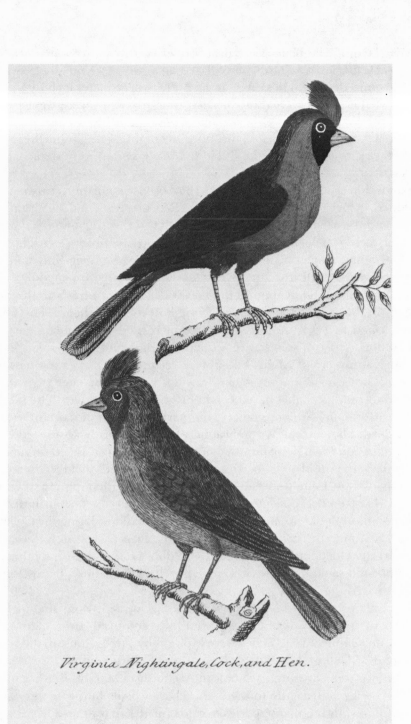

Virginia Nightingale, Cock, and Hen.

18 / One of Eleazar Albin's American species, the "Virginia nightingale," now the northern cardinal (*Richmondena cardinalis*), included in his *Natural History of English Song-birds* (p. 84).

attractive layout. The plates were neat copper engravings of a male and female bird of each species. The birds were placed on a twig, with no other background or foreground detail. All but three of the twenty-three plates include a picture of the egg of the species. This was the first time that eggs were depicted. It was difficult to obtain the egg of every kind of bird, and the then-rare "Red-pole cock and hen" (*Acanthis flammea*), the "Virginia nightingale" or northern cardinal (*Richmondena cardinalis*), and the Siskin (*Carduelis spinus*) were depicted without their eggs.

Two foreign species were included in this book, the northern cardinal already mentioned, which Albin knew both as a "Red grosbeak" and "Virginia night-ingale," and the canary (*Serinus canaria*), which was the green-and-yellow natural bird then being experimented with in pet shops to produce brighter yellow plumage. Some copies of *A Natural History of English Song-birds* had colored plates; others were left uncolored. The text was designed for cage-bird enthusiasts and described the distinguishing marks of the cock and hen, the time and manner of nest building, and "of the young how to order them." This little book was published in 1737 and reissued twice in response to public demand. The third edition, of 1759, sold for "2/6 plain or 7/6 coloured."

Though a number of Albin's books were reissued after 1741, no new title was published, nor do any known Albin drawings bear a date later than 1741. Eleazar Albin would probably have been in his sixties at that date. The fact that he had "a great family" in 1714 points to his marriage about the turn of the century and his birth about 1680. An indication of his date of death was recently discovered in a London newspaper (by Ronald S. Wilkinson). The *Daily Advertiser* of 22 February 1741 (old style, or 1742 new style) carried an advertisement for a sale of books by John Robinson at his shop in Southampton Street, Covent Garden. He offered a catalogue of "bibliotheca Curiosa" which included "scarce and uncommon Books, in most Languages and Faculties; Being the Collection of Mr Eleazar Albin, (the curious Drawer of Birds, Insects, &c) lately deceased, and of two private Gentlemen gone abroad."[12] Albin's daughter Elizabeth may have died about the same time. At St. Giles' church "Elizabeth of James Jones" was buried on 1 August 1741.

At the sale of the Portland Museum in 1786, lot 2809 consisted of "original drawings of birds, By Albin most beautifully coloured after nature, 202 in number, on vellum, 2 vols." They were brought by James Robson, the bookseller and friend of George Edwards, for £30 17s. The two volumes, with 198 plates (some known to be missing), are now in Archbishop Marsh's Library in Dublin.

Albin's books added little to the knowledge of birds but were very attractive and useful in showing many species in color for the first time. They were small, set a standard of illustration of the bird-and-branch kind, and introduced the eggs of the species for the first time. A few illustrations broke new ground with backgrounds sketched in, and many of Elizabeth's had more detailed foregrounds and better drawing of birds than those of her father. In doing his own

drawing and coloring, perhaps some of his own etching, and by publishing his own first book about birds, Albin set a pattern that was followed by many later bird artists.

Bird Books Illustrated by Eleazar Albin

Albin, Eleazar. *A Natural History of Birds, with Copper Plates, Curiously Engraven from the Life. Published by the Author, and Carefully Colour'd by his Daughter [Elizabeth] and Self, from the Originals, Drawn from the Live Birds.* 3 vols. 1731–38. 306 hand-colored plates (vol. 1, 101; vol. 2, 104; vol. 3, 101).
 Artists: Eleazar Albin; Elizabeth Albin, 41 signed plates; Fortin Albin, 1 signed plate.
 Etchers: Henry Fletcher, G. Thornton, Eleazar Albin(?).
 Colorers: Elizabeth Albin, Eleazar Albin.

————. *A Natural History of English Song-birds, and Such of the Foreign, as Are Usually Brought Over and Esteem'd for Their Singing. To Which Are Added Figures of the Cock, Hen and Egg of Each Species, Exactly as Copied from Nature by E. A., and Curiously Engraven on Copper.* 1737. 23 hand-colored plates.
 Artist: Eleazar Albin.
 2d ed., 1741.
 3d ed., 1759.
 Pirated eds., 1754, 1791, 1825.

4

Mark Catesby

(1683–1749)

MARK CATESBY, naturalist and pioneer ornithologist, was born into comfortable circumstances on 3 April 1683 and was baptized six days later at Castle Hedingham, Essex. His father, "John Catesby gent," was a lawyer, owner of a farm, and landlord of several properties.

Of his education and early life little is known, but George Edwards revealed one factor pertinent to his future career when he said that Catesby "hapned to fall into the acquaintance of the great naturalist Mr Ray, who then lived in Essex not far from him. This acquaintance inspir'd Catesby with a genus for natural history."[1] Even the little spelling mistake (*genus* instead of *genius*) was highly appropriate in the circumstances, because Catesby was destined to add greatly to the knowledge of bird genera and species.

After spending some time studying natural history in London, Catesby went at the age of twenty-nine to stay with his sister Elizabeth and her husband in Williamsburg, Virginia. His father had died six years earlier, leaving him enough money to live on. After a visit to the West Indies in 1714, he returned to Virginia and remained there until 1719, when he went home to England. While in America he collected seeds and botanical specimens and sent his packets and parcels home to Thomas Fairchild, a Hoxton nurseryman. The contents of these parcels made his name familiar in scientific circles in England. When the Royal Society gave its approval and backing to a plant-collecting expedition to Carolina

in 1722, Catesby was recommended by one of the patrons, William Sherard, as a man "pretty well skill'd in Natural History designs and paints in water colours to perfection."[2] Sherard was acquainted with John Ray, and while visiting Ireland in 1694 had transmitted to Ray his findings of several plants. Ray may subsequently have discussed Catesby with Sherard, for after Ray's death, Sherard took an interest in him.

William Sherard was a learned naturalist, usually referred to as Consul Sherard by his friends in recognition of his residence in that capacity at Smyrna for some years. He had acquired a fortune in Asia but lived modestly in London, devoting his time and a considerable portion of his wealth to the pursuit of his favorite study, natural history. Many of the seeds that Catesby gathered were sent to Consul Sherard, who took them to his brother James to propagate in his extensive garden at Eltham. The plants in this garden were described in *Hortus Elthamensis,* published in 1732. This publication described a number of new plants collected by Catesby.

Sherard's letters to Dr. Richard Richardson, another botanist friend of John Ray and plant collector, reveal some details of his efforts to obtain subscribers for Catesby's expedition. Sherard described Catesby as "a gentleman of small fortune, who lived some years in Virginia with a relative," and praised his watercolor paintings. Sherard said that at that date, 12 November 1720, Catesby was planning to go "over with General Nicholson, Governor of Carolina. The gentleman allows him 20*l* a year, and we are endeavouring to get subscriptions for him; viz. Sir Hans, Mr Dubois, and myself, who are all that have yet subscribed to him; but I am in hope to get the Duke of Chandos, which will be a good help."[3]

Drawing the Duke of Chandos into the affair, however, complicated it rather than helped, for he was deeply involved with the Africa Company, and Catesby is next reported all set to become "engaged with the Duke of Chandos" to collect in Africa, not America.[4] The duke was a very liberal patron of science and the arts, and Sherard had hoped for a generous contribution toward Catesby's expenses. It took some time to sort out exactly where Catesby was to do his collecting, but by 7 December 1721 Sherard was writing again, hopefully if more cautiously this time, "I believe Mr Catesby will be going to Carolina in a month; I have procured him subscriptions for near the sum he proposed!"[5] At the end of January he wrote to Richardson, "Mr Catesby goes next week for Carolina; he has put off his going till the last ship; I have got him sufficient subscription without putting you or Dr Iredale to charges; and as his obligations are more to me than all the rest, I hope he will make me suitable returns, that I may furnish my friends."[6]

Catesby did indeed make Sherard very adequate returns. By October 1722 he had supplied "two quires of dried Plants, 40 of which where new," and many more were to follow.[7]

After Sherard, Sir Hans Sloane was the main subscriber to Catesby's expedi-

tion. Sir Hans was always eager to promote such ventures and to obtain new specimens for his own collections, as he was a great collector of all kinds of "curiosities." Sloane was particularly interested in the natural history of the New World, having made his own voyage to Madeira, Barbados, and Jamaica in 1687 as physician to the Duke of Albemarle when the duke was appointed governor of Jamaica. Sloane wrote an account of the natural history of these islands on his return, and brought back several plants for Ray as well as numerous shells, animals, insects, and other finds for his own collections. By this time his museum had become famous. Sir Hans lived in Bloomsbury Square from 1696 to 1742 and held open house there for friends and visitors who came to inspect his collections. This museum was bought by the nation in 1753 and formed the nucleus of the British Museum's natural history collection.

Catesby sent Sloane consignments of plants while he was in Carolina, and one of his letters to Sloane, dated from Charles Town (now Charleston, South Carolina), 15 November 1723, indicated that they did not always have a smooth passage. "I hope you have received the remains of a Cargo of Plants, Birds, Shells, etc., which unfortunately fel into the hands of pirats," he wrote. "I shall be glad to hear the damage less than I expect."[8] Though on this occasion Sloane suffered some loss at the hands of pirates, he was usually the gainer from such encounters. When British seamen committed acts of piracy on the Spanish Main, they customarily took natural history collections destined for the king of Spain to Jamaica for sorting before sending them on to England. Sir Hans Sloane seems to have had something of a monopoly of this trade and received a great deal of booty from Jamaica.

During the four years he spent in Charles Town, Catesby collected seeds, plants, animals, fishes, snakes, and birds. Some specimens he sent back to England in any seagoing vessel whose captain he could persuade to accommodate his barrels and parcels on board. Most of the packages arrived safely, but, as we have seen, some were lost when pirates interfered with their passage. Catesby was careful to make notes, sketches, and drawings as a record in case any specimens were lost in transit.

He used two methods of preserving the birds he caught and shot. He either kept them in alcohol or dried them slowly in an oven and then stuffed them. He attempted to retain the freshness of the plumage colors and deter destructive insects by covering the stuffed birds with tobacco dust. These specimens and his own field sketches from living birds were the only evidence he had when he returned to England and commenced writing an account of the birds of the New World. No one had previously attempted such a thing in the area he had visited, so there was no chance of checking his work or of consulting others. In fact, his was to be the only attempt to record the natural history of an American colony in colonial times.

That Catesby was well aware of the uniqueness of his specimens is evident from his letter to Sloane dated 12 March 1723:

Honble Sir,

I hope you have ere this recieved from Capt Rave (who sailed from hence the 10 of May last) a Box of dryed Birds, shels, and insects. . . . Concluding you have recd. those by Capt: Rave I doe not repeat sending any of ye same again, with one I sent before I now send 7 kinds of wood pecker which is all the kinds except one I have discovered in this Country. . . . I am at a loss to know for want of hearing from you whether all kinds of Birds thus pre-served will be acceptable to you or whether those only that are remarkable for colour or shape. however the Icons of all I hope to produce which will make no small addition to ye history of Birds. The names of ye Birds are Six kinds of woodpeckers, Jay, Blew Bird, Red winged Starling Acolchichi of Willughby's Appendix, to-whee ye black bird with red on ye brest, Head of an Oyster catcher; Head of ye round crested Mergus. I am now setting out for the Cherukees a Nation of Indians 300 miles from this place and who have lately declared war with another Nation which diverts them from injuring us and gives me an opportunity of going with more safety what perticular commands you'l please to send me—shall be faithfully observed to ye best of my capacity.[9]

Catesby's birds were the crested jay (*Cyanocitta cristata;* Figure 19), red-winged blackbird (*Agelaius phoeniceus*), rufous-sided towhee (*Pipilo erythrophthalmus*), oyster catcher (*Haematopus palliatus*), hooded merganser (*Mergus cucullatus*), and six kinds of woodpecker; hairy (*Dendrocopos villosus*), ivory-billed (*Campephilus principalis*), downy (*Dendrocopos pubescens*), pileated (*Dryocopus pileatus*), red-bellied (*Centurus carolinus*), and redheaded (*Melanerpes erythrocephalus*).

This letter accompanied the consignment, which included a curious parcel that Catesby understandably felt called for an explanation: "The Bird's head in Box has a Body as big as a goose and web footed." What had happened, one wonders, to the body?

On 15 August 1724 Catesby wrote again to Sir Hans Sloane: "My design was Sr (til you'l pleas to give me your advice) to keep my Drawings entire that I may get them Graved, in order to give a general History of the Birds and other animals which to distribute separately would wholly ffrustrate that designe, and be of little value to those who would have so small fragments of the whole."[10] Evidently he was permitted to keep his collection of drawings intact, though Sloane was eager to see all species as soon as they were discovered and drawn.

Illness in November 1722 prevented Catesby from collecting, but he was op-timistic again when he wrote the following May on a rich haul of birds.

The largest of the Birds seems to be of the Cuckow kind it retires from this Country in the Winter—2 the Virginia Nightingale is sufficiently known—3 other kind of red Bird is here only in Summer—4 The Blew Bird is the only one of the kind I ever saw and seems to be of the Coccothraustes kind the third I believe that is yet known 5 The Smallest Bird I call a Tricolor tit You will please to give it a more proper name.

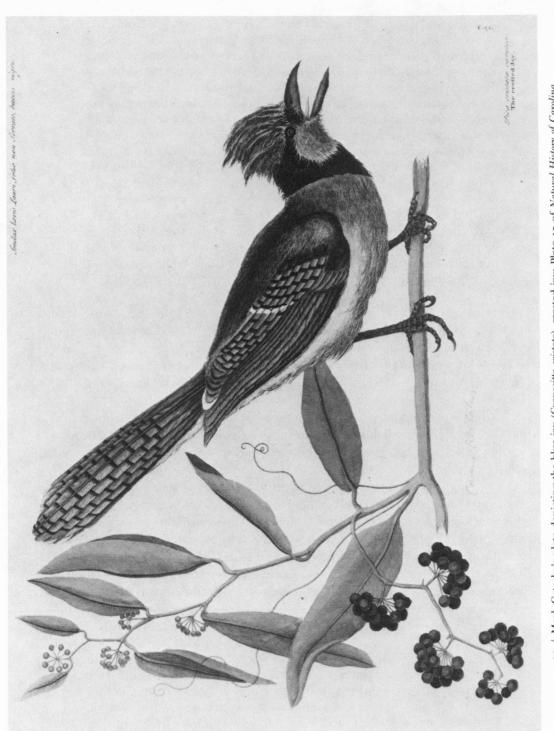

19 / Mark Catesby's plate depicting the blue jay (*Cyanocitta cristata*), crested jay; Plate 15 of *Natural History of Carolina*.

they breed here but retire south in winter—It's Nest is not extraordinary—6 the red wingd Blackbird is both gregarious and graniverous associating with 3 other kinds of that family in prodigious flocks and doe much mischief to rice and other grains. 7 The Bird with a red head is a Wood pecker the 6th of its kind here 8 The Bird with a Yellow Spot on its Crown is called here a King Bird Not improperly whether on Account of its Golden Crown or from its tyrannizing quality for it persues and puts to the rout all Birds from the biggest to the least.

Catesby ends this letter with a request for another "case of bottles for snakes and boxes for birds."[11] The birds he names may be identified as *Richmondena cardinalis, Piranga rubra, Guiraca caerulea, Passerina ciris, Agelaius phoeniceus, Melanerpes erythrocephalus,* and *Tyrannus tyrannus.*

In January 1725 Catesby was planning a trip farther afield, and on the fifth he wrote to Sir Hans Sloane to tell him of his plans and seek his continued support. It was a delicate matter, but Catesby put his case firmly. "I am So preparing to goe to the Bahama Islands to make a further progress in what I am about. This will add another Year to my continuance in America. And tho' I doe not expect a continuance of my full subscriptions yet I hope by your interest and continuance of your favours, I may expect the greater part of it. . . ."[12] His application was successful and in September 1725 he visited the Bahamas.

Catesby was delighted with the birds he found there and made detailed notes about the ricebirds, or bobolinks (Figure 20), which were migrating in great numbers. He listened to them as they passed overhead on their way to Carolina while he lay on deck at Andros Island. His descriptions of the ricebird and seventy or so other species were used by Linnaeus in the tenth edition of *Systema Naturae.* Linnaeus also adopted many of Catesby's descriptive names and incorporated them in scientific nomenclature, so that we are today still using some of Catesby's original terms. The bobolink is a case in point; its scientific name is now *Dolichonyx oryzivorus,* from Greek *oryza,* rice, and Latin *voro,* to devour.

Returning to England in 1726, Catesby went to live at Hoxton, where a number of his plants were flourishing in Thomas Fairchild's nursery. He devoted the next seventeen years to producing his *Natural History of Carolina, Florida, and the Bahama Islands, Containing the Figures of Birds, Beasts, Fishes, Serpents, Insects and Plants; Particularly Those Not Hitherto Described or Incorrectly Figured by Former Authors.* Not many of his figures came into the category "hitherto described or incorrectly figured," however, for his material was the basis of the first account of the flora and fauna of America. By 1743, when the work was completed, he had produced 220 colored plates to accompany the text.

Before Catesby began work on the project he sought advice on how to proceed with such a large undertaking. "At length by the kind advice and Instructions of that inimitable Painter Mr Joseph Goupy, I undertook, and was initiated in the way of, etching them myself, which I have not done in a Graver-like manner,

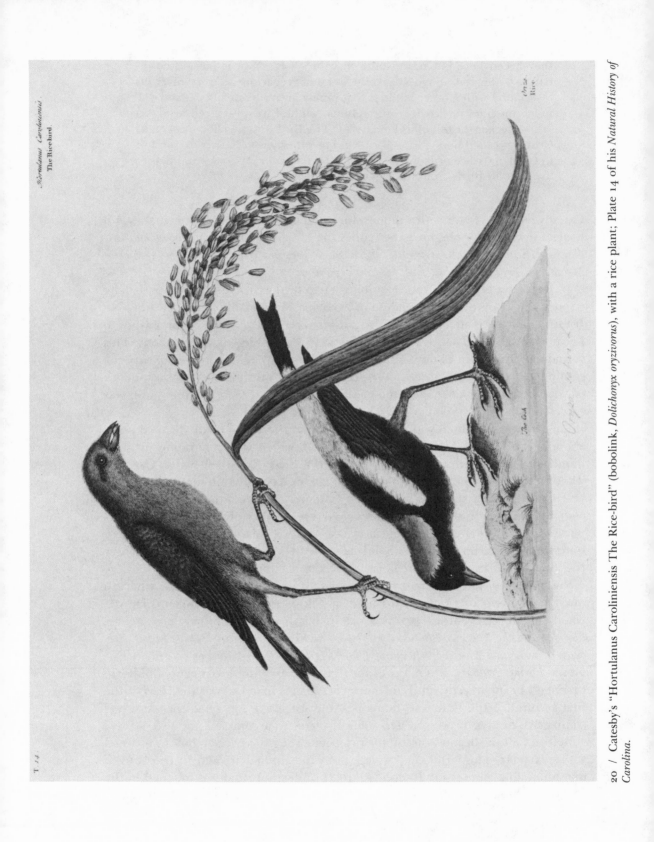

20 / Catesby's "Hortulanus Caroliniensis The Rice-bird" (bobolink, *Dolichonyx oryzivorus*), with a rice plant; Plate 14 of his *Natural History of Carolina*.

choosing rather to omit their method of cross-Hatching, and to follow the humour of the Feathers, which is more laborious, and I hope has proved more to the purpose."[13] Catesby initiated the practice of using folio-sized colored plates in natural history books. This size of paper permitted him to depict small and medium-sized birds and plants in their natural size. Only the larger birds had to be drawn to a reduced scale (but he did not reduce them consistently).

On 22 May 1729 Catesby attended the Royal Society meeting, by invitation, and exhibited the first published part of his *Natural History of Carolina.* One of the fellows of the Royal Society, Peter Collinson, a Quaker botanist of renown, had lent Catesby the money necessary to cover the cost of publication, free of interest. This first part consisted of twenty plates, together with descriptions of the birds delineated. Nine more parts, costing two guineas each, were planned. When completed, they were bound into two volumes. Catesby colored the plates of the early issues himself, but later others "under his directions" did the bulk of the coloring. Notwithstanding, he assured his readers that the plates were "all touch'd up and finish'd by his own Hand." Catesby's coloring was bold though not always accurate. His reds, in common with those of other watercolor painters of book plates of that period, were particularly unhappy.

The first eight plates have no backgrounds, just the etched and colored bird in the middle of an otherwise blank page. Plate 9, however, has the bird on a branch with leaves and fruit of the "chinkapin" (chinquapin) shrub, and from then on Catesby included plants, though the plant species are not always appropriate to the birds. He realized that to work a separate plate for each plant and animal species was going to be far too large a task for him to accomplish. He therefore placed insects on plates designed primarily to illustrate birds, birds on plates whose main figure was a plant, and so on.

Though Catesby noted the size of the bird in his written description, no indication of the size may be had from the plates. Usually his choice and scale of background were good—he was the first ornithologist to show such imagination in his illustrations—but the discrepancy between the sizes of plant, insect, and bird is sometimes misleading.

Catesby gave some thought to the problem of which bird of a pair he was going to reproduce, and eventually wrote, "As the males of the Feather'd kind (except a very few) are more elegantly coloured than the Females, I have throughout exhibited the Cocks only, except 2 or 3; and have added a short description of the Hens, wherein they differ in colour from the Cocks, the want of which method has caused great confusion in work of this nature."[14] One of the "2 or 3" exceptions is Plate 14, which shows a rice plant and both the male and female bobolinks (*Dolichonyx oryzivorus*) (Figure 20).

Catesby's birds are reasonably relaxed and often shown moving a wing or stretching for an insect or fruit of some plant. The golden-winged woodpecker (northern flicker, *Colaptes auratus;* Plate 1), for example, is holding out its wing to show off the brilliant coloring. The insects are charming, and are usually de-

scribed in the text as part of the bird's diet. Catesby tried to discover what the birds ate and inspected the stomach contents of those he shot. In this manner he discovered the "Gum-Elimy" berries in the stomach of his "Red-leg'd thrush" (*Mimocichla plumbea*).

Putting some life into a drawing of a rigid dead specimen has always presented a problem to bird artists. Some of the early artists arrived at a solution that would never be used today. They simply admitted defeat and drew an obviously dead specimen, either hanging up by its feet, suspended by its beak from a thread, or, as in Catesby's case, flat on its back with its claws in the air. His "Turdus pilaris migratorius The Fieldfare" is depicted lying dead on a stump of "aristolochia The Snake Root" (Figure 21). If Catesby failed to capture life in many of his bird portraits, here he has portrayed death in a remarkably realistic manner.

Catesby's arrangement of the bird species was nearly that of Willughby and Ray's *Ornithology*, a copy of which had traveled with him to Carolina. He had to find English names for many of his species, hitherto unknown and undescribed. "Very few of the Birds having names assign'd to them in the Country, except some which had Indian Names; I have call'd them after European Birds of the same Genus, with an additional Epithet to distinguish them."[15] Understandably, he sometimes confused very similar species and subspecies, especially when both northern and southern forms of a species were seen in Carolina.

In the text Catesby described the bird's size, its plumage, and its diet, so far as he could ascertain it. He often referred to a European species in order to give the reader a better idea of the shape and size of a similar New World species. Migratory habits were also mentioned. Nearly all of this evidence was derived from his own observation.

This conscientious, highly gifted amateur completed the first volume of *The Natural History of Carolina* in 1731. Recognition of his merit came in February 1733, when he was elected a fellow of the Royal Society. He had given valuable service to the society, not only during his collecting years but after his return to England, when he drew items for its register book and did some reviewing for its journal. One of the volumes he had been asked to review was an early edition of Linnaeus' *Systema Naturae*. He refused the assignment, perhaps because he knew his limitations with regard to systematics. He credited William Sherard with the scientific names of the plants in his books. As there was no one to whom he could turn for scientific names of birds, however, he had to choose many of the Latin terms himself. Linnaeus incorporated many of Catesby's new birds in the later editions of his *Systema Naturae*, and he was not the only naturalist to use Catesby as source material for his own work. George Edwards, Thomas Pennant, George Shaw, and Johann Reinhold Forster all used *The Natural History of Carolina* to improve their sections on American birds.

In 1743, when the last part of the second volume was completed, Catesby might have been expected to retire. He was then sixty years of age and had worked very hard. In 1746, however, he produced a supplement consisting of twenty more

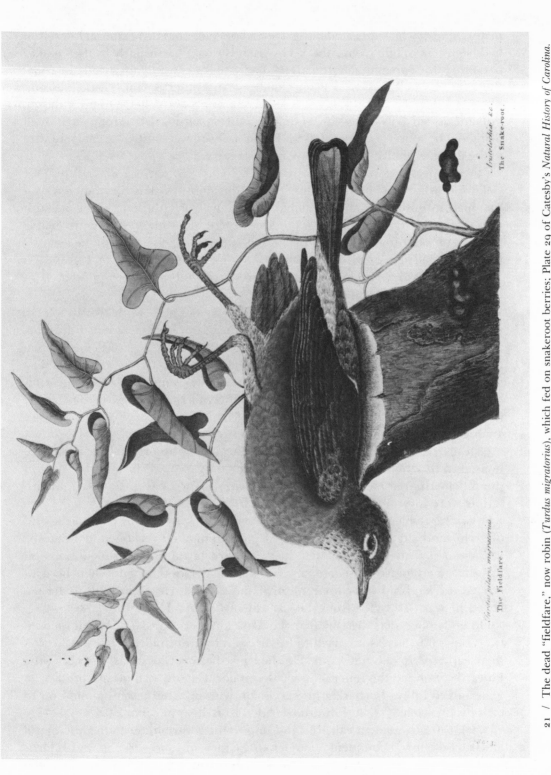

21 / The dead "fieldfare," now robin (*Turdus migratorius*), which fed on snakeroot berries; Plate 29 of Catesby's *Natural History of Carolina.*

plates, nine of which depicted birds. He had not collected this material himself; it had been sent to him from America by friends there, particularly by the Quaker botanist John Bartram, whose parents had emigrated to Pennsylvania in 1682. Bartram was well known to Peter Collinson and other botanists, and was employed by Lord Petre as a seed collector. His business flourished and his fifth son, William, added to its success by sending beautiful paintings of native plants which delighted botanists in England. Both father and son were also of great assistance to the authors of bird books and their illustrators.

Catesby presented a special copy of *The Natural History of Carolina* to Peter Collinson, who wrote in it: "This edition of this noble work is very valuable as it was highly finished by the ingenious author who in gratitude made me this present for the considerable sums of money I lent him without interest to enable him to publish it for the benefit of himself and family, else through necessity it must have fallen a prey to the book-sellers." Eventually Collinson's grandson sold this copy to a London bookseller for £15 10s. It was later purchased by Aylmer Burke Lambert (1761–1842).

Catesby added to his book "A List of Encouragers of this work" which was, in effect, a list of the 160 subscribers. Some Americans were included: John Bartram, William Byrd, and Thomas Penn, "Proprietor of Pa.," all of Pennsylvania, and Lord Baltimore, after whose family the Baltimore oriole (now northern oriole, *Icterus galbula;* Catesby's plate 48 in vol. 1) was named, as its orange-and-black plumage reproduced the colors of the armorial bearings of the Calvert family, founders of Maryland. Sir Hans Sloane and George Edwards were among Catesby's friends who subscribed to his book.

Catesby dedicated the work to Queen Caroline. The original drawings are housed in the Royal Library at Windsor, including two which were the work of the much-admired German painter of flowers Georg Ehret. Catesby's manuscripts were given to the Royal Society.

A visiting nobleman, Emanuel Mendes da Costa, saw Catesby toward the end of his life and left the only physical description of him. He reckoned that Catesby was about seventy years old, "tall, meagre, hard-favoured and sullen look and was extremely grave or sedate, and of a silent disposition; but when he contracted a friendship was communicative and affable. He often told me he believed he was descended from the Catesby of Richard III."[16]

On 2 October 1747 Catesby married Mrs. Elizabeth Rowland. When he died two years later he was reported to be survived by two children, Mark, who was then eight years old, and Ann. He died just before Christmas 1749. George Edwards attended the funeral on 23 December. Catesby had always been most generous to Edwards, sharing his specimens with him and teaching him how to etch his own plates when Edwards decided to write a bird book.

Mark Catesby made a valuable and important contribution to ornithological illustration. He was confident enough to break new ground—to portray his birds more naturally than before, with foliage backgrounds, and to adopt the folio

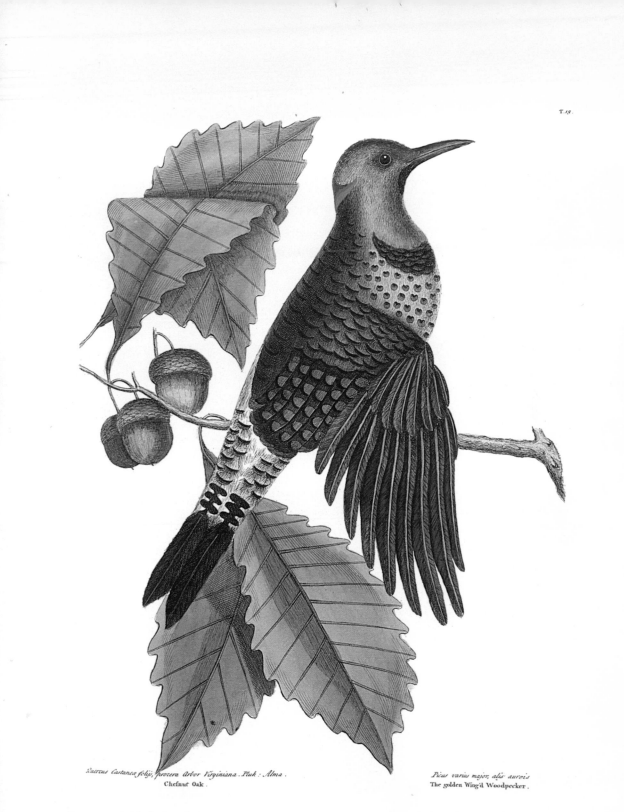

T. 18.

Quercus Castanea foliji, procera Arbor Virginiana . Pluk: Alma .
Chefnut Oak .

Picus varius major, alis aureis
The golden Wing'd Woodpecker .

PLATE 1 / Mark Catesby's golden-winged woodpecker, now yellow-shafted flicker (*Colaptes auratus*);
Plate 18 of his *Natural History of Carolina*.

format. He depicted the natural history of one area in its entirety, and often drew from living models. He was the first in a long line of ornithologists to teach himself to translate his drawings into a medium that produced multiple copies. As his was the earliest published natural history of a part of the New World, he has been called "the father of American ornithology." This achievement is the more remarkable when one remembers that he was originally sent to Carolina as a botanist, to collect seeds and plants.

Book Illustrated by Mark Catesby

Catesby, Mark. *The Natural History of Carolina, Florida, and the Bahama Islands, Containing the Figures of Birds, Beasts, Fishes, Serpents, Insects and Plants; Particularly Those Not Hitherto Described, or Incorrectly Figured by Former Authors, with Their Descriptions in English and French.* 2 vols. 1731–43. Supplement, 1746. 220 plates, 109 of birds with 113 figures.
 Artists: Mark Catesby, Georg Dionysius Ehret (2 plates).
 Etcher: Mark Catesby.
 Colorers: Mark Catesby and others.
 2d ed., revised by George Edwards, 1754. 109 plates colored more intensely; some small errors corrected.
 3d ed., 1771. 109 plates of birds.

5

George Edwards

(1694–1773)

Geoge Edwards' portrait shows him to be a portly, kindly gentleman, perhaps even a jolly sort of man. He had the ability to make friends easily, and the opinions of his friends confirm the impression made by his portrait. He was a man of great simplicity, liberal and well disposed toward his neighbors, and a cheerful companion. Though he was a good artist, he was diffident and humble about his work.

The idea of writing a bird book did not occur to Edwards until he was in his late forties, though he had been drawing and painting bird pictures long before that. He had always been interested in natural history, but his father had been adamant in directing him toward a business career. After educating him under the tuition of two clergymen and at Leighton-Stone School, his father apprenticed George to a tradesman in Fenchurch Street, London. The busy metropolis was very different from the pleasant countryside around Stratford, Essex, where he had lived since his birth, but fortunately his master, John Dod—a Greek and Latin scholar and a strict Christian—was kind and courteous to his young pupil during the seven years he spent in his house learning his trade as a bookkeeper and accountant. He also had some lessons in general commerce. This training, so his father thought, would prepare him to be a successful businessman.

During the years of his apprenticeship Edwards had access to a collection of books covering a wide range of subjects which were kept in a room next to his

bedroom. This library had belonged to a physician, Dr. Nicholas, a deceased relative of John Dod. Edwards wrote later:

> I spent my Evenings, and often the greater Part of my Nights, in turning over these Books, and reading such parts of them as suited best with my Genius: This Practice I followed for two or three Years in the latter part of my Time with Mr Dod, which I believe gave me a very disadvantageous Turn of Mind for I could not think of confining myself to Business, which probably would have raised my Fortune in the World. My Head was filled with a confused Mixture of Voyages, Travels, Astronomy, Experimental Philosophy, Natural History, Painting, Sculpture, and many other Things, which gave me an Inclination to visit Foreign Parts, in order to convince my Senses of some Things which Yet had been only conceived by the Mind. So in the Year 1716, regardless of Gain I laid aside all Thoughts of confining myself to Business.[1]

That was the year his apprenticeship ended. In 1718 he set off for the Netherlands, and so began five years of wandering through Europe as he pursued his interest in natural history. He returned to England for two unproductive years before setting off again, this time for Norway. There he was taken captive by a Danish guard, but fortunately was soon released. When the ship returning him to England was detained in the Scilly Isles, Edwards spent the time fishing and watching the sea birds on the cliffs. The following year he traveled through France dressed as a vagrant.

Back in England in 1720 and in need of employment, Edwards made some natural history drawings and got good prices for them. He was particularly good at drawing birds. With commissions from James Theobald and other members of the Royal Society, drawing occupied him for a number of years. In 1731 he was off again on an extended tour of the Netherlands and Brabant. This time he was traveling to some purpose. In Antwerp, Brussels, and Utrecht he searched the print shops and book markets for scarce books and prints. He also studied the pictures of great masters in the galleries of the Low Countries.

On returning home, he was offered the post of librarian at the College of Physicians through the good offices of Sir Hans Sloane, who was at that time president of the college and also of the Royal Society. Sir Hans employed Edwards to draw the curiosities in his private museum. He also appointed him unofficially as his secretary, thereby providing Edwards with both employment and a place to live. Edwards took up his appointment at the end of 1733 and moved into apartments in the college. His tasks were not onerous, and to the advantage of a steady income was added that of sufficient leisure to pursue his own interests. He had a library to hand with volumes on natural history and could continue his watercolor work with greater ease.

As Edwards says next to nothing about his job, it is difficult to know just what it

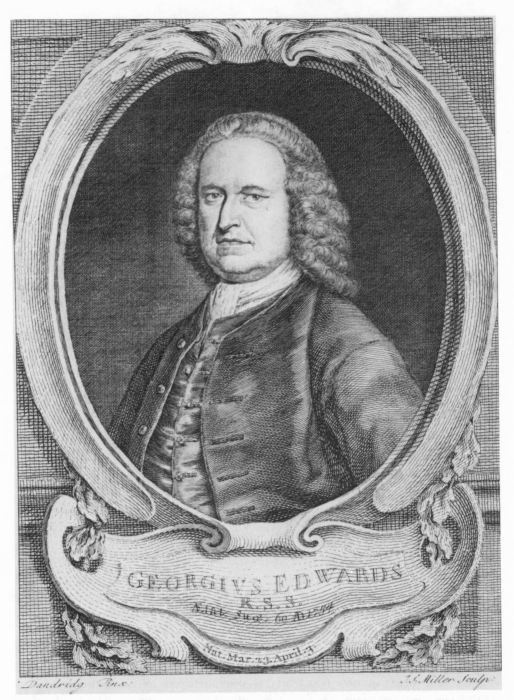

22 / Bartholomew Dandridge's portrait of George Edwards, engraved by J. S. Miller. This engraving formed the frontispiece to Edwards' first volume of *Gleanings of Natural History* (1758). His friend James Robson said Edwards was "of a middle stature, rather inclined to corpulence: of a liberal disposition and a chearful conversation. All his acquaintance experienced his benevolent temper, and his poor neighbours frequently partook of his bounty" (James Robson, *Some Memoirs of the Life and Works of George Edwards* [London, 1776], p. 25).

entailed and how much stock he had under his control in the library. The College of Physicians' library had been catalogued in 1660 by an earlier librarian who was also a famous ornithologist, Dr. Christopher Merrett. Merrett became librarian in 1654 but lost his job when the bulk of the library, along with his house, was destroyed in the Great Fire of London. We can only assume that new volumes had been acquired before Edwards was appointed librarian. No doubt Sir Hans Sloane made sure that the college got a sufficient share of books and curiosities to keep its librarian occupied.

Linnaeus visited Sir Hans Sloane and his splendid private museum when he was in England in 1736. We have no record of a meeting between Edwards and Linnaeus, but they corresponded after Linnaeus returned to Sweden. Edwards' large circle of friends included numerous scientists and noblemen with an interest in science, and he drew and painted the natural history objects owned by many of them. Edwards' books were a direct result of these drawings and his access to specimens and other artists' drawings of birds. At the end of the 1750s he wrote:

> I have been collecting for more than twenty years, and for a good part of the time employ'd by many curious gentlemen in London to draw rare and foreign birds as they were possessed of, and never neglected to take draughts of them with their permission for my own collection; and having stored up some hundreds, I showed them from time to time to curious gentlemen who favour'd me with their visits, and in looking them over, several of them have told me that there were amongst them that had not been figured or described by any Author, and that it would be worth my while to publish them, but I was backward in resolving to do it because I knew not so much of many of the Birds, as to know from what Country they came from, which is very material in Natural History. They answered that as I had taken the Draughts from Nature, and the like Birds might never be met with again, it was better to preserve the figures without knowing their Countries, than not at all.[2]

So Edwards resolved to publish *A Natural History of Uncommon Birds*. The volumes were illustrated from his drawings and the species included were selected from those not previously figured or described, or of which very little was known. The bird models were for a "great part . . . living when I drew them; others were in cases well preserved and dry, and some were kept in spirits."[3] His book came out in parts, as was the custom, and was published in quarto format. The parts took seven years to issue, from 1743 to 1751, and were then bound into four volumes. One of the birds not previously figured was the first known bowerbird, which he illustrated in 1750. This was the golden regent bowerbird (*Sericulus aureus aureus*), which he said was from Asia but later was established to have come from Vogelkop, New Guinea.

Edwards' diffidence in commencing on such a project is expressed in many of

his comments in the book. "As I never till very lately had any design to appear in Print, I have neglected to study the art of writing correctly, and am sensible of the many faults that may be found in this book; but hope the candid Reader will overlook them, since my chief aim was rather to be understood than to write correctly."[4] Not many authors today could describe in French and English each bird and other "curious" creature they were illustrating. Edwards realized that his work was not scientific and that the descriptions were not couched in the usual scientific language, but he is easily understood. Nor did he worry unduly about nomenclature, for his book was issued before the publication of Linnaeus' complete system of binomials for all classes of animals and birds. Indeed, Linnaeus was to consult Edwards' books for the new species they contained, and he borrowed many of Edwards' English names, Latinizing them to form his binomials.

The plates of *Uncommon Birds* show a wide variety of birds "from designs copied immediately from Nature and curiously colour'd after Life." Edwards had, "for variety's sake, given them as many different turns and attitudes as I could invent."[5] Some of Edwards' birds are bending over, some have a foot raised, a few are flying, but they are far from being vivacious. They are not so stiff, however, as those done by his friend Catesby. Some birds are seen attending their nests, and an occasional egg is shown within the nest. When the male and female of a species differed in plumage, Edwards depicted both if they were available to him. The contents of the bird plates varied: one had a bird and a mammal, another a bird and a lizard, and so on. One notable plate is the first good picture of the great auk (*Pinguinus impennis*) (Albin's effort had been much cruder).

Edwards had consulted his printers and friends as to how to "decorate the birds with airy grounds, having some little invention in them; the better to set off the whole I have, in a few plates, where the Birds were very small, added some foreign insects to fill up the naked spaces in the plates; these I esteem no part of the proposed work; nevertheless I have been equally careful to be exact in them both as to the drawing and colouring."[6] Catesby had already used this device for filling a page, though for economic rather than decorative purposes. Edwards was honest enough to admit that the insects had no relationship to the birds. He had, of course, never seen most of his birds in their natural habitats, so he could not draw appropriate backgrounds for them. He supplied some stylized foliage and grass for some bird figures, but even the plants were environmentally incorrect in many cases.

Edwards colored the plates of twelve sets himself, then supervised the coloring done by others. He was very particular about this task, and though the coloring is not always accurate by modern standards—too few shades are employed—at least the plates are not excessively colored. In fact, Edwards' birds and their coloring are sincere attempts at accurate portrayal rather than artistic productions. He resolved never to part with any uncolored etched prints while he was

alive in case unskilled colorers should work on them and spoil them. He deposited a copy of each print in the library of the College of Physicians after carefully coloring it himself from his original drawing. This copy was to serve as a reference for future inquirers. As we shall see, this careful plan did not prevent piracy later.

At the end of volume 4 Edwards wrote a detailed description of the techniques he had employed to reproduce his watercolor drawings. "Some brief instructions for etching or engraving on copper-plate with Aqua fortis" sounds ambiguous, but Edwards' plates were mainly done by etching, with a little engraving afterward. He gives the recipe for the ground that covered the copper plate and instructions on how to fix the ground and trace the design, and describes the needles to be used for drawing the design through the ground. Rather than immerse the plate in a bath of acid, he poured the "aqua fortis" (the popular name for nitric acid) over the plate and left a film of it on the surface for about half an hour for the lighter parts of the design, and then "stopped out"; that is, he coated these parts with varnish to protect them from further applications of acid. He repeated the process of pouring the acid on and stopping out until the blackest areas had been etched; the process took about one and a half hours. These details were given so that others could benefit from his experience in learning to etch his own plates and so save much expense.

It took some time to master this technique. Edwards explained:

> When I have practised a little while, I resolved to do such new and uncommon birds, as I had in my possession, since I saved expences and only employed my time. I was discouraged, upon first thinking of the Work, at the great Expence of graving, printing, and other things, which, I knew would be a certain cost attended with a very uncertain Profit, till my good friend Mr Catesby put me on etching my Plates myself, as he had done in his Work, and not only so, but invited me to see him work at Etching, and gave me all the necessary Hints and Instructions to proceed, which Favour I think myself obliged publickly to acknowledge.[7]

The bird on which Edwards practiced until he mastered the craft of etching was the brambling (*Fringilla montifringilla*). The Ayer Library (Field Museum, Chicago) has Pennant's copy of Edwards' *Uncommon Birds* which has inserted in it an etching bearing a note in Pennant's handwriting: "Edwards' first Essay towards Etching a Bird." This bird illustration bears the caption "The great pied Mountain Finch or Bramlin 1739." A nice little portrait of a bee appears on the same sheet of paper. In a copy of Edwards' later book, *Gleanings of Natural History,* in the Library of the Linnean Society of London is an etched print of the brambling on which there is a note: "Edwards' first tryal at Etching A.D. 1739." This copy, once in the possession of Henry Seymer of Dorset, a contemporary of Edwards, was donated to the Linnean Society by Major Vivean Seymer. Perhaps

Edwards was so pleased with the results of his efforts that he printed a few copies of his first etching to present to his friends.

The first volume of *Uncommon Birds* was completed in 1743 and the fourth volume in 1751. To mark the successful completion of the work, Edwards was awarded the gold medal of the Royal Society by the president, Martin Folkes. This was the coveted Copley Medal, the oldest award bestowed by the Royal Society, which is given for outstanding work in the field of science and was first presented in 1731.

Another honor was bestowed on Edwards two years later, when he was elected a fellow of the Society of Antiquaries. But he had to wait until 1757 to become a fellow of the Royal Society. An earlier attempt in 1744 had failed for some unknown reason, and the application had been withdrawn two weeks later. Edwards contributed a number of papers to the Royal Society's *Philosophical Transactions*. These papers were collected by James Robson, a London book-seller, and issued with the Linnean index to Edwards' works in 1776, three years after Edwards' death.

The success of *Uncommon Birds* encouraged Edwards to embark on further volumes. Three additional volumes were really supplements to the first book but were issued under a new title, *Gleanings of Natural History*. The pages were separately numbered, but the plates (one portrait of Edwards and 150 etchings) were numbered continuously with those in *Uncommon Birds*. All of the volumes contain a considerable number of British birds, but the greater proportion are foreign species.

In order to draw these uncommon birds, Edwards had to obtain his material from many quarters. He visited his patrons, friends, and acquaintances in order to inspect their collections and sometimes asked to borrow a specimen for a day or two. One unusual source was mentioned in part III of *Gleanings*. This part he dedicated to Earl Ferrers (1722–78), who, as Captain Washington Shirley, had contributed a large number of birds that had been intended for the pleasure of Madame Pompadour. The gallant captain (or was he just a buccaneer?) had captured this booty as part of a French prize. As Edwards chirpily commented, "It's an ill wind that blows nobody good."

The Indian plants and birds in his books were a result of Edwards' access to Governor Gideon Loten's excellent collection of drawings. Loten, a Dutchman, had been governor of Ceylon from 1752 to 1757. He was interested in natural history and was a good draftsman and artist himself. The collection of water-colors had been done largely by a Eurasian employed by Loten for the purpose of recording all the exotic flora and fauna of Ceylon and the Malay Archipelago. Pieter Cornelis de Bevere was a member of Governor Loten's household and executed beautiful watercolor drawings, 103 of which represented birds. This collection is valuable for the accuracy with which the portraits of live birds or freshly killed specimens were delineated. Fortunately, Loten took his collection to England, where he lived for a while. During his residence there Edwards and

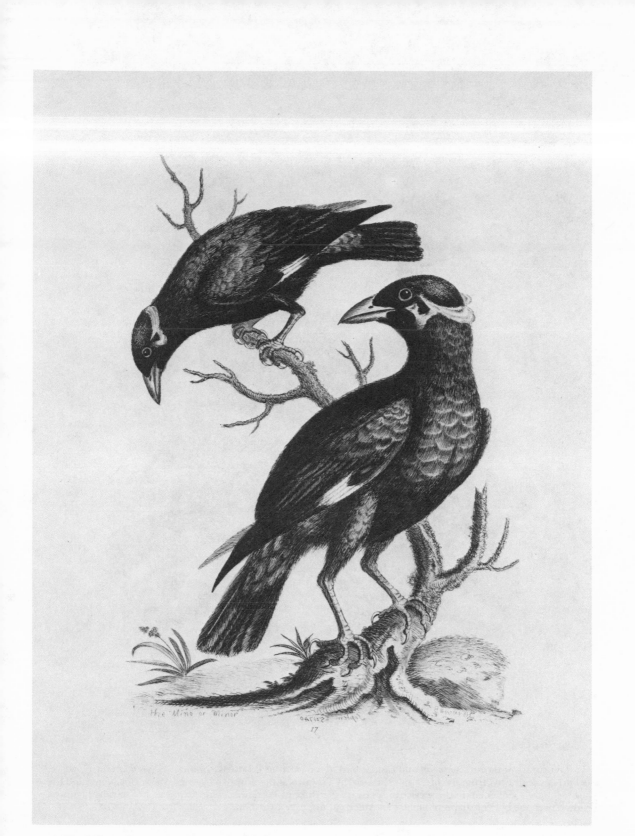

23 / The hill or talking mynah (*Gracula religiosa*), or, as Edwards called it, "minor" bird; Plate 17 of *Uncommon Birds*.

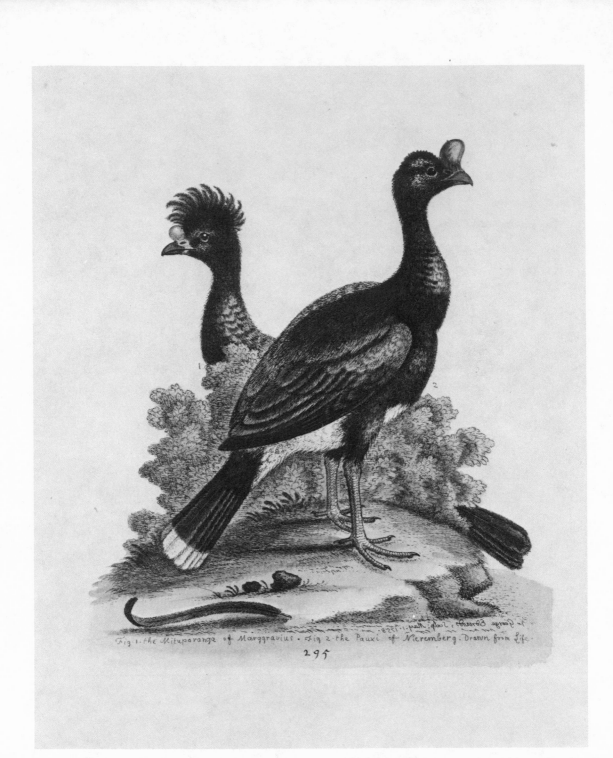

Fig 1. the Mituporanga of Marggravius. Fig 2 the Pauxi of Nieremberg. Drawn from Life.

295

24 / The curassow bird (*Crax rubra*) and cashew bird (*Crax pauxi*) in Edwards' *Gleanings of Natural History,* vol. 2. The birds were drawn "from the life," the "Curasso" by Edwards at the house of Charles Wager of Chelsea and the "Cushew" by a "Gentleman in the service of his Grace the Duke of Portland." The "Cushew" was so called because the knob over the bill "in shape resembles an American nut called Cushew."

other naturalists benefited from this fortunate circumstance. Loten's collection seemed destined to be cared for in England, for after being in Dutch ownership for about a century and a half, it was acquired by the British Museum (Natural History) in 1925.

Birds from North America figured largely in Edwards' books. They came from two main areas, Hudson Bay territory and Pennsylvania. In addition there were a few birds from Carolina provided by Catesby. The first collection of Hudson Bay birds were those formed by Alexander Light and James Isham. These two men returned to England about 1745 and entrusted their specimens to Edwards. In his *Uncommon Birds* Edwards commented: "Mr Isham has been employ'd for many Years in the Service of the Hudson's Bay Company, and has for some years past, been Governor under them at different times, of several of their Forts and Settlements in the most Northern habitable parts of America; where at his leisure times, his commendable Curiosity led him to make a collection of all Beasts, Birds and Fishes of those Countries."[8] Among the birds collected by Light was a northern phalarope that had been caught off the coast of Maryland, and a figure of this bird appeared in 1743 under Edwards' name of "Coot-footed Tringa."[9] It is now classified as *Lobipes lobatus*.

The Pennsylvania birds were the result of Edwards' correspondence with William Bartram. William had been the despair of his family, especially of his father, the eminent botanist John Bartram, because he insisted on taking an interest in ornithology as well as botany. William Bartram was the first American-born ornithologist to investigate the avifauna of the New World; up to that time this work had been carried out by Englishmen. William was a prolific correspondent and an excellent draftsman. Edwards declared that Bartram "obliged me at one time with fourteen American birds, mostly non-descripts with some short accounts and observations concerning them, in a letter dated Pensilvania June 1756. All which birds are figured in this Second Part of my Gleanings," published in 1760.[10] Among these Pennsylvanian birds were some which two centuries later crossed the Atlantic and were added to the British list as rare visitors. They included the white-throated sparrow (*Zonotrichia albicollis*) in 1909 (Edwards had given this bird its English name, and his illustration of this species on Plate 304 was after a drawing by Bartram) and the myrtle warbler (*Dendroica coronata*).

The dedications of the seven volumes testify to Edwards' patrons and the sources of his bird models. Volumes 1 and 3 were dedicated to the President and Fellows of the College of Physicians; volume 2 to its president alone, Sir Hans Sloane; volume 5, of 1758, to the Trustees of the British Museum, who now owned Sir Hans Sloane's collections; volume 6 to John Stewart, third earl of Bute, who purchased Edwards' 900 sketches and the original gouache drawings for his books some time before Edwards' death and took them to his home, Luton Hoo, in Bedfordshire (they are now in the British Museum [Natural History]; and volume 7 to Earl Ferrers. Volume 4 is dedicated "To God."

The *Literary Anecdotes* of John Nichols expand Edwards' references to his patrons in his preface. Of Sir Hans Sloane we know quite a lot in addition to the fact that he employed Edwards "for a great number of years in drawing minature [*sic*] figures of animals &c, after Nature, in water colours to increase his very great collection of fine drawings by other hands, which drawings are now all fixed in the British Museum." Little further is added to the Duke of Richmond's name, but he would be Charles Lennox, the second duke (1701–50), a great patron of the arts and science. He lent Edwards his bird specimens from Surinam, which were set up and preserved in "a glass case." Edwards' third patron was Richard Mead, physician in ordinary to the king. Mead earned a great deal of money as a doctor to the fashionable London world and used his "fortune, house and everything in his power to contribute to the promotion of learning, science, arts, mechanics and in short every thing that tended to the public benefit and honour of his country."[11]

"Martin Folkes esq the last of my deceased principal patrons was a freind [*sic*] and intimate acquaintance of the other three."[12] Folkes was an antiquarian and man of science, a graduate of Cambridge University and fellow of the Royal Society from 1714, serving that institution as vice-president in 1722–23 and succeeding Sir Hans Sloane as president in 1741. He was also a member of the Spalding Society, a literary and antiquarian society formed in 1712. In that year Mark Catesby, then residing in St. Luke's parish, London, was named one of the first members.

These men assisted in many ways—by financial support, by introductions to friends who owned birds, by obtaining specimens, by giving friendly encouragement, finally by subscribing to Edwards' books and obtaining other subscribers.

Some of Edwards' designs were pirated by contemporary manufacturers and Edwards protested indignantly against this misuse of his bird figures.

> I have observed that several of our manufacturers that imitate China Ware, several print sellers, and printers of linen and cotton cloths have filled the shops in London with images, pictures and prints, modelled, copied or drawn, and coloured, after the figures in my History of Birds. . . . Most of wit, knowledge, and public occurrences, have also in their magazines, Mercuries, etc. made free with my figures and descriptions of animals to embellish their pamphlets, though the figures are generally so miserably lamed and distorted that the judicious part of the world can form but a mean opinion of the work from which they are plunder'd.[13]

No fewer than seventeen birds were copied by the Chelsea porcelain manufacturers. Five of these Chelsea models may be seen at the Victoria and Albert Museum, London. The models of the "white partridge or ptarmigan" (*Lagopus mutus*), touraco (*Tauraco macrorhynchus verreauxi;* Figure 25); "crested red or russet

butcher birds" (*Lanius cristatus*), little hawk owl (*Surnia ulula*), and the "dusky and spotted duck" (*Histrionicus histrionicus* and *Anas poecilorhynchus*) form part of the Shreiber collection in the Department of Ceramics. These and the other twelve birds are fully discussed in H. Bellamy Gardner's article on the Chelsea birds (listed under "Chapter Sources" in the bibliography). They were modeled in soft paste in the raised anchor period (1747–53) of the Chelsea factory. It was not until 1862, when artists received copyright protection, that this sort of thing was stopped. Designs for such articles manufactured today are specially commissioned from the artists by the manufacturers.

Edwards was more likely to have been flattered by the legitimate use made of his work by later ornithologists. Many of the faithful descriptions of the birds and their portraits, never drawn before, were used by Linnaeus for his *Systema Naturae*. Two letters from the correspondence between Linnaeus and Edwards (1758–60) are preserved in the archives of the Linnean Society of London. From these letters we find that Edwards sent Linnaeus seventy-five prints from the *Uncommon Birds*, and later a further twenty-five. Though Edwards did not worry about scientific names for his birds, he was careful to make an index of their English and French names, a large number of which he had invented himself. After Edwards' death, Linnaeus was asked by Edwards' publisher to supply an index of Latin names. Linnaeus complied, though he confessed he had done so rather hastily, and the result was not always accurate. The 350-odd names he supplied, however, are some measure of Edwards' achievement in describing so many species at that time in history.

Edwards' work was often used by William Swainson and John Latham. A number of Swainson's watercolors now in the Balfour Library, Cambridge, have penciled notes at the bottom: "Altered from Edwards." Latham's watercolor studies, which are preserved in the British Museum (Natural History) Zoology Library, have inserted in the bound volume some odd plates from Edwards, on which Latham based his illustrations of those species. Subsequent books on ornithology offer many other acknowledgments to both his text and his illustrations.

Edwards' most influential patron, Sir Hans Sloane, retired from public life in 1742 and went to live at Chelsea. From then until Sir Hans's death, eleven years later, Edwards went to Chelsea nearly every week, either by coach or by boat on the Thames, in order to keep him in touch with events and the "common news of the town." Sir Hans was meticulous in reimbursing Edwards for his journeys to Chelsea, still fulfilling his role as benevolent patron. Edwards visited Sir Hans Sloane for the last time on 10 January 1753; Sloane died the following day.

In August 1760 Edwards complained in a letter to Linnaeus about "the slowness of old age."[14] His *Gleanings* took another four years to complete, and by then Edwards was sixty-six years old. In 1769 he retired from his post at the College of Physicians and went to live in a small house at Plaistow. He lost the

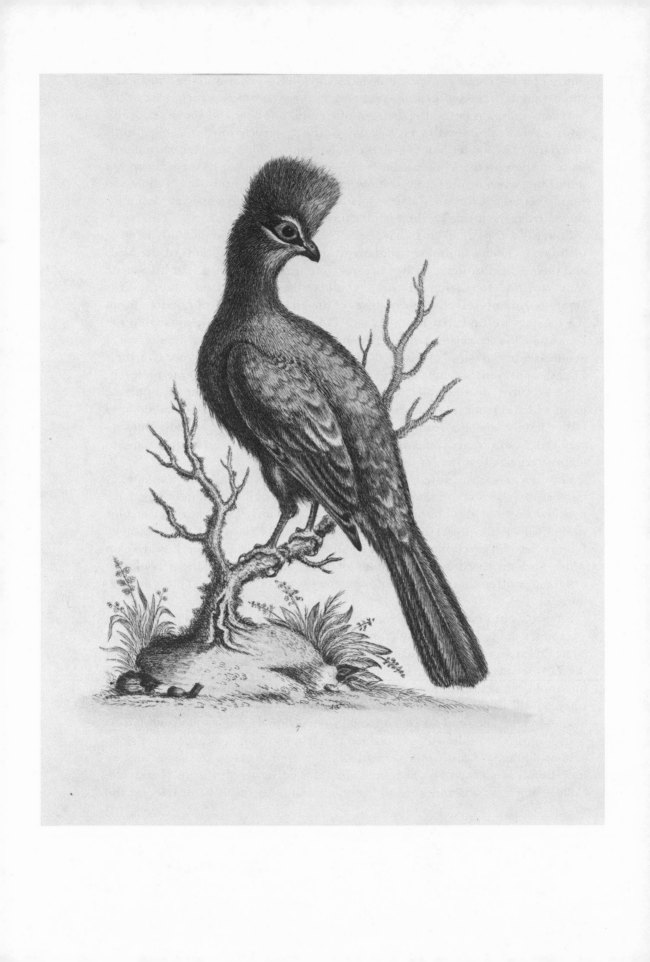

7

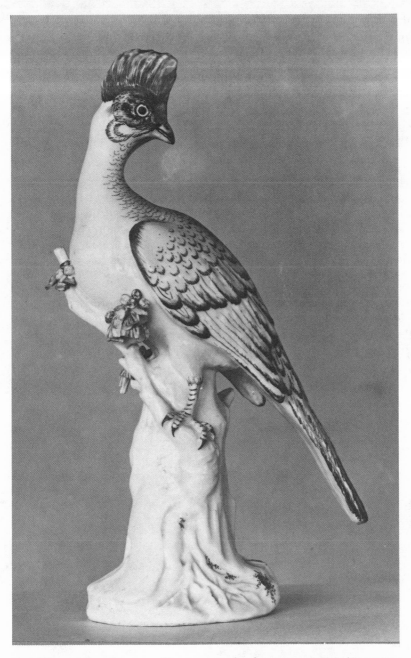

25 / The red-tipped touraco (*Tauraco macrorhynchus verreauxi*) from *Uncommon Birds*, vol. 1, Plate 7, of which Edwards said, "This bird is about the bigness of a Magpye or Jay. It is very active flurting up its tail, and raising its crest; it swells its throat and utters a hoarse and disagreeable sound. This bird is now living at Col. Lowther's house in St. James's Park where I have been permitted to make drawings of it for several persons of distinction." The Chelsea porcelain model, dated c. 1750, is based on Edwards' etching.

sight of one eye and suffered from a kidney stone and cancer. He sold all the remaining prints and copies of his books to his friend James Robson, the bookseller of The Feathers, New Bond Street.

Edwards died on 23 July 1773 and was buried in his native parish of West Ham. On his memorial stone an inscription recording his long service to the College of Physicians concluded, "His Natural History of Birds will remain a lasting monument of his knowledge and ingenuity."[15] Edwards would have been modestly pleased.

Books Illustrated by George Edwards

Edwards, George. *A Natural History of Uncommon Birds and Some Other Rare and Undescribed Animals.* 4 vols. 1743–51. Frontispiece and 210 plates (189 of birds).
 Artist, etcher, and colorer: George Edwards (with other colorers).
————. *Gleanings of Natural History, Exhibiting Figures of Quadrupeds, Birds, Insects, Plants. Most of Which Have Not, till Now, Been Either Figured or Described.* 3 vols. 1758–64. With portrait and 150 plates, 128 of birds (vol. 1, Plates 211-60; vol. 2, Plates 261–310; vol. 3, Plates 311–61).
 Artist, etcher, and colorer: George Edwards (and other colorers).
 New, large-paper ed., 1802–5.

6

Thomas Pennant

(1726–1798)

Thomas Pennant was born at Downing, the family seat, near Whitford in Flintshire, on 14 June 1726. At the age of twelve he was given a copy of Willughby and Ray's *Ornithology,* and to this present he attributed his early taste for ornithology and a love of natural history in general. He was educated at Oxford University. After completing his studies he traveled extensively throughout Britain and Europe, and in 1754 he visited Iceland.

His contacts with naturalists whom he met in his travels about the country widened his interests. His journeys on horseback took him over much of Wales, into Scotland and the Hebrides, and to the Isle of Man. In Lincolnshire in May 1768 he visited Sir Joseph Banks at Revesby Abbey, on the strength of an acquaintance formed in March 1766, when Sir Joseph "called on me at my lodgings in St. James's Street [London] and presented me with that scarce book *Turner de Avibus.*"[1] Together they made many botanizing trips. In 1774 Pennant stayed at Bulstrode in Buckinghamshire for a few days with the Dowager Duchess of Portland, a liberal patroness of naturalists. Her chaplain, the Reverend John Lightfoot, was also a well-known naturalist. Lightfoot enjoyed country rambles and longer excursions while searching for plants, fossils, and other new or interesting items. He accompanied Pennant on his tour to the Hebrides, and on their return Lightfoot wrote *Flora Scotica,* which he dedicated to the duchess. Pennant wrote the section "Caledonian Zoology," describing the animals and birds they had seen on their tour. The book was published at Pennant's expense.

Like other wealthy young men, Pennant made a grand tour of the Continent. His account, written in 1765, sets out his route and observations. He made detailed records of the natural history collections belonging to European naturalists, but he left few records of birds sighted in the field. The few he mentions, however, were interesting species, such as the black woodpecker (*Dryocopus martius*); capercaillies (*Tetrao urogallus*); rock ptarmigan (*Lagopus mutus*); hazel hens (*Lyrurus tetrix*), which he saw in Germany, and storks (*Ciconia ciconia*), which had young in the nests they had built on housetops.

In Holland Pennant made the acquaintance of Peter S. Pallas. Their conversation "rolled chiefly on natural history"[2] and motivated Pennant to write his *Synopsis of Quadrupeds,* which he later expanded under the title *History of Quadrupeds.* The earlier publication established him as a naturalist of ability and he became known to many British scientists in consequence. His correspondence with the Selborne curate Gilbert White, begun in 1767, shortly after his return from Europe, provided him with a considerable amount of new material for his books. Pennant's letters to White have been lost, but White's to Pennant form nearly half of the text of *The Natural History and Antiquities of Selborne in the County of Southampton,* published in 1789. The other half of White's book consisted of letters concerning antiquities from Daines Barrington, a fellow of the Royal Society. White and Pennant continued to correspond until 1790.

In 1767 Pennant was elected a fellow of the Royal Society and was thereby brought into contact with more scientists. Pennant did not seek out people with the same interests solely for his own benefit; like his more famous friend Joseph Banks, he used his influence and wealth to promote the study of natural history. Both men saw the great advantages provided by accurate pictures of plants, insects, and birds to anyone who wished to identify species, and they patronized not only authors but also the artists and craftsmen who helped to produce illustrated natural history publications. In his autobiography Pennant said, "I cannot help mentioning the services to the profession of the art of engraving, by the multitude of plates performed by them for my several works."[3] He then listed his published books and the number of plates each contained. Altogether there were 802 plates.

Pennant was less well endowed than Banks, who inherited £6,000 a year at the age of eighteen. Pennant was forced to resign from the Society of Antiquaries of London in 1760, a year after he was elected a fellow, "being married and in narrowing circumstances." He had married Elizabeth Falconer, daughter of James Falconer, of Chester, and they had two children, David and Arabella, before Elizabeth's early death in 1764. This was the second blow to strike him within a year, for his father had died some months earlier. After Elizabeth's death Pennant traveled to Paris and The Hague on his grand tour. Two years later he became sheriff of North Wales. He continued to be active in Welsh public life for thirty years, so that in 1793 he could claim, "I still haunt the bench of justices."[4] Twelve years after Elizabeth's death he married again. His second

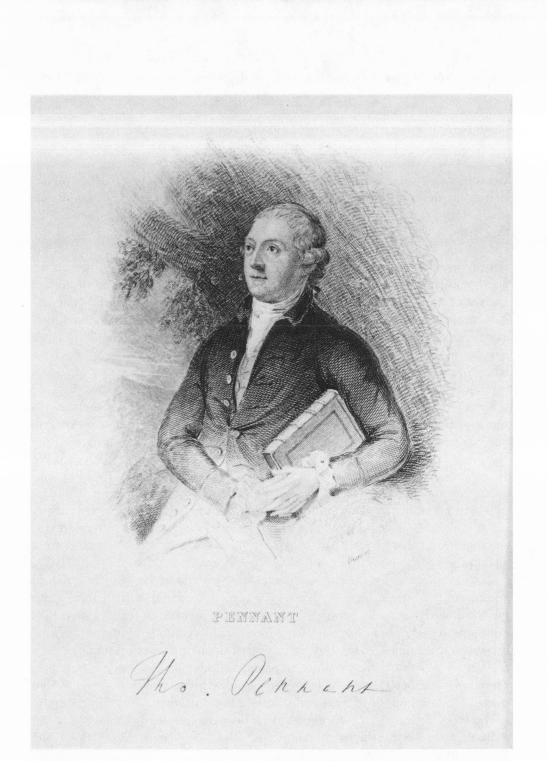

PENNANT

Tho. Pennant

26 / William Home Lizars engraved this portrait of Thomas Pennant in 1833 after Gainsborough's full-length portrait (now in the National Museum of Wales), an oil painting done in 1776, when Pennant was fifty years of age.

wife was Ann Mostyn, daughter of his near neighbor and close friend Sir Thomas Mostyn. Pennant had two more children by her: Sarah, who died at age fourteen, and Thomas.

Pennant had corresponded with Linnaeus since 1755, and Linnaeus obtained Pennant's election to the Royal Society of Upsal two years later. He may also have been instrumental in getting Pennant to undertake an up-to-date account of British zoology. Linnaeus realized that many species had been added to the British list since 1678, when Willughby and Ray's *Ornithology* was published. Ray had noted about 160 British birds (it is difficult to be more exact, as some of his descriptions are a little vague and he did not always positively assert that a species was known to be British). When Pennant came to publish his account of British birds in 1766, he added many more names. One of these new species was a sedge warbler (*Acrocephalus schoenobaenus*), which he had discovered while staying with Banks in Lincolnshire in 1768. Gilbert White wrote in his journal on 3 November 1775, "We have found at times in the parish of Selborne alone about 120 species of birds, which are more than half the number that belongs to Great Britain in general; and more than half as Many as Linnaeus can produce in the Kingdom of Sweden. Mr Pennant enumerates 227 species in Great Britain and Linnaeus about 221 in his native country."[5]

Four parts of Pennant's *British Zoology,* which gave an account of the animals, reptiles, amphibians, fishes, and birds of Britain, were published between 1761 and 1766. Pennant then issued a fifth part with 25 plates, bringing the total number of plates to 132, of which 11 were mammals and some 121 depicted life-sized birds. Writing about these illustrations in 1791, Pennant said, "They were all engraven by Mr Peter Mazel, now living. The painter was Mr Peter Pallou, an excellent artist, but too fond of giving gaudy colours to his subjects. He painted for my hall, at Downing, several pictures of birds and animals, attended with suitable landscapes."[6] Sadly, we can no longer see these Paillou paintings at Downing, for the house was gutted by fire in 1922 and demolished in 1953.

British Zoology was a lavish production and proved to be very popular on account of the colored plates. Albin's work had covered both British and foreign birds, while Catesby and Edwards had taken more interest in foreign species, so Pennant takes the credit for producing the first colored illustrations of birds in a book which attempted to list and portray all of the British species, many of them life-size. The drawings sometimes depicted the pair of the species, but more often only the male; occasionally a nest was added to the picture. Peter Paillou contributed most of the designs and colored the prints, the color being extended to the trees, branches, and foregrounds. These really splendid folio plates cost Pennant so much that the British charity school at Clerkenwell Green, for which the profits from the book were intended, came off rather badly, as did Pennant himself. Nevertheless, they showed what could be done in the production of good, large pictures of British birds. Much of the credit must go to Mazell, the meticulous and tidy etcher, for his fidelity to Paillou's drawings.

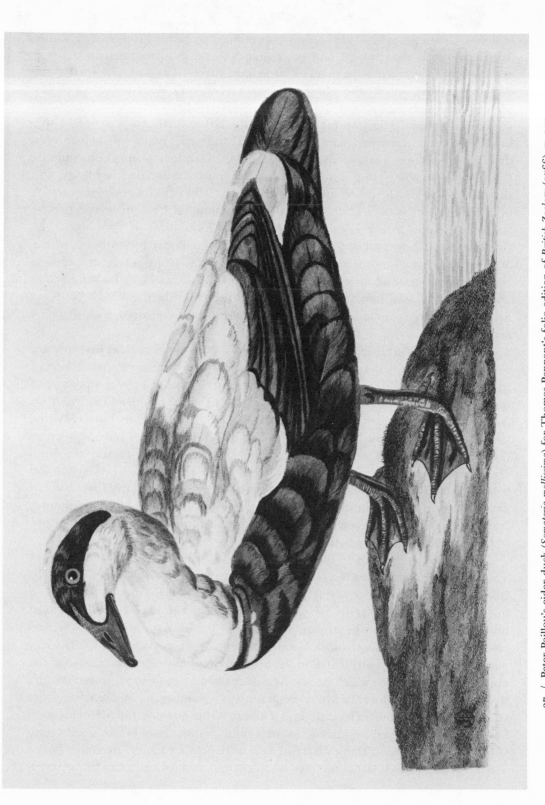

27 / Peter Paillou's eider duck (*Somateria mollissima*) for Thomas Pennant's folio edition of *British Zoology* (1766), p. 152.

107

Peter Paillou (c. 1712–c. 1784) was apprenticed to Jacob Tribble of St. Anns, Westminster, in 1724 for £8, and subsequently became a prolific artist. A large number of his watercolor pictures of birds have survived and may be seen at the British Museum and in the McGill University Library, Montreal. Most of the plates in the later editions of *British Zoology* were smaller versions of his figures for the first edition. Paillou was better with the larger birds, such as owls, game birds, falcons, and herons, than with the small songbirds. When he did one large drawing to occupy a whole plate, it was detailed and in proportion, but the figures in plates depicting a number of species, such as finches, buntings, and thrushes, were much stiffer and less well drawn. Paillou exhibited a watercolor of a female capercaillie (*Tetrao urogallus*) accompanied by a male red grouse (*Lagopus lagopus*) at the Free Society of Artists Exhibition of 1763 and then fifteen years later exhibited "A Horned owl (from Peru) in feathers" at the Society of Artists. In 1780 he lived in Red Lion Row, Islington, having moved recently from Paradise Row in the same London village. (A Peter Paillou born in 1762 who exhibited miniatures from 1786 after entering the Royal Academy Schools in 1784 may be a relation, but should not be confused with the bird artist.)

Charles Collins' drawings were used sparingly—unfortunately, as his birds are lively creatures, much nearer in style and vivacity to Barlow's than those of Pennant's other painters. Collins who lived from 1680 to 1744, was a painter of animals as well as birds. He issued a set of prints that reproduced twelve of his paintings of British birds, six etched by Henry Fletcher and six by James Mynde, which are extremely rare today. A number of his watercolors may be seen in museums and libraries, including a very fine painting of a buzzard in the Cecil Higgins Museum, Bedford, signed and dated 1739. His common buzzard (*Buteo buteo;* Figure 28) in Pennant's *British Zoology* of 1766 is particularly fine. Nine of Collins' exquisite oil paintings, part of a set of twelve, may be seen at Anglesey Abbey, near Cambridge, each an informal composition of several species showing remarkable veracity for the period.

Collins painted from the birds in the London museum and menagerie of Taylor White, a judge on the North Wales Circuit and a wealthy collector. His collection, which includes several hundred paintings by Collins and Paillou, is now in the McGill University Library in Montreal. White liked his specimens in his aviaries and dens to be drawn, and he kept a very large number of watercolors of these animals and birds, besides those in other menageries. White was a patron of the arts and influential in the acquisition of excellent paintings for the Foundling Hospital, of which he was treasurer from 1745 to 1771. Judge White's circuit included the locality where Pennant was a magistrate, and no doubt the two men met in their official capacities. Gilbert White gives us a further clue as to how Pennant obtained permission to use Collins' drawings in White's collection. Gilbert White wrote to Daines Barrington on 12 April 1770: "The collection of Taylor White Esq., is often mentioned as curious in birds etc: can't I be intro-

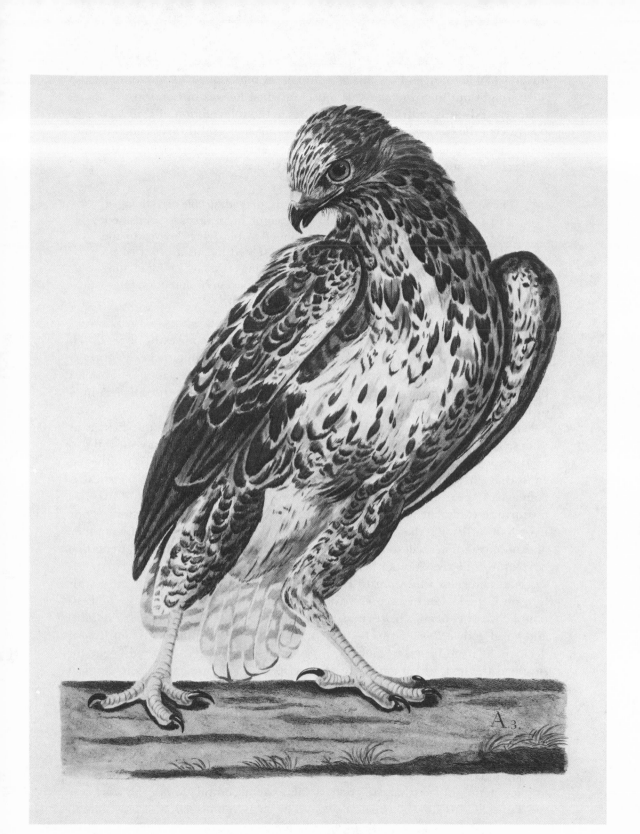

28 / Charles Collins' splendid buzzard (*Buteo buteo*) for the folio edition of Pennant's *British Zoology*, p. 66.

duced when in town, and see this museum of my namesake?"[7] Pennant must also have sought out the owner of this museum when he was in London.

George Edwards contributed three plates to the folio edition of *British Zoology:* portraits of the black-winged stilt (*Himantopus himantopus;* Edwards called it long-legged plover), the scaup duck (*Aythya marila*), and the rock ptarmigan (*Lagopus lagopus*). Pennant wrote in his autobiography:

> The worthy and ingenious George Edwards, that admirable ornithologist, at first conceived a little jealousy on my attempt; but it very soon subsided. We became very intimate, and he continued to his dying day ready and earnest to promote all my labours. He presented me, as a proof of his friendship, with numbers of his original drawings from which his etching had been formed. These I keep, not only in respect of his memory, but as curious testimonies of his faithful and elegant pencil.[8]

Some plates in the fourth edition of *British Zoology* also bore the legend "G. Edwards pinxit": a "rose-coloured ousel" (*Sturnus roseus*), a nutcracker (*Nucifraga caryocatactes*), and a good picture of a plunging gannet (*Sula bassana*). The last picture also bears the signature of R. Murray and appears to be the only example of his etching in a bird book.

Pennant's other artist was Peter Brown, a flower painter to the Prince of Wales. He flourished (as the old biographies would say) from about 1760 to 1791, though not very well, according to Gilbert White, who told his brother in 1776 that "Brown I think is in gaol in St George's Fields," adding heartlessly, "but artists never work more steadily than when under confinement."[9] Brown's misfortune is treated more sympathetically in another of White's letters "Poor Brown the artist! it is the fate of most ingenious foreigners; they have no manner of economy. Forster will soon be in the same condition; he and his son dress like noblemen, and give £60 per ann. for an house!"[10] (Johann Reinhold Forster, a German naturalist who went to England in 1766 and took his son Georg with him on Captain Cook's second voyage, was also under the patronage of Pennant.) Two of Pennant's plates in *British Zoology*—a white owl (barn owl, *Tyto alba*) and a red godwit (*Limosa* spp.)—bear the note "P. Brown pinxit." When Brown decided to issue his own book, *New Illustrations of Zoology,* in 1776, Pennant supplied the text, which gave a brief description of the new species in English and French. Pennant had some pertinent comments to make on this book. "In this year Peter Brown, a Dane by birth, and a very neat limner, published his illustrations of natural history in large quarto with L plates. At my recommendation Mr Loten lent to him the greatest part of the drawings to be engraven, being of birds painted in India. I patronized Brown, drew up the greatest part of the descriptions for him, but had not the lest concern in the preface."[11] Brown had implied in the preface that the greatest value to the compilation of the work was the Tunstall Museum (he copied twelve of its birds, ten insects, and one animal)

rather than Pennant's influence. He then compounded this error of judgment in Pennant's eyes by speaking (on p. 48) of "my great patron Marmaduke Tunstall." The book has some attractive illustrations in it, not very well colored by Brown. The ground is detailed and the bird figures are occasionally accompanied by an insect. The book formed a kind of supplement to George Edwards' *Natural History of Uncommon Birds* and *Gleanings of Natural History* but was of much lesser quality. Brown borrowed a *Cuculus bengalensis* from Edwards, a black-backed eagle (*Aquila chrysaetos*) from Taylor White, and seven specimens from Pennant's own collections, including a yellow-crested woodpecker (*Celeus flavescens flavescens*), an ostrich (*Struthio camelus*), a boatbill (*Cochlearius cochlearius*), a Surinam tern (*Chlidonias nigra surinamensis*), and a grayheaded duck (*Tadorna cana*). Otherwise Brown relied heavily on Tunstall's birds and on Governor John Loten's drawings—"ex pictis Gov. Loten 20 birds and 1 insect."

Pennant had completed his *British Zoology* in 1766. Gilbert White's brother Benjamin, a bookseller in Fleet Street, London, suggested that another edition be issued, and agreed to give Pennant £100 for the right of publication. The two volumes of the second edition were published in 1768–69, and a supplement, often regarded as the third edition, was issued in 1770. The 103 plates do not compare with those in the first edition. They are much smaller, octavo, and the figures more cramped. In 1768 the name of a new artist appeared, "Desmoulins." F. A. and J. B. S. F. Desmoulins were Parisians whose drawings of birds were reproduced in the books of Pierre Sonnerat and Pierre-Joseph Buchoz in Paris. Pennant used Desmoulins's drawings of an egret (*Egretta garzetta*), a crane (*Grus grus*) and a great white heron (now considered a color morph of *Ardea herodias*).

When Pennant came to prepare the fourth edition for the press in 1776–77, he found sufficient material to extend the work to four volumes. Some idea of the activity that preceded it may be obtained by a comparison of the roughly 160 bird species known to Ray in 1678 and the 242 species listed by Pennant one hundred years later. Pennant had really done his work well in arousing interest in the British avifauna. He acknowledged assistance from Daines Barrington, Sir Joseph Banks, J. R. Forster, Dr. John Latham, George Edwards, and Gilbert White. He owed White a great deal and caused that gentleman to be mildly irritated over the correcting of data for this edition. White wrote to his brother John on 27 February 1776, "I have seen a copy of Mr Pennant's new edition of the Brit. Zoo. but he had put the matter into some stranger's hands, and has left standing many old errors, so that sheets must be cancelled; and I must correct over again what I have corrected 'til I am quite sick!! The printing also is very incorrect."[12] It was printed at Warrington for Benjamin White.

For the fourth edition of 1776–77 there was a notable addition to the list of artists. In background and upbringing Moses Griffith was very different from Pennant. He was born at Bryn Graer, in Lloin, Caernarvonshire, with few advantages in life. He was clever with a pencil and came to Pennant's notice in 1769.

Pennant decided to help him study drawing, engraving and etching, and took him on extended tours of Scotland in 1769 and around their native Wales in 1770 and 1773. Griffith's designs were handed over to Peter Mazell for reproduction in Pennant's natural history books. Seven bird plates in *British Zoology* were signed by Moses Griffith: the sea eagle (*Haliaetus albicilla*); jackdaw (*Corvus monedula*) and crow (*Corvus corone*); male and female blackbirds (*Turdus merula*); male and female sparrows (*Passer domesticus*); greater and lesser redpolls (*Acanthis flammea rostrata* and *Acanthis flammea cabaret;* Figure 29); jacksnipe (*Lymnocryptes minima*) and snipe (*Capella gallinago*); and red-breasted goose (*Branta ruficollis*). In 1781 Griffith etched the plates for Pennant's *Tour in Wales*. The etchings were adequate for these topographical records but inferior to his tinted drawings. Griffith settled in 1781 at Whitford, near Holywell and Downing, where he obtained employment as an etcher. He married Margaret Jones of Whitford. After Pennant's death in 1798 Griffith was employed by his son David Pennant to execute some two hundred watercolors and sketches of Welsh views during the period 1805 to 1813. The National Library of Wales bought several hundred of his watercolors when Pennant's library was sold in 1938. Pennant left £200 in his will to trustees for Griffith's son and daughter. Moses Griffith died on 11 November 1819 at Wibnant, near Holyhead.

Pennant dedicated *British Zoology* to the Duchess Dowager of Portland, and also noted that James Bolton (the duchess' protégé) "favoured us with a description of" a black sandpiper shot in Lincolnshire, which we now call the purple sandpiper (*Erolia maritima*).[13] Other specimens came from museums, including a "brown sandpiper" or short-billed dowitcher (*Limnodromus griseus*) bought in a London market for the Tunstall Museum.

Marmaduke Tunstall was elected a fellow of the Royal Society in 1771, four years after Pennant. It is evident that Pennant often used Tunstall's specimens. Tunstall moved to his estate, Wycliffe, in Yorkshire, in 1776 and transferred his collections there from Welbeck Street, London, about four years later. This move was a loss to many London-based authors but a substantial gain to Thomas Bewick of Newcastle. Tunstall died in 1790, and after a short interval George Allan, of the Grange, near Darlington, bought the collection for just under £77—far less than it would have brought if the sale catalogue had been better prepared.

It was through George Allan that Pennant and Bewick came into contact. Pennant corresponded with Allan from their introduction in 1775 until Pennant's death. In a letter dated 17 July 1790 Pennant wrote, "I have bought Mr Bewick's pretty books on Quadrupeds. As I am most intent on illustrating my own work with prints, let me beg your interest for some of his. I have some little claim on Mr Bewick, as my works are a considerable help to him."[14] A short time later Bewick and Pennant were writing to each other. Pennant lived to see Bewick's first volume of *History of British Birds* published, and in August 1798 urged Bewick to "introduce into your book all the birds omitted in mine, which

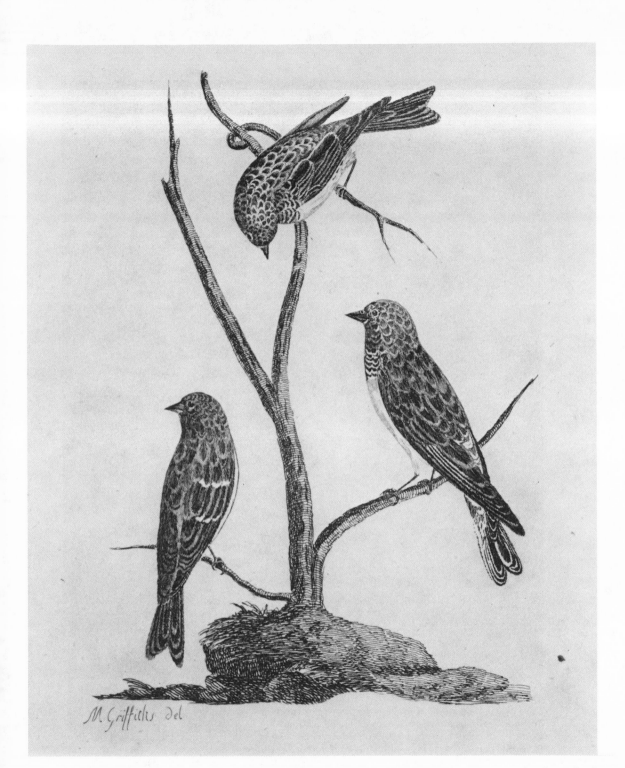

29 / Moses Griffith's plate of greater and lesser redpolls (*Acanthis flammea rostrata* and *Acanthis flammea cabaret*) for the fourth edition of Pennant's *British Zoology*, Plate 54.

30 / A self-portrait of Moses Griffith, dated 1811, in the National Library of Wales. In Whitford churchyard a memorial tombstone to Moses Griffith is inscribed: "In memory of Moses Griffith ingenious selftaught artist who accompanied Thomas Pennant the Historian on his tours, whose works he illustrated by his faithful pencil. Died November 11th 1819 aged 72. He was a native of Bryncoes parish Caernarvonshire, and educated at Botwnnog Free School."

will make yours a perfect work."[15] Bewick presented Pennant with a copy of his book and Pennant wrote a charming letter of thanks. The gift must have greatly cheered Pennant in the last few months of his life.

Like Bewick, Pennant's other contemporaries found much to quarry in his books, but modern writers often denigrate his *British Zoology*. The illustrations of the birds in the first folio edition and the fifth edition of 1812 were a great improvement on those in Willughby and Ray's *Ornithology*, though those in the second to fourth editions were not good. It was useful at that time for ornithologists to have colored illustrations of all known British birds, even though faulty hand-coloring made them not entirely trustworthy, and the practice of making two or three species out of one whose plumage varied by age, season, and sex was a curse that lay heavily on all eighteenth-century ornithologists. Despite these faults, Pennant's work rescued ornithology from near oblivion and brought zoology to the fore as a worthwhile pursuit at a time when most naturalists' enthusiasm lay exclusively in botany. Even if its influence had been less pervasive, it would still be worthy of a high place in our regard for its effect on Thomas Bewick, to whom it "opened out the largest field of information" and whom it inspired to produce greatly superior illustrations of British birds.[16]

Pennant's *Arctic Zoology*, a compilation of information from scattered sources published in 1784–85 in two volumes, was perhaps a more valuable contribution to ornithology. Originally Pennant intended only to sketch the zoology of King George III's dominions in the North American fur countries, but when the American colonies separated from the northern territories, Pennant adopted the vague and misleading title *Arctic Zoology*. The second volume, with fifteen plates, dealt with the birds of the region. The frontispiece of volume 1 showed a pair of snowy owls (*Nyctea scandiaca*), one of which held a rock ptarmigan (*Lagopus mutus*) under one foot and was being threatened by an arctic fox. It was signed "P. Paillou pinxit. P. Mazell sculp." The title page of volume 2, also signed by Mazell, depicted a "pied duck," (*Camptorhynchus labradorius*, extinct). Peter Brown drew the American avocet (*Recurvirostra americana*; Figure 31) and Moses Griffith the St. John's falcon—that is, the rough-legged hawk (*Buteo lagopus*)—the red owl (*Otus asio*), mottled owl (*Ciccaba virgata*), and barred owl (*Strix varia*) (all looking like stuffed images on perches), and a Baltimore oriole pair shown with their nest and identified as the same as the "Bastard Baltimore of Catesby i.49" (now the northern oriole, *Icterus galbula*). (Pennant's own copy of Catesby's *Natural History of Carolina* is now in the Pierpont Morgan Library, New York. He had purchased it from Catesby's nephew, a Covent Garden haberdasher). All of these plates were signed by Mazell as the "engraver." Mazell exhibited at least two of the engravings he had executed for this book at the Society of Artists' exhibition of 1783.

Several unsigned plates in this and other books by Pennant make one wonder whether Pennant made any sketches himself. Casey Wood has written that the copy of *Arctic Zoology* in the McGill University Library is a unique copy of a de

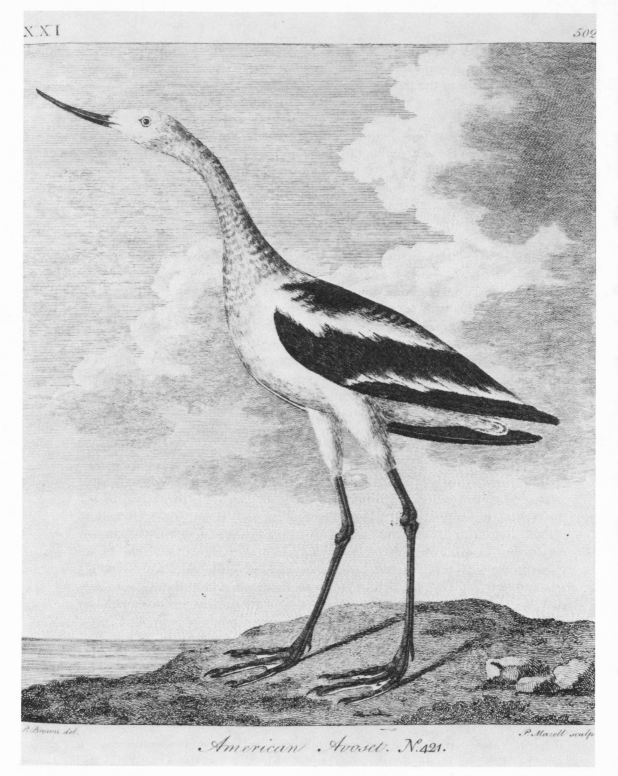

P. Brown del. *P. Mazell sculp*

American Avoset. N.º 421.

31 / Peter Brown's drawing of the American avocet (*Recurvirostra americana*), from a specimen in the Leverian Museum, etched by Peter Mazell for Pennant's *Artic Zoology,* vol. 2, Plate 21.

luxe edition with more than 170 watercolor drawings of natural history species and scenes in arctic regions. "These drawings are on separate leaves or they decorate the wide margins of the text and are by Mercatti and Moses Griffith and in many cases from sketches by Pennant himself."[17] Unfortunately, he offers no evidence for this last assertion. Did Pennant merely do these drawings for his own pleasure and not for the purpose of illustrating his books? If he were capable of making his own drawings, why did he employ so many others to illustrate his books?

A long list of contributors appears in the preface to *Arctic Zoology*. Sir Joseph Banks's collection, with several new species of birds and other fauna from his voyage to Newfoundland in 1766 and to Iceland in 1772, had been a rich source for Pennant. One of Banks's most assiduous correspondents, an Edinburgh physician named Charles Bladen, had sent specimens and copious notes on the birds of the American colonies while he was acting as physician to the British forces there. He sent cases of bird specimens to Daines Barrington as well and Barrington gave some of them to Sir Ashton Lever for his museum, where they were no doubt seen by Pennant.

Pennant also acknowledged the use he had made of bird specimens in the museum of the Royal Society as a direct result of his own and Barrington's foresight. Barrington and Pennant knew that they could not ask officials of the Hudson's Bay Company for skins because the authorities forbade their officers to deal privately in skins. What they could do was to suggest that officers collect bird skins for the Royal Society Museum for the furtherance of knowledge of the natural history of the region. This suggestion was acceptable, and we find Andrew Graham, "long resident in Hudson's Bay," sending "multitudes of specimens of animals to the late museum of the Royal Society, at the instance of my respected friend the Hon. Daines Barrington."[18] Sixty-four of these specimens came from Severn House, seventeen from Churchill, and another seventeen species from Albany, including three robins (*Turdus migratorius*), a yellow-billed magpie (*Pica nuttalli*), a whooping crane (*Grus americana*), and a pelican (*Pelecanus erythrorhynchos*) from York Fort. These packages had been dispatched in 1771 and many more followed until by 1781 the collections of the Royal Society had become so considerable that they had outgrown their accommodation and were donated to the British Museum—hence Pennant's allusion to the "late museum of the Royal Society."

Accompanying many of the specimens were notes and observations written by Thomas Hutchins of York Fort, where Andrew Graham was second in charge. Hutchins commented that "the Indian name is inserted throughout both in compliance to Mr Pennant's directions, and also because very often I knew not the proper European epithet."[19] So Pennant had obviously been instrumental in issuing instructions for the collecting and recording of birds in the Hudson Bay region.

Pennant's *Arctic Zoology*, patchy though it was, remained the standard work on

the fauna of the area until Dr. John Richardson and William Swainson's *Fauna Boreali-Americana* was published in 1829–37. Their publication was made possible by energetic collecting by interested ships' personnel on expeditions to the northern coasts of North America in search of the northwest passage in the 1820s and 1830s.

Species from India did not reach Britain in any numbers until after 1830. Before that date, knowledge of the birds of this vast area depended very largely on the collections of drawings made by East India Company personnel. Pennant planned to use some of these drawings for a book called *Indian Zoology*. Only a fragment of this work was produced, however, in 1769. After Peter Mazell had etched twelve plates to accompany the pages of descriptive text in English and French, Pennant abandoned the project. He gave the colored plates, plus three unpublished ones, to J. R. Forster to use in his *Indische Zoologie* in 1781. Then John Latham used Pennant's material for his *Faunula Indica*. In 1790, Pennant recovered some of his earlier enthusiasm and did a more complete job. His small book was again called *Indian Zoology*, but its sixteen plates, executed by Mazell, were left uncolored.

Among the new Indian birds that Pennant described and named in 1769 were the anhinga (*Anhinga rufa melanogaster*), also called darter; the painted stork (*Ibis leucocephalus*); the comb duck (*Sarkidiornis melanotos*); and the pied harrier (*Circus melanoleucos*). In the 1790 edition he added figures of three "Taylor birds" (*Orthotomus sutorius*) all sewn up in a neat nest with their heads peeping out (Figure 32); flammeus flycatchers (*Pericrocotus flammeus*), one dangling dead from a thread tied to a branch while others look on unconcernedly; a faciated couroucou (*Harpactes fasciatus*) and a black-capped pigeon (*Ptilonopus melanospila melanauchen*), both dead on their backs with their claws in the air; a little horned owl (*Otus bakkamoena*); a redheaded cuckoo (*Cuculus pyrrhocephalus*); a red woodpecker (*Picus miniaceus*); a double-spurred partridge (*Galloperdix bicalcarata*); a red-tailed water hen (*Amaurornis phoenicurus*); a black-backed goose (*Sarkidiornis melanotos*); and a spotted-billed duck (*Anas poecilorhyncha poecilorhyncha*). These plates were attractively executed by Mazell. John Loten, Sir Joseph Banks, and Pennant shared the cost of the etching.

As an attempt to portray the birds of India, the effort was of course feeble. Little serious attention was paid to the avifauna of this subcontinent for another forty years, and even then the work was still based on drawings, this time those collected by Major General Thomas Hardwicke. Pennant's attempts to produce worthwhile works on Arctic and Indian zoology were premature, and both titles were misleading. The subjects demanded much deeper knowledge than Pennant possessed and deserved greater study than he was prepared to undertake. By these two titles Pennant invited the comments made by Horace Walpole, who with his customary acerbity wrote, "He is a superficial man and knows little of history or antiquity; but he has a violent rage for being an author. He sets out with ornithology, and a little natural history, picks up his knowledge as he rides."[20]

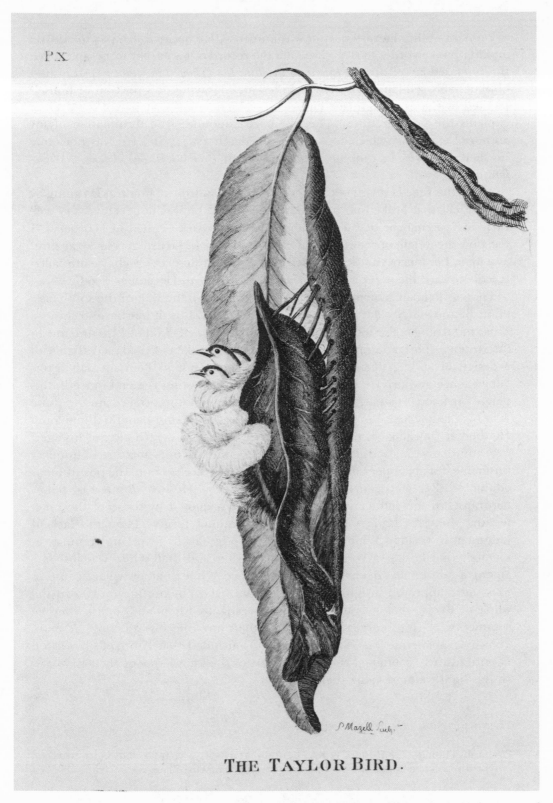

THE TAYLOR BIRD.

32 / Tailorbirds (*Orthotomus sutorius*) in their nest, from Pennant's *Indian Zoology* (1790). The birds are named for their practice of building a nest within a cup that they make by sewing the edges of one or two leaves together, using their bills as needles and plant fibers or silk from insect cocoons and spiders' webs as thread. Sydney Parkinson modeled this drawing on one by Pieter Cornelis de Bevere.

Pennant's other literary output was immense. He decided in 1793 to add yet another book in order to straighten out the record of his earlier work, and called this intended last effort *The Literary Life of the Late Thomas Pennant Esq.* It is most objectionably self-laudatory. He included an engraving of a portrait of himself painted by Gainsborough (see Figure 26). The opening sentence of the preface explains the peculiar title: "The title-page announces the termination of my authorial existence, which took place on March 1st, 1791." He was not quite finished, however; in 1796 he published yet another book, *The History of White-ford and Holywell.*

About this time Pennant became confined to his ancestral home at Downing by an accident that broke one of his kneecaps. That he was not feeling very well early in 1798 may be deduced from a letter to Bewick penned in February: "I feel now the weight of years and ill health; both which, I trust, to bear up against, as a man. Long may you flourish according to your deserts."[21] His health failed rapidly toward the end of the year and he died on 16 December 1798.

Thomas Pennant's memorial monument is fixed to the wall of the south aisle of St. Beuno and St. Mary parish church, Whitford. It is of marble and shows a Muse mourning at the foot of a pillar. It has also a medallion of Pennant and an inscription: "This monument is erected rather, as a token of filial piety than with a design of adding duration to the memory of Thomas Pennant. His active benevolence and private virtues will ensure him a lasting remembrance in this neighbourhood. His literary labours will obtain him immortality among those who by a laudable use of their talents have instructed and benefited mankind. He died at Downing his native seat Dec. 16, 1798 in the 73rd year of his age."

From what we know of Pennant as a man, he was a strange mixture of humility (his name did not appear on the title page of *British Zoology* until the posthumous edition of 1812) and conceit (vide his *Literary Life*). He was admired by fellow naturalists of the eighteenth century and much quoted by those of the nine-teenth. Modern admirers of Gilbert White cannot forgive Pennant's lack of judgment in treating White patronizingly. To be fair to Pennant, we must re-member that he was a voluminous letter writer and that White was just one among a vast number of correspondents. Gilbert White's narrow village compass must have appeared insignificant to Pennant, who was putting on record the whole of British zoology. Samuel Johnson recognized Pennant's merit when he commented, "He observes more things than any one else does."[22] A more knowledgeable critic, Sir William Jardine, concluded that Pennant's works on natural history "contained the greater part of the knowledge of their times."[23] In this light we must value them.

Thomas Pennant's Illustrated Books

Pennant, Thomas. *The British Zoology.* London, 1761–66. 132 folio plates (1st issue, 98 bird plates; 2d issue, 121 bird plates; 3d issue, 122 bird plates).

Artists: Peter Paillou, 97; George Edwards, 3; Peter Brown, 2; Francis Barlow, 1; Charles Collins, 1; 9 signed ✳ ; unsigned, 8.
Etcher: Peter Mazell.
Colorer: Peter Paillou.
Folio appendix: 25 plates (23 of birds).
 Artists: Peter Paillou, 18; George Edwards, 2; Peter Brown, 1; Charles Collins, 1; unsigned, 2.
 Etcher: Peter Mazell.

————. *The British Zoology.* 2d ed. 2 vols. 1768–69. (When reissued with supplement in 1770, regarded as 3d ed.) 103 octavo plates.
Artists: vol. 1, 3 plates of birds, Peter Paillou. Vol. 2, 12 plates of birds: Peter Paillou, 3; George Edwards, 2; Charles Collins, 1; J. B. S. F. or F. A. Desmoulins, 3; unsigned, 3.
Etcher: Peter Mazell.
Supplement, 2 additional bird plates.
 Artists: Peter Paillou, 1; Desmoulins, 1.

————. *The British Zoology.* 4th ed. 2 vols. 1776–77. 98 plates of birds.
Artists: Moses Griffith, 7; Peter Paillou, 7; George Edwards, 3; J. B. S. F. or F. A. Desmoulins, 3; Sydney Parkinson, 1; unsigned, 77.
Etchers: Peter Mazell, R. Murray (1).
Colorer of special Royal Folio Edition: Peter Paillou?

————. *The British Zoology.* 1812. Issued by David Pennant and Edward Hanmer. 96 plates of birds.

————. *Genera of Birds.* 1773, no plates. 2d ed., 1781, 16 plates. Incomplete, no signatures.

————. *Arctic Zoology.* 2 vols. 1784–85. Supplement, 1787. Vol. 2, 15 plates of birds.
Artists: Moses Griffith, 3; Peter Brown, 1.
Etcher: Peter Mazell, 15 signed.

————. *Arctic Zoology.* 2d ed. 1797. 3 vols.: vol. 1, quadrupeds and birds; vol. 2, birds, reptiles, fishes, insects. 67 plates (17 of birds).

————. *Indian Zoology.* 1769. 12 plates, 11 of birds. 2d ed. 1790. 16 plates (14 birds, 1 squirrel, 1 fish).
Artists: Sydney Parkinson after drawings by Pieter Cornelis de Bevere.
Etcher: Peter Mazell.

7

William Hayes

(1735–1802)

WILLIAM HAYES, the eldest child of Charles Hayes and his second wife, Elizabeth, was baptized at St. Luke's, Chelsea, on 19 March 1735. A gentleman's son, he apparently was given no opportunity to acquire professional qualifications or to learn a trade by which he might earn his living. His father was in the service of the crown and his first wife was buried at Windsor. When Charles Hayes died, in 1753, William shared in the estate equally with his two brothers and three sisters, but as the house was mortgaged and the will listed few other assets, his legacy was very small.

On 15 March 1755, a few days before his twentieth birthday, William Hayes obtained a bishop's license to marry Mary Pitts, with the consent of his mother, who still lived at Chelsea. William and Mary were married the next day at St. Martin-in-the-Fields, William's parish church. Over the next fifteen years he was busy raising an ever-increasing family and making drawings that would be used for the publication of his first book, *A Natural History of British Birds*. During this time Mary Hayes died and William married again. In all, Hayes had twenty-one children, but only ten survived to adulthood. As Hayes's family increased, his income became less adequate for its support and he became progressively poorer. He was a good bird artist, however, and his impressive large portraits of British species earned some income from wealthy patrons. His connection with these patrons may have come initially through his parents and his father's position as a servant of the crown.

Hayes's drawings were used to make forty folio etched and hand-colored plates, including 47 bird figures, for his *Natural History of British Birds,* issued in parts between 1771 and 1775. Hayes executed all but eight of the plates himself, noting on some that he had used "aqua fortis," on others that he had both drawn and etched the plates; on a few the signature merely implied that he was the artist. At this stage he appears to have been learning how to produce his own plates from Gabriel Smith, the etcher of the other eight plates in his book. Smith, a London engraver, etched Hayes's plates depicting a jay (*Garrulus glandarius;* Figure 33), a green woodpecker (*Picus viridis;* Plate 2), a Canada goose (*Branta canadensis*), a lapwing (*Vanellus vanellus*), a wood pigeon (*Columba palumbus*), a barnacle goose (*Branta leucopsis*), a female kestrel (*Falco tinnunculus*), and a hen harrier or marsh hawk (*Circus cyaneus*).

This series of plates, with explanatory text, was issued in folio format. The text, printed in two columns, gave a verbal description of each figure, a brief diagnosis in Latin, the name of the bird in Latin, French, and English, and other miscellaneous information in English. Hayes's own observations formed the most interesting and useful portion of the text.

Hayes's partiality for birds with brightly colored plumage may account for the inclusion of three plates of rare Eastern pheasants in a book that was otherwise devoted to British wild birds. Among the British species were some ducks, a chough (*Pyrrhocorax pyrrhocorax*), a kite (*Milvus milvus*), some eagles, and a pair of long-tailed tits (*Aegithalos caudatus*) with their elaborate nest. The tits' nest was unusual in this book; most of the other plates showed only one bird or a pair, with little other detail. Another exception was the single egg accompanying the picture of a lapwing (*Vanellus vanellus*). The cuckoo (*Cuculus canorus*) appeared on two plates, the second showing a young bird being fed by a pied wagtail (*Motacilla alba yarrellii*). Some of the birds are depicted in the act of walking or preening and appear quite lively. The larger portraits are very good, but the small birds are not so faithfully drawn.

At this period artists were making no attempt to draw to a fixed scale, so when Hayes wanted to do justice to a bittern (*Botaurus stellaris*) he used an extra-large sheet of paper and folded it to the correct page size. He used a normal-sized sheet for his excellent portrait of the brant and barnacle geese (*Branta bernicla* and *Branta leucopsis*). Many of these plates were signed with the printing reversed, showing Hayes's lack of experience in writing on copper plates in reverse so that the printed words would read from left to right.

The material for *A Natural History of British Birds* was collected in the 1760s and was based largely on the live birds and specimens that Hayes saw in Buckinghamshire. Either he visited this county frequently and at all seasons of the year or he lived there for some time. He was less impecunious during this period than in his later years, and could afford to keep birds in captivity, many of them over a period of years. He kept some "ringtails" (one of the harrier or *Circus* species or the young of the golden eagle, *Aquila chrysaetos*), a pinioned kite

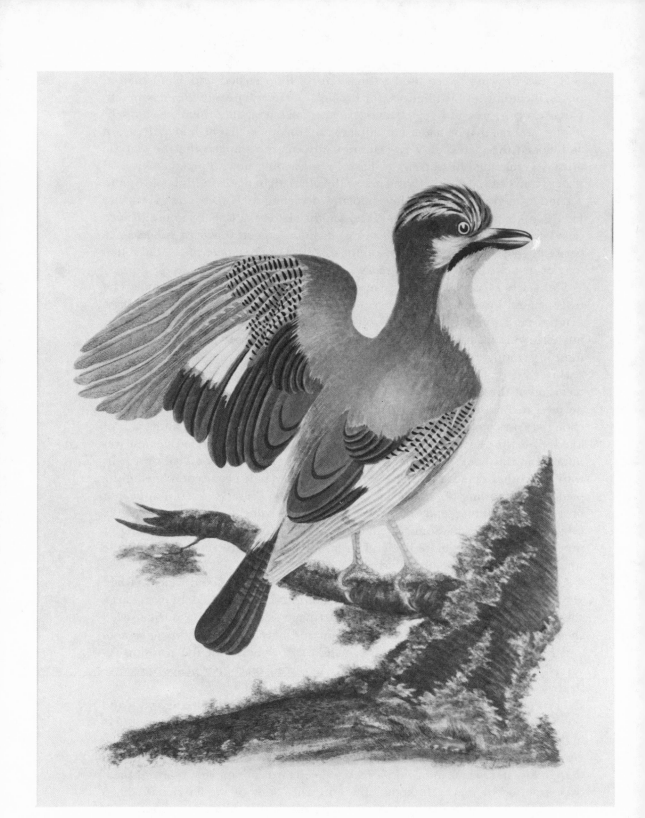

33 / The jay (*Garrulus glandarius*) from William Hayes's *Natural History of British Birds* (1775), Plate 7. It was etched by Gabriel Smith from Hayes's drawing, on a plate 15″ by 11″.

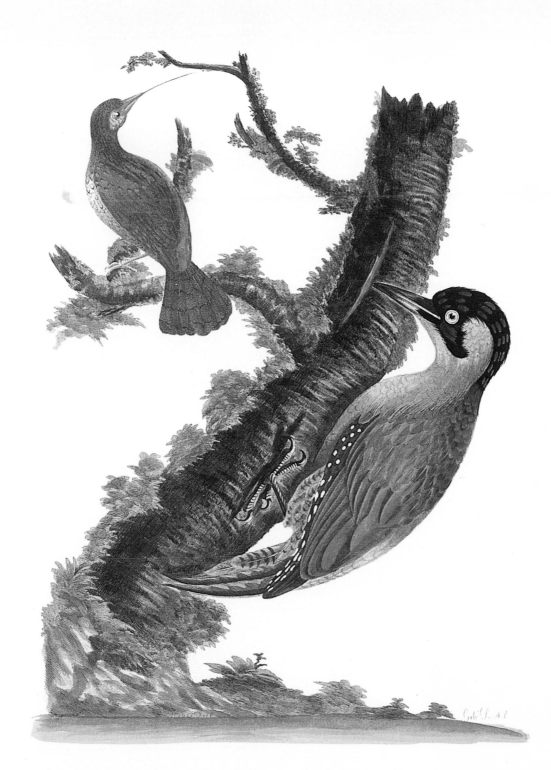

PLATE 2 / William Hayes's green woodpecker (*Picus viridis*) and wryneck (*Jynx torquilla*), Plate 10 of *A Natural History of British Birds* (1775).

Milvus spp.), and a sparrowhawk (*Accipiter nisus*), of which he said, "The one that I kept amongst others would attack the common Buzzard and puttock if fed before him." The puttock was probably a marsh harrier (*Circus aeruginosus*). Of a young cuckoo (*Cuculus canorus*) he found he commented, "The subject of this plate was taken out of the grey-eye water-wagtail's nest, and I kept it untill winter when it died." One of his field observations deals with a winter visitor to Britain, the fieldfare (*Turdus pilaris*): "About Marlow in Buckinghamshire I have seen great flocks of these birds and the Red-Wing" (*Turdus iliacus*). He was also fortunate to see bramblings (*Fringilla montifringilla*); "In the year 1768 there was a great number of these birds on and about Weckham Heath." Turtle doves (*Streptopelia turtur*) were present "all the year" but were particularly sought after in spring, when "their young ones were frequently taken to town by persons which frequent the London markets, in the cherry season, and sell them to the dealers in birds."

Hayes may have been a visitor to Bulstrode, the Buckinghamshire seat of the Duchess Dowager of Portland, who kept many exotic foreign species. She also had some British species then considered to be rare, among them brant geese (*Branta bernicla*). Hayes drew a very good portrait of one of them. His goldcrest (*Regulus regulus*) specimen was "taken in the Duchess of Portland's garden where there is great number of them." The duchess' birdkeeper, a man named Ned Salmon, assisted Hayes by sending him specimens and notes. Salmon fed the duchess' pair of choughs (*Pyrrhocorax pyrrhocorax*) on raw beef, and he captured a kite (*Milvus milvus*) in a steel trap because it "had made great destruction amongst the golden pheasants" (*Chrysolophus pictus;* Figure 34). The trap cannot have hurt it much, as Hayes says he kept it for five years. Hayes included these species in his book, along with a female kestrel (*Falco tinnunculus*) that Salmon sent him labeled as a "sparrowhawk" (a mistake still frequently made). When Hayes wrote his text, from 1771 to 1775 he referred to Salmon as though he were still alive, though in fact he had died some time previously. Mary Delaney, a close friend of the duchess who frequently stayed at Bulstrode, wrote in a letter dated 2 September 1768, "The Duchess has had a great loss in regard to her birds. Ned Salmon, the Keeper of the birds, and who had the honour of showing them to the king and queen, is just dead of the small pox—to her Grace's great concern, as he was a nonpareil in his way."[1] Hayes's information concerning the inhabitants of Buckinghamshire seems to have been curtailed when he returned to live in Chelsea. When his son Charles was born, in 1772, Hayes took him to be baptized at his old parish church, St. Luke's. William and his second wife, Ann, had at least seven children while they were living at Chelsea, between 1772 and 1780.

Hayes dedicated his first book to Elizabeth Percy, Countess of Northumberland, who succeeded her father as Baroness Percy in 1750 and inherited the ancestral seat, Syon House, on the banks of the Thames opposite Kew. Syon House stood close by Osterley Park, which was to figure largely in Hayes's subsequent career and fortunes. Both of these houses were being remodeled by

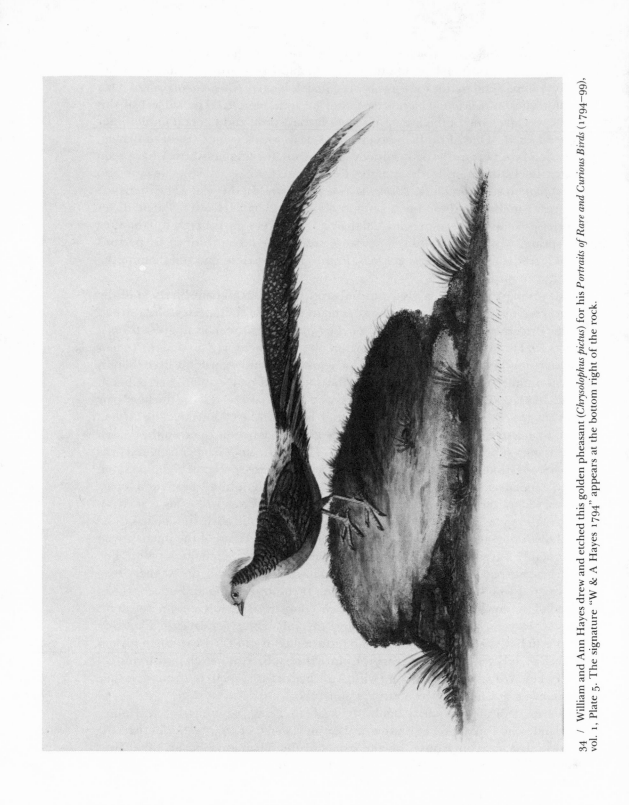

34 / William and Ann Hayes drew and etched this golden pheasant (*Chrysolophus pictus*) for his *Portraits of Rare and Curious Birds* (1794–99), vol. 1, Plate 5. The signature "W & A Hayes 1794" appears at the bottom right of the rock.

Robert Adam in the 1760s, and the Countess of Northumberland could have been instrumental in introducing Hayes to the Childs, the owners of Osterley, though there was another link with the Childs, through the Portland family. The Portlands' family banker was Child of Temple Bar, London, owned by Robert Child and his wife, Sarah. Sarah Child was as enthusiastic a collector of exotic birds as the Duchess of Portland.

In the mid-1780s Hayes went to live in the village of Southall, Middlesex, a short walk from Osterley Park. The last four of his twenty-one children were born there and baptized at the local church, St. Mary's Chapel, Norwood, between 1786 and 1791. While living at Southall and for some years previously, Hayes drew the birds kept in a "menagerie" in the grounds at Osterley Park. The word "menagerie" was used indiscriminately at that time for a collection of birds or animals or the building that housed them. In this case, the menagerie was a building in the park housing a collection of birds.

Robert Child inherited Osterley from his uncle in 1763 and over the next ten years he spent large sums to enhance the house and gardens. The menagerie was built by the lower lake on the eastern edge of the park so that the waterfowl could be kept near the more exotic birds that required protection from the English weather. Horace Walpole, who visited Osterley in 1773, admired the "menagerie full of birds that came from a 1000 islands, which Mr Banks has not yet discovered."[2]

Hayes had painted pictures for other bird enthusiasts who wanted paintings of the live birds in their collections. The Childs commissioned him to produce some paintings, and so did John Montagu, the fourth earl of Sandwich. The earl had a mistress on whom he showered presents of pet dogs and parrots. In 1778 Hayes dedicated to him a collection of plates produced from his drawings of exotic and British birds. Some of the original drawings are now at Mapperton House, Dorset, still owned by the Montagu family. When the Earl of Sandwich died, in 1792, Hayes lost his patron, just as he had lost the Countess of Northumberland in 1776 and Robert Child in 1782. Mrs. Child—who became Lady Ducie at her remarriage in 1791—continued to be his patroness, but at her death in 1793, Hayes was left without a wealthy patron, and by 1794 his plight was desperate. His daughters were still at home, though some of them were of a marriageable age, and he was obliged to support them. His eldest son had been a cripple from birth and was unlikely ever to be able to earn a living. Thus most of his ten surviving children were dependent on him.

In an effort to relieve his situation, Hayes turned to the numerous drawings and more than sixty etched copper plates that he had used in 1782 for a small book called *Rare and Curious Birds Accurately Drawn from Specimens in the Menagery at Osterley Park*. This book had been distributed to only a few people. Hayes now decided to use all of the materials he had at hand, to add bird species whenever the opportunity arose, and to solicit subscribers for a book to be called *Portraits of Rare & Curious Birds . . . in the Menagery of Child the Banker at Osterley Park*. The

text betrays the fact that some of the species were drawn elsewhere than at Osterley, sometimes by other members of his family.

The title page declared that the book had been prepared by "W. Hayes and family." In an advertisement printed in each of the book's two volumes, William said that the work had been done by himself and "seven of his pupils"—usually taken to mean his children, but the "pupils" may also have included Ann, his wife. The earliest plates, done between 1779 and 1785, were signed "W. & A. Hayes"; later plates had the additional names and initials of his children, and many bore composite signatures, such as "W. A. E. & W." (William, Ann or Annette, Emily, and William, Jr.) and "E. M. & Ann" (Emily, Matilda or Maria, and Ann). Thus the seven pupils included two sons, Charles and William; Ann (wife or daughter); and daughters Matilda, Emily, Maria, and perhaps Annette.

Annette, who later married a Mr. Richards, issued a third edition of the Osterley birds in 1846, identifying herself on the title page as "daughter of the late William Hayes of Southall." She signed six plates of one particular copy of the 1794–99 edition, in ink, one inch up into the body of the plate: "Annette 1828."

The number of people involved and the extraordinary lack of organization within the family resulted in wide disparity in the illustrations present in the known copies of this book; few signed drawings and plates are common to all. When an order for a copy was received, the family assembled any available plates with accompanying text, hurriedly re-etched any damaged plates, and added the latest etching of a new species that one of them had produced or a new drawing of an earlier plate that Hayes thought unsatisfactory. This unique collection of plates and text would then be sent off to the subscriber. There is no other way to explain the variations in the plates, the signatures, and the drawings and the many versions of some birds drawn and etched by different members of the family. The British Museum (Natural History) Zoology Library owns a particularly interesting copy of *Portraits,* bearing the signatures of seven of the Hayes family. The following remarks refer to this copy, bound in two volumes and dated 1794 and 1799.

Both Ann and M. Hayes signed the plate of the "numidian crane *Anthropoides virgo*" in 1794. This species excited William's greatest admiration, for he wrote, "This is the most pleasing bird in the Osterley collection and received the name of Demoiselle on account of its elegant form, its graceful attitudes, and affected gestures." Ann and William worked together on a plate labeled "Painted pheasant male," our golden pheasant (*Chrysolophus pictus*), and Ann also assisted "E. M. Hayes" with the corresponding plate showing the female. "M. Hayes," who helped etch the demoiselle crane, may have been Maria, who also did a "shaft-tailed Whidah" (now queen whydah, *Vidua regia*) in 1794, or Matilda (1776–1827), who helped her father more than any of the others. Matilda signed five plates as her own work, among them some of the parrots and parakeets in the aviaries, such as the blue-headed parrot (*Pionus menstruus*). Emily (1774/75–

1830) did two plates, one of a curassow male (*Crax globulosa*) and another of a black-capped lory (*Domicella domicella*). Her brother Charles (1772–1826) signed the plates of the beautiful touraco (*Tauraco persa*), the "amaduade," and the "pencilled Chinese pheasant." "Amaduade" was a name they had taken from the comte de Buffon for the red avadavat (*Estrilda amandava*). This colorful bird was a great favorite with the children, and quite a few of them attempted to draw and paint this species. "Pencilled Chinese pheasant" is a charming way of describing our silver pheasant (*Gennaeus nycthemerus*). Charles also assisted his father with the splendid crowned African crane (*Balearica pavonina*), which William said was one of several of this species in Lady Ducie's collection. He had chosen this one because it was "in the most perfect state of plumage."

The artists' styles vary. William's as might be expected, shows the greatest facility. Ann's drawing has a certain delicacy, and Matilda's shows firmness of line and an imaginative use of stipple in the etched plates. Charles also used a partly stippled ground, as in the foreground of the touraco plate. The other signed plates are more undeveloped in style and lacking in finesse. All are colored brightly, even harshly on occasion, no doubt in an attempt to do justice to the many colorful and beautiful species in this remarkable collection.

Hayes's text, which includes some interesting notes about the birds, is a fascinating example of eighteenth-century name dropping. Quite a number of aristocratic women were aviculturalists at this time and exchanged birds and information on the species in their aviaries. Hayes noted that the black-capped lory "in Lady Ducie's collection, from which this drawing was made, corresponds exactly with one now in the possession of Lady James, which her ladyship did me the honour of informing me, had laid an egg since her ladyship had it in her aviary." The crowned pigeon (*Goura cristata*) drawn by Matilda (see Figure 35) was another of Lady Ducie's birds. The Osterley birds were certainly well looked after and many survived for years.

Among the exotic birds there were also some British species considered at that time to be uncommon. A shelduck (*Tadorna tadorna*), a shoveler (*Spatula clypeata*), a spoonbill (*Platalea leucorodia*), a bearded tit (*Panurus biarmicus*), a hoopoe (*Upupa epops*), a waxwing (*Bombycilla garrulus*), a goldcrest (*Regulus regulus*), a pair of crossbills (*Loxia curvirostra*), a pair of black grouse (*Lyurus tetrix*), a white stork (*Ciconia ciconia*), and a buzzard (*Buteo buteo*) were among these British species. A bird that was then considered common but that later became extinct and had to be reintroduced was the great bustard (*Otis tarda*). Hayes said that in 1794 these birds could be found "frequently on Salisbury Plain, sometimes in troops of fifty or more." Only thirty years later Selby was to have great difficulty in finding a live great bustard to draw, and failed completely to trace one in the wild state in East Anglia.

Another, now more familiar species, the Bohemian waxwing (*Bombycilla garrulus*), is represented in the Zoological Library at South Kensington by a charming watercolor portrait done by William on 26 January 1789. He noted that a

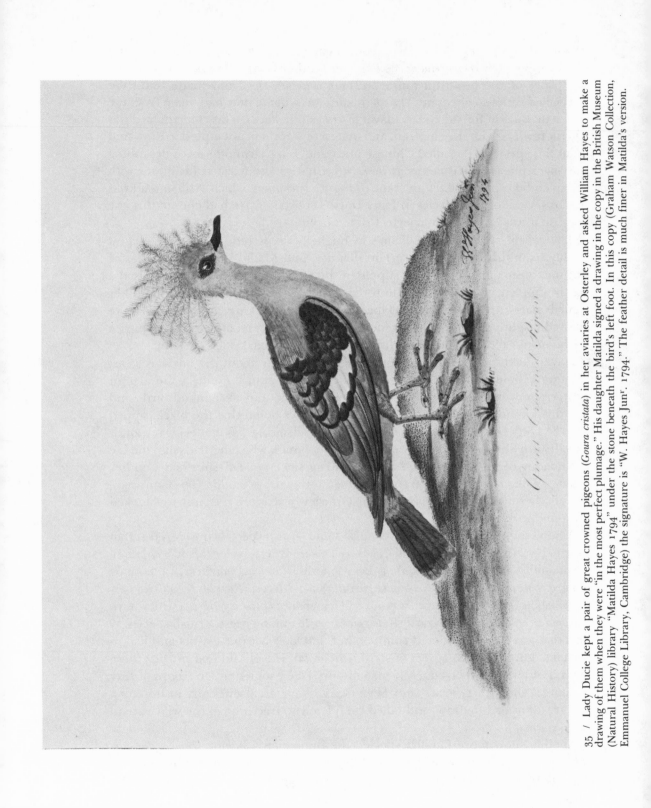

Great Crowned Pigeon

35 / Lady Ducie kept a pair of great crowned pigeons (*Goura cristata*) in her aviaries at Osterley and asked William Hayes to make a drawing of them when they were "in the most perfect plumage." His daughter Matilda signed a drawing in the copy in the British Museum (Natural History) library "Matilda Hayes 1794" under the stone beneath the bird's left foot. In this copy (Graham Watson Collection, Emmanuel College Library, Cambridge) the signature is "W. Hayes Junr. 1794." The feather detail is much finer in Matilda's version.

pair had been shot near Hanwell the previous December, and the male had lived for some time in the menagerie at Osterley. The Reverend George Henry Glasse, rector of Hanwell from 1785, may have secured it. This watercolor drawing and four more at South Kensington are the only ones in public ownership in Britain. In the advertisement printed in the volumes Hayes said that his original drawings of the Osterley birds "were honoured with a place in the library of Robert Child at Upton in Warwickshire." Forty-nine watercolors of the rarer English species and a few of the Eastern birds drawn by William and A. Hayes between 1779 and 1789 are now in the McGill University Library, Montreal.

William Hayes made some embossed pictures as well as drawings of the unusual birds at Osterley and in other private collections. He may have got the idea from the Irishman Samuel Dixon, who worked first in Dublin and then opened a picture shop in London in 1765, where he sold his own embossed bird and flower paintings. Dixon used copper plates to emboss the design on fairly thick paper, from the back, and then painted the relief impression by hand. Some of his designs were copied from George Edwards' *Uncommon Birds,* and Dixon's later imitators used Edwards' *Gleanings of Natural History* as their source of bird models. Hayes's bird pictures were larger than Dixon's. Those known still to exist are dated in the 1760s. Not many of Hayes's embossed pictures exchange hands nowadays, but one that was sold at Sotheby's in 1962 fetched £370. The Print Room of the Victoria and Albert Museum, London, has two examples of this type of work, an eagle owl (*Bubo bubo*) at the entrance to a cave and a white-tailed sea eagle (*Haliaetus albicilla*) standing on a dead seabird.

The 1794 volume of *Portraits* was dedicated to Thomas Pennant; the second volume, published in 1799, was dedicated to Hayes's patron, the Reverend George Henry Glasse, whose parish of Hanwell lies to the east of Norwood, Southall, where Hayes lived. In 1799 Glasse took it upon himself to publish a public appeal for financial help for Hayes:

> His income, which has scarcely ever exceeded ninety-pounds per annum, has been altogether unequal to the support of a very numerous family of children; ten of whom, the survivors of twenty-one, born in wedlock, are (with the exception of the eldest daughter) destitute of all means of support save only the sum already mentioned, and the produce of some works of ingenuity, undertaken for the benefit of their parents, in which several of them, from their tender age, are as yet unqualified to join. The eldest son has been a cripple from his infancy. The father has for some time been afflicted with the disorder known among medical persons by the name of *Angina Pectoris;* which is too generally known to terminate fatally, after a period of severe and protracted suffering. In the month of April last, he was compelled to quit his little home, and had to sustain a heavy expence, and many grievous difficulties, before he could procure a situation for his family. At length he found a small cottage, where, within

the last three weeks, six of the children have been attacked by a malignant fever; while their unhappy mother was totally incapacitated from administering to their relief, in consequence of a dreadful accident, which unfortunately happened a few days before the children were taken ill, and which totally deprived her of the use of her limbs. The object of this Address, is not merely to provide immediate assistance for this distressed family, but to obtain a small fund for the purpose of apprenticing some of the children, extricating the father of the family from the hands of a severe and threatening creditor, and making (if possible) a little provision for his wife, in case of her surviving him, as the whole of his income terminates with his life. It is proper to mention, that this Address to the feelings of a generous nation, in behalf of suffering worth, was made without the privity of the parties themselves.

G. H. Glasse.[3]

This appeal was made in an advertisement for *Portraits,* which was then being issued in monthly parts, each with four plates.

The Literary Fund, established by the Reverend David Williams in 1790 to provide "temporary Relief to temporary Distress" among authors and their dependants, sent a donation of £20, and the dean and chapter of Canterbury Cathedral donated ten guineas. In spite of this relief, Hayes must have been appalled when he found out about Glasse's appeal and the manner in which the details of his poverty had been made public. He would have been even more distressed had he known that Glasse could easily have helped him out of his own pocket. In 1793 Glasse had inherited a large fortune, which he proceeded to squander. In 1809, finding himself in financial difficulties, Glasse hanged himself in the Bull and Mouth Inn, St. Martin's-le-Grand.

Hayes's work on the Osterley birds came to an end late in 1799. His illness and the constant worry about his family and the endless fight against poverty had taken their toll. He lived only two more years, and was buried on 13 March 1802, aged sixty-seven, in the St. Mary Norwood churchyard. His gravestone is still there, bearing the inscription "Sacred to the memory of William Hayes of Southall in this parish, gentleman, who died and was buried here anno. dom. 1804" (*sic*). The stone was placed in the churchyard at a much later date, when the family was more affluent and the exact date of William's death was no longer remembered. William had been unfortunate in many ways: too large a family, too small an income, and insufficient patronage in the days when patronage was essential for a poor man's success. The patrons who took an interest in Hayes's work either died many years before him or failed to realize the extremity of his need. The one person whom Hayes trusted with full knowledge of his distress, the Reverend G. H. Glasse, betrayed that trust.

In 1802 Ann Hayes was left penniless with six daughters to support. The Literary Fund came to her aid with another donation of £10 to further her plans to run a school for girls with the assistance of her eldest daughter, who was a

teacher. Ann lamented that she had been very ill, and so had some of her girls, including Matilda, on whom "I had great reason to build my hopes of assistance towards their support" because she had "many years made painting her study, and had arrived to that degree of excellence in the branch she professed, as to justify those hopes, but, an attack of a nervous fever which was of long duration and terminated in the loss of the use of both her hands, deprived me of this resource"[4] Despite's Ann's forebodings, Matilda recovered and during her lifetime painted many more pictures, one of which—a peacock—was exhibited at the Royal Academy in 1801. Ann's school flourished and she was able to provide for her other children. The younger members of the Hayes family prospered, and by 1871 William Hayes's grandson was the owner of an establishment in Southall with three servants. When he died, in 1883, he left his daughter and only next of kin more than £11,000.

Emily's subsequent career throws an interesting and hitherto unsuspected light on the last fifteen years of her father's life. The Post Master General's Minutes in the Post Office Archives, London, reveal that on William's death Emily took over his job as postmaster at the Southall post office. On 6 March 1802, in "the room of her father deceased," she was officially appointed the new postmistress from 28 February of that year. The first mention of payment of William's annual salary of £12 was recorded in 1788. In 1801 there was a move to get the twopenny post extended to a new office at Hounslow (which then came under Southall). This move was countered by the Reverend Dr. Glasse, the Reverend Mr. Maule, and others, on the grounds that William Hayes was a very efficient postmaster and that he stood to lose perquisites amounting to £66 19s. 8d. a year. The proposal, the report maintained, threatened the livelihood of Hayes, who, had "a family of 8 or 9 children, only one of whom is wholly provided for."[5] The proposal was dropped, but it must have seriously worried Hayes, who was by then a very sick man.

Evidently Emily helped her ailing father in the post office before she succeeded him. Twenty-seven years later Emily fell into arrears with her payments at the post office and was given five days in which to pay them off. She was unable to do so and was dismissed on 5 April 1829. Emily died the following February, aged fifty-five, and was buried at St. Mary Norwood.

Charles Hayes, William's son born in 1772, must have gladdened his father's heart by his aptitude for painting and his love of birds. His own bird book, *The Portraits of British Birds Including Domestic Poultry and Water Fowl*, with 144 etched plates, was published between 1808 and 1821. The bird figures are sleek and elongated, a sure sign that Charles was working from skins. His coloring was not accurate and he had a most peculiar habit of placing a branch of a tree at the edge of the ruled area of the illustration, either at the bottom of the plate or to one side of it, and then putting his bird on the branch, leaving the rest of the space empty (see Figure 36). Charles's text was placed opposite each plate, on one leaf only, and contained little of value. Fifty of his original drawings, dated

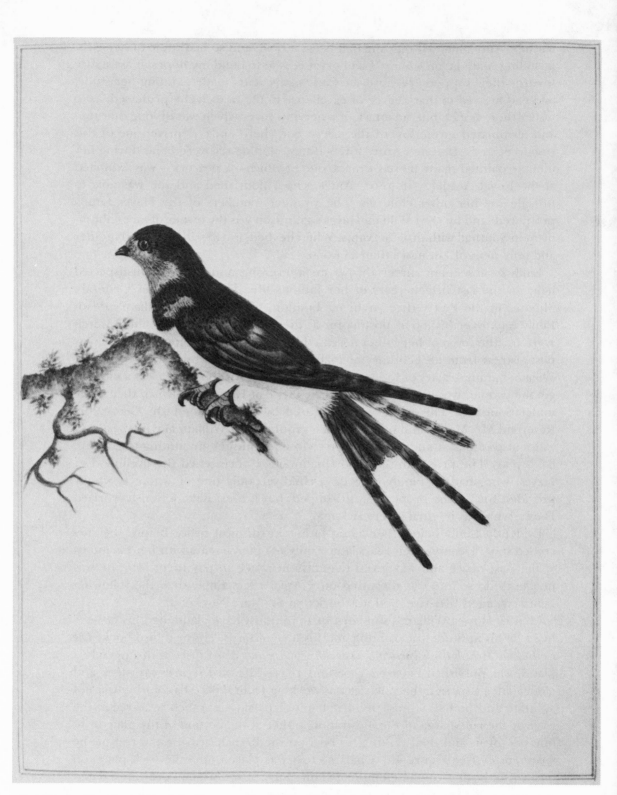

36 / Charles Hayes's picture of the "house swallow" (*Hirundo rustica*), Plate 130 of *The Portraits of British Birds,* from a very rare copy of this title containing 144 plates. Charles knew this species to be "one of the Birds of passage that visits us early in the Spring, and takes its departure in the Autumn for a warmer Climate."

1812–14, are in the McGill University Library, Montreal. He died at Southall and was buried at St. Mary Norwood on 2 January 1827.

The Hayes family recognized that they had a wonderful opportunity to produce a book portraying some very colorful and interesting birds, and grasped it firmly. It is unfortunate that they were unable to organize their work and obtain enough subscribers to make a full, uniform edition worthwhile. Hayes was fortunate in having gifted children to help him, though some of the youngsters had their talent pressed into service prematurely when Hayes fell ill. Nevertheless, the portraits of the Osterley birds form a record of a unique collection and add some colored pictures of foreign species to the small number then available. Hayes was the first author systematically to record a single private collection of live birds; such a project was not attempted again until 1846, when the birds and animals belonging to the thirteenth earl of Derby were recorded by John Edward Gray, in *Gleanings from the Menagerie and Aviary at Knowsley Hall*, with lithographic illustrations by Edward Lear and David W. Mitchell.

William Hayes's *British Birds*, another selection, was the better work artistically. It is a pity that he lacked access to a complete collection of British birds and sufficient resources to publish a comprehensive work. His background and domestic circumstances weighed heavily against him, but given those obstacles, his achievements are praiseworthy.

Books Illustrated by William and Charles Hayes

Hayes, William. *A Natural History of British Birds, with Their Portraits, Accurately Drawn and Beautifully Coloured from Nature*. 1771–75. 40 plates.
 Artist, etcher, and colorer: William Hayes.
 Etcher: Gabriel Smith, 8 signed plates.
————. *Rare and Curious Birds Accurately Drawn and Colored from Specimens in the Menagerie at Osterley Park*. Dates and number of plates vary. (Copy at Zoological Society of London, dated 1782, has 66 plates.)
New ed. *Portraits of Rare and Curious Birds with Their Description. Accurately Drawn and Beautifully Coloured from Species in the Menagery of Child the Banker at Osterley Park near London*. 2 vols. 1794–99. Approximately 100 plates.
 Artists, etchers, and colorers: William Hayes and family. Not all plates are signed. British Museum (Natural History) copy: Ann, 1; Ann and M., 1; Ann and E. M., 1; Ann and W., 1; Charles, 3; C. and W., 1; Emily, 2; Maria, 1; Matilda, 5; W. C. and M., 1; W. A. E. and W., 1. British Library copy: 94 plates; Matilda, 11; E/Emily, 3; Charles, 3; W., 2; W. W. and E., 1, unsigned, 74.
New ed.: *Figures of Rare and Curious Birds Accurately Drawn from Living Specimens and Faithfully Coloured*. 1822. One part only with 4 plates.
3d ed.: *Portraits of the Curious Exotic Birds Which Formerly Composed the Osterly Menagerie With descriptions*, by Annette Richards, daughter of the late William Hayes of Southall. 1846.
Hayes, Charles. *The Portraits of British Birds Including Domestic Poultry and Water fowl*, by C. Hayes the son of the late Mr William Hayes, Author of the much admired work entitled The Osterley Menagerie. 1808–21. 144 plates. (Very few copies have survived; the number of plates varies.)
 Artist, etcher, and colorer: Charles Hayes.

8

John Latham

(1740–1837)

Latham dominated ornithology for half a century, and a perusal of his works leaves no doubt that he was not only a great worker, but in the front rank among the scientists of his time. It must always be borne in mind that Latham, as well as following his profession, visited all the museums, published his works, etched every copper plate in his original work, stuffed and set up almost every animal in his very extensive museum, and put together, with his own hands, a great many of the very cases in which they were disposed. The magnitude of the work is self evident.[1]

THIS testimonial was written by Gregory Macalister Mathews in 1931. At the time of John Latham's death, nearly a century before Mathews' appreciation, his friends were equally generous in their praise and expressed concern at the deep loss they felt when this very elderly, lovable ornithologist finally quitted the scene he had dominated for so long.

Dr. Latham was a man born at the right time, with the appropriate qualities to perform an onerous task. He determined to describe all known species of birds and to record the discoveries of new species as they occurred, at a time when the number of discoveries was increasing at an accelerating pace. For fifty years he was the chief recorder of the world's avifauna.

Latham was born on 27 June 1740 at Eltham, in Kent. He was an intelligent

boy and progressed well at the Merchant Taylor's school and later, when he followed in his father's footsteps in medical training. He studied anatomy under the famous Dr. William Hunter and related subjects at London medical schools. When he was twenty-three years old he married and began to practice medicine at Dartford, in Kent.

Once he became established in his practice, Latham found time to give more attention to natural history. He gradually built up a collection of specimens and acquired books on the subject. In 1770 his first article was published in *Philosophical Transactions*. This publication led to correspondence with other naturalists, including Thomas Pennant, who received a kind note from Latham in February 1771 praising his *British Zoology*. They remained on good terms until Pennant's death, in 1798, and their letters were full of news about new species and comments on new books.

In 1772 Sir Ashton Lever introduced himself to Latham and the two men strove to outdo each other in adding rarities to their respective collections. They were both very generous men and they shared their excitement over new species. In August 1776 Lever dashed off a short note that is indicative of their enthusiasm:

> Dear Latham,
> Having plundered Amsterdam, Leyden, Haarlem, the Hague, Rotterdam, Delft, Maesensluys, the Brill and Helvoetsluys, I am now returned to England, and in consequence of the above voyage shall have more duplicates for you. You shall see me soon, as I have wonderful things to tell you,
> Yours with compliments to Mrs L.
> ASHTON LEVER.[2]

Latham must have been sorry to see this friend in difficulties a few years later. Sir Ashton Lever was compelled for financial reasons to part with his collections in 1788, and they were disposed of by lottery. When the museum was finally sold off in 1806, Latham purchased a number of items for his own collection.

Another famous acquaintance was Sir Joseph Banks. In 1775, while Banks was president of the Royal Society, Latham became a fellow. His election opened up a new source of specimens and skins for him. Some of the collections from Banks's voyage to the South Seas with Captain Cook were housed in the Royal Society Museum. Further specimens had been deposited in the Leverian Museum, and Banks himself kept a wonderful collection that his friends were always welcome to inspect. Membership of the Royal Society at this time was an open sesame to many natural history collections in private hands.

Latham took a prominent part in the founding of the Linnean Society in 1789. He was acquainted with Dr. James Edward Smith, who had purchased Linnaeus' library from the Swedish naturalist's son; this acquisition had given birth to the

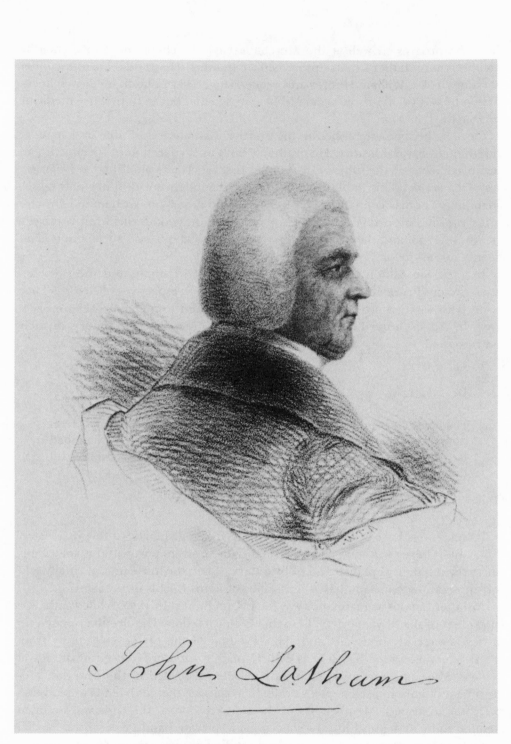

37 / The portrait of John Latham lithographed for the frontispiece to the fourth volume of the magazine *The Naturalist* (1838–39), edited by Neville Wood.

idea of forming a Linnean Society. Sir Joseph Banks and Thomas Pennant were made honorary members, and when the society held meetings, they and many other naturalists had the opportunity to exchange news, specimens, and publications.

Dr. James Edward Smith had studied anatomy under John Hunter, brother of the William Hunter who had taught Latham. All four shared an interest in anatomy, both animal and human, and also had a common interest in forming extensive collections of natural history objects. The British Museum, formed in 1753 on the basis of Sir Hans Sloane's museum, was not then providing an adequate service in preserving and exhibiting specimens of birds. Sir Hans Sloane's collection had been rich in plants but poor in zoological items, and few birds were added after the British Museum was formed. In the eighteenth century the main collections accumulated on voyages usually went to museums of learned societies or were purchased by private individuals, and did not find their way to the British Museum. Naturalists therefore had no alternative but to form their own collections, if they could afford to do so, or constantly to beg admission to the museums of friends and acquaintances.

Another useful private museum was Marmaduke Tunstall's, situated in London until about 1776. We know from Latham's comments in his book about birds that Tunstall had at least four species of grosbeaks in his museum; Latham used them as models.

With his wide acquaintance among collectors and other scientists of similar tastes, Latham was ideally placed to contribute to the growing literature on birds. The number of foreign bird specimens at his disposal made him more ambitious than other contemporary authors, who dealt mainly with the British avifauna. His aim was to publish a book describing and depicting all known species of birds.

Linnaeus increased the list of birds published in his *Systema Naturae* throughout successive issues until the tenth edition, published in 1758, listed 444 species. This was the edition in which he systematically gave every species of bird a binomial, and on which following ornithologists based the scientific naming of bird species.

Over the next thirty to forty years, further additions were made to the numbers of species discovered and described, at what must have seemed an alarming rate to anyone trying to keep track of them. Certainly Latham took on an enormous task when he set out to collate all the descriptions of birds from all known sources and to add new birds as and when they were brought home from voyages while the work was in progress. The first part of *A General Synopsis of Birds* appeared in 1781; five more lengthy parts were issued by 1785. When bound they formed three volumes and included 106 etched plates. Latham then attempted to catch up with additional new birds in supplements issued in 1787 and 1801. The plates in the supplements were numbered in sequence with those in the main body of the work. By 1801 Latham had drawn, etched, and colored 142 plates himself; his text described far more species than the number illus-

trated. Five hundred copies of the main volume were printed, but only 250 copies of the second supplement.

Many of the birds included were from Australia, which had been settled in 1788. Governor Arthur Phillip (1738–1814) had been sent out to Botany Bay with a shipload of convicts, officers, and supplies to colonize the country. Somehow the officers found time to collect samples of the flora and fauna. From original drawings made on the spot, Latham described a number of new birds for Phillip's book about the voyage, published in 1789. One of the birds was a new parrot named for Thomas Pennant, *Psittacus pennantii* (now *Platycercus elegans,* crimson rosella), from a specimen communicated by Phillip and first figured in his book. By including Australian birds in his supplements, Latham listed birds from virtually every corner of the world, many of which had been unknown to Linnaeus.

Latham arranged the birds under their vernacular names with a list of synonyms under each, including the Linnean binomial if one had been assigned. He omitted the Latin equivalents of his English names for birds collected by Cook's party. Another naturalist, the Prussian Johann Friedrich Gmelin, used many of Latham's descriptions in a work of his own and attached scientific names, Latinized from Latham's English names. Latham thereby lost the pleasure and honor of originating a great many species' scientific names. He did not make this mistake again.

Working with such a quantity of new specimens with no detailed knowledge of where the birds had been found and few field notes indicating what the other sex of the specimen looked like or the variations in plumage met with in the field, Latham understandably made errors. He frequently failed to recognize the relationship of the female, male, and juvenile of a species and made two or even three species of them. According to William Swainson, a fellow member of the Royal and Linnean societies, Latham's poor memory accounted for other errors.[3] To his credit, Latham created a number of new genera to accommodate his new species, demonstrating that the Linnean system was adaptable and flexible. This practice did not meet with the approval of some of Linnaeus' pupils, who wished to retain the classification exactly as Linnaeus had left it. The great increase in our knowledge of birds gained from the additional number of species made this conservative view untenable, as all acknowledged later. In making his innovations Latham was more farsighted than his contemporaries.

In his preface Latham explained why he had drawn so many plates: "To each genus will be joined one copper-plate at least of some new bird not figured before, if possible, for two reasons: the one to point out to the eye of the less-informed naturalists, wherein one genus differs from another; the other, to add somewhat to the stock of engravings in ornithology." (The word "engraving" is used synonymously here with "etching"; Latham etched his own plates.) The plates are very simple in form: a figure of a bird perched on a branch, with little background or further detail of habitat. The figures are stiff but are reasonably

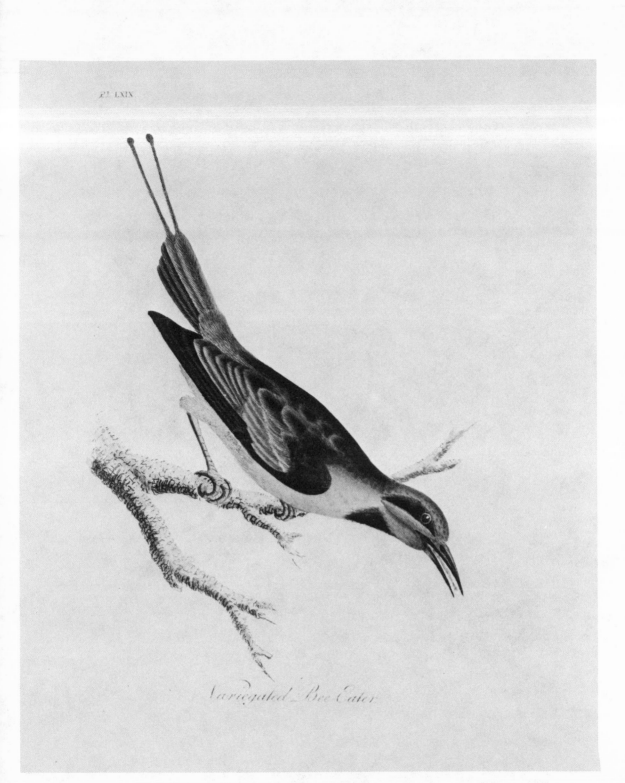

Variegated Bee Eater

38 / Plate 69 in vol. 4 of John Latham's *General History of Birds*, depicting the "Variegated Bee-eater *Merops ornata*," now the rainbow bee eater (*Merops ornatus*). Latham took the drawing from John William Lewin's book on the birds of New Holland (Plate 18), which identified it as inhabiting mountains and frequenting the Hawkesbury River. This is one of the drawings Latham made without ever having seen a specimen of the subject.

Pl. XLIX.

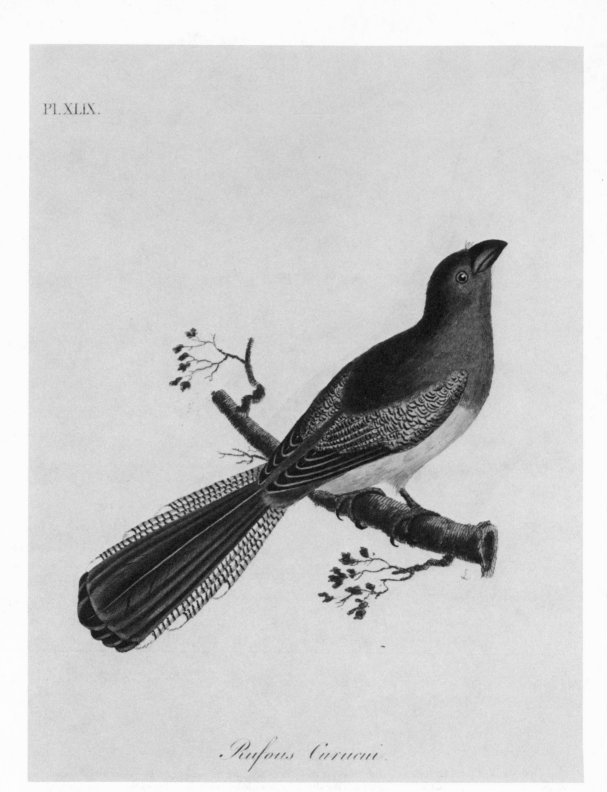

Rufous Curucui.

39 / Latham's "Rufous Curucui" from his *General Synopsis of Birds,* vol. 1, pt. 2, Plate 21, which he had seen in Bullock's Museum. He said it inhabited "Cayenne." The black-throated trogon (*Trogon rufus*) is a Neotropical species, with a range from Honduras to northeastern Argentina.

well executed, considering that he was often drawing from specimens long dead. Some are more accurate representations than others, and the coloring also varies. Latham noted where he had seen the original specimens; his dusky plover or New Zealand dotterel (*Pluvialis obscura*), for example, is stated to be in Sir Joseph Banks's collection, his venerated or sacred kingfisher (*Halcyon sancta;* Figure 40) and cardinal honey eater (*Myzomela cardinalis*) in Lever's museum, and so on.

The text of *A General Synopsis of Birds* contained a brief description with the locality from which the specimen was obtained—often just a vague area or even a continent. Latham used some of the field notes that Dr. Daniel Charles Solander and Dr. Johann Reinhold Forster had made on Captain Cook's voyages. He also used other books, including the comte de Buffon's *Histoire naturelle des oiseaux,* a monumental work in ten volumes with more than a thousand plates published between 1770 and 1786.

Latham followed John Ray in dividing the species into two major groups, land birds and water birds. The land birds were dealt with in the first two volumes and the water birds in the third. After the second supplement was issued, Latham's publisher, Leigh and Sotheby, issued another *Supplementum indicis ornithologici* in 1801 to establish the nomenclature of the forms. Latham had already published his own systematic catalogue of the birds of the world arranged by the Linnean binomial system with the species under scientific names. The two volumes of *Index Ornithologicus* appeared in parts between 1790 and 1801. Such familiar birds as the Australian black swan (*Cygnus atratus*), the sacred ibis (*Threskiornis aethiopica*), and the frigate petrel (*Pelagodroma marina*) were established in these lists.

By this time Latham had amassed a fortune from his medical practice and his publications, and his fellow scientists recognized him as the leading authority on birds. During the years 1796–1819, when he lived in Romsey, he became interested in the antiquities of the district and prepared a manuscript on the history and archaeology of Romsey Abbey, illustrated with numerous drawings and plans. Fate then dealt him a series of blows and he lost most of his money. Now nearly destitute, he went to live in Winchester with his married daughter, Mrs. William N. Wickham.

Another of Latham's daughters, Ann, drew in watercolors; her father used some of her original drawings of birds to illustrate his books from 1789 on. She was baptized at Dartford on 26 August 1772 and named after her mother. Like most of Latham's large family, Ann predeceased her father. When he went to live with Mrs. Wickham, she was his only surviving child.

In 1809 Latham had written to Colonel George Montagu (author of the first dictionary of birds) saying that he was contemplating a second edition of his *General Synopsis of Birds*. His revision of Thomas Pennant's *British Zoology* was issued by David Pennant in 1811. Latham had helped to revise Pennant's *Indian Zoology* in 1793. For ten years we hear no more of him; then in 1821, at the age of eighty, he began to issue a revision of the *General Synopsis,* with much new

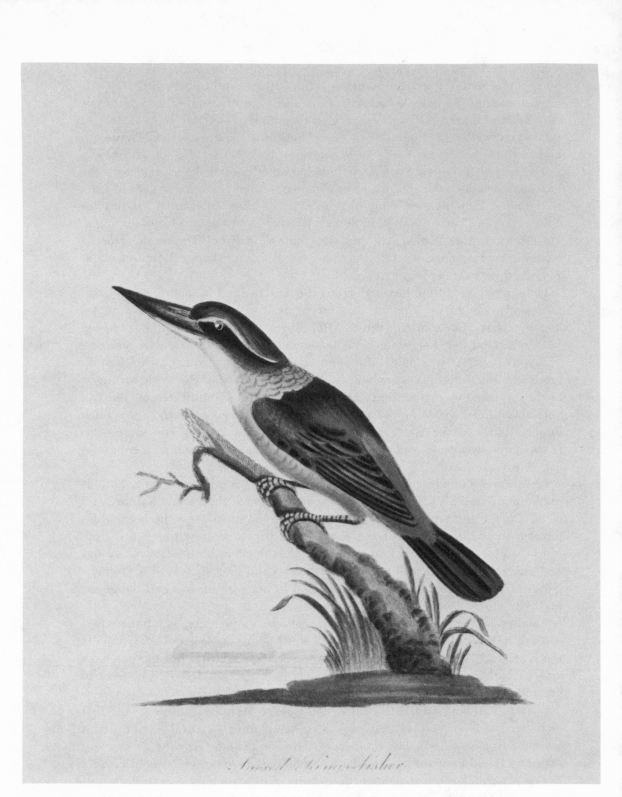

40 / The "Sacred Kings-fisher" of Latham's *General Synopsis of Birds*, vol. 1, Plate 27, drawn and etched from a specimen in the Leverian Museum. He said that it inhabited "Otaheite and other Society Islands in the South Seas." The sacred kingfisher is now *Halcyon sancta*.

material and retouched and new plates, under a new title, *A General History of Birds*. The last of its ten volumes appeared in 1828. The work was illustrated with 193 plates and cost £21.

Even after this great effort, Latham still worked on, but in a letter to Sir William Jardine dated 9 September 1831 he seems to feel beaten by the amount of new material coming to hand: "A second edition, of the Indian Ornithology is now wanted and indeed I have completed one of my old systems, but the new names multiplying so fast have so puzzled me, that I have laid it on the shelf."[4] Latham's contribution to our knowledge of Indian birds was immense. Even today, after a century and a half of work on the Indian avifauna, more than sixty species of Indian birds bear names given them by Latham. He described and identified many of these birds from drawings, long before a live or dead specimen of the species was seen in Britain or the rest of Europe. Latham used Major General Thomas Hardwicke's collection of drawings of Indian birds by native artists. Hardwicke had amassed an enormous number of drawings while he was employed in the army of the East India Company. Latham also used Lady Impey's collection of drawings, acquired when her husband was chief justice of Bengal. Sir John Anstruther, who held the same office during the years 1797–1806, also employed Indian artists. Latham frequently mentioned the drawings Anstruther brought to England as the authority for his descriptions.

More than a hundred new Australian birds were first described and named by Latham. He used specimens belonging to Banks and others, and again many of his original descriptions were based on drawings. Ray and Willughby had relied on drawings made by others of birds they themselves had never seen, and George Edwards used Loten's drawings, but heretofore these were the only authors to rely on drawings to any degree, and they did not use them to the same extent as Latham, nor did any other naturalist after him.

Latham's problem was that he was attempting to cover all foreign species at a time when specimens were not easily transported. The skinning and drying of specimens is a time-consuming and skilled operation, and the methods used in Latham's day were so primitive that specimens quickly deteriorated and had to be discarded. Smaller birds were dropped inside glass jars containing "spirits of wine," rum, or some other form of alcohol and tightly stoppered. Both the larger dried specimens and the jars containing smaller birds were bulky objects. The sailing ships of the eighteenth century, with a full complement of men on board, were exceedingly crowded. It was difficult to find room for parcels and packages, and the sailors resented the loss of locker space for such purposes. At the end of the eighteenth century, when Joseph Banks joined Cook on his voyage of discovery, the advantage of having naturalists and artists on board was just beginning to be appreciated. Others were slow to follow the precedent, and it was not until the nineteenth century, when trained naturalists who had some knowledge of taxidermy were sent on expeditions, that enough usable specimens reached Britain to reduce reliance on drawings. In Latham's time, Englishmen

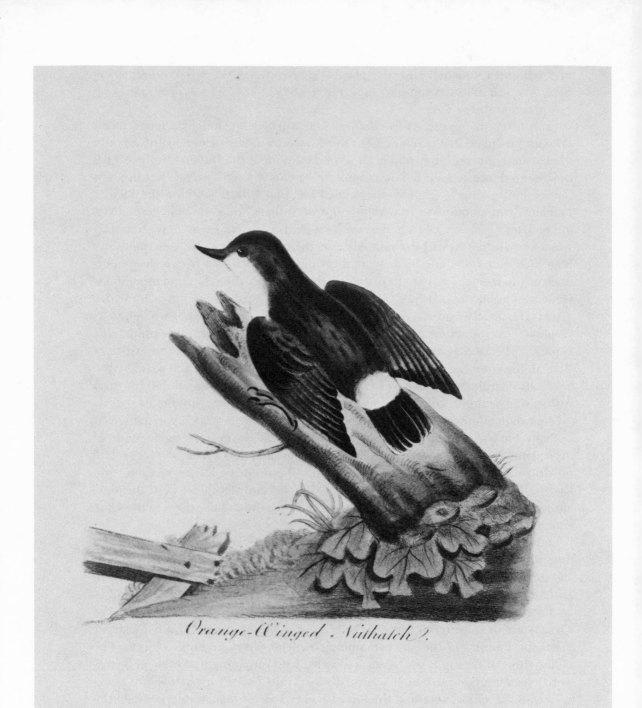

Orange-Winged Nuthatch

41 / The "Orange-Winged Nuthatch," shown with its wings held out to demonstrate the color pattern, in Latham's etching for Plate 63 of his *General History of Birds,* vol. 4 (1822). This Australian species, drawn from a specimen in Bullock's Museum, is now called the Australian sitella (*Neositta chrysoptera*).

posted abroad had drawings of natural history objects made by natives or by naturalists on their own staff. The drawings formed a permanent record whereas specimens were liable to deteriorate in hot, wet climates. The naturalists' pencil sketches were stored compactly during the voyage home and then colored when time allowed. Many drawings were sent to England from India, Ceylon, Australia, North America, and Trinidad while Latham was recording all new species as they were discovered. (A detailed study of the drawings used by Latham, by F. C. Sawyer, is listed in the "Chapter Sources.")

Latham received a few specimens, such as the Abyssinian birds sent by Henry Salt, a traveler and collector who had been sent by the British government to Abyssinia in 1809 to carry presents to the king and report on the state of the country. The Earl of Seaforth, while governor of Barbados from 1801 to 1806, shot several birds and sent them to Latham as a gift.

When his *Index Ornithologicus* was completed in 1801, Latham's list of the world's birds amounted to 3,000 species: 2,363 land birds and 637 water birds. When one remembers that Linnaeus knew of 444 bird species in 1758, the immense activity of the collectors and enormous labor required of Latham to record their discoveries can be appreciated. He had named some two hundred species and supplied the first descriptions of many more.

Old age did not manifest itself for another few years after the completion of his *General History* in 1828. In 1835 his eyesight began to fail, but Lord Palmerston reported in the autumn of 1836 that he had visited Latham and found him "well, hearty and cheerful, eating a good dinner at five."[5] He was still surprisingly active up to the beginning of February 1837. Then he failed very rapidly and died on the fourth, aged ninety-seven. He was buried in his much-loved Abbey Church at Romsey.

Books Illustrated by John Latham

Latham, John. *A General Synopsis of Birds.* 3 vols. in 6 parts. 1781–85. 106 plates.
 Supplement I, 1787. 23 colored plates.
 Supplement II, 1801. 13 plates.
 Artist, etcher, and colorer: John Latham.

————. *A General History of Birds.* 10 vols. and Index. 1821–28. 193 plates.
 Artist and etcher: John Latham.
 Colorers: John Latham, Sarah Stone.

Phillip, Arthur. *Voyage of Governor Phillip to Botany Bay.* 1789. 55 etched plates, 19 of birds, drawn by John Latham and his daughter Ann, etched by Peter Mazell.
 2d ed. 1790. Plates colored.

9

John Walcott

(1754/55–1831)

JOHN WALCOTT was a descendant of the Walcott family of Creagh, county Limerick, a small parish and village about fifteen miles from Limerick and three miles from Rathkeale, in southern Ireland. In the mid-eighteenth century this area was the scene of enthusiastic support for the new Methodist religion. John Walcott's father, also named John (c. 1730–76), was a cultured man with an interest in natural history. He collected a fine library with many titles on British and foreign topography, history, literature, and natural history. The senior Walcott was elected a fellow of the Society of Arts in 1766 and died ten years later at Bath, in Somerset.

John Walcott succeeded to his father's Irish estates in 1776, and the following year, at St. Michael's Bath, he married Ann Lloyd, daughter of John Lloyd, a wealthy businessman who was a close friend of the Countess of Huntingdon and one of the devisees of her will. The countess, who had a house in Bath, built a chapel there in 1765 for the Methodist-style sect known as the Countess of Huntingdon's Connection. John Walcott belonged to this sect for some years, and his sister Susanna later married one of its ministers, the Reverend Thomas Young of Margate.

John and Ann Walcott attended the services at the countess' chapel in The Vineyards until Ann died, in 1782. The sermon preached at her funeral in this chapel (twenty-two dreary pages long) can have been little comfort to a young

man who had just lost his pious wife at the age of twenty-six. The Reverend Thomas Pentycross declared, "Neither should it be denied unimportant, in her short, retired history, that when the offer of marriage was first made to her, she refused to listen to it, tho' eligible and respectable, till her continuance at this chapel was consented to."[1] Walcott was described elsewhere as "a gentleman of fortune"[2] and must have been a most eligible suitor, but Ann Lloyd was evidently a determined young lady.

Despite Walcott's nonconformist views, his children were baptized in the Church of England. His own death is not recorded in the registers of the nonconformist chapels of Bath, though he attended the Argyle Independent Chapel during the last years of his life.

On 15 November 1783 John was married again, this time to Dorothy Mary Lyons, daughter of John Lyons, at St. Andrew's Holborn in London. Their sons were given the names of famous naturalists: Edmund Scopoli Walcott was born at Teignmouth in 1785, and William Henry Linnaeus Walcott was born at Greenwich in 1790.

To other naturalists Walcott was a somewhat obscure figure, as he lived for the most part outside London and thus worked away from the main center of contemporary scientific activity. He was not a member of the Linnean, Royal, or Zoological societies, though he joined the local Bath and West of England Society in 1777. He was known to Dr. John Latham of Kent and had access to the specimens in Latham's private collection, as well as to those in the Lever Museum.

His first publication was *Flora Britannica Indigena,* published at Bath in 1778, when he was still in his early twenties. This book had 168 or 169 plates, unnumbered, etched in outline and left uncolored. A year later Walcott issued a book detailing the "petrifications" or fossils found near Bath; then a gap of some years occurred before he appeared in print again. In 1788 he issued a book on amphibia and fishes, based on Linnaeus's work. His move to Teignmouth, on the Devonshire coast, four years earlier must have been a decided asset for his study of fish; while in Teignmouth he made many drawings of them. He was living at Greenwich when he worked on the first volume of his *Synopsis of British Birds,* but later moved to Bristol, Southampton, Highnam Court in Gloucestershire, and finally back to Bath in 1829. Two years later, at the time of his death, his address was Great Pulteney Street, Bath. It was quite common in those days for a gentleman to draw his income from his own estates and lease property for periods of three or more years from other landowners when he did not wish to reside entirely on his own estate.

Walcott made hundreds of drawings. In his preface to *History of British Fishes* (1836), William Yarrell expressed his "obligations to W. Walcott, Esq., of Bristol for the use of a valuable MS with a collection of more than one hundred drawings of British fishes executed by his father, the author of the Synopsis of British Birds." This reference shows Walcott to be an artist of considerable worth, whose

42 / Portrait of John Walcott engraved for the frontispiece of his *Flora Britannica* (1778).

drawings were known to other naturalists and valued by so particular and accurate a worker as Yarrell.

Many of Walcott's drawings survive. Five volumes containing approximately 540 pen-and-ink and wash drawings, more than 100 of them depicting birds, were sold at Sotheby's in July 1974 for £110 and resold later that year to the Yale University Library. The McGill University Library in Montreal has three small watercolor drawings of birds by Walcott.

His bird drawings were etched by Peter Mazell to illustrate the two volumes of *Synopsis of British Birds,* published in 1789 and 1792. Walcott says in the preface that "the birds, with a figure of each, were copied by the Author from nature. He procured two hundred by his own industry." The drawings were obviously done from dead specimens and are not animated. Some of the specimens were badly set up; the peacock (*Pavo cristatus*) was a very tattered specimen with splayed legs, and a land rail or corncrake (*Crex crex*) is tipped forward on its perch. Other plates are much better and include some attractive birds. So many of Walcott's drawings of birds have too thick a neck that this characteristic makes his style immediately recognizable. This error is particularly noticeable in the long-necked birds, such as the African heron, now purple heron (*Ardea purpurea;* Figure 43), which he said had been shot in Ashdown Park near Lambourn, Berkshire, and the glossy ibis (*Plegadis falcinellus*), which he drew from a model in the Lever Museum. Even birds with naturally thick necks, such as the finches, are depicted with this feature exaggerated.

Controversy over the harm said to be done by the rook (*Corvus frugilegus*) has raged for many years. Even today, after reports by the Ministry of Agriculture and independent inquiries by scientists, many farmers remain convinced that the rook is a harmful bird. Walcotts balanced view in 1789 was that rooks "are gregarious; feed on insects, worms and grain; but make ample recompence to the farmer, for the loss of the latter, by destroying that pernicious grub the larvae of the Tree Beetle, Scarabaeus Melolontha Linn." Walcott was careful to give the Linnean names for all the species he mentioned and followed Linnaeus' arrangement of birds. His picture of the rook (*Corvus frugilegus;* Figure 44) included an outsize drawing of the "pernicious grub."

Walcott wrote one of the earliest descriptions of the rock pipit or water pipit (*Anthus spinoletta*) under the heading "Sea-lark." It was found on the coast of Devon all the year, he wrote, building its nest in tufts of thrift (*Armeria maritima*) on the sides of the cliffs and seeking its food among the seaweed at low tide. This description was obviously written from his own personal observation. Some of his information came from "an old soldier I employed in the West of England, to procure me birds for this work."[3]

The most interesting illustration, though it is not a good likeness, is that of a crested tit (*Parus cristatus;* Figure 45). Walcott is thought to be the first ornithologist to record the presence of this charming species in Britain. He said it had been seen "lately" in Scotland. Another bird with which Walcott's name

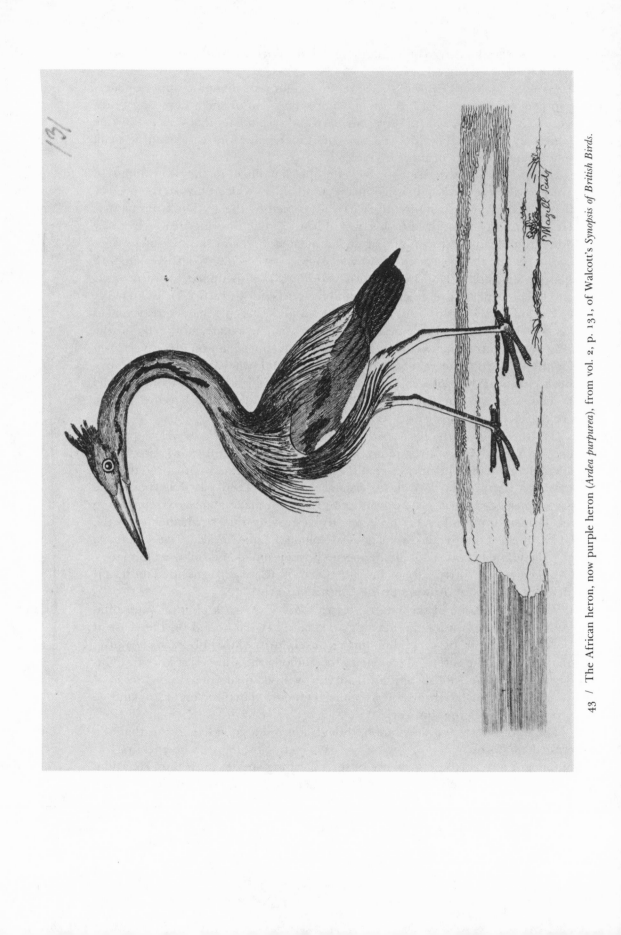

43 / The African heron, now purple heron (*Ardea purpurea*), from vol. 2, p. 131, of Walcott's *Synopsis of British Birds*.

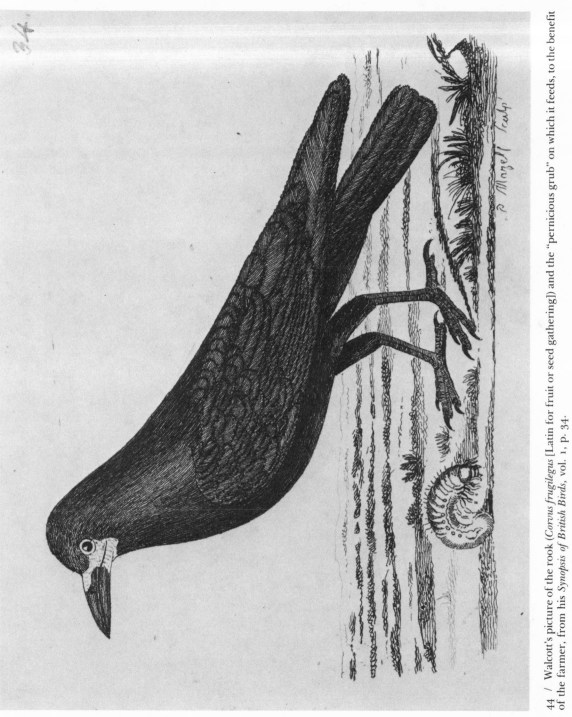

44 / Walcott's picture of the rook (*Corvus frugilegus* [Latin for fruit or seed gathering]) and the "pernicious grub" on which it feeds, to the benefit of the farmer, from his *Synopsis of British Birds*, vol. 1, p. 34.

P. Mazell Sculp!

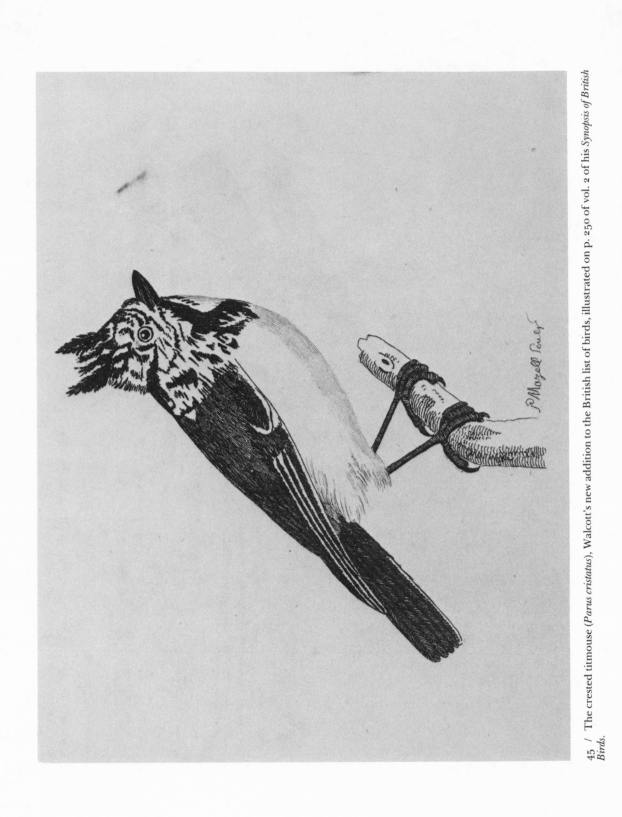

45 / The crested titmouse (*Parus cristatus*), Walcott's new addition to the British list of birds, illustrated on p. 250 of vol. 2 of his *Synopsis of British Birds*.

should be associated is the red grouse (*Lagopus lagopus scoticus*); he was the first author to use the name "red grouse" for the "red game" of earlier writers. This bird is the Scottish form of the willow grouse or willow ptarmigan.

The two volumes of *Synopsis of British Birds* were almost square. One leaf was devoted to each of the 255 British species, and printed on one side only. An etching of a figure of the species occupied the top half of the page, with a verbal description of the bird and notes on its habitat and food below. Only the adult male of each species was depicted, each bird being placed on a branch or rock, neatly etched and competently printed from Mazell's copper plates. Nearly all of the plates bear Mazell's signature but there are no artists' signatures. When Walcott borrowed a picture from elsewhere—as from M. J. Brisson's *Ornithologia,* published in Paris in 1760—he marked his plate with an asterisk. The etchings are generally uncolored, though one or two copies have been reported with the birds colored by hand, perhaps by the owners of the books themselves.

The *Synopsis* was printed by "W. Justins of Shoemaker Lane for the author"; Walcott was thus his own publisher. He sold the books through White & Son of Fleet Street (Gilbert White's brother), Robson & Clarke of New Bond Street (James Robson, who had taken such a keen interest in Edwards' work), and T. Mathews, Strand.

The book is now very scarce and is sought after by collectors for its rarity value rather than for any intrinsic scientific or artistic merit. Edward Donovan, the nineteenth-century naturalist and author, stated that the work was then already scarce when he wished to purchase it (he died in 1837). A copy in the library of McGill University, Montreal, bears a note quoted from Donovan: "I am credibly informed that no more than twenty-five copies of the work were struck off. The plates were subsequently destroyed. The figures I know to be genuine, and to be in general copies from the birds in the Leverian Museum. I offered four guineas for a copy to Thompson nearly thirty years ago, but I could not then procure it."[4] It seems incredible that only twenty-five copies should have been printed. (And did Walcott really need three booksellers to sell so few?) It is true, however, that hardly any copies are available in libraries today, and it is extremely difficult to obtain this book on the secondhand market.

For the rarer species, which he had been unable to shoot for himself, Walcott had recourse to other collections. The most important, both to him and to many other bird artists of the period, was the magnificent museum collected by Sir Ashton Lever, who amassed an enormous conglomeration of shells, fossils, stuffed birds, native weapons, and all the other miscellaneous "curiosities" so beloved by collectors of the late eighteenth century. By 1774 his lavish expenditures had impaired his fortune, and he decided to try to recoup some of his outlay by moving the museum from his home near Manchester to London and charging an admission fee. He leased Leicester House in Leicester Square and filled sixteen rooms and the intervening corridors with his treasures. Despite an admission fee of 5s 3d, he found that he could not keep his museum up to the

standards he wished, and so obtained an act of parliament to dispose of it by lottery. The museum passed into the hands of James Parkinson and had a further lease of life at a different site, the Rotunda near Blackfriars Bridge, from 1788 until 1806. Parkinson fixed too low an entry fee, however, and he was forced to sell the museum in 1806.

Walcott lived in London from 1789 until 1804, and during this period he had the opportunity to use Lever's collection of bird specimens, to meet other ornithologists, and to visit Latham in Kent.

Though he lived forty years after completing the *Synopsis of British Birds*, he seems to have taken no further interest in birds. He died on 5 February 1831, when he was about seventy-seven years old. His collection of birds is supposed to be in the Bristol Museum but has not been identified.

John Walcott was a very industrious naturalist who spread his interest and energy over a wide field. In consequence, his single work on birds was lacking in deep knowledge of the subject, though some of his comments show that he had observed a number of species in the field. Though his illustrations were distorted representations of the birds, his book is interesting as a record of the species known to be British by 1792, and it added to the growing number of illustrations of British birds.

Book Illustrated by John Walcott

Walcott, John. *Synopsis of British Birds*. 2 vols. 1789–92. 255 plates.
　　Artists: John Walcott, c. 200; John Latham; François N. Martinet (Brisson's artist). Etcher: Peter Mazell.

10

William Lewin

(1747–1795)

WILLIAM LEWIN was born on 10 February 1747, the son of William Lewin, a rate mariner, and his wife, Ann. He was baptized at St. Dunstan, Stepney, on 6 July 1748. The church of St. Dunstan was attended irregularly by many seamen who eventually found their last resting place in its churchyard. It was a convenient parish for such men to live in, with easy access to the river and the ships in the Pool of London. Lewin grew up in Stepney, then a small village separated by green fields and large marshy tracts from the neighboring villages of Mile End and Bethnal Green. The East End of London, surrounded by good farmland, was then home to both rich and poor. Huguenot weavers had brought great prosperity to the area, and whole streets in Bethnal Green and Mile End were filled with weavers' houses with the characteristically large windows in their upper rooms. To the south, Poplar was little more than a village street lined with the trees from which it took its name, and the parish was largely made up of the empty Isle of Dogs. This region of marsh and field, dominated by the trades of shipping and weaving, formed the background to Lewin's life and that of his children.

About 1768/69 William married a woman named Susanna. Two sons were baptized at St. Dunstan's, Stepney: John William on 15 April 1770, when he was eighteen days old, and James in February 1776. William Lewin was living in Poplar parish, in 1770 where he either owned or occupied property worth £10. The Lewins moved to Mile End Old Town before 1776 and remained there until

1786, when their daughter Sophia was baptized at St. Dunstan's. Another daughter, Ann, was baptized there in 1783.

In 1776 Lewin was described as a pattern drawer. Perhaps he designed some of the chintzes that were manufactured in this district. These fabrics incorporated many flowers, birds, and insects in their patterns. By 1783 Lewin was referring to himself as a "painter of Mile End Old Town,"[1] and he seems to have been a pupil of Edward Hodgson, a flower painter and drawing master of Mitre Court, St. Paul's Churchyard. Hodgson exhibited paintings, mainly flower pieces, at the Free Society of Artists from 1763 to 1783, and in 1764 he also entered two drawings by his pupil Lewin. Both of these drawings were of a human figure, done in red chalk. In 1782 Lewin exhibited again at the Free Society of Artists, this time sending in two pictures of auriculas, another of a cucumber and butterfly, and a flower piece. He was listed as a resident of Mile End Old Town, but the exhibition organizers were ignorant of his Christian name. His paintings of natural history subjects provided his livelihood, supplemented by occasional work on book illustrations. For Captain George Dixon's *Voyage Round the World,* issued in 1789, Lewin did seven drawings that were etched by Peter Mazell. They represented two views, dorsal and ventral, of a crab; some shells; and five birds: a yellow-tufted bee eater (*Moho nobilis*) from the Sandwich Islands, a white-winged crossbill (*Loxia leucoptera*) from the northwest coast of America, a Patagonian warbler (*Cinclodes antarcticus*), an ovenbird from the Falkland Islands, and a jocose shrike from China, now known as the red-whiskered bulbul (*Pycnonotus jocosus*). Each bird had its reference in Latham's *Synopsis* indicated.

Lewin's own books on birds and insects were published during the last six years of his life. By his own account he had taken twenty years to prepare the text and collect his sketches and drawings before he started to issue *The Birds of Great Britain, with Their Eggs, Accurately Figured* in 1789. It was illustrated with original watercolor drawings.

At the end of the 1780s, when Lewin was preparing the hand-painted plates for his book about British birds, he moved to Darenth, in Kent. Possibly this move was a result of an illness and consequent recommendation of a change of air. Darenth was only a short distance from both London and Dartford, where his friend Dr. John Latham lived. In addition, the peace and quiet of a small Kent village would be welcome for the publishing projects Lewin now had in hand.

Darenth was a small village on the banks of the river of the same name, with chalk hills forming a background. The countryside was rich in birds, butterflies and insects, wild flowers and ferns. Lewin also had a garden that was attractive to birds. Latham received a present of male and female siskins (*Carduelis spinus*) shot by Lewin in his garden, and in July 1791 Lewin showed Latham a pair of red crossbills (*Loxia curvirostra*) that had built a nest near Dartford, but, owing to visitors' excessive curiosity, no eggs were laid and the birds deserted the nest. It

was in the marshes of Kent that Lewin discovered the water pipit (*Anthus spinoletta*) in 1790. He illustrated it the following year as a "dusky lark." He was one of the first naturalists to mention this species as being a British bird.

In 1791 John Latham, Thomas Marsham (then secretary of the Linnean Society), and John Beckwith, an entomologist, sponsored Lewin's membership in the Linnean Society. Their recommendation described him as a "practical naturalist" and the "author of a work on the birds of Great Britain with their Eggs."[2] Lewin was elected a fellow on 20 December 1791.

From the list of members of the Linnean Society we know that Lewin moved from Darenth to Hoxton a short time before the 1794 list was published. In the autumn of 1795 Lewin must have been aware that his health was failing, for on 12 November he wrote his will, leaving all his "works and books of birds and insects in natural history together with all my plates, drawings and engravings and also all the copyright . . . to my dear wife Susanna." The will was proved on 30 December 1795 and Susanna obeyed William's request "to be buried in a decent manner in the parish burial ground of Edmonton or Tottenham" by interring him at Edmonton on 10 December 1795.[3] Lewin's courage had enabled him to complete the hand-painted illustrations for the first edition of his British avifauna and the etched plates for the first four volumes of the second edition.

Among all our bird illustrators, William Lewin is unique in using original watercolors to illustrate his book on British birds. He painted the 323 illustrations (271 birds, 52 eggs) sixty times over for his subscribers—and then received complaints that he had limited the edition to so few copies! In his preface to the first edition of *The Birds of Great Britain with their Eggs* he wrote:

> Many gentlemen have expressed concern, and indeed their disappointment, on my confining the number of subscribers to sixty; but when it is known, that the whole of the drawings are executed solely by hand, without the assistance of copper plates, and considered that their number will amount to more than 20,000, and which I have undertaken to deliver in less than four years, I flatter myself I shall be justified in their opinion; as it is my fixed intention in whatever matter I may undertake, to be particularly careful not to engage myself to perform more than I can complete.

William Swainson saw Lewin's drawings and said that he "generally painted his subjects in body colours upon vellum; his style was bold and colouring powerful, without in general being highly finished." This is a fair and reasonable summing up of Lewin's standard of painting. Swainson also described Lewin as not only "the best zoological painter of his day" but "one of the most practical naturalists."[4] He based this judgment on Lewin's fieldwork and his noteworthy practice of using live birds rather than relying entirely on specimens.

The first volume of *The Birds of Great Britain,* which was dedicated to John

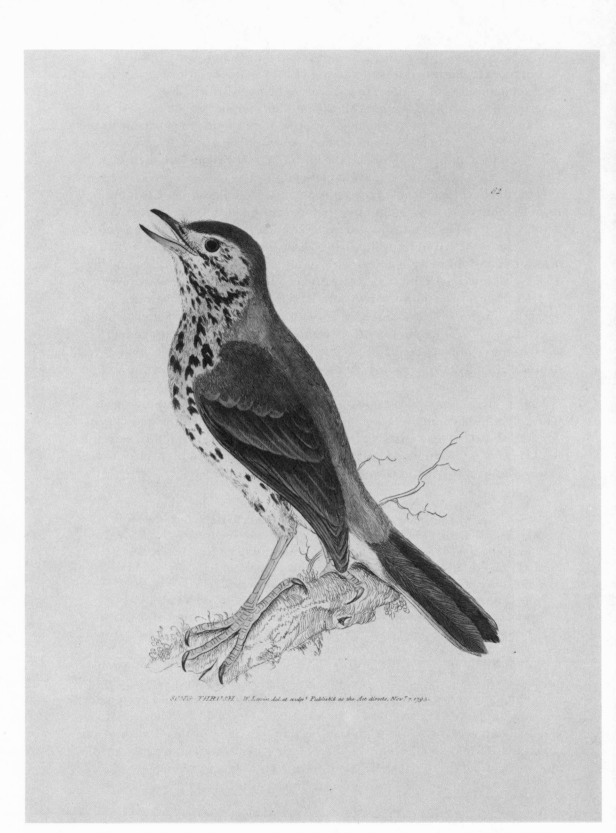

46 / The song thrush (*Turdus philomelos*) drawn and etched by William Lewin for the second edition of his *Birds of Great Britain* (1795), Plate 62.

Latham, had a frontispiece depicting an aberrant great tit (*Parus major*) with a crossed bill, signed "W. Lewin 1789"; the body of the book was devoted to birds of prey and their eggs. Lewin's sparrowhawk (*Accipiter nisus;* Figure 47) was shown with spread wings, his spotted or peregrine falcon (*Falco peregrinus*) was preening, and many others were shown in much livelier attitudes than the birds of earlier artists. Some of Lewin's best work appears in this first volume—in particular the great eared owl, now the eagle owl (*Bubo bubo*)—for he was good at painting the larger birds. Usually only adult male birds were figured, but he added females when their plumage differed. The composition of the plates was the usual bird and branch common at that time, but he placed the watercolor painting within ruled borders.

As the book progressed, Lewin's work deteriorated. He was less adept at drawing the small birds and his portraits of waders were unconvincing. Nevertheless, he made great efforts to give as complete a record of the British avifauna as possible. In the preface he acknowledged "much obligation to Mr Pennant . . . as well as to several other of my friends for their many kind communications. . . ." When he was unable to see a bird in the field or obtain his own specimen, he sought it out in museum collections. Of the green-headed bunting, now ortolan (*Emberiza hortulana*), he commented, "This is a singular species, and was caught by a bird-catcher in Mary-le-bon-Fields. It is now in the collection of Marmaduke Tunstall, Esq." Lewin had an opportunity to inspect Tunstall's birds in the 1770s, while this collection was in London. Dr. Latham's museum had a pygmy curlew, now curlew sandpiper (*Erolia ferruginea*), which had been shot by William Boys of Sandwich. It is difficult to determine whether a "red godwit" in Tunstall's Museum was a bar-tailed (*Limosa lapponica*) or black-tailed (*Limosa limosa*) godwit, but is probably the former, as the bird Lewin identifies as "Jadreka snipe Scolopax Limosa, Linn. or Lesser godwit, and in Shepey it is called the rock snipe," is definitely the black-tailed godwit. Lewin recorded a number of vernacular names used for his birds; his addition of the Linnean names gave the book greater scientific value than it would otherwise have had.

The coloring of some of the fifty-two paintings showing carefully drawn eggs is less delicate than it might be, but the eggs are a most useful feature. This book represents the first attempt to illustrate the eggs of all known British birds. Lewin was able to include them because one of his patrons, the Duchess Dowager of Portland, had hundreds of cards of eggs, both British and foreign. The Portland Museum and its owners had a great influence on the fortunes of the Lewin family.

The second duke of Portland, William Bentinck (1708–62), and his duchess were a most interesting, cultured couple. Before her marriage she was Lady Margaret Cavendish Harley, the only daughter and heiress of the second earl of Oxford—the "noble, lovely little Peggy" celebrated by the poet Matthew Prior.[5] They had a menagerie and aviaries at Bulstrode, in Buckinghamshire, and a museum of shells, precious stones, snuffboxes, and porcelain in Privy-Garden,

47 / The sparrow hawk (*Accipiter nisus*) drawn and etched by William Lewin for Plate 20 of the second edition of his *Birds of Great Britain*, vol. 1.

Whitehall. After the duke died, the duchess continued to maintain the museum and employed eminent professional naturalists to care for the specimens. The botanical and conchological sections of the museum were cared for by the Reverend John Lightfoot when he was not performing his duties as her chaplain and curate of Colnbrook, near Uxbridge. Lightfoot was a friend of Thomas Pennant and of James and Thomas Bolton, all of whom were acquainted with Lewin. Her museum contained few bird specimens (she much preferred birds alive and free at Bulstrode) but a large collection of their eggs, many of which had been sent to her by James Bolton. From these eggs William Lewin drew 146 sketches, which are now in the McGill University Library, and from the drawings he collated the fifty-two illustrations depicting British birds' eggs.

Lewin made up for the Portland Museum's lack of birds by visiting other collections, including Sir Ashton Lever's museum, probably both when it was still in Lever's possession and when James Parkinson owned it, from 1784 on. Lewin's text not only indicates the source of his specimens but adds a few field notes and records the earliest appearance of certain species in Britain. Of the bee eater (*Merops apiaster*), for example, he said in 1794 that "we have no account of any of these birds migrating to England before this."

He no doubt regretted his decision to issue his British bird book with original watercolor illustrations. Its publication took longer than the four years he had anticipated, and the demand for the book warranted more copies than the sixty he could manage to produce without help. Even before he finished painting the last bird in the first edition, he set about preparing etched copper plates in order to issue a second edition, with much less labor. Quite a number of the plates in the second edition (issued during the years 1795 to 1801) are dated 1793.

William Lewin etched and signed all the plates in the first three volumes of the second edition. Then, halfway through volume 4, issued in 1797, plates signed by his sons start to appear. Plates 104–336 were done by Thomas, Thomas William, and John William Lewin. The change-over occurs on Plate 104, "Redtail, or Redstart" (*Phoenicurus phoenicurus*), which was signed "T. Lewin" and dated 1793. In the preface William stated that "the natural history was chiefly compiled from original observations by himself and his sons and where their knowledge was defective, the descriptions were taken from the best writers on the subject." The text was essentially the same as in the earlier edition, except that a French version was now added.

The father's twenty-one etched egg plates differ greatly in their treatment from those of his sons. They used stipple for shading, but William used fine parallel lines. William's 112 bird figures are much neater and his use of line is much more disciplined. The sons used freer lines, and some scribbling is evident in places. William's larger birds and birds of prey are better than the other birds, though some of his etched buntings are improvements over earlier versions. Swainson said that Lewin's etchings "appear to have been done with too much rapidity to allow that precision and clearness in the details so necessary in sub-

jects of this nature. His birds are always easy, full of animation and very correct in their proportions yet in his attitudes he sometimes overstepped nature."[6] Although Lewin was indeed in a hurry—he was dying—the rest of the criticism is truer of his sons' work.

Among the sons, John William made the largest contribution to the book after his father's death. He was responsible for 142 bird plates, some of which—the crested tit (*Parus cristatus*) and avocet (*Recurvirostra avosetta*), for example—are quite good. Thomas William etched and drew twenty-two bird plates, including the crested, eared, dusky, and red-necked grebes (*Podiceps cristatus, P. nigricollis, P. auritus, P. griseigena*) in volume 6, all of which are rather stiff portraits (see Figure 48). Thomas Lewin contributed only two bird plates, but he did the largest number of egg plates, thirty-six in all.

Many of the drawings by William, Thomas, and Thomas William Lewin are now in the McGill University Library. Casey Wood has written that William's renderings of 146 British birds' eggs were painted on ninety sheets of thick paper, with the title, description, and index in William's handwriting.[7] McGill also owns 44 watercolors of British and foreign birds by Thomas William Lewin, and the British Museum (Natural History) owns seventy-five more; perhaps he planned a publication of his own. McGill has seven paintings of birds signed by yet another member of this talented family, R. Lewin. A Richard Lewin who lived in the Hoxton area in 1794 was paying land tax on a property worth £10 in Poplar parish—just as William Lewin had done in 1770–71. No doubt William's choice of Hoxton as a place of residence in 1794 was influenced by Richard's presence there.

After William's death, in 1795, his patrons continued to help his son John William. When John decided to emigrate to Australia in 1798, the third duke of Portland, who was then home secretary, wrote on his behalf to Governor John Hunter, introducing John William as a "painter and drawer in natural history" entitled to "the usual Government rations in the settlement."[8] This was a necessary authorization, as the very young colony (then called New Holland) had only about 5,000 white residents, 90 percent of them convicts, and supplies were still being imported from England and had to be strictly rationed. Dru Drury, a wealthy London goldsmith and keen entomologist, gave John money and collecting instructions, a gun "6 feet in the barrel," and advance orders for copperplate engravings of insects.[9]

John William Lewin arrived in New Holland on 11 January 1800, having missed the previous boat, the *Buffalo*, on which his wife, Maria, had sailed. He had turned down a good offer to join a scientific voyage of discovery in the role of naturalist, but when he reached New Holland he went on a much less promising expedition to Tahiti and was shipwrecked for nine months in 1802. He was granted 100 acres of farmland outside Parramatta in 1804. An additional 200 acres in the district of Mintos was granted to him in 1809 in the name of his infant son. He called the Mintos property Mount Arden, after his patroness

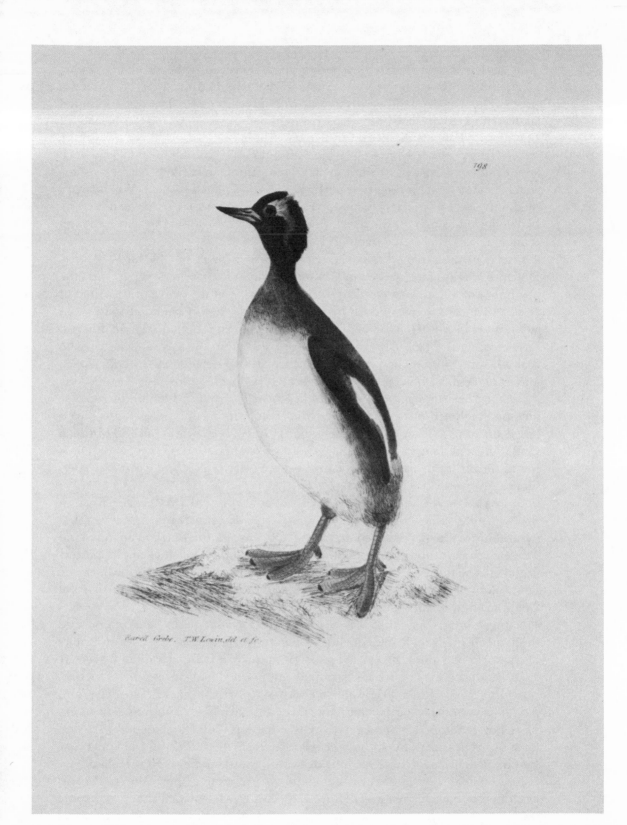

Eared Grebe. T.W. Lewin, del et fc.

48 / Thomas William Lewin's "Eared Grebe," the black-necked grebe (*Podiceps nigricollis*), Plate 198 of vol. 6 of his father's *Birds of Great Britain*. This illustration was published two years after William Lewin's death, when his sons were doing the etchings to complete the second edition of this title, started by William about 1793.

Lady Arden. Rather than settle at either place, however, he persisted in opening a succession of little shops in poor areas where he had no hope of making a profit. He was constantly in financial difficulties, despite Drury's continued sponsorship. Drury had sponsored his membership in the Linnean Society of London in 1802/3, and one of four letters written by John which are now in the society's library (dated 7 March 1803) thanks him for "getting me mad an associate of the linian society." John's spelling and grammar suggest that he was less well educated than his father, or perhaps a less disciplined student. When Drury died, in 1804, he was cut off from that source of support. He used the insects he had collected to publish *Prodromus Entomology* in 1805, hoping to make enough money to pay his passage home to England.

In the meantime, he turned his attention to a book on the birds of New Holland. The preface, written by Thomas Lewin, said that the first part was "the beginning of a work which is intended to comprehend the whole of the Birds of New Holland as they come to the author's hand." Lewin obtained sixty-seven subscribers in New Holland but only six people in England showed any interest in it. Among the British subscribers were Alexander Macleay, a collector who had advanced him money on his departure from England; Sir Joseph Banks; and Lady Arden, to whom he had dedicated his book on insects.

Birds of New Holland with Their Natural History, printed in London in 1804–8, included eighteen plates with a very brief text. The accurate illustrations were based on John William's field observations. They were of the bird-and-branch kind, but some interesting details, such as beaks and tongues, were included. A few of the birds, such as the Australian regent bowerbird (*Sericulus chrysocephalus;* Figure 49), were new to science.

In 1813 Lewin had a few copies of his book printed by George Howe in Sydney under a new title, *Birds of New South Wales*. It was the first illustrated natural history book published in Australia. It was also the first book of any kind with etched illustrations to be published there. Despite this achievement, however, John William lost heart and gave up the attempt to record all the birds of the new colony. No one else seriously attempted this enormous task until John Gould arrived for that purpose in 1838.

Natural history painting was a precarious occupation in the colony, and though John William had less ability for painting topographical scenes and views of the town of Sydney, he earned more from this kind of illustration. Governor Lachlan Macquarie became his patron and appointed him coroner in 1810, thus providing him with a steady income. At Macquarie's request, he drew and painted the animals, birds, and plants brought back by expeditions sent to explore new territory. He drew the first koala that was found, among other species. Most of his drawings are in the Mitchell Library, Sydney. The McGill University Library also owns thirty of his bird drawings, mostly done in New Holland.

John William Lewin died on 27 August 1819, after a short illness. He was described as having been a shy, quiet man with few friends, but the few people

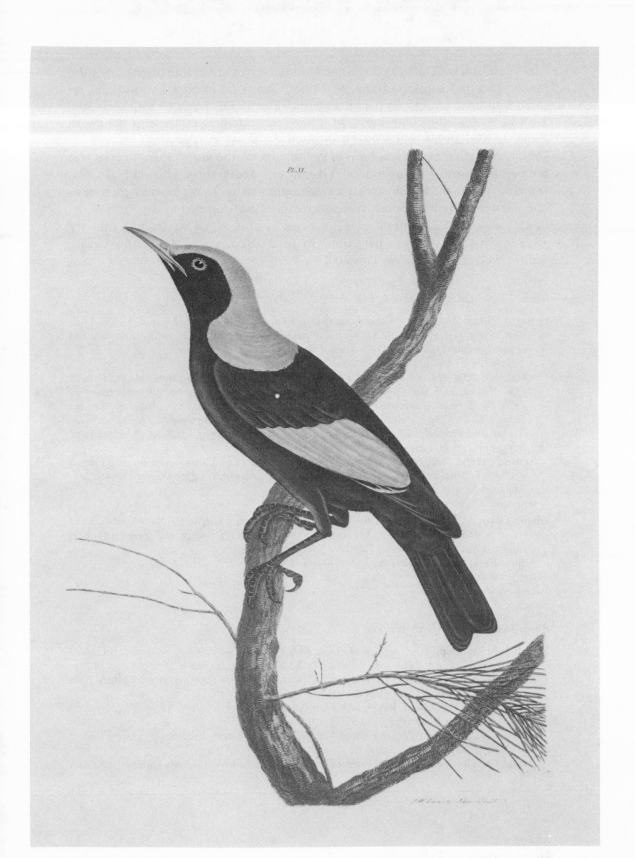

49 / John William Lewin drew and etched the Australian regent bowerbird (*Sericulus chrysocephalus*), which he called king honeysucker, for Plate 6 of *Birds of New Holland* and Plate 17 of *Birds of New South Wales*.

who knew him well, such as Governor Macquarie, regarded him highly. His wife, Maria, who had supported him throughout his years in New Holland and assisted him by drawing and painting plants, returned to England with their son, William Arden, the following year. There she saw new editions of his books about Australian birds and insects through the press in 1822.

William Arden Lewin was born in Parramatta on the last day of 1805 but was not baptized until 8 October 1806. Like Mount Arden three years later, he was probably given the name Arden as a compliment to J. W. Lewin's patroness, Lady Arden. The New South Wales secretary of state agreed to pay "Mrs M. A. Lewin, widow of Coroner Lewin," a pension of £50 a year from 1 January 1824.[10] This pension was paid until 10 June 1850, when Maria Ann Lewin, widow, died in the London Hospital.

Books Illustrated by William Lewin

Lewin, William. *The Birds of Great Britain, with Their Eggs, Accurately Figured.* 7 vols. London, 1789–94. 271 original watercolor paintings of birds, 52 of eggs. (Four special copies, painted on vellum, are known to exist.)
 Artist: William Lewin.
 2d ed. *The Birds of Great Britain, Systematically Arranged, Accurately Engraved, and Painted from Nature, with Descriptions (in English and French), Including the Natural History of Each Bird; From Observations the Result of More than Twenty Years Application to the Subject, in the Field of Nature, . . . The Figures Engraved from the Subjects Themselves by the Author and Painted under his Immediate Direction.* 8 vols. 1795–1801. 336 plates (278 hand-colored etchings of birds, 58 of eggs).
 Artists, etchers, and colorers: Birds: William Lewin, 112; Thomas Lewin, 2; Thomas William Lewin, 22; John William Lewin, 141; 1 unsigned. Eggs: William Lewin, 21; Thomas Lewin, 36; Thomas William Lewin, 1.
 Reissued 1812.

Dixon, George. *A Voyage Round the World; But More Particularly to the North-west Coast of America. Performed in 1785, 86, 87 and 1788 in the King George and Queen Charlotte, Captains Portlock and Dixon.* London, 1789. 21 plates.
 Appendix 1. Natural History. 4 bird plates.
 Artist: William Lewin.
 Etcher: Peter Mazell.

Books Illustrated by John William Lewin

Lewin, John William. *Birds of New Holland, with Their Natural History. Collected, Engraved and Painted after Nature, with a Preface by Thomas Lewin.* London, 1804–8. 18 plates.
 Artist, etcher, and colorer: John William Lewin, with some plants drawn by Maria Ann Lewin and some plates colored with her assistance.
 2d ed. *Birds of New South Wales, with Their Natural History.* Sydney, 1813. 18 plates.
 Artist, etcher, and colorer: John William Lewin.
 3d ed. *A Natural History of the Birds of New South Wales.* London, 1822. 26 plates. Issued posthumously by Maria Lewin.
 4th ed., 1838. 26 plates, with a list of synonyms added by Thomas Campbell Eyton.

11

James Bolton

(d. 1799)

I n the eighteenth century any naturalist worthy of the name had to be a competent botanist and zoologist with specialized knowledge of at least one branch of natural history. James Bolton was a naturalist in this tradition. His interests were moths, butterflies, ferns, fungi, flowers, and birds. He spent most of his life in and around Halifax, in west Yorkshire, studying the natural history of the area in some depth. Essentially a field naturalist, he made frequent excursions with his brother Thomas and their friends.

The Bolton brothers compiled a catalogue of plants growing around Halifax which was published in John Watson's *History of the Parish of Halifax* of 1775. James's first major publication was *Filices Britannicae: An History of the British Proper Ferns* (1785–90), the earliest British monograph on ferns. An equally valuable book, *History of Fungusses Growing about Halifax* (published in 4 volumes, 1788–91), was the earliest British publication devoted exclusively to fungi. Both books contained many new species and many identified as British for the first time. Bolton wrote about them from his own field observations. All of his illustrations were drawn direct from nature, sketched exactly as he saw the objects in front of him. He candidly admitted that this practice did not always make for good design of the book plate, but said that his sole concern was to make an accurate record.

In 1792, when he was about to commence work on a book about British birds,

he wrote to his friend John Ingham, an Illingworth schoolmaster: "I have not painted a bird this nine or ten years, and yet have so much of this ugly self-sufficiency about me, that I think I can do it tolerably, after a few days' practice."[1] During the next two years Bolton constantly practiced drawing familiar garden and hedgerow birds, and by 1794 was ready to issue the first few plates and text of his *Harmonia Ruralis: Or an Essay towards a Natural History of British Song Birds*.

Eleazar Albin had dealt with the same small group in his *Natural History of English Song Birds* in 1737, but his interest had been focused mainly on how to catch and train singing birds suitable to be kept in cages. His twenty-three hand-colored plates were stiff and poorly executed, so there was scope for much improvement in this particular field. Bolton's aim was to improve on Albin's book by giving accurate pictures of both sexes of each species as well as their nest and eggs. While he was obviously aware that the likely market for his book consisted of cage-bird owners, Bolton politely pointed the way to a better appreciation of songbirds. "The lady who gives place in the apartments of her house to a few pretty song-birds," he suggests, "may wish to be informed of their manners, nests, eggs, food, places of resort, etc. in a wild state, or state of nature."[2]

Bolton allotted one plate to each species, with a hand-colored etching, usually of the male, occasionally both male and female, and a descriptive text on the facing page. The following plate depicted the species' eggs and nest, with a written account of its construction and the materials used, the sites chosen, and the number and color of the eggs on the facing page. This plan of alternate bird and nest is followed throughout the two volumes, with forty plates in each volume. The additional frontispiece of the first volume depicted a Dartford warbler (*Sylvia undata*).

The very detailed text was prepared with great care and accuracy, the fruit of personal observation in the field as well as an inspection of specimens in hand. Bolton described every part of the bird, from the tip of its beak to the end of its tail, carefully noting any distinctive marks on the plumage. His word pictures, in fact, were frequently more evocative of the character of the bird than his art.

The coloring varies, as it usually does in hand-colored plates. A few copies of the first issue are finely colored, but other copies of the first edition are painted quite carelessly, with a limited range of pigments. There are many dark greens, harsh reds, and completely wrong shades in some illustrations of birds and eggs. On some plates the wash of color has been carelessly applied, and many species have inaccurately placed eye marks. In the later editions, issued after Bolton's death, the coloring is so much improved that at a casual glance it almost seems a different book.

Bolton frequently links the picture of the bird with that of its food plant. He puts the "misselthrush" (*Turdus viscivorus*; Figure 52), for example, on a bough with mistletoe growing on it, and the goldfinch (*Carduelis carduelis*) on a thistle. The blackcap (*Sylvia atricapilla*) is also associated with its food by a penetrating

50 / Portrait of James Bolton by Butler Clowes (d. 1782), a mezzotinter and engraver who kept a printshop in Gutter Lane, Cheapside, London. Bolton is reputed to have been apprenticed to him.

51 / One of Bolton's best plates depicted a male and female wheatear (*Oenanthe oenanthe*), which he called also "stone chatter." He described it as the prettiest bird for shape and colour too, that was ever seen by me" (*Harmonia Ruralis*, vol. 2, p. 77).

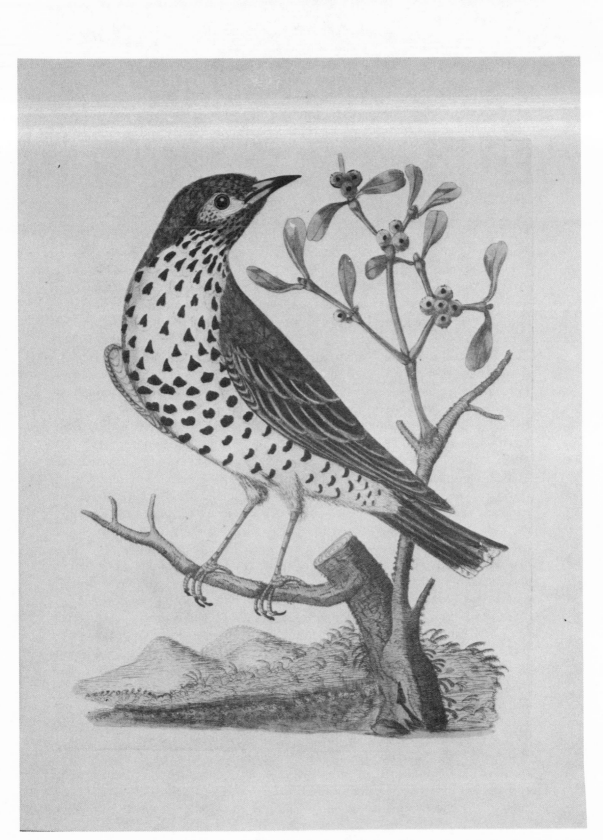

52 / The mistle thrush (*Turdus viscivorus*), with "berries of misseltoe," from Bolton's *Harmonia Ruralis*, vol. 1, p. 3.

glance at a fly. Just as one gets used to this sensible imitation of Catesby's better plates, a quite incompatible combination arrests the eye. Bolton assured his readers, however, that he was aware that some of the insects introduced in the second volume had nothing to do with the bird with which they were pictured. "It is not intended that the insects represented should be considered as part of the food of the bird it accompanies on the plate; they only serve to occupy such spaces on the plate as if left without any kind of object would give an appearance of poverty and emptiness to them."[3] The insects' names are placed alongside the short description of the bird at the foot of the plate.

Most of Bolton's specimens had been procured in the neighborhood of Halifax. He set about acquiring them in various ways and enlisted the help of a friend right at the beginning of his search. In a letter from Stannary Yard, 10 February 1792, he went straight to the point: "Friend John Ingham," he wrote, "In the course of the spring I shall be in want of the birds in the list below, and desire your assistance in procuring them. My boy brings some powder and shot, and I will very willingly make you a proper compensation for the time it may cost you. When both cock and hen can be got the cock will always be preferable." He then gave a list of twenty-five numbered species, some of them under names we should have difficulty in recognizing nowadays; "straw smalls," for example, were whitethroats (*Sylvia communis*). He revealed his familiarity with some birds by giving clues as to when and where to find them: "16, the common yellow wagtail, found about ploughed ground in the month of May" (this is the species *Motacilla flava*), and "19, the blackcap, a summer bird, concealed in woods, the head of the cock black, of the hen brown, comes in April." *Sylvia atricapilla* is one of the best songsters which visits the British Isles in the summer months. He then went on to suggest how Ingham could make the job easier: "If you can procure from any of the idle boys of your neighbourhood, in the course of building time, the nests with eggs unset of the following numbers, the nest not to be much ruffled or torn, I will pay you sixpence each for them." Bolton ends these instructions with a reminder that "birds for drawing should not be much ruffled and the colour of their eyes should be noted while living or as soon as dead."[4] Obviously Bolton was highly organized and methodical in his work.

On the Bolton brothers' collecting expeditions, James collected ferns, plants, fungi, and later birds, while Thomas built up a valuable collection of fossils and shells. On Thomas' death, in 1778, James arranged the sale of this collection, which seems to have been entirely lacking in bird specimens, though there were some birds' eggs. Thomas had been knowledgeable concerning plants, and George Edwards referred to him as a "florist" in 1757.[5] At this time the Boltons sent the rare birds they procured to other authors; Edwards, for example, acknowledged receipt of a "grey phalarope" (*Phalaropus fulicarius*).[6]

James Bolton corresponded with several distant acquaintances, among them Dr. John Latham of Dartford and the Reverend John Lightfoot of Uxbridge. Dr. Latham lent him the specimen of the Dartford warbler (*Sylvia undata*) to make a portrait for the frontispiece to *Harmonia Ruralis*. Lightfoot was the domestic

chaplain to the Dowager Duchess of Portland at her country seat, Bulstrode, in Buckinghamshire, and curator of the botanical and conchological sections of her private museum. Both the duchess and her relation the Earl of Gainsborough were generous patrons of the Bolton brothers. When Thomas Bolton's museum was dispersed, the duchess purchased the birds' eggs for ten guineas. James Bolton assisted in the collection of material for the duchess' museum, sending lichens to Lightfoot for cataloguing. On page 40 of his *Harmonia ruralis* Bolton remarked, "In the year 1782 I sent a pair of these birds [pied flycatchers (*Ficedula hypoleuca;* Figure 53)] very neatly shot, together with their nest and eggs to her Grace the late Duchess Dowager of Portland." Bolton was also aware that "the eggs of many of the British birds are excellently figured in a superb work, now publishing by Mr Lewin. These were painted from the natural subjects in the Portland Museum, most of which subjects were collected in Yorkshire, and communicated to that noble repository by me."[7] Lightfoot was present when Bolton was the subject of after-supper conversation at Bulstrode in December 1783 ("a curious character of a Mr Bolton of Halifax"), but we are left in ignorance of what was said.[8]

When the duchess died in 1785, Lightfoot wrote dolefully to Bolton, "The loss of my Noble Friend is still a burden on my mind. To enhance my grief I am appointed to allot and name her fine collection for Sale by Auction against next February. This engrosses all my thoughts. To see everything I took so much delight in sold to the best Bidder almost rends my heart. If they will let me put your Eggs into the sale I will do it. But I fear they will not."[9] The sale catalogue included not only many cards of birds' eggs, but also some fine drawings of plants by Bolton. Lord Gainsborough bought "Icones fungorum circa Halifax sponte nascentis finely col. by Bolton" for £7 10s. Also of interest to us—and to a Mr. Toppin, who paid a high price for them—were two lots of paintings of birds by Bolton. The first was a set in "a volume containing 34 excellent fine drawings of birds and plants beautifully coloured after nature"; the second was listed as "a collection of 20 paintings in water-colours of the most rare British birds with short notes and observations made from Nature, by James Bolton, very fine" (these paintings went for £12).[10] A collection of twenty-one watercolor drawings of birds executed by Bolton in 1782, according to the signature and date on the drawings, was sold in 1955 for £320. The description in the 1955 bookseller's catalogue reads very much like that of Mr. Toppin's £12 set of 1786. These drawings, each measuring 13″ by 10″, were accompanied by eighteen pages of notes and observations on "the most rare British birds."[11]

Most of Bolton's original drawings were done on vellum and colored with watercolors, though he worked also in black and white. Some drawings and paintings were intended not as book illustrations but for sale as artwork. The British Museum (Natural History) owns many of Bolton's watercolors of fungi and flowers but, regrettably, none of his bird paintings.

Having completed his drawings, Bolton then etched his own plates. In his book on ferns, published in 1785, he wrote:

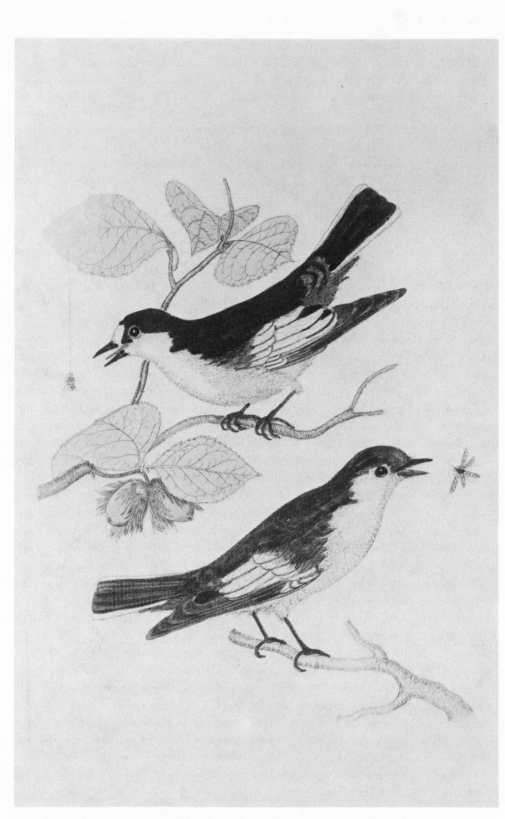

53 / A pair of pied flycatchers (*Ficedula hypoleuca*), Plate 39 in vol. 1 of Bolton's *Harmonia Ruralis*.

The drawing and etching of the figures are performed wholely by my own hands, from a close and careful inspection of the plants. The employing of an engraver would have been attended with a considerable and certain expense; and as the reimbursement was very uncertain, I chose to undertake it myself, though I have never before practised the art of etching, that I might hazard only the loss of so much of my own time.[12]

If "birds" were substituted for "plants" in the first sentence, these words might equally have been part of the preface to *Harmonia Ruralis.*

The cost of having plates engraved by a trained craftsman was too great. In a letter to his brother in February 1777, Gilbert White reported an interview he had had with an engraver when he was trying to get some quarto-sized drawings engraved. The engraver told him that the "quarto drawings cannot be well executed under 8gns a piece."[13] With typical frankness, Bolton again mentioned the expense involved in producing artwork in the preface to *Harmonia Ruralis:*

Ornithology being a very extensive branch of Natural History, complete works on that subject, if well executed, must be attended with very great expense to the publisher, and consequently must cost an high price to the purchasers of copies. I hope therefore, it will not be unacceptable to the lovers of song-birds to be possessed of an History of these alone, separated from all the rest.

That his work was indeed most acceptable, even popular, is proved by a posthumous reprint in 1824, a reissue in 1830, and a pirated edition of 1845.

Very little is known of Bolton's domestic affairs other than that he had a wife called Sally and two sons, one of them named Thomas. In a letter to Sir Joseph Banks on 5 January 1798, George Caley mentions that Bolton had been "a weaver by trade, but for about one year & a half back has kept a small public house."[14] This occupation gave him more leisure time for writing and illustrating his books on natural history. Bolton's flower and insect paintings provided additional income, and as a natural history artist of some note he may also have taken pupils. William Martin, who was a native of Mansfield in Nottinghamshire, was sent to Halifax in his twelfth year to take drawing lessons from Bolton. Martin, understandably, also "imbibed a taste for natural history" from his master, and in 1796 he was elected a fellow of the Linnean Society.[15] By that time Martin was well established as an artist and drawing master himself. In the modern directories of artists and engravers, Bolton is always listed as a flower painter, though his work was of much broader scope. His books were popular and therefore profitable, but because they were all published in the last fourteen years of his life, they contributed less than his paintings to his standing as an artist during his lifetime. Today it is his books that keep his reputation alive, while his paintings are lost.

Bolton lived in and around Halifax, at Causey Hill (now Causeway Head) and

54 / The whitethroat (*Sylvia communis*) and its nest and egg, Plates 79 and 80 in vol. 2 of Bolton's *Harmonia Ruralis*.

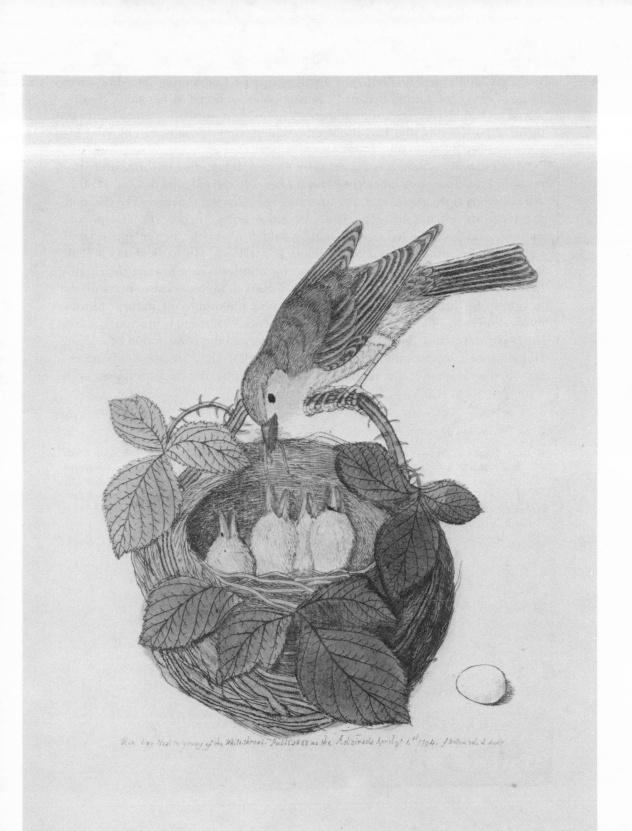

Hen egg Nest & young of the White throat. Published as the Act directs April 1st 1794. J Dolman del. & sculp

Warley Clough, and finally in the small village of Luddenden. He died on 7 January 1799 "of a rapid decline." An acquaintance noted in her diary that he would be "much regretted by all who knew his modest worth, and particularly by those of his friends who had the most frequent opportunities of enjoying his conversation."[16]

In many ways Bolton was a Yorkshire Gilbert White, but unfortunately the record of his close observations of natural history in the parishes around Halifax are scattered throughout several books and not collected together, like those of the Hampshire naturalist. This is a pity, since Bolton wrote well and pictur-esquely, and his collected observations would probably be better appreciated today than his attractive though mediocre illustrations. His work shows a neat, methodical approach, the result of a concise mind working toward clearly de-fined objectives. There are glimpses of this quality in his letters also, particularly in one to his brother in which he sums up his philosophy of natural history illustration in one (largely unpunctuated) sentence: "Drawing is the Soul colours the body and both I find are absolutely necessary to the constitution of a good Imitation of any Natural Object tho' ever so small as they are absolutely neces-sary to the existence and motion of a Swallow, a Trout, a Dormouse, or a Man."[17]

Book Illustrated by James Bolton

Bolton, James. *Harmonia Ruralis: Or an Essay towards a Natural History of British Song Birds Illustrated with Figures the Size of Life, of the Birds, Male and Female, in Their Most Natural Attitudes, Their Nests and Eggs, Food, Favourite Plants, Shrubs, Trees, etc. etc. Faithfully Drawn, Engraved and Coloured after Nature.* Halifax, Yorkshire, 1794–96. 81 plates.
 Artist, etcher, and colorer: James Bolton.
 Later impressions, colored by other artists: 1824, 1830, 1845.

12

Edward Donovan

(1768–1837)

THERE is something strange about Edward Donovan. He was prominent for some years in London, where he kept a private museum that he opened to the public. He was well known to other naturalists of the late eighteenth and early nineteenth centuries as an illustrator and author of books on flowers, insects, fishes, shells, quadrupeds, and birds. He was also a fellow of the Linnean Society. Yet very few accounts of him were written and none gives any clue as to what he was like as a person, what he looked like, where he lived, or who his friends were. Perhaps his contemporaries' sympathy was alienated by the fact that he left a large family in destitute circumstances, though he had once been a wealthy man. Normally when a bird artist died, at least one other author wrote an account of his life and work. When Donovan died, though two or three sources listed his publications, he was scarcely mentioned. Among his contemporaries only William Swainson commented on his work, and then it was with undeserved severity.[1] Donovan's friends seem to have vanished like his money.

As a very young boy he had been interested in natural history, collecting shells and preserving insects. His first book was published in 1783, when he was fifteen years old. Until 1790, when *The Botanic Review; or the Beauties of Flora* was published, he signed his work "Edward O. Donovan." The title page and twenty-one plates of that work, and those of his many later books, were signed simply "E. Donovan." He drew, etched and engraved, and colored all of his illustrations by hand.

Donovan's ten-volume *Natural History of British Birds,* published between 1794 and 1819, contained, as his subtitle claimed, "a selection of the most rare, beautiful and interesting birds which inhabit this country." As for where the young Donovan had managed to obtain these rare species, the answer is given in an 1817 catalogue of his London Museum and Institute of Natural History, in which he wrote about his collecting activities. He had "commenced his course of collecting before the year 1788" by purchasing from collectors and friends. By 1817 he could claim:

> The assemblage of British birds is admitted to be most splendid and complete, consisting of about 400 species and extraordinary varieties, and besides containing every known rarity of the British series in any other collection, may be considered as possessing at least 100 more than any other Museum. The two sexes of the same species are constantly placed together in the same case, and these are very frequently accompanied by the nest, the eggs and the young. The whole amounting to about 1000 British Birds, many of which are of peculiar beauty.[2]

This extract is noteworthy in several respects. Not only did Donovan thoroughly appreciate the "peculiar beauty" of the British avifauna when many of his contemporaries were pursuing more gaudy foreign species, but he arranged his specimens in a most intelligent manner. He grouped examples of the same species at different stages of their development, along with the nest and eggs, in the same showcase. His museum was thus made more valuable by being scientifically arranged and not left as the usual jumble of assorted specimens exhibited by his contemporaries. It is interesting to note that he started his collecting before 1788—that is, before he was twenty. He must either have had very indulgent parents or have been left with considerable means at his disposal at a very early age. The reason the bird section of his museum could not be rivaled was that he had bought up several other excellent collections, including "part of the collection of [James] Leman, reputed one of the earliest preservers of Birds in England; the Collection of British Birds formed by Dr Latham; the British Birds of Mr Green of Westminster; and the entire collection of the British Series in the late Leverian Museum."[3]

Donovan's unsurpassed collection was still in the process of being gathered together as he wrote his *British Birds.* The book was issued in fifty monthly parts, each with two plates, priced at 2s 6d. The plates, according to the cover, were "drawn from specimens in the collection of the author." Often only a few strokes of the pen suggested the bird's contour, which was completed with watercolors. Stippled flecks (rather than dots) occasionally enhanced the effect he achieved.

Variations in the quality of the plates can probably be attributed to the varying skills of the taxidermists who set up the bird models. Donovan tried very hard to show originality in the presentation of his birds, and to put some life and spirit into his figures. With some figures he succeeded, but others are lacking in grace.

Unfortunately, he followed the tradition of bird-and-branch presentation in 244 plates. Had he portrayed the family groups of male, female, young, nests, and eggs assembled in the glass cases of his museum, as described in his catalogue, his plates would have made a genuinely useful contribution to ornithology and would have advanced the art of ornithological illustration.

The more brightly colored males were chosen for the portraits; no females or juveniles were shown. The hand-coloring of these birds was delicately and beautifully done, giving the book considerable artistic merit. He painted the figures smoothly with gouache. The foregrounds of tree branches, grass, and stones were also colored. There were no backgrounds.

Donovan's text was verbose. He wrote laboriously and he relied greatly on other sources. The descriptions, he said, came from the "Systema Naturae of Linnaeus; with general observations either original or collected from the latest and most esteemed English ornithologists."[4] Though he consulted Linnaeus, he made no effort to arrange his own birds systematically; the genera and species are all mixed up. The actual information conveyed in the descriptive part of the work was rather meager.

Of the many interesting birds in Donovan's book, the one that probably excited him the most was the ring-necked duck (*Aythya collaris;* Figure 55), which he described in 1809, in volume 6. He had found the specimen, he said, in the Leadenhall Market (a meat and poultry market in Gracechurch Street, London), where he had been told that it had come from Lincolnshire. This claim for the fen country is not altogether trusted today, but the claim that Donovan bought and then described a species entirely new to science has not been questioned. The species is Nearctic, and though it is common on woodland ponds in North America, the records of its appearance in Britain are very few. Donovan called it a "collared duck" when he saw the indistinct chestnut collar round the neck of the adult male bird. It was not a very well-chosen name, since this diagnostic feature is so faint that it is observable only when the bird is held in the hand.

Donovan's *British Birds* and *General Description of the Principle Objects of Curiosity Contained in the London Museum* (published in 1807) give some idea of the rare species of British birds that were displayed in his museum. Many of these specimens were the first to be identified as British species and added to the national list. The "spotted falcon" of English authors was the peregrine falcon (*Falco peregrinus*), whose different plumage states from young to adult birds caused much confusion in the minds of the naturalists of the eighteenth and early nineteenth centuries. Donovan also had a "rough-legged falcon—one shot nr. London a few years ago and is the specimen from which Dr Latham inserted it in the English catalogue." A rough-legged hawk is still a rarity today in Britain, where it is known as a rough-legged buzzard (*Buteo lagopus*).

The claim that another of Latham's birds, a "cream-coloured courser" (*Cursorius cursor*) shot in Kent, "is presumed to be the only specimen known in Europe" would hardly stand up to examination. Nor could the price Donovan

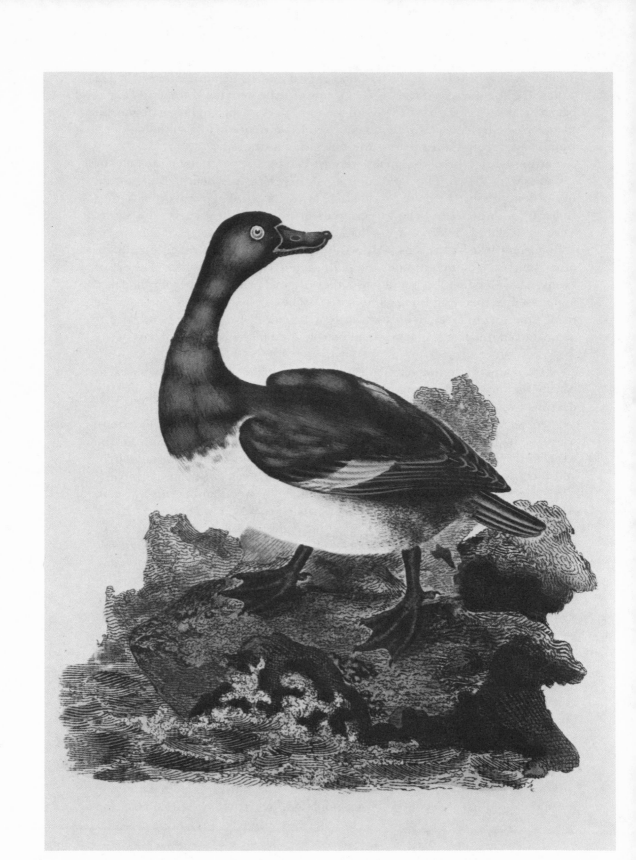

55 / The ring-necked duck (*Aythya collaris*), discovered and named "Anas collaris Collared Duck" by Edward Donovan in his *Natural History of British Birds,* vol. 6 (Plate 147).

paid for it—83 guineas—be justified. Other specialties included a roller (*Coracias garrulus*), which Donovan painted with wings held aloft (Figure 56); a bee eater (*Merops apiaster*); a cirl bunting (*Emberiza cirlus*), which had recently been discovered in Devonshire by George Montagu; and a black-crowned night heron (*Nycticorax nycticorax*) "shot near London 1782."

Donovan had purchased 500 lots at the Lever Museum sale in 1806. This acquisition gave a boost to his efforts to add to his *British Birds*, which had appeared in five volumes in five successive years, from 1794 to 1798, then stopped. In 1809 volume 6 appeared, with more new and rare species drawn from Donovan's acquisitions from the Lever sale. Donovan had had a good opportunity to look over all the birds in the Lever Museum and to know what he wanted to buy long before others had the chance to look closely, since he was the compiler of the sale catalogue. He catalogued the entire museum in 410 octavo pages, listing 7,879 lots to be sold over 65 days. Among his own purchases were a kite (*Milvus milvus*) for £1, and a specimen of the great auk (*Pinguinus impennis*) for 10 guineas.

The prices that Donovan paid were considerable. Ironically, the fact that he had made such a good job of the sale catalogue contributed to the high prices he had to pay for the lots he bought. If someone as knowledgable had been available to do a similar service for Tunstall's, Selby's, and Jardine's museums, the sad fate of those excellent bird collections might have been averted. They were knocked down at a fraction of their real value as a result of poor cataloguing.

One of the earliest signs that Donovan had become an inveterate collector who spared no expense was his purchase of many of Dru Drury's magnificent accumulation of insects in 1803, when it was dispersed after his death. These specimens formed the nucleus of his own insect collections. Entomology was Donovan's principal interest. He published several books on the subject, and his drawings and etchings of insects were the best part of his published work. Donovan's fishes were also well drawn. The fishes, insects, shells, and quadrupeds were all described under titles similar to *The Natural History of British Birds*, with the exception of the three-volume *General Illustrations of Entomology*, dedicated to Sir Joseph Banks, which dealt with the insects of China, India, and Australia. The Australian insects in Drury's collection had been sent by John William Lewin, son of William Lewin.

In 1826 Donovan began to issue a companion volume to his *British Birds*. Called *The Natural History of the Nests and Eggs of British Birds*, it was a worthy attempt to publish a separate work dealing with this aspect of bird life. Unfortunately, he got no further than the first five parts, with seventeen hand-colored plates. He had intended to issue twenty-four parts. The plates were beautifully colored, and it is to be regretted that he did not complete this book.

He began work on the *Nests and Eggs* when he was in the midst of issuing another title. *The Naturalist's Repository*, started in 1822, can be regarded as a very early periodical publication, as it appeared regularly in monthly issues (from

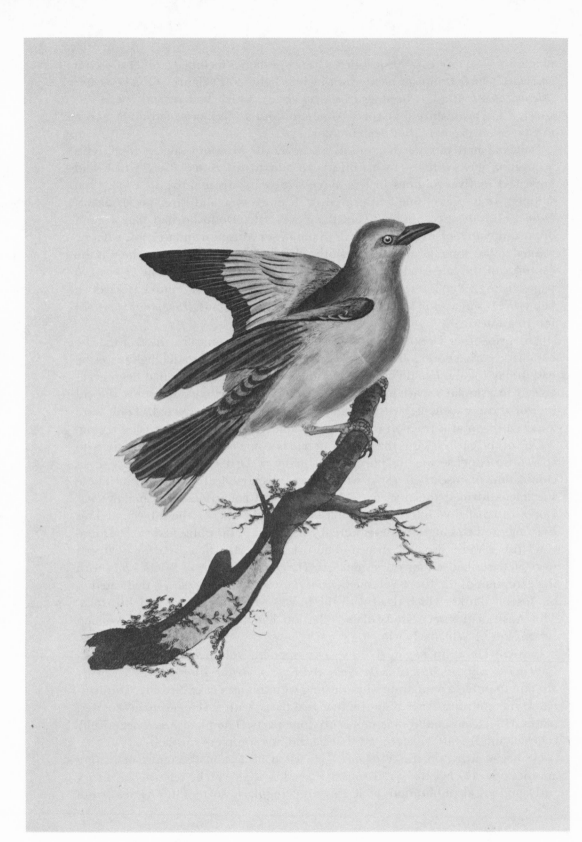

56 / Edward Donovan's lively portrait of a roller (*Coracias garrulus*), lightly etched and then painted with gouache, Plate 33 in vol. 2 of *The Natural History of British Birds*.

April 1822 to March 1827) and was a "miscellany of exotic natural history exhibiting rare and beautiful specimens of foreign birds, insects, shells, quadrupeds, fish and marine productions"—all the things in which Donovan delighted.[5] The periodical formed a kind of supplement to his other works. The foreign birds were drawn from the small collection of specimens in his museum. The bird section had been built up to form the finest source then in existence for the study of British birds, but Donovan could never resist buying beautifully colored foreign birds at sales. Twenty-six plates depicted these exotic birds, neatly etched, one bird to a plate. The illustrations were of the bird-and-branch kind, with both figure and foreground colored. In etching the plates, Donovan again used stipple in places, as in the flowers that accompany the "speckled manakin" (*Pardalotus punctatus;* Figure 57).

Donovan was not always to be found within the confines of museum walls, as his many books and catalogues would suggest. One of his finest publications was the two-volume *Descriptive Excursions through South Wales* (1805), with illustrations executed from his own sketches of landscapes made during six summers of travel through Monmouthshire and South Wales (1800–1805). On his excursion in 1802, in the company of friends who were geologists, he met up with the artists John Varley, Joshua Cristall, and young William Havell at Dolgelly, and the very large party greatly enjoyed one another's company. Donovan's sensitive pictures of the preindustrial countryside between Bristol and Pembroke form a record of lasting value.

The great expenditure on his many publications and his museum reached such proportions that this once wealthy man found himself in financial difficulties at an age when he should have been able to enjoy a comfortable retirement. In 1833, when he was sixty-five, Donovan published a pitiful seven-page *Memorial of His Case with Certain Book-Sellers,* detailing his losses at their hands. From his first publication (*British Insects,* 1792), he wrote, "it was agreed that the Booksellers should have an equal half with myself in that work; and afterwards the same proportion of the other publications which have been produced as partnership concerns between us from that time to the present." A full set of all his books sold for £100, and from their sale Donovan should have had a good income. The booksellers, however, had managed "by long protracted accounts, and verbal representations wholly unsupported by any documental proofs . . . to engross properties of very considerable value to themselves, and then allege their right to *destroy the accounts* and set up the Statute of Limitations to stifle all further investigation." In other words, by withholding accounts for six years under the applicable statute, the booksellers could ruin him by avoiding payment. According to Donovan's estimate, the retained property was worth between £60,000 and £70,000. His memorial concluded with a request for contributions so that he might take his case to the court of chancery. But apparently the results of this appeal were not sufficiently encouraging to allow Donovan to take his case to court; he filed no suit between the date of the appeal, 1833, and

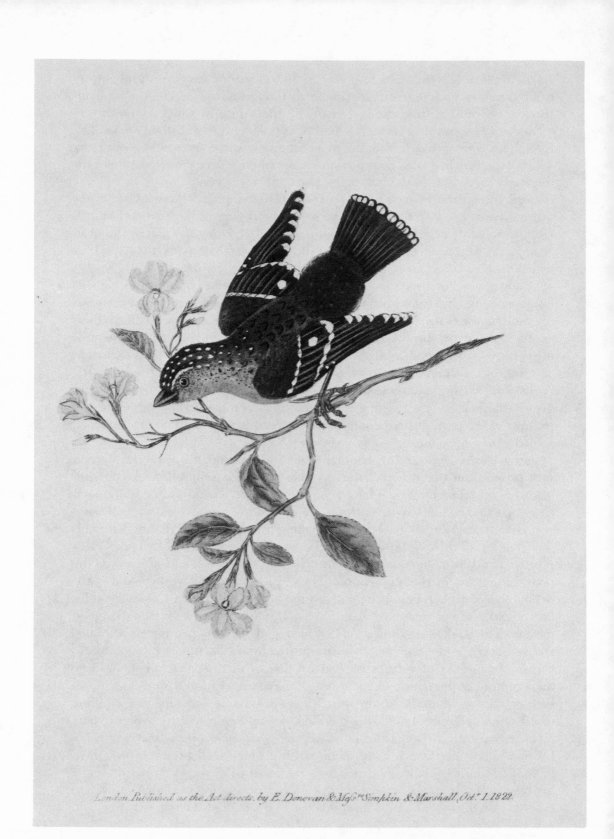

London Published as the Act directs by E. Donovan & Mess.rs Simpkin & Marshall, Oct.r 1. 1822.

57 / The "speckled manakin" (*Pipra punctata*), one of the foreign birds included in Donovan's *Naturalist's Repository* (vol. 1, Plate 19). This illustration demonstrates Donovan's etching and stippling technique. He painted the bird in its natural size, 4″, perched on a sprig of *Goodenia ovata,* an Australian plant that had flowered in the Royal Botanic Gardens at Kew. This Australian species is now called yellow-tailed diamondbird or spotted pardalote (*Pardalotus punctatus*).

1837, when he died in John Street, Kennington Road, London. No doubt his friends were appalled at the thought of the costs of a lengthy court case with an uncertain outcome. Had he not declared in his memorial that his transactions had been verbal and "wholly unsupported by any documental proofs"?

Signs of Donovan's pending crisis had been evident a long time before his memorial was published. As far back as 1817 he had attempted to recoup some of the £15,000 he had expended on his natural history collections. In that year he made the heartbreaking decision to sell off his museum in Brydges Street, Covent Garden. He had been charging a shilling admission and sixpence for a catalogue, but these sums could hardly have covered the cost of maintenance, let alone the sum expended to buy the specimens.

Since even the sale of Donovan's museum did not end his financial difficulties, one must assume that the prices obtained were disappointing. It was a sad end to what James Parkinson described as "the most complete collection of British natural history which has ever yet been formed; a museum, not confined to any one particular branch, but comprehending alike the three great departments of nature, zoological, botanical and mineral productions of the island, upon the grandest scale imaginable."[6]

In the face of such distressing evidence that Donovan's reward for a life and fortune devoted to natural history was poverty and unhappiness, one hesitates to be too critical of his work. *The Natural History of British Birds* was started in his youth, when he had plenty of money and enthusiasm and an expanding collection, and finished in middle age, when his wealth was gone, his museum sold, and his spirit broken. His willingness to share his excellent collections with other naturalists—in particular with George Graves, a near neighbor—was most praiseworthy. His work is artistically good and his plates of birds show originality and are more spirited than those executed by his contemporaries and some of his successors. From a scientific point of view, however, neither the bird portraits nor the descriptions approach the high standards of his work on insects.

Books Illustrated by Edward Donovan

Donovan, Edward. *The Natural History of British Birds; or a Selection of the Most Rare, Beautiful and Interesting Birds Which Inhabit This Country.* 10 vols. London, 1794–1819. 244 plates (each vol. 24 plates, except vol. 4, which has 28). Vol. 1, 1794; vol. 2, 1795; vol. 3, 1796; vol. 4, 1797; vol. 5, 1798; vol. 6, 1809; vol. 7, 1816; vol. 8, 1817; vol. 9, 1818; vol. 10, 1819.
Artist, engraver/etcher, and colorer: Edward Donovan.
Reissued 1799, vols. 1–5 only.
2d ed., 10 vols., 1813–20.
————. *The Naturalist's Repository, or Miscellany of Exotic Natural History Exhibiting Rare and Beautiful Specimens of Foreign Birds, Insects, Shells, Quadrupeds, Fish and Marine Productions.* 5 vols. London: 1822–27. 180 plates, 26 of birds: vol. 1, 11; vol. 2, 8; vol. 3, 5; vol. 4, 2.
Artist, engraver/etcher, and colorer: Edward Donovan.
Reissued 1834.

13

George Graves

(b. 1784)

GEORGE GRAVES was born on 23 May 1784 at Newington, south London, the son of William Graves and his wife, Mary. His father was a member of the Society of Friends and the "constant and undeviating friend and assistant" of the Quaker botanist William Curtis, whose publications included many beautiful plates colored by William Graves.[1] George grew up among people whose business was the writing and publishing of books, and seems to have entered the book trade as a matter of course. At the age of twenty-two, in 1806, he was described as a bookseller, then as a "colourer of natural history" from 1810 to 1815, and as "an artist" after 1816.[2] These descriptions were really only facets of the same trade. At one time or another George Graves was an author, an editor, an etcher, a colorer, and a publisher, as well as a bookseller and an artist.

His father had commenced the coloring of plates for William Curtis' *Flora Londinensis* about 1771 and was reported to be still working as a colorist at the age of seventy-three, in 1827. One result of the close association between William Graves and the Curtis family was that George went to live for a time in the home of William Curtis' younger brother Thomas, who was the publisher of *Flora Londinensis,* and there George courted Thomas Curtis' daughter Mary. George Graves and Mary Curtis were married on 4 November 1806. Their first child, a daughter whom they named Mary Ann, was born 23 February 1807.

It was a poor start to their married life. The Southwark Monthly Meeting of

the Society of Friends could not condone such behavior and set in motion the process of disowning the couple. Their parents can have been of little assistance to them, for Mary's father had recently died and George's parents had only just completed their own large family with the arrival of their eleventh child, Thomas, in April 1806.

Mary and George Graves had eight children and five addresses before 1820, with attendant financial difficulties. Their early years were spent in Walworth. They moved in 1820 to Peckham, in the London borough of Camberwell, south of the Thames, and appear to have remained there for some years. In the preface to *Monandrian Plants,* published in London in 1828, William Roscoe informed his readers that all of the plates had "been engraved and coloured under the care and direction of Mr George Graves junior of Peckham." The 112 plates were hand-colored lithographs, so George's sixteen-year-old son had moved with the times and adopted the new process of lithography as his medium. However, both he and his brother William Curtis Graves, another of George's sons who became a printer, continued the family tradition of service to the printing trade into the third generation.

Much of George Graves's financial trouble stemmed from his connection with *Flora Londinensis.* William Curtis died in 1799 with his ambition to publish a complete natural history of Britain unrealized. The account of the plants growing around London had formed part of his plan, but it had not been received with the acclaim or support it deserved, and the book proved a financial loss to Curtis. In January 1815 George Graves became part owner of the plates, stock, and materials of *Flora Londinensis,* including some plates of birds and insects. His ownership of *Flora Londinensis* was to give him as much trouble and occasion as much loss as it did to its former owners, so that by March 1821 he was in debt for the enormous sum of £600. He was then editing a new edition, with William Jackson Hooker, which appeared between 1817 and 1828 in five volumes with 702 hand-colored plates depicting the flowers life-size. But this edition was no more successful than the first. Not until 1834 did all those concerned with the book finally manage to disentangle themselves from it. By that time everyone concerned—lenders of money, printers, booksellers, stationers—had suffered a loss and was glad to wind up the business. No doubt Graves was more relieved than any of them.

Graves was associated with William Jackson Hooker in other publications. Dr. Hooker had been appointed Regius Professor of Botany at Glasgow University in 1820, and was the author and editor of many botany books and periodicals. In 1828 he was working on *Icones Filicum* with Robert Kaye Greville, another eminent botanist, then living in Edinburgh, and they needed a colorist. The following January, Graves went to Scotland to visit them, with a view to moving north of the border in order to color their prints and, he hoped, those of other naturalists in the north, such as James Wilson, Sir William Jardine, and Prideaux John Selby. In July 1829 Selby wrote to Jardine that he was

very glad to find that there is such a probability of Graves coming to Edinburgh as a regular establishment will do much for bringing the colouring of natural history plates to perfection & even, although he may not obtain everything, a school of that kind will oblige other colourists to exert themselves to the utmost in order to obtain patronage or encouragement. He is a talky little fellow, & not a little conceited upon the two subjects you mention.[3]

Graves was unfortunately prone to give unwanted advice about the printing and coloring of natural history plates. He once wrote to that very prickly naturalist and excellent bird artist William Swainson, suggesting that Swainson print his plates only in very light black or gray ink, or that he use sepia, the better to show off the watercolors when the plates were painted by hand.[4] Swainson must have regarded this advice as impertinent, and it is perhaps as well that his reply has been lost.

In order to convince Hooker and Greville and the other naturalists of his expertise, Graves offered to color some specimen plates for them. When he asked Selby what price he paid his colorer for each plate, Selby replied that he thought it was threepence, and Graves declared that such "a sum ought to colour them in a very superior manner to the style in which they are done, which he thinks vile."[5] The promise of sufficient work induced Graves to move to Edinburgh, first to Minto Street, later to 7 Springfield. Though Hooker and Greville found work for him, Jardine and Selby do not appear to have used his services.

We have some evidence as to how this plan worked out. The Hooker correspondence at Kew (where Dr. Hooker had a distinguished career as director of the Royal Botanic Gardens from 1841) includes two letters from George Graves, dated 4 and 10 March 1831. Graves was then coloring some plates for inclusion in Hooker's *Botanical Miscellany* and also a number of plates depicting ferns for his *Icones filicum*. Of these plates Graves wrote, "Dr Greville informs me you object to their being done by candlelight, this will not be the case with the remaining numbers if I have them all before the end of August as we do not commence with Candle-light until the 20th October and tomorrow finishes the present season."[6] Accurate coloring by flickering candle flames must have been difficult, and the results variable.

By 10 March, Graves was writing to say that if Dr. Hooker had "a plate or two of the ferns ready, I shall be quite glad of them as I am at this time entirely without employ, and all my folks are wanting occupations, so that anything you can send me I shall be glad of and prevent our being idle."[7] His lack of employment and the proximity of the famous botanic gardens of Glasgow and Edinburgh gave him the opportunity to prepare his last botanical title, *Hortus Medicus,* for publication in 1834.

Graves's competence as a botanist was recognized when he was elected a fellow of the Linnean Society on 17 March 1812. He was a member for the next twenty-two years. Though the reason for his resignation in 1834 was not stated, letters

in the society's archives indicate that Graves had fallen behind with his subscriptions and owed £50.

By 1841 Graves was back in the south. The census taken in that year recorded his presence, with his wife, two unmarried daughters, and a son, in Park Street, in the St. George's district of Camberwell, where they remained until 1845. Sometime during that year they left the house in Park Street, owing some rent. Their subsequent movements are unknown.

Graves's other two publications were more concerned with birds. His *Naturalist's Pocket Book* of 1817 discussed birds, but only two plates of birds were included, and they showed only beaks and feet. It is on his *British Ornithology* that his claim to ornithological fame rests. In this book he attempted to describe every known species of British bird. It took him from 1811 to 1821 to complete this task. This seems an inordinately long period, especially as he already had some plates completed before starting the main part of the work, but he was also working on other publications at the same time and may well have been employed by printers as a colorist. In the advertisement printed in the first part of *British Ornithology*, dated from Walworth January 1, 1811, he stated, "The work will be complete in about forty-eight numbers, forming four octavo volumes . . . a considerable number of the drawings and engravings are now finished, having been made for the late William Curtis, author of *Flora Londinensis* . . . who had it in contemplation to publish a work on the same subject of which they were to have formed a part." The parts were eventually bound into three volumes, dated 1811, 1813, and 1821, each with forty-eight hand-colored etchings. All of the plates were meticulously signed and the exact date of publication was given in a footnote. The parts were initially priced at 5s. each. This large sum no doubt proved detrimental to sales, and it was reduced to 2s. 6d. each. It was possible to buy the book with uncolored or hand-colored plates, the more expensive plates in the colored edition putting the price of the complete book up to £7 17s. 6d.

The drawings for Graves's plates were gathered from various sources. Some, as his advertisement described, were already at hand, among them the common merganser (*Mergus merganser*) and common goldeneye (*Bucephala clangula*). Many of the Curtis drawings that he inherited were the work of Sydenham Edwards, who drew for Curtis from 1798 onward. He had done nearly all the drawings for the *Botanical Magazine*, a large proportion of those for *Flora Londinensis*, and many animals and birds in watercolors. His work may be seen at the British Museum, Kew, and the Victoria and Albert Museum. Three other signatures appear on Graves's plates. Two were etchers who signed only their last names: Weddell (in vol. 3: eagle owl [*Bubo bubo*], long-eared owl [*Asio otus*], and black-crowned night heron [*Nycticorax nycticorax*]), of whom nothing further is known except that he also etched some botanical plates, and Warner. This may well have been the I. Warner who did the plates in Andrew Tucker's *Ornithologia Danmonensis* of 1809. Warner was the signatory in volume 2 to a pied flycatcher (*Ficedula hypoleuca*), a capercaillie (*Tetrao urogallus*), a black-headed gull (*Larus*

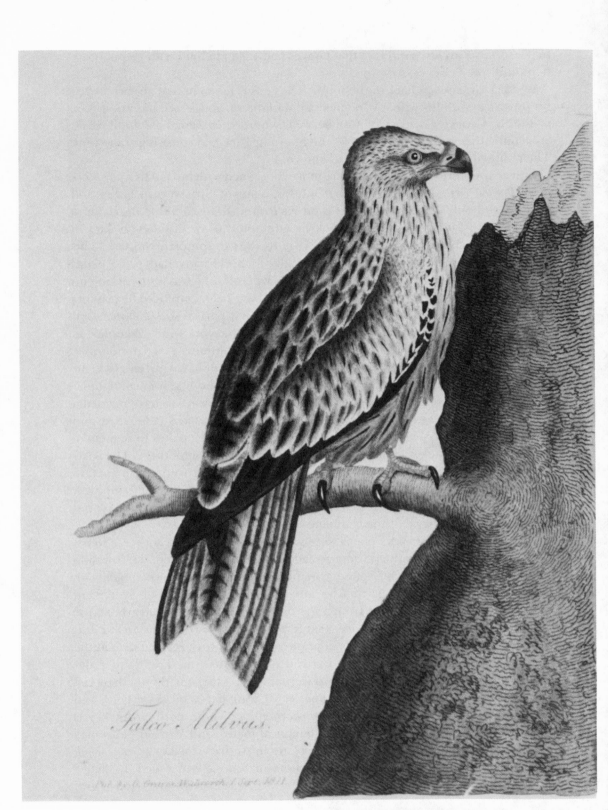

Falco Milvus.

58 / George Graves etched this picture of the red kite (*Milvus milvus*), had it printed very lightly with brownish ink, and then hand-colored the plate. The result is a softness of feathering not seen in sharply etched plates. The picture was published in his *British Ornithology* (vol. 1).

ridibundus), a black-winged stilt (*Himantopus himantopus*), a redshank (*Tringa totanus*), a common tern (*Sterna hirundo*), and a spoonbill (*Platalea leucorodia;* Figure 59). Graves mentions that a pair of spoonbills were kept for some years in the famous garden of rare plants at Belmont House, Vauxhall, the home of Colonel E. J. A. Woodford, hence their availability for drawing.

William Samuel Howitt's contributions included a common snipe (*Capella gallinago;* Figure 60), a pheasant (*Phasianus colchicus*), a long-tailed tit (*Aegithalos caudatus*), a little egret (*Egretta garzetta,* drawn from the specimen in Bullock's Museum), and a short-eared owl (*Asio flammeus*). Howitt, a self-taught painter in oils and watercolors, confined himself to sporting subjects and illustrations of natural history. His bird portraits were very carefully drawn and quite vivacious. He was also a fine etcher and the author of a number of illustrated books depicting animals. He did some illustrations for the catalogues of Bullock's Museum when it was in Liverpool, and later when it was taken to London.

Quite frequently Graves writes in the text of *British Ornithology,* "We are indebted for our figure . . . to Mr Bullock of the London Museum"; for the pratincole (*Glareola pratincola*), for example, and the snowy owl (*Nyctea scandiaca*), shot on the Isle of Unst. William Bullock was a jeweler and silversmith by trade, and a very successful businessman. He owned mines in Mexico, and on visits there in 1822 and 1827 he collected a variety of natural history items. Apart from valuable Mexican bird skins, he also acquired Australian birds from collectors soon after that country's colonization. Captain Cook and Sir Joseph Banks, among others, presented him with specimens from the South Seas, and he obtained African birds from collectors when they returned to England. He started gathering his curiosities together in the 1790s and published the first of a long series of catalogues of his museum in Liverpool in 1799. He enlarged the collection considerably by buying many lots when similar museums were dispersed, including that of Sir Ashton Lever. Rare British birds acquired in this way became the source for illustrations in many contemporary bird books.

The museum was such a success in Liverpool that Bullock determined to try to make an even greater profit from it by moving it to London. He opened it to the public at 22 Piccadilly in 1805. Seven years later a large hall, built as a museum and exhibition hall by the architect Peter Frederick Robinson, was erected for Bullock at a cost of £16,000. This building was known as the Egyptian Hall for its architectural style; the sides were inscribed with hieroglyphics. The museum did a brisk business and was still flourishing when Bullock decided to auction it himself. The sale of the 2,248 lots realized £9,974.

Graves was living at Walworth, in south London, while he published the first two volumes of *British Ornithology,* and had ready access, for a one-shilling admission fee, to Bullock's collection during the years 1805–19. Graves was able to get examples of rock ptarmigan (*Lagopus mutus*) in their different plumage phases from both Bullock and his friend Arthur Harrison of Parliament Street, whose specimens of birds Latham also used. Arthur Harrison was a dealer in natural

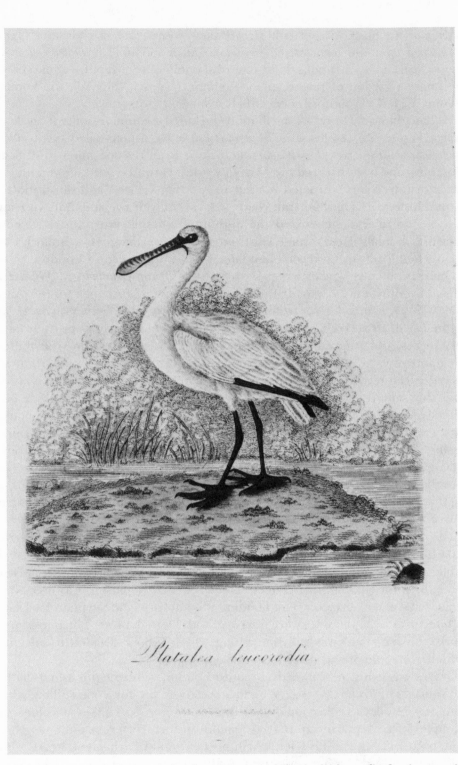

Platalea leucorodia

59 / I. Warner etched Graves's drawing of the spoonbill (*Platalea leucorodia*) for the second volume of *British Ornithology*.

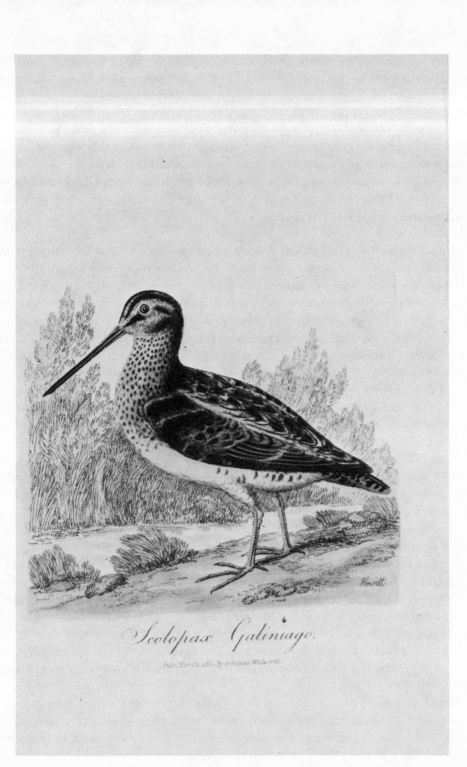

60 / William Samuel Howitt etched the figure of the common snipe for Graves's *British Ornithology* (vol. 2). This species is the *Capella gallinago* of America, *Gallinago gallinago* of Britain.

history specimens. Benjamin Leadbeater, another dealer of Brewer Street, who was the supplier to the British Museum for many years, gave Graves assistance with the skin of a "wood grous" or capercaillie (*Tetrao urogallus*).

Some of Graves's bird illustrations are very similar to those in Edward Donovan's *Natural History of British Birds,* published between 1794 and 1819. So few specimens of the rarer species were available for copying that the same specimens were used by a number of artists. In consequence, their drawings depict the species in identical positions and states of plumage. Both Graves and Donovan may well have used the Lever Museum specimens, Graves while they were on view in London and Donovan after he purchased 500 lots at the sale of 1806. Similarly they both used Bullock's museum.

The Leadenhall Market was always worth a visit by ornithologists for the unusual and rare birds that turned up on its poultry stalls. Apart from the birds taken in the fens, there were, particularly in severe winters, large supplies of wild ducks from Holland, woodcocks (*Scolopax rusticola*) and snipe (*Gallinago* spp.) from Ireland, pigeons from France, and black cocks (*Lyrurus tetrix*) from Scotland. This market, in Gracechurch Street, also had live animals for sale, and cage birds. Graves frequented the market and found some birds he required for *British Ornithology* there. In the section dealing with the red-breasted merganser (*Mergus serrator;* Figure 61) he said, "During the last winter we procured three birds, two males and one female, at Leadenhall Market; and we purchased one male bird of a man who was retailing poultry in the streets, and had this and two or three fine Sheldrakes to dispose of as Wild Ducks." The shelduck (*Tadorna tadorna*) is fairly numerous in Britain. Another species that he found at Leadenhall was "*Scolopax lapponica* a Red Godwit," which "had been sent with other fen birds from the fens of Ely." Graves continued, "The only specimen we have been so fortunate as to meet with live we shot on Riegate Heath, Surrey." This was in November 1816, and the specimen is the bird we now call *Limosa lapponica*, the bar-tailed godwit.

Graves owned a live brant goose (*Branta bernicla*) for some time, but it did not inspire him to make a very lively drawing of this species. Nevertheless, some of his figures show a determined effort to break away from the stiff portraits of the eighteenth century. A barn swallow (*Hirundo rustica*), for example, is shown in lively flight chasing a fly. An occasional bird is seen to be tentatively stretching a wing or gingerly taking a step forward. Though his birds are always recognizable, frequently inaccurate proportions detract from the good impression made by the livelier figures.

One bird per plate is the general rule. Birds exceeding 7 inches in length were "given of half their natural size." The bird, the male of the species, stands on a sawn-off log with some scenery sketched in the foreground and background. The coloring of the plates is not gaudy, and many of them are quite delightful illustrations for their period. Graves began coloring the plates, not completely, but working to a very odd system of selective coloration, described in his preface: "Colours are at least but indifferent guides in distinguishing the species from

Mergus serrator.

Pub. by B. Graves Dec. 1, 1821

61 / The male red-breasted merganser (*Mergus serrator*) etched by Graves on 1 December 1821 and included in the third volume of his *British Ornithology*. Graves had obtained this specimen from the Leadenhall Market.

change of season, climate, and food, all having a share in producing a change of colour. The author has deviated therefore from the general practice of giving only as marks of specific distinction such characteristics in the bill, legs or any other parts (not liable to be affected by the above causes) as will clearly point out the species." He showed only a few signs of keeping to this method of coloring the birds in the first few plates. This method of coloring is seen in the picture of a blue tit (*Parus caeruleus*), where a pale wash has been applied all over the body, with only the blue, black, and white areas clearly defined and colored, the back and underparts left unpainted save for the pale wash of color. In view of Graves's explanation of his unusual method of coloring, his title claiming "accurately coloured representation of every known species of British birds" is misleading, to say the least.

Of the text little need be said. It was short, giving a verbal description of each species with little additional information, and added nothing new. The length of the bird was stated, which was just as well, for Graves did not consistently maintain his declared intention of etching birds more than 7 inches in length "half their natural size."

British Ornithology met with sufficient success to induce Graves to commence a second edition in 1821, of which two volumes appeared. He was his own publisher of *British Ornithology* and also of a rare companion volume, *Ovarium Britannicum*, with fifteen hand-colored plates, dated 1816. The fifty figures included some eggs of domesticated birds as well as wild species.

From his childhood Graves was used to seeing the processes involved in publishing. As book production was familiar to him, he became competent on the technical side of the business. Unfortunately, he lacked the discipline and expertise required of a writer and editor, and his own books were disorganized. The unnumbered pages and plates were in no systematic order. His work is of value for the pleasing illustrations, which demonstrate his technical skills and sense of artistic design. His etched plates are notable for their softness and considerable charm. Though not widely known or praised, they form an interesting link between the old-style illustrations of the eighteenth century and the better figures of the nineteenth century.

Books Illustrated by George Graves

Graves, George. *British Ornithology, Being the History of British Birds with an Accurately Coloured Representation of Every Known Species of British Birds*. 3 vols. London, 1811–21. 144 plates (most copies colored, a few uncolored).
 Artists: George Graves, William Samuel Howitt, Sydenham Teak Edwards.
 Etchers: George Graves, William Samuel Howitt, Weddell (3 in vol. 3), I. Warner (7 in vol. 2).
 Colorer: George Graves.
———. *The Naturalist's Pocket Book*. London, 1817. Birds, pp. 58–138. Two bird plates: Book 1, Plate 1, depicting heads, showing the beaks of 15 species; Plate 2, depicting the feet of 13 species.

14

Prideaux John Selby

(1788–1867)

Prideaux John Selby was a landowner and squire with ample leisure to observe the animals, birds, insects, and fish on his property and in the beautiful surrounding Northumbrian countryside. He was a keen sportsman, equally good with rod and gun. He was born in Bondgate at Alnwick, on 23 July 1788. A year later his father, George Selby of Beal, purchased the 643-acre estate of Twizell House, three miles south of Belford in Northumberland, for him. He was educated at Durham School and then stayed the usual terms at University College, Oxford, as a gentleman commoner. When his father died, in 1804, he became the owner of Twizell House.

After college, he spent his time in running the estate and carrying out the duties expected of a country gentleman. He was a magistrate, deputy lieutenant, and high sheriff of Northumberland. After these duties were done, for his own interest he enthusiastically supported a number of natural history societies and contributed many articles to their journals. In 1832 he became a member of the Berwickshire Naturalists' Field Club, which had been instituted the previous September by his close friend Dr. George Johnston, who was three times mayor of Berwick-upon-Tweed and a keen naturalist. Selby was elected a fellow of the Royal Society of Edinburgh and of the Linnean Society of London, and when he traveled to London to attend the meetings, he enjoyed the companionship of many friends. He kept a scholarly record of the habits and lives of birds and insects that he saw in the field. For his work and his publications on these

subjects he was granted an honorary M.A. at Durham in 1839. He also became very interested in arboriculture and botany, and planted his extensive grounds at Twizell with specimen trees and conifers. His *History of British Trees,* published in 1842, gave detailed accounts of all the native British species. It was illustrated with nearly two hundred engravings, many after pencil drawings done by Selby, and included the results of thirty years' experience in planting and caring for the trees at Twizell.

In December 1810 he married Lewis Tabitha Mitford, the second daughter of Bertram and Tabitha Mitford, who resided at Mitford Hall, a stately stone mansion almost encircled by the river Wansbeck, near Morpeth, Northumberland. He was on good terms with his in-laws, who shared his tastes and background. The Selbys' three daughters were born at Twizell House, and he continued to live there until his death in 1867.

Selby's interest in birds had been in evidence from an early age. As a schoolboy he had compiled careful notes on the lives of the birds in his native county, supplemented with sensitively colored drawings. He enjoyed hunting and shooting and made a large collection of bird skins. He was fortunate in having a butler who was a skilled taxidermist, and Selby also learned how to set up birds and preserve them, trying out different methods recommended in journals, with varying success. These specimens were to be the models for his illustrations in one of the most beautiful atlases of British birds which has ever been published.

Selby's *Illustrations of British Ornithology,* dedicated to the Wernerian Natural History Society of Edinburgh, was issued in nineteen parts over thirteen years. There was no text printed along with the 89 plates of land birds, usually collected into one volume, or the 129 plates of water birds bound up in a second volume, with an additional four plates showing anatomical details. A subscription to the *Illustrations* cost £105. As usual, there were various issues, uncolored and colored, one on India paper, and so on. William Swainson reported at the time that Selby was the exclusive author of "the most splendid and costly work yet published on the birds of Great Britain."[1] The plates, of elephant folio size (27″ by 21-1/2″), showed most of the birds in their full size. This was the second attempt to portray all birds known to be British in life-size illustrations (Pennant's was the first); only the very largest species were reduced in scale. Both sexes were shown on a single plate when their plumage differed, only one member of the pair when the plumage was similar. Sometimes the male and female occupied separate plates (e.g., the bustards) and occasionally more than one small species was depicted on one plate.

Selby etched his drawings on copper plates and then either took or sent the plates to William Home Lizars in Edinburgh. Either Lizars himself or one of his workmen took a pull from Selby's plate and worked on any parts necessary to bring the plate to a very fine state of completion. Selby and Sir William Jardine both purchased their copper plates and etching ground from Pontifex of London, and their letters refer to the progress made in drawing and "biting" or

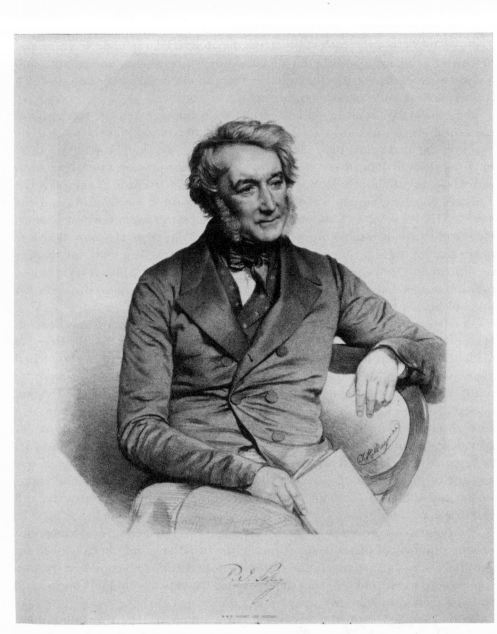

62 / T. H. Maguire's portrait of Prideaux John Selby.

etching their plates. If they made a mistake or accidentally overetched a plate, they relied on Lizars to correct it by burnishing to lighten it.

The copper plates were superbly executed and the monochrome printed plates have an austere beauty unmatched in other bird books illustrated by line. Every feather is clearly visible, with all the details of the large flight feathers and the softer plumage standing out in immaculate precision. Tone, shade, and texture were all exploited to the fullest extent and demonstrate the best of which copper etching and engraving were capable.

The coloring is usually good and attractive. Some plants in the foreground, tree trunks, rocks, and so on were painted with watercolors. This work was done by a very talented young man named Daniel McNee, who had been apprenticed for four years to John Knox of Glasgow, a landscape painter. On taking a job with Lizars in Edinburgh, McNee took the opportunity to enroll as a pupil at the Trustees' Academy, and he was elected a member of the Royal Scottish Academy in 1829. He returned to Glasgow in 1832 and thereafter was a portrait painter. He became president of the Royal Scottish Academy in 1876. He colored Selby's plates during the short time he was in Edinburgh at the beginning of his successful career. He cannot have done all of Selby's coloring, however, for the coloring varies considerably in quality. Lizars doubtless employed others for some of Selby's plates.

On sixteen of the plates Captain Robert Mitford's clear signature may be seen. He was Mrs. Selby's favorite brother, and later rose to be Admiral of the Red. He made drawings first for Selby, later also for Jardine, and sometimes also etched the plates, having learned this art from Thomas Bewick. He accompanied the two friends on shooting and fishing expeditions and was regarded with affection by both. Selby poked gentle fun at "the Captain," as they always called him, in a letter to Jardine dated January 1830. "The Captain is still with us, he has been at a small sea-piece for the last fortnight, but it is no further advanced than when he began, the sea has been painted I believe 15 times."[2] Mitford's "sea-piece" was just one of many paintings he did. All three friends worked in oils and watercolors, and exhibited paintings in art exhibitions at Edinburgh, Newcastle, and Dumfries.

The *Illustrations* proved so popular that they were reissued several times with varying numbers of plates. Many copies of the book have since been broken up and the plates sold separately for framing, so that complete copies of the two volumes are scarce and now very highly valued. A copy was sold in London at a Sotheby auction in February 1984 for £15,500.

About 1819 Selby issued a separate quarto volume of letterpress describing the land birds, but very few copies were printed. The volume was reissued in octavo in 1825, and a text describing the water birds appeared in 1833. By issuing the text separately, Selby avoided having to deposit copies of the expensive plates at the Stationer's Office. He deposited the required eleven copies of the text in order to secure copyright on it. Lizars advised Audubon to

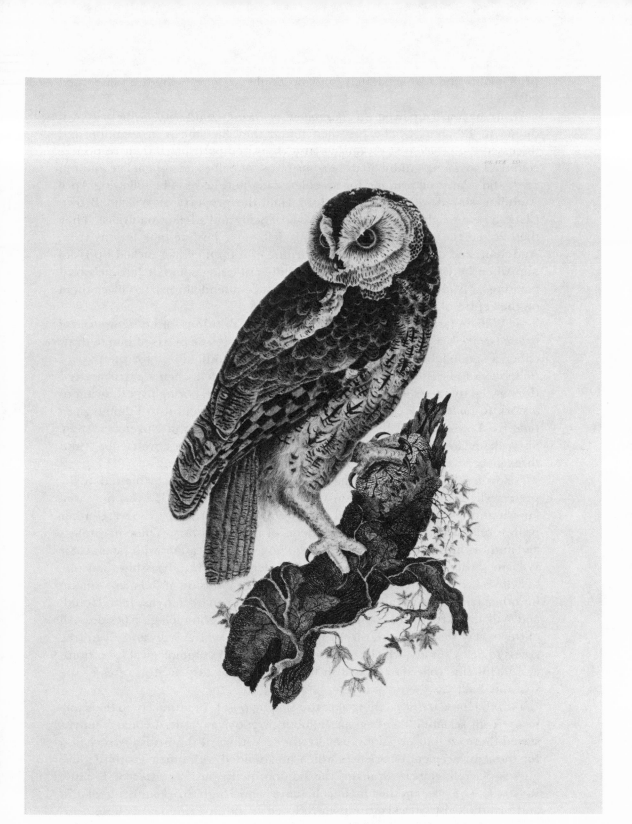

63 / Prideaux John Selby's superb etching of a tawny owl (*Strix aluco*) for Plate 25 of his *Illustrations of British Ornithology.*
The owls are among the best of Selby's beautiful etchings, on plates measuring 27″ by 21½″.

print plates and text separately, and no doubt he gave Selby the same good advice.

While he was employed on *Illustrations of British Ornithology*, Selby met Audubon in Edinburgh. The two men found they had much in common and discussed the problem of producing large, life-sized portraits of their respective countries' avifauna. Audubon drew some birds for Selby and also, in late autumn 1826, did a large oil painting for his eldest daughter, Lewis. The following April Audubon stayed with Selby at Belford Hall, the property of William Brown Clark, a near neighbor and brother-in-law of Selby and a fellow naturalist. They then visited the Mitfords together. Both Selby and Jardine took lessons from Audubon, and Selby later reminded Jardine of a tip they had picked up from him when he wrote in February 1827 mildly criticizing some of Jardine's bird paintings: "Audubon's great maxim also must be attended to viz: to place them on the centre of gravity."[3]

Sir William Jardine helped Selby with about five drawings for his *Illustrations of British Ornithology*. At the beginning of September 1829 Selby asked him to draw either a spoonbill or a stork "as large as the paper will allow" for the part of *Illustrations* to be issued in November.[4] He was delighted when a parcel arrived (forwarded by Lizars, who transmitted all their packages) bringing a drawing of a stork (*Ciconic ciconia*). Selby etched this drawing and sent it to Edinburgh in time for Lizars to print the eighth part of the *Illustrations* in November 1829. Sir William later helped Selby with the drawings of an "egret Egretta alba"[5] and three jaegers: *Stercorarius longicaudus, S. parasiticus, S. pomarinus*.

Following the publication of this work, which he did mainly by himself, Selby preferred to work in conjunction with other ornithologists. He was now well known and greatly respected, and had a wide circle of friends who were either professional scientists or amateur students of natural history. These naturalists and authors he pursuaded to contribute to his joint publications with Jardine. Sir William Jardine, the seventh baronet of Applegirth, in Dumfriesshire, was one of Selby's two closest friends; the other was George Johnston of Berwick. Among his other friends he numbered the ornithologists Leonard Jenyns, John Gould, and William Yarrell, and many eminent botanists and entomologists besides. All of them were welcomed to Twizell by a very hospitable Mrs. Selby and given free access to Selby's study, which contained his books and entomological collections, and to his fine collection of British birds, which was displayed in cases in the spacious hall.

Twizell House was something akin to a staging post for naturalists on their way to or from scientific meetings in Edinburgh and Newcastle. Leonard Jenyns stayed there on four occasions, usually after meetings of the British Association for the Advancement of Science, which he attended with other Twizell House guests: Yarrell; Robert Graham, the Edinburgh Regius Professor of Botany; Robert K. Greville, another famous botanist; and Hugh Strickland, a geologist and ornithologist. Strickland was introduced to Jardine on one of these occa-

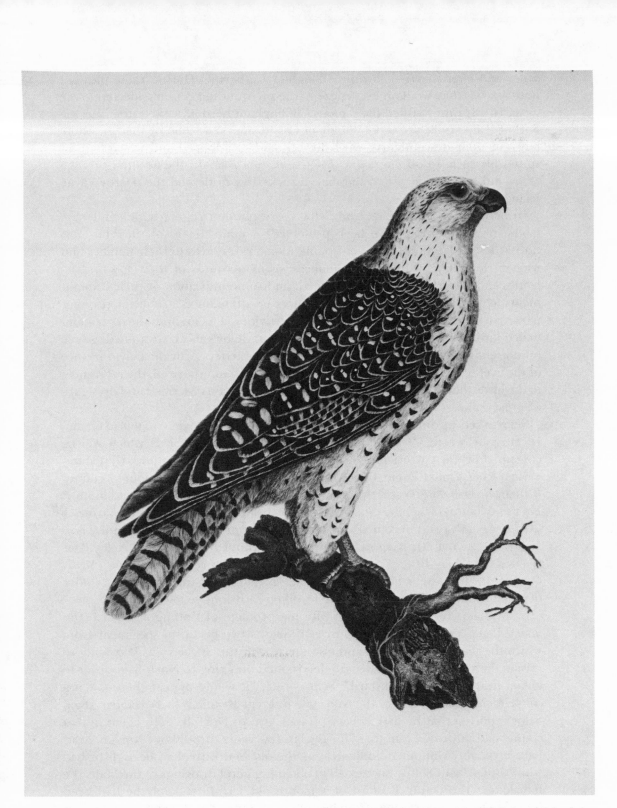

64 / The jerfalcon or gyrfalcon (*Falco rusticolus*) from Iceland, drawn by Captain (later Admiral) Robert Mitford, for Selby's *Illustrations of British Ornithology*, Plate 14, from a specimen in the collection of Joseph Sabine.

sions, and later married Jardine's daughter Catherine. During these pleasant houseparties they went on excursions in the surrounding countryside and to the coast. In 1834 they visited the famous Chillingham herd of white cattle near the Earl of Tankerville's seat, Chillingham Castle, and saw some of the fine white bulls (or their descendants) which Bewick had so admired and which had inspired his large wood engraving *The Chillingham Bull*. In the autumn of 1838 Selby and his friends visited Bamburgh rocks and castle and the nearby Farne Islands.

In between visits, Jardine and Selby corresponded regularly. Their letters (about three hundred have been preserved) contain details of their business transactions relating to their joint publications; references to their families and wide circle of friends and acquaintances; many accounts of their sporting activities and the specimens they obtained; and some indication of their commitments as public figures in their references to attendance at quarter sessions, participation in elections, and other public activities. Throughout the correspondence Jardine's sense of humor is very evident; Selby's more restrained, gentle humor enlivens the shorter letters he wrote. The letters provide a vivid picture of the lives of these two naturalists and country squires. Above all, the references to the birds that they shot, purchased, or were lent, then described and drew, are of great value.

Selby asked Jardine to help him locate birds that he had been unable to obtain. In 1824 he wrote, "I have now got drawings of all the birds which will be contained in the 1st series, with the exception of the Red Goshawk (F. Palumbarius) Ring Tailed Eagle, Great Bustard (Otis Tarda) cream coloured runner (Cursorius Isabellinus) and the Mountain Linnet or Twite (Fringilla montium)." He was delighted when he quickly received a beautiful specimen of the goshawk (*Accipiter gentilis*) and in return sent Jardine a specimen of an Iceland gull (*Larus glaucoides*), saying, "It is set up by myself . . . without Body Wines."[6] Selby later realized that his "Ring Tailed Eagle" was an immature golden eagle (*Aquila chrysaetos*). The twite is now called *Acanthis flavirostris,* a name that is descriptive of its outstanding diagnostic feature in winter, a bright-yellow bill.

Sir William could not assist him with the problem of finding a bustard (*Otis tarda*). Later letters reveal the sources of Selby's two beautiful specimens from which the plates were drawn and also the reason this species was becoming so rare in the 1820s. "I have at length determined on going to Norfolk in order to obtain drawings of the Bustard," Selby wrote, "it would appear there is not a single *Male Bustard* alive in the wild state in great Britain." In December 1824, Selby reported that he had "a very pleasant trip to Norfolk." His agent in that county had informed him that "for the last few years throughout Norfolk nests have invariably contained addled eggs—the old hen Birds had been disturbed while sitting." But Selby "succeeded in obtaining good drawings of the Male, the female and the young Bustard of 1 month old." Unfortunately he had been forced to make his drawings from birds in confinement and dried specimens, as

he "had not the satisfaction . . . of seeing them in the wild state."[7] He worked on the two plates of the great bustard (*Otis tarda;* Figure 65) for a fortnight after his return home before he was fully satisfied with them.

Selby was a painstaking artist in both watercolors and oils. He sent some of his paintings to Edinburgh exhibitions, and he always tried to visit the art exhibits there during his annual visits. He and Jardine were elected honorary members of the Royal Scottish Academy in 1827. Selby's letters mention an oil painting of an eagle; another of his two dogs, Dick and Bill, with dead game; and a third painting called *Pastor and Starling,* which he presented to Jardine at the conclusion of the 1828 Edinburgh exhibition.

On a visit to Jardine Hall in 1825 Selby discussed with Jardine the idea of a joint publication describing and illustrating foreign bird species. Though this was to be Jardine's first publishing venture, he did most of the organizing work while Selby played a minor role. Between 1826 and 1843 they produced four quarto volumes of *Illustrations of Ornithology.* Though its title was similar to that of Selby's first book, it differed from the earlier work in its inclusion of very few British birds and the presence of many foreign species that were rare or new to science. The drawings were executed by many artists, and the printing was done by Lizars. Both Selby and Jardine worked hard on the drawings, text, and plates, but only thirty-five plates give a clear indication that they were executed by Selby. Many others are so obviously in his style, however, that he must have either drawn or etched them and omitted to initial them. The letters between Jardine and Selby reveal that Selby worked on twenty-nine plates in the first series alone. Jardine and Selby etched some of the plates, but when they ran short of time they sent the drawings straight to Edinburgh so that one of Lizars' engravers could transfer them to copper plates.

Selby also helped Sir William with two volumes in Jardine's Naturalist's Library series. He prepared the text for *Pigeons* in 1835 and for *Parrots* the following year. Selby's text was illustrated by Edward Lear, who prepared some parrot drawings expressly for this work. In May 1834 Jardine was able to tell Selby, "We have got some remarkably beautiful parrots from Lear."[8] Selby's text covered a short history of the family of the birds, synonyms, and a description of each species with its habits and distribution. The fourth volume of this series contains four plates signed by Selby, depicting a gray partridge (*Perdix perdix*), a red grouse or willow ptarmigan (*Lagopus lagopus scoticus*), a rock ptarmigan (*Lagopus mutus*) in winter, and a male black grouse (*Lyrurus tetrix*).

As he grew older, Selby maintained his lively interest in his favorite pursuits, entomology and ornithology, but his growing family left him with less time to enjoy them. Lewis Tabitha's death in 1859 deprived him of a very loyal and loving wife who had helped make his home a center of comfort and happiness for forty-eight years. He died on 27 March 1867, after a short illness, and was buried in Bamburgh churchyard. He had been a regular worshiper at Bamburgh church for many years and throughout his life had preserved a firm faith.

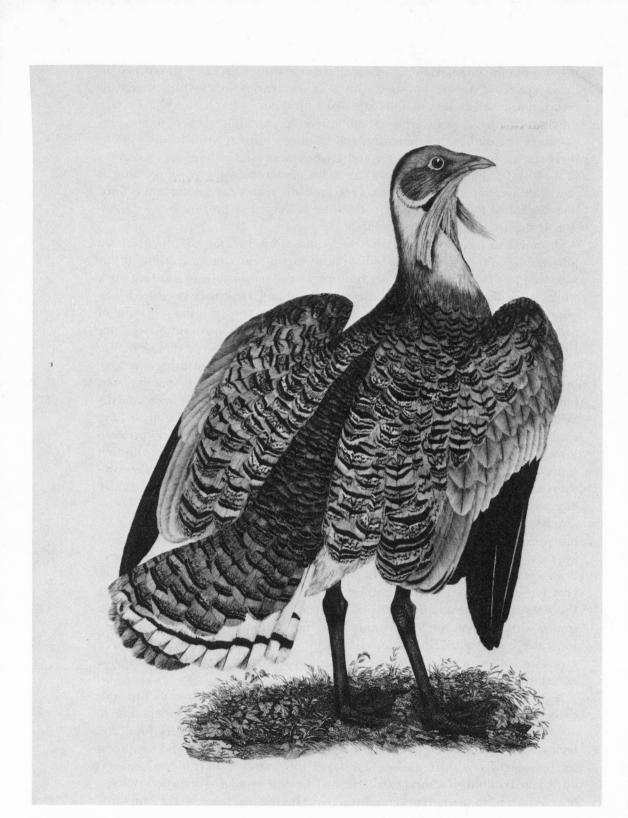

65 / The male great bustard (*Otis tarda*) which Selby drew in Norfolk from a specimen belonging to the Reverend Robert Hamond of Swaffham, Plate 64 of *Illustrations of British Ornithology*.

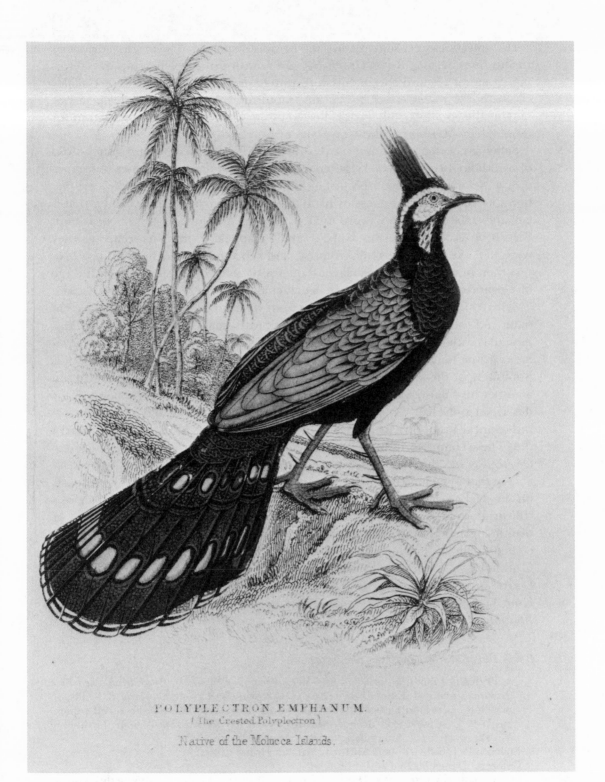

POLYPLECTRON EMPHANUM.
(The Crested Polyplectron)

Native of the Molucca Islands.

66 / One of the few plates in Jardine's Naturalist's Library volumes for which Selby did the drawing. The Palawan peacock pheasant or crested polyplectron (*Polyplectron emphanum*) appeared on p. 159 of *Gallinaceous Birds*, published in 1836.

His collections were sold in 1885 and became dispersed. The original drawings for his *Illustrations of British Ornithology* are now in private ownership in California. Some of his bird specimens were purchased by A. H. Browne of Callaley Castle, but were neglected and became motheaten. Many other bird specimens, notably the South African birds collected by Sir Andrew Smith, were secured for the Zoology Museum of the University of Cambridge.

Selby has been quite undeservedly and unfairly neglected by later generations of ornithologists. He was very gifted as an artist, and the two volumes of *Illustrations of British Ornithology* are outstandingly beautiful. In many people's estimation, the clarity and crispness of his figures give them an austere beauty that is lacking in the pretty lithographs in H. L. Meyer's and John Gould's books about British birds. Gould's plates had far greater appeal to the Victorians, as they were well executed, cheerfully colored, and reproduced by lithography, a process then in vogue. The cool, classical quality of Selby's plates belongs to the age of elegance and could never have been achieved by the Victorian John Gould.

Selby's bird figures were the most accurate delineations of British birds to that date, and the liveliest. After so many books with small, stiff bird portraits, this new atlas with its life-size figures and more relaxed drawing was a great achievement in the long history of bird illustration. It was unfortunate that Selby was publishing at the same time as Audubon, whose magnificent aquatints eclipsed all other bird illustrations of the period in both size and dramatic quality. Selby described only half as many species as Audubon, and he did not make ornithological history by including scores of new species, as the American artist did. These comparisons need not influence us today. Selby's *Illustrations of British Ornithology* was the finest and largest book about British birds and was remarkable in that it demonstrated copperplate work at its very best when this craft was on the decline. Hugh Strickland said of Selby's work, "The plates of Mr Selby's 'Illustrations of British Ornithology' are certainly the finest examples extant of ornithological etchings, though they are nearly equalled by some of the plates etched by Sir W. Jardine, Mr Selby and Captain Mitford in the 'Illustrations of Ornithology'."[9] Much credit is also due to the engravers and printers in W. H. Lizars' firm, who went on to issue other bird books with illustrations printed from both steel and copper plates, but never surpassed the work done for *Illustrations of British Ornithology*.

Books Illustrated by Prideaux John Selby

Selby, Prideaux John. *Illustrations of British Ornithology, or Figures of British Birds Their Full Natural Size.* 2 vols. Edinburgh, 1821–34. 218 plates and 4 with anatomical details, of which 89 were land birds and 129 water birds. Uncolored and hand-colored copies.
 Artists: P. J. Selby, c. 200; Robert Mitford, 16 clearly signed; Sir William Jardine, 5 (stork; egret; arctic, longtailed, and pomarine jaegers).
 Etchers: P. J. Selby; Robert Mitford; William Home Lizars.
 Colorers: Daniel McNee and others.
 Many reissues; 2d ed., 1833; Henry Bohn issue of 1841 with title-page vignette colored.

Jardine, Sir William. *Gallinaceous Birds*. Naturalist's Library, Ornithology, vol. 4. Edinburgh, 1834. 31 plates.
 Artist: P. J. Selby (4 signed plates).

——— and P. J. Selby. *Illustrations of Ornithology*. 4 vols. Edinburgh, 1826–43. 207 plates.
 Selby signatures as artist: vol. 1, 4; vol. 2, 16; vol. 3, 6; vol. 4, 9.

15

Sir William Jardine

(1800–1874)

S IR WILLIAM JARDINE was similar in many ways to his close friend P. J. Selby. He succeeded to his father's estate at an early age and accepted the responsibilities as well as the privileges that his position in society gave him. He was born in Edinburgh on 23 February 1800 and was educated in Scotland and then at York, where his father sent him "to learn English." In 1817 he entered the University of Edinburgh, where he attended both medical and literature classes and studied natural history and geology with Professor Robert Jameson. His tutor in anatomy was John Lizars. Other members of the Lizars family whom he met through John played an important part in his future career. This broad-based curriculum reflected Jardine's wide interests. He was to become a recognized authority on ichthyology; he was a good botanist, entomologist, and geologist as well, and became a keen ornithologist.

There is no record of his having received any drawing instruction, apart from one or two lessons from Audubon with Selby in 1826, but he was capable of drawing and etching his own birds and fishes for book illustrations. He also painted wildlife pictures in oils and watercolors. Jardine was a very keen sportsman and collected many specimens for his private museum at Jardine Hall, Dumfriesshire, a large and imposing house situated about five miles northwest of Lockerbie, by the river Annan. He succeeded his father as seventh baronet of Applegirth in Dumfriesshire in 1820. He was the deputy lieutenant of the county of Dumfries in 1841 and a member of the Royal Commission on Salmon

Fisheries in England and Wales in 1860. He was also a member of the General Assembly of the Church of Scotland for some time in the 1830s. He was regarded as the chief ornithologist in Scotland, and as such was honored as a fellow of the Royal Societies of both Edinburgh and London.

Their healthy outdoor life kept Selby and Jardine active and fit into old age. Jardine had an accident in 1836 which could have seriously altered that state of affairs, but fortunately lived to tell the tale, with his characteristic good humor, in a letter to Selby. "Were you ever run away with?" he asked. It was "bad enough to be going full speed in a gig with the beasts ears on his neck, but to see the reins break is something more exquisite."[1] He caught his foot in the loose harness and was very fortunate to escape with only shock and bruises.

Jardine was most fortunate in his family and friends. His first wife, Jane Home Lizars, was the daughter of Daniel Lizars of Edinburgh, the founder of the firm of engravers. She was also the sister of his tutor, John Lizars, and of William Home Lizars, who engraved, etched, and printed so many of the plates in Jardine's books and magazines. Sir William and Lady Jardine had three sons and four daughters. Catherine, their second daughter, was so competent an artist that she helped her father with his later books. She married Jardine's geologist friend Hugh Edwin Strickland in 1845. Some of her watercolors of birds, dating from 1846 to 1873, are preserved in the British Museum (Natural History).

Jardine was twelve years younger than Selby and initially he was guided and influenced by his older friend. After Jardine's election to the Linnean Society, Selby hoped that Sir William would be encouraged to visit London more often. He looked forward to introducing Jardine to his friends, particularly to General Thomas Hardwicke, the owner of a very valuable set of Indian bird drawings. Jardine later used these drawings for his and Selby's *Illustrations of Ornithology*. Jardine provided the main driving force and organizing talent, and his name appeared first on the title page. The two authors' respective roles in preparing this book, whose nineteen parts were issued between 1826 and 1843, are clearly revealed in their letters. Jardine frequently exhorted Selby to do a drawing or etch a plate, or get one of his friends to do one, and send it to Lizars in Edinburgh. They obtained new and rare birds from friends, collectors, agents, and museums in order to be able to describe the species briefly and illustrate them. The species of birds were mainly of foreign origin, and many were new to science. Jardine and Selby were assisted by William Home Lizars, Jardine's brother-in-law, in the etching of their 207 plates.

George T. Fox's *Synopsis of the Newcastle Museum* (1827) contains a note on the forthcoming work: "Selby and Jardine in their projected Illustrations of Ornithology intend to figure and describe in the first place all the new species which at present lie hid in the collections of this country for which purpose the British Museum, that of the University of Edinburgh, of the Linnean Society and of the East India Company have been liberally thrown open to them." It seems strange to us today that such learned societies and professionally staffed re-

67 / Sir William Jardine, in a photograph in the Royal Scottish Museum, Edinburgh.

positories could still contain undescribed species as late as the nineteenth century, but the influx of new species was great and the number of ornithologists small. Fox was not the only person who had been reached by Jardine's advance publicity campaign. Many other authors and naturalists were aware of his project and requirements, and gave assistance when they could, using the pages of his book to publish their own first descriptions of new species.

Selby and Jardine drew some of the birds themselves. Selby signed his plates so inconspicuously that it is difficult to find his initials tucked away in the grass. He signed at least two plates as both artist and etcher. Jardine's minute initials are also difficult to spot, especially when he forgot to etch them in reverse on the copper plate so that they would print the right way round. They were a very modest pair when it came to signing their own plates, but meticulous in attributing other people's work to its proper source.

Three of their other artists contributed only a single plate each. Alexander F. Rolfe, who exhibited many natural history paintings, usually fishes, at Suffolk Street from 1839 to 1869, drew an attractive Sabine's puff-back shrike (*Dryoscopus sabinii*) for Jardine. Robert Mitford, Selby's brother-in-law, drew and etched the plate of an Alpine accentor (*Prunella collaris*). A plate depicting a Sabine's gull (*Larus sabini*) was signed "Thompson"; this was probably John Thompson, William Yarrell's wood engraver and artist.

James Stewart, a painter who lived at Gillenbie, near Lockerbie, contributed eighteen plates. Jardine and Selby had the use of his drawings until at least 1843. Lizars paid him a guinea a drawing in the 1840s, and he was highly regarded by Jardine, Selby, and Lizars. (He is not to be confused with James Stewart, 1791–1863, an engraver who was elected Royal Scottish Academician in 1829 and emigrated to Cape Colony in 1833.)

Jardine and Selby acknowledged their indebtedness to John Gould for two drawings, a dusky and a white-throated scytalopus, in volume 4. These wrenlike birds of South America, now called tapaculos, have short tails and harsh voices. They are now classified as *Scytalopus magellanicus fuscus* and *Scytalopus indigoticus*, respectively. Jardine's association with Gould commenced soon after Gould took up his appointment at the Zoological Society in 1827. Gould sent Sir William three drawings in September 1830 and charged him £1 16s. for them, saying that they were "the only ones I have been able to get done for you owing to Mrs Gould's being very much indisposed. She is now much better and Mr Vigors has this day looked out several birds to figure for you which shall be done immediately and forwarded to you."[2] Jardine lent birds to Gould (including a beautiful purple heron [*Ardea purpurea*]) for Gould's later books, and promised to get Scottish subscribers for Gould's first book, on Himalayan birds. When Jardine received his copy of the first part of this book in December 1830, it was accompanied by a letter explaining, "It is Mrs Gould's first attempt at stone drawing which I hope you will take into consideration."[3] Perhaps if Lizars had not been his brother-in-law, Jardine would have been tempted to draw his own birds on lithographic stones when he saw Mrs. Gould's charming illustrations.

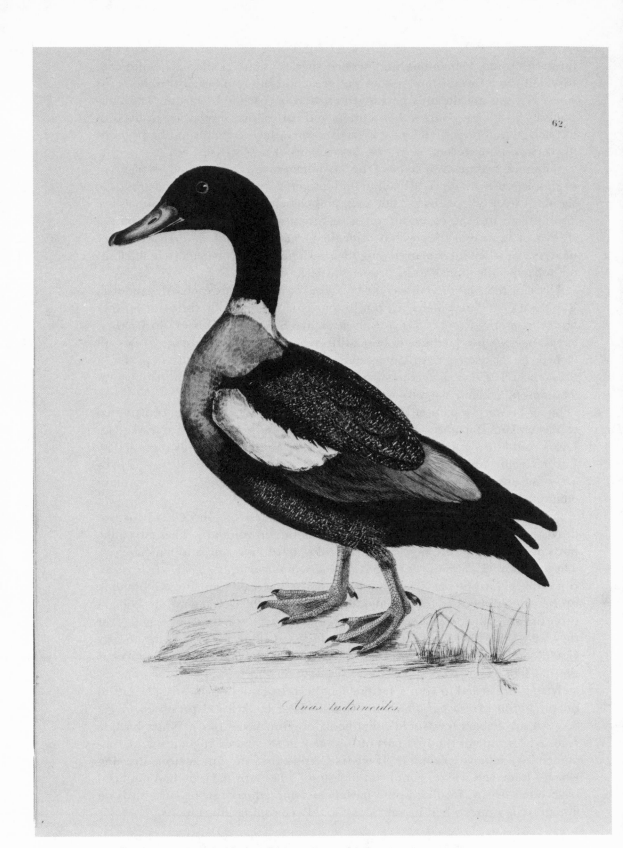

Anas tadornoides

68 /The New Holland (Australian) sheldrake, which Jardine and Selby named *Anas tadornoides* in 1828, when it was new to science. Jardine drew and etched its portrait for the first series of *Illustrations of Ornithology*, Plate 62, and later included it in his *Illustrations of the Duck Tribe*. This species is now called *Tadorna tadornoides*.

It was Gould that arranged for Edward Lear, his assistant in 1835, to do some drawings for Sir William. Lear was very overworked at the time and his drawings were not reproduced until the third volume of *Illustrations of Ornithology* was published. Selby and Jardine greatly admired and appreciated Lear's drawings, and they gave practical expression to their approval by subscribing to Lear's own book, *Parrots*.

Gould stayed a few days at Jardine Hall in August 1837, on his way to "Loch Awe where he is delivered to kill a big trout." Jardine told Selby that Gould had also "been spinning some *Funny tackle* here & with perseverance has killed a few trout. He never saw black game alive before & was delighted. Missed his first shot at an old cock from perfect anxiety. (He is a first rate shot)."[4] The following May, Gould set sail for Australia. Robert Mitford, also a friend of Gould's, met up with him on board one of the men-of-war in which he traveled. No doubt they reminisced about the happy times they had spent shooting and fishing with Jardine and other sportsmen in Dumfriesshire and Northumberland. Jardine remained on good terms with Gould and heard from him at intervals while he was exploring Tasmania and collecting birds in Australia.

The birds included in *Illustrations of Ornithology* came from all over the world, many from countries or regions newly explored. Among the new birds named by Selby and Jardine were *Chlamydera nuchalis,* the great gray bowerbird, which was sent from the Port Darwin district of the Northern Territory of Australia. Bulwer's petrel was another outstanding discovery named by them. The Reverend James Bulwer (1794–1879) had been sketching in Madeira and collecting birds when he came across this bird in 1827 and sent some specimens to Sir William. Jardine and Selby called it *Procellaria bulweri* after the discoverer of the new species, but it is now known as *Bulweria bulwerii,* Bulwer's petrel.

Apart from odd bird skins sent on occasion to Sir William or to Selby, they had their own collectors whom they paid to cover an area more thoroughly and collect systematically. Selby had correspondents in India, but the most successful of their collectors was Dr. (later Sir) Andrew Smith, who was employed in South Africa as an army surgeon but earned additional income from his collecting activities. Jardine reminded Selby of Dr. Smith in September 1827: "I have six months since ordered Dr. Smith to make a complete collection of S. African birds, he is to collect 4 sets of each and they will come under £70 & leave us two spare sets to make what we like."[5] The botanist James Bowie, who died in 1853, was a second source of birds from the Cape. Jardine also bought skins collected in Gambia, Madagascar, and Tobago (where James Kirk was in residence), Egypt and Nubia (where Jardine's friend Dr. A. Leith Adams traveled), and India. Sir William spent a large sum on the purchase of bird skins which numbered 12,000 specimens representing some 6,000 species by the 1870s.

The birds figured in *Illustrations of Ornithology* varied in style but on the whole were accurate representations, if a little lacking in animation. The figures were placed on twigs and branches, but only the bird figures were colored in the

prints intended for subscribers who wanted a colored edition. The coloring was superintended by Patrick Syme, a drawing master and flower painter. He had published his own book, *Treatise on British Song Birds*, in 1823, with fifteen colored plates by Lizars.

Having achieved success with *Illustrations of Ornithology*, Jardine turned his thoughts to providing a popular account of natural history in a succession of small illustrated volumes at a price within reach of all educated people, not just the very wealthy. He again enlisted the help of his friends and acquaintances, and between them they produced forty volumes over the period 1833 to 1846, giving popular accounts of many groups of the vertebrate kingdom. He called this ambitious series the Naturalist's Library, and employed some of the best artists, including Selby, Swainson, Stewart, and Lear, to work on the illustrations for the fourteen volumes dealing with birds. Jardine did some drawings and wrote nine of the bird volumes, including *Hummingbirds; Peacocks, Pheasants, and Turkeys; Gallinaceous Birds; Birds of Great Britain and Ireland;* and *Nectariniadae, or Sunbirds.*

W. H. Lizars did the steel engravings and etchings—more than 4,000 figures in all, distributed over 1,280 plates, of which 446 line illustrations were devoted to birds. The volumes appeared at three-month intervals. Each volume contained a biography of a well-known naturalist in addition to the ornithological matter, and many portraits of these naturalists were engraved by Lizars. For each bird a brief description was given, with its synonym, and some notes on interesting behavior patterns. In the first two bird volumes, about hummingbirds, the colored plates had no backgrounds, just the bird standing on a twig or branch, and only the birds were painted. The other volumes had more detailed settings for the birds, though again, only the figures of the birds were colored. In all of the pocket-sized volumes the engravings were of a very high standard, clearly demonstrating the fine detail that could be obtained only by the use of steel as a material for line illustrations.

William Swainson wrote a volume concerned with flycatchers and a two-volume *Birds of Western Africa*, illustrated with 97 of his own drawings. James Stewart was the main artist for the Naturalist's Library, however, and did a considerable proportion of the plates (177 were signed by him) and much of the coloring of the bird figures. A number of the original watercolor drawings that Stewart prepared for the Naturalist's Library are now in the British Museum (Natural History).

Yet another nature lover was involved in the production of the Naturalist's Library volumes. The texts of nine of the volumes were printed by Patrick Neill, a graduate of Aberdeen University and a fellow of both the Linnean Society and the Royal Society of Edinburgh. Though little known today, he was influential among Scottish naturalists and writers, and was respected by naturalists in England as well. Thomas Bewick made a point of visiting his printing shop in 1823. Bewick had been highly delighted by Neill's collection of tame birds at Canonmills Cottage, his home in a beautifully kept garden in a village just outside

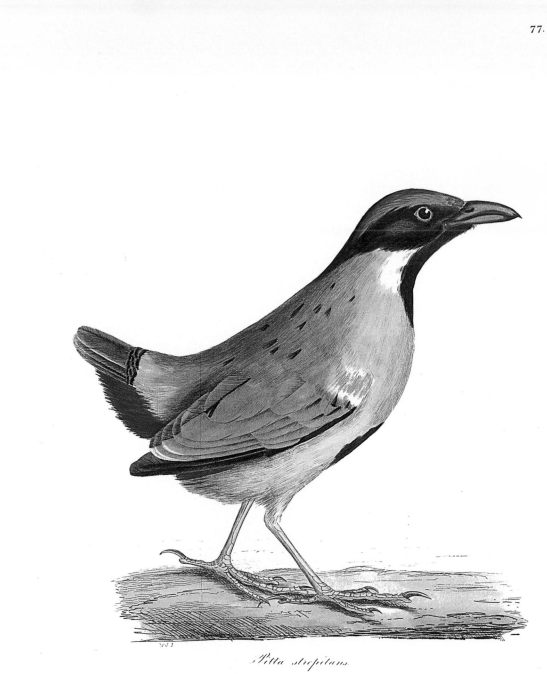

Pitta strepitans.

PLATE 3 / Sir William Jardine's "noisy pitta" (*Pitta strepitans*), from *Illustrations of Ornithology*, vol. 2, Plate 77.

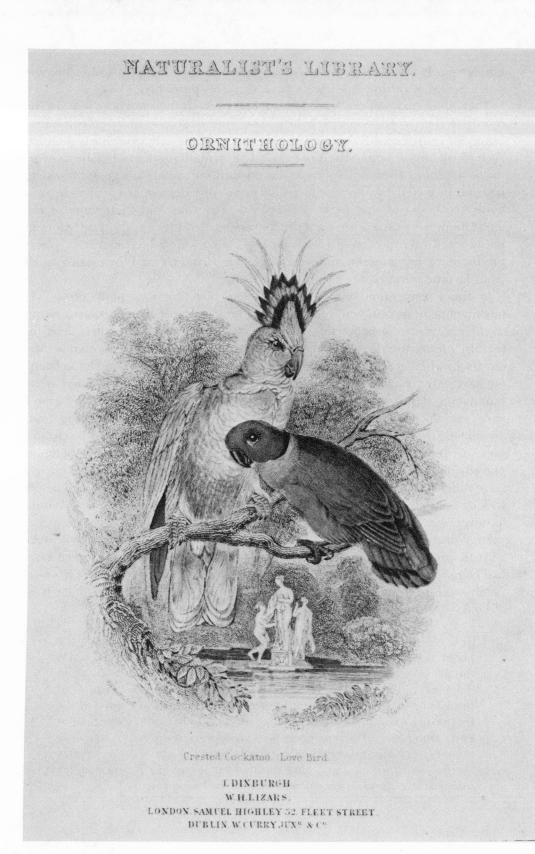

Crested Cockatoo. Love Bird.

EDINBURGH.
W. H. LIZARS.
LONDON. SAMUEL HIGHLEY 32. FLEET STREET.
DUBLIN. W. CURRY JUNᴿ & Cᵒ

69 / James Stewart's title-page vignette for Selby's *Parrots*, in the Naturalist's Library (Ornithology series, vol. 6). The bird species are Leadbeater's cockatoo (*Cacatua leadbeateri*) and black-collared lovebird (*Agapornis swinderniana*).

Edinburgh. It was Neill that put Audubon in touch with Lizars and so became instrumental in getting Audubon's book of plates published.

The little volumes of the Naturalist's Library served their purpose well. In the course of the ten years during which they were issued, knowledge of natural history increased greatly among people who could not otherwise have obtained such instruction. The modest price ("4/6d" is printed on the red cloth spine of the copies in the Graham Watson Collection at Emmanuel College, Cambridge) had encouraged their purchase by readers who were denied the costly zoological illustrated books of that period. There was a reissue, and then some of the illustrations were used again for a similar series called Lloyd's Natural History in the 1890s. To the illustrations from Jardine's work were added some new plates produced by chromolithography, and the engravings that Lloyd had copied from Jardine were colored by chromolithography.

Jardine's fertile mind was never free from plans for new publications, yet more compilations and books to spread the knowledge of the new species being discovered and to provide better pictures of those birds now familiar to scientists. In a letter to Selby dated 15 January 1834, he referred to his own artistic efforts toward a new book: "I have been drawing a great deal upon blocks lately, but have only got a few cut which I shall bring with me—they are intended as the foundation of a Genera Avium which might in time even grow into a *Systema*. I have been working out what little groups I have here with me and making *pencil drawings* of the characters of them, good candlelight work when the bairns are noisey."[6] Jardine was drawing on wood blocks preparatory to having them engraved. With all those new species passing through his hands, and with such a large collection of birds in his own museum, it is not surprising that Jardine was seeking better ways of classifying and grouping bird species. His Genera Avium, however, was destined never to be published.

Sir William was especially fond of ducks, and informed Selby in December 1831 that he would like to write a book entirely devoted to them. Edward Lear had begun to issue parts of the first separately published monograph on a bird family—the parrots—just one year before Jardine contemplated a similar type of book. "I am inclined," he wrote,

> to begin some Great Monograph, taking plenty of time and doing the plates as well as it is possible—the Ducks would make a beautiful work, the plates of a large size the letter press of say royal octavo with wood diagrams of the Genera and different species. I have lately got fond of this group.—They are also interesting from the variety of form and the shapes of young and old.—By sending an order!!! to Gould to lay hold of every thing like a Duck or goose we should very soon get an immense number . . . and at no very great expense for species would decrease after the first great influx and I have no doubt that any one in this country would at once lend us specimens in their possession for use.[7]

Unfortunately, he took too long to put this idea into practice, and Thomas Campbell Eyton, a wealthy Shropshire collector, forestalled him. Eyton's *Monograph of the Anatidae or Duck Tribe* fitted Jardine's description of the ideal monograph on this group. Published in 1838, it had wood-engraved diagrams and large plates, six of them hand-colored lithographs after good drawings by Lear, and eighteen uncolored lithographs. Having had his plan preempted, Jardine must have felt very disconsolate, and his slender quarto volume *Illustrations of the Duck Tribe,* published in the following year, was far from the "Great Monograph" he had wanted to publish.

Jardine wrote to William Yarrell in mid-1837 to tell him that he was contemplating writing a textbook on British avifauna. Yarrell replied, "I am of the opinion that we need not interfere with each other and I hope we shall find room enough for both. It is my intention to paddle my own canoe along my own way, and if possible without jostling or even splashing any one."[8] Jardine's account of British species was spread over four volumes of the Naturalist's Library, published between December 1837 and July 1843. Yarrell's *History of British Birds* was published between 1837 and 1843. A third ornithologist, William MacGillivray, was then also preparing a similar book, which he began to issue at the same time as Yarrell and Jardine (1837–52), under exactly the same title that Yarrell had chosen. MacGillivray was decidedly the loser in the ensuing rivalry for subscribers. Yarrell and Jardine had different markets, and both made a profit.

Sir William Jardine's third major published work on ornithology was another compilation with the assistance of fellow writers and artists. Jardine efficiently organized contributions from abroad, as well as from British authors, in his *Contributions to Ornithology,* published in five volumes from 1848 to 1853. It was a subscription work and appeared somewhat irregularly. If we regard it as a kind of annual progress report on ornithology, then it was the first British periodical devoted entirely to ornithology. This publication is outstanding for the number of eminent contributors and its excellent illustrations.

Among the contributors, Jardine naturally provided much of the material, which dealt with rare birds and their nests and eggs. New species reported included the last bowerbird to be discovered in Australia, the fawn-breasted bowerbird (*Chlamydera cerviniventris*), which John MacGillivray (son of William) found near the tip of Cape York in 1849. T. C. Eyton, who was very interested in anatomy, sent papers to Jardine from 1849 on, and several of his articles dealt with birds' anatomical features. John Gould contributed papers from 1850 on, and Philip Lutley Sclater, who did so much to encourage bird artists in the late nineteenth century, was a contributor in 1851.

Among the continental ornithologists who took an interest in the publication was Gustav Hartlaub, a German authority on West African birds, who sent seven drawings along with his papers. An English authority on Indian birds, Edward

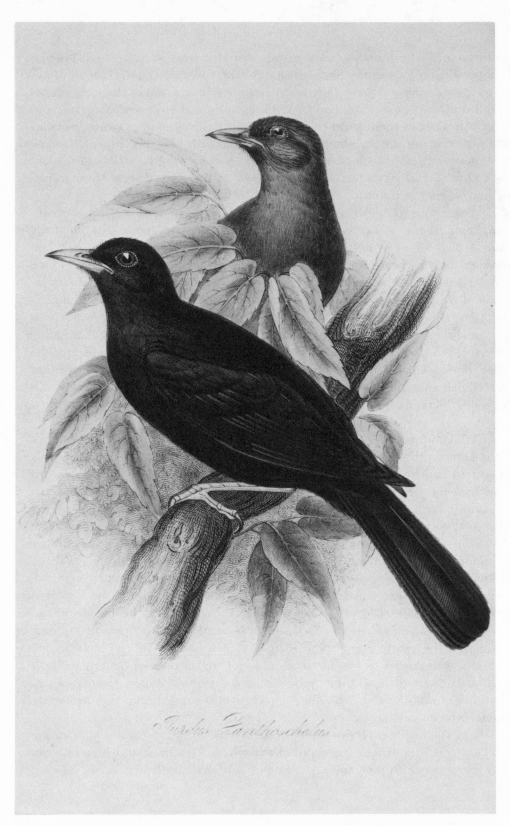

70 / Sir William Jardine's illustration of *Turdus xanthoschelus* (now yellow-legged thrush, *Platycichla flavipes xanthoscelus*), one of the few etched plates in *Contributions to Ornithology* (Plate 1, 1848). Three specimens of this bird were sent to him by James Kirk from Tobago.

Blyth, contributed information on Indian species and drawings of them. The articles contained much interesting and new information on birds from Africa, India, and South America.

Contributions to Ornithology had some of the most beautiful illustrations in any periodical published to that date. The plates were colored by hand after the black outline had been printed either from lithographic, copper, or zinc plates or by the anastatic process (described in Appendix B). Jardine's daughter Catherine, now married to Hugh Strickland, signed about forty of the plates with her initials, C. D. M. S.; hers was the largest contribution of signed drawings. Her birds were charming, accurate portraits. Five of the plates, executed in France by Jean-Charles Chenu and Paul Oudart, illustrated an article on the Parisian ornithological collections. These plates showed South American cotingas and tanagers, all colorful species. Sir William Jardine signed very few plates himself, but it is likely that some of the unsigned plates were drawn by him.

Apart from being an attractive book of scientific and artistic value, *Contributions to Ornithology* is also a most interesting book from a technical point of view. It was the second bird book in which the application of papyrographic printing was demonstrated. Catherine Strickland did the drawings for most of the papyrographic plates. Hugh Strickland had used papyrography in his own book, *The Dodo and Its Kindred,* published in 1848. Here he explained how the artist prepared a sketch for the printer "by merely using lithographic chalk instead of a lead pencil, to print and publish his original sketches (without redrawing or reversing) at any interval of time."[9] The advantage lay in the artist's ability to sketch in the field and then hand the sketch to the printer without first translating it into the lines and style required by an engraver. (The method is described in Appendix B.) Since most artists who wished to do their own work for book illustrations were using lithography by this time, Strickland's recommendation of papyrography did not find favor. Jardine was enterprising enough to experiment with it himself, however, and to allow Catherine to employ the method—with some success, as Figure 71 shows.

Hugh Strickland was killed in 1853 while geologizing in a railway cutting. Catherine returned home to Jardine Hall with his library and collections until she could find a permanent home for them in some institution. She and her father lost their enthusiasm for *Contributions to Ornithology* and produced no further volumes. It was reissued in the 1860s, but Sir William Jardine's literary output was severely curtailed after Strickland's death, which affected him deeply. Strickland's early death was followed by that of William Home Lizars in 1859, then of Selby in 1867 and of Lady Jardine in 1871.

During the 1870s Sir William spent most of his time caring for his collections of skins and specimens at Jardine Hall. He prepared a catalogue of his museum, giving details of the 6,000 bird species in it. He had just received the proofs from his publisher in 1874 when he went off to Sandown in the Isle of Wight for a holiday. There he was taken ill, and after a few days he died, on 21 November.

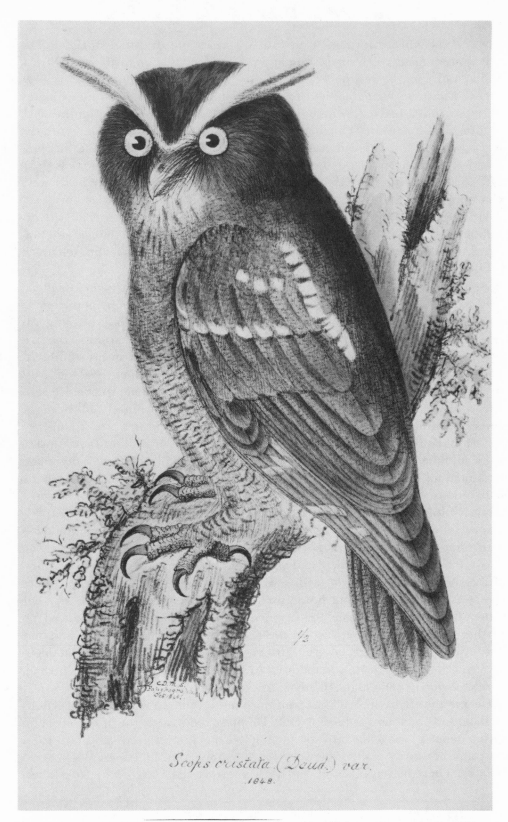

Scops cristata (Daud.) var.
1848.

71 / Catherine Strickland's papyrographic illustration of *Scops cristata*, Plate 10 in Sir William Jardine's *Contributions to Ornithology* (1848). The crested owl is a Central American species, now *Lophostrix cristata*. The plate is signed "C.D.M.S. / Papyrography / Oct. 1848."

The proofs were never corrected, nor was the catalogue published. This was most unfortunate; when his collections were sold at auction in London in 1886, at the instigation of his heir, Richard Bowdler Sharpe lamented that the catalogue prepared for the sale was "simply ridiculous, for if I remember rightly it recorded types of Linnean species like the Peregrine Falcon and the Common Swift" (*Falco peregrinus* and *Apus apus*). Dr. Sharpe attended the sale on behalf of the British Museum and purchased 516 specimens for the Natural History museum. Dr. Sharpe said that Jardine's collection was an important one, full of historical specimens, but it was very difficult to identify the type specimens as the sale room was very crowded. He wrote, "The fate of this most interesting collection is one of the saddest memories I have . . . the collection ought to have fetched more thousands of pounds than it did hundreds." Dr. Sharpe mentioned many of the collectors who had sent birds to Sir William, and whose bird skins had figured in his many books. He also saw at the sale "many beautiful skins of Bustards" which he would have liked to purchase, and he bewailed the fact that "the bid offered by the Museum was outdone by someone who wanted the specimens for fly-fishing!"[10] That would have afforded Sir William, a keen fisherman, wry amusement.

Jardine's comparatively small collection of British birds, 432 specimens, was sold to the Edinburgh Museum for £200. The residue, some eight or nine thousand specimens, fetched only £217 2s. 6d when they were auctioned in 1886.

Jardine's editorial work had been considerable. He was one of the editors of the *Magazine of Zoology and Botany* in 1836–38, *Annals of Natural History* in 1838–40, and joint editor of the *Edinburgh New Philosophical Journal*. He also contributed to the *Edinburgh Journal of Natural and Geographical Science*, which included some engravings by Lizars from his drawings. The Royal Scottish Museum in Edinburgh has a collection of manuscript notes and drawings for *Contributions to Ornithology* among a mass of other manuscript notes, journals, scrapbooks, reprints of articles, and the like. A number of Jardine's manuscript notes, original drawings, and letters, some of which relate to the Naturalist's Library, are in the British Museum (Natural History). A few letters addressed to him are in the same museum, along with the original manuscript and notes and cuttings for his edition of Alexander Wilson's *American Ornithology*. This edition, including additional notes and an account of the life of his fellow-Scotsman Wilson, was published in 1832. Lizars engraved the ninety-seven illustrations for the three volumes from the original quarto illustrations in Wilson's first edition of 1808–14, with the size reduced to octavo.

The books that Jardine left contain much of interest and scientific value, as well as many beautiful plates. He was one of the earliest ornithologists to attempt to interest a wide public in ornithology by the publication of illustrated books on natural history at modest prices. Jardine was a very competent bird artist, though not a great one. He was a prolific author and was able to organize the production of books with several contributors. He employed the best artists of

the day to illustrate his publications, and these artists and contributors were happy to work with him on more than one occasion. If Jardine was fortunate in his family, friends, and business associates, they in turn were privileged to know so genial and intelligent a man.

Sir William Jardine's Illustrated Bird Books

Jardine, Sir William. *Illustrations of the Duck Tribe.* Privately printed, 1839. 9 plates (from *Illustrations of Ornithology;* nos. 29, 62, 95, 135, 136, 147 from vols. 1–3; nos. 23 and 29 from vol. 4).
 Artists: Edward Lear, 3; P. J. Selby, 4; James Stewart, 1; Sir William Jardine, 1.
 Etchers: P. J. Selby, Sir William Jardine, William Home Lizars.

———. *Leaves from the Book of Nature: Containing the Principle Illustrations in Sir William Jardine's Naturalist's Library.* Edinburgh: W. H. Lizars, 1846. More than 1,200 hand-colored figures on 117 leaves, elephant folio.

———. *Contributions to Ornithology for 1848–1852.* 5 vols. Edinburgh, 1848–53. About 103 plates, 70 of birds, hand-colored, plus anatomical plates and plates of nests and eggs.
 Artists: Catherine D. M. Strickland, 42 (papyrography in 1848–49 vols., lithography in 1850–52 vols.); Sir William Jardine, c. 15 (some etched, others produced by papyrography and lithography); Paul Louis Oudart ("pinx. et lith."), 2; H. J. (Honore Jacquinot?), alone and with others, 7; E. N., 1 lithograph; Jean-Charles Chenu, 3.
 Etcher: W. H. Lizars (some prints from *Illustrations of Ornithology*).
 Papyrographic printer: P. H. de La Motte.
 Lithographers: Reeve & Nichols; Lemercier of Paris.

——— and P. J. Selby. *Illustrations of Ornithology.* 4 vols. Edinburgh, 1826–43. 207 copperplate illustrations, colored or monochrome.
 Contributors: J. E. Bicheno, J. G. Children, Major General Thomas Hardwicke, T. Horsfield, Robert Jameson, Sir T. Stamford Raffles, Nicholas Aylward Vigors.
 Artists: Sir William Jardine, 39; P. J. Selby, 35; Edward Lear, 19; James Stewart, 18; John Gould, 2; Alexander Rolfe, 1; Robert Mitford, 1; John Thompson, 1. Some unsigned plates from drawings in Hardwicke's collection of Indian bird paintings.
 Etchers: P. J. Selby, Sir William Jardine, W. H. Lizars.
 Colorer: Patrick Syme.

———, ed. The Naturalist's Library. Edinburgh, 1833–43, 1845–46. 14 vols. of ornithology with 446 hand-colored steel engravings by W. H. Lizars.
 Vol. 1. Jardine, Sir William. *Hummingbirds.* 1833. 35 plates unsigned.
 Vol. 2. Jardine, Sir William. *Hummingbirds.* 1834. 31 plates unsigned.
 Vol. 3. Jardine, Sir William. *Gallinaceous Birds,* pt. 1, *Peacocks, Pheasants, and Turkeys.* 1834. 31 plates.
 Artists: James Stewart, 3; P. J. Selby; some after Gould and Audubon.
 Vol. 4. Jardine, Sir William. *Gallinaceous Birds,* pt. 2, *Partridges, Quails, Grouse.* 1834. 31 plates.
 Artists: James Stewart, 14; P. J. Selby, 4.
 Vol. 5. Selby, P. J. *Pigeons.* 1835. 31 plates.
 Artist: Edward Lear, 30.
 Vol. 6. Selby, P. J. *Parrots.* 1836. 31 plates.
 Artists: Edward Lear, 30; James Stewart, title-page vignette.
 Vols. 7 and 8. Swainson, William. *Birds of Western Africa.* 1837. 2 vols. 66 plates.
 Artist: William Swainson.
 Vols. 9, 11, 12, 14. Jardine, Sir William. *Birds of Great Britain and Ireland.* 4 vols. 1838–43. 128 plates.
 Artist and colorer: James Stewart.

Vol. 10. Swainson, William. *The Natural Arrangement and Relations of the Family of Flycatchers, or Muscicapidae.* 1838. 31 plates.
Artist and colorer: William Swainson.
Vol. 13. Jardine, Sir William. *Nectariniadae, or Sunbirds.* 1843. 31 plates.
Artist and colorer: James Stewart.
Summary of signed bird plates: Selby, 4; Stewart, 177; Swainson, 97; Lear, 60.
Unsigned plates, including a few after Gould and Audubon, 108.

Wilson, Alexander. *American Ornithology; or the Natural History of the Birds of the United States,* edited by Sir William Jardine, with illustrative notes and life of Wilson by Sir William Jardine. 3 vols. Edinburgh, 1832. 97 copperplate illustrations copied from Wilson.

16

John James Laforest
Audubon

(1785–1851)

AUDUBON came to plan and execute the drawings for his monumental *Birds of America* largely as the result of his failure as a businessman. Conversely, he failed as a businessman because his interests and inclinations lay in the field of natural history. His decision to prepare *The Birds of America* was a desperate plan formulated in desperate circumstances, and was carried through to completion at enormous cost to himself and his family. Not only are the volumes of *The Birds of America* a tremendous achievement for one man, but the human story behind them is the saga of a struggle against its author's own failings and a triumph over many adversities.

Audubon was the natural son of Jean Audubon, a French sea captain, and Jeanne Rabin, a Creole of Haiti. His mother died the year he was born, and the infant was taken by his father to France, where his wife, Anne Audubon, accepted the child and brought him up as her own. He was legally adopted and christened Jean-Jacques Fougère Audubon.

Jean Audubon was a man of some substance, with estates in Haiti and Philadelphia and a villa near Nantes. It was at the villa that the man we know as John Audubon was brought up and developed a passion for natural history, drawing, and music. Alcide Dessalines d'Orbigny, a naturalist and family friend, taught

the boy how to stand quietly watching the activities of wild birds, and where to search for flowers and plants. Audubon gathered leaves and flowers in order to paint them. While in Paris in 1802, he had six months of formal art instruction from Jacques-Louis David, the founder of the French classical school, who held that perfect form, correct drawing, and balanced composition were absolutely essential in painting. Audubon hated this discipline, but it was to bear fruit many years later in his own work, and it became the foundation of his legacy to bird art.

When Audubon was eighteen years old, he was sent off to Mill Grove, his father's estate in Philadelphia. He then returned to France in 1805 for a year-long visit with his parents. Returning to America, he started a business with a partner in Kentucky, became naturalized, and was known henceforth as John James Laforest Audubon. In 1806 he married English-born Lucy Bakewell, the daughter of a farmer who owned land adjacent to Mill Grove.

From 1807 to 1819 Audubon's life was one long series of business ventures and failures, interspersed with financial crises. His troubles were largely self-inflicted, since he either would not or could not concentrate on any one thing and was out in the fields shooting and fishing when he should have been attending to his business. He was never satisfied with the place in which he found himself, always supposing that the next town would be better for his store and trade, or the people there more sympathetic.

During this period he and Lucy moved frequently, trying to find employment to support their family of two boys, Victor Gifford, born in 1809, and John Woodhouse, born in 1812. In 1819 Audubon went bankrupt, having lost the money his father had invested in Mill Grove, money lent to him by his in-laws, and Lucy's money. He had even managed to ruin George and John Keats by his friendly though misguided advice to George, who was in the United States trying to make his fortune and support his dying brother, the poet. In September 1819 Audubon had advised George to invest the larger part of his capital in a Mississippi cargo boat, which promptly sank. Though Audubon could hardly be blamed for the accident, George was convinced that Audubon had swindled him. George later recouped his losses and became a rich and highly esteemed citizen of Louisville, but his success came too late to be of any assistance to John Keats.

It was just as well that Audubon turned away from trying to earn a living by trade and used his artistic talent instead. He started by making chalk portraits of his friends and neighbors, and supplemented his limited income by teaching drawing and French. He also assisted, in various capacities, the staff of the Western Museum in Cincinnati, which was principally concerned with natural history. Here he learned the art of the taxidermist.

During these difficult years he maintained his interest in natural history and made numerous drawings of birds. He showed them to the staff at the Western Museum sometime early in 1820 and was so encouraged by their reception that he determined on the great enterprise that was eventually to make him famous.

His ambition was to paint life-size figures of all the birds of America north of Mexico and publish them in a book. The plates were to include scenes and plants of the birds' natural habitats. He proposed to draw all of his figures from nature and for that purpose intended to travel the length and breadth of North America collecting and drawing all the specimens he could obtain.

The journeying and collecting were stupendous undertakings. At that time the valley of the Ohio represented the American frontier; the Indian lands beyond the Mississippi were virtually unknown to whites. The terrain was not easy, for there were few roads beyond the eastern seaboard, and the land east of the Great Plains was almost entirely covered with virgin forest. Audubon was to cover many thousands of miles in this inhospitable but beautiful country.

Now that he knew what he wanted to achieve in life, his old idleness vanished. Whatever the difficulties and setbacks, he could always rely on past experience and pay his way by teaching French, drawing, music, dancing, and fencing and by drawing portraits. Nevertheless, he could never have achieved his ambition without the staunch support of Lucy. She supported herself and the two boys as a governess in New Orleans until Audubon started to receive the first returns for his labors on his bird book.

As early as 1804 Audubon had been out in the countryside shooting and collecting birds. He was an excellent shot and had always been a keen sportsman. Now this facility was to be used in earnest. We have a description of how Audubon dressed for the occasion when out shooting. He wore elegant pumps with satin knee breeches and a ruffled shirt. This was back in 1803, when he was still a somewhat dandified Frenchman, but his sartorial taste was always eccentric.

Despite outward appearances, Audubon was no mean ornithologist. He had conducted some serious experiments to discover the extent of the olfactory powers of birds of prey. He had also banded, with silver threads, the first birds to be studied specifically for evidence that a migratory bird returns to exactly the same nesting site each year. This trial had taken place in a cave on the banks of Perkiomen Creek, in Pennsylvania; the species chosen was *Sayornis phoebe,* a flycatcher (Figure 72).

Setting off in 1820 down the Ohio and Mississippi with his dog, Dash, and a youth called Joseph R. Mason, Audubon collected and drew birds with great enthusiasm. He continued his travels for the next six years, occasionally returning to New Orleans for a short visit with his family. He was eventually to travel from the Florida keys to Labrador, but he never managed to get farther north, or farther west than Texas. He traveled on foot, and by boat down the great rivers of the continent. He had to rely on friends to supply him with specimens of birds that inhabited areas he never reached.

Nothing seemed to go smoothly for Audubon. He was often miserably poor and could not afford to buy drawing materials. He frequently had to waste time in earning money for the next stage of his journey. Once he left two hundred drawings in a wooden box while he went away for several weeks and returned to

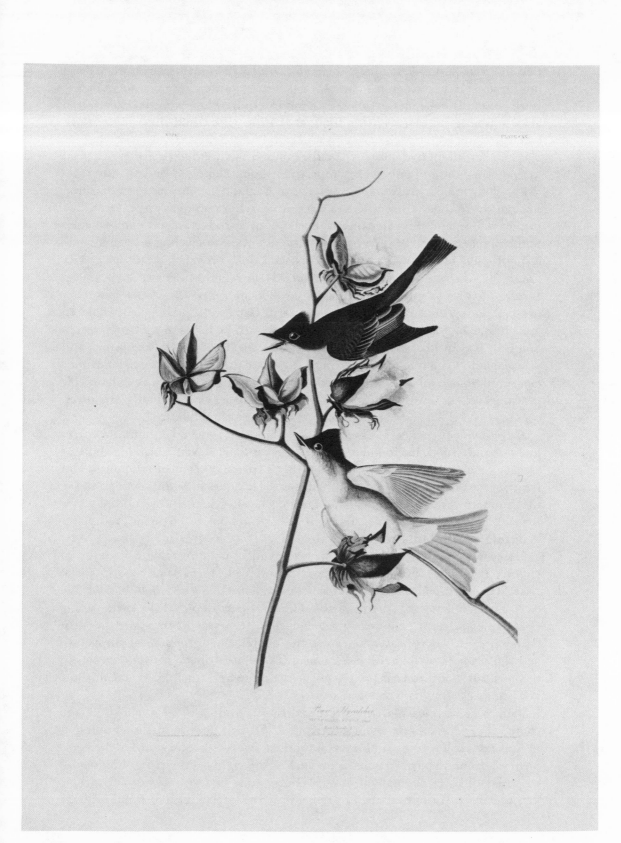

72 / The eastern phoebe (*Sayornis phoebe*), the subject of Audubon's early banding experiments. He drew the birds for Robert Havell's aquatinted Plate 120 of *The Birds of America*.

find that rats had nested among them and ruined them. His distress was almost unbearable. His courage matched his calamities, however, and with immense spirit he set off to begin the three years' labor required to repair the damage and loss, consoling himself with the thought that now he could draw them much better.

When Audubon had collected a large enough portfolio of drawings, he tried to find a printer and engraver to reproduce them. Failing to find an American firm willing to do the work, he sailed for England in May 1826 in a cotton steamer. He did not know where to begin to search for a publisher, engraver, or printer in England. Provided only with a letter of introduction to a family named Rathbone, he arrived at Liverpool with the intention of earning his living while trying to sell subscriptions for his proposed book, provided he found a publisher. He was received well in Liverpool. He showed his pictures at the Royal Institution and became something of a showman with his American frontiersman looks, unusual clothes (he wore a wolfskin coat), and long curly hair. In Manchester he was not a success, but in Edinburgh he had a much better reception. He procured some rooms from a Mrs. Dickie at 26 George Street and proceeded to exhibit his drawings there. He made the acquaintance of Sir Walter Scott and many other cultured people in Edinburgh. He also exhibited his drawings at the Royal Institution. The learned societies gave him a great welcome and received and honored him as a distinguished guest.

Audubon approached booksellers to try to obtain some advice on how to get his book published. He found a kindred spirit at Patrick Neill's printing shop, as Neill was a member of the Wernerian Natural History Society of Edinburgh and the friend of many other Scottish naturalists. He advised Audubon to go to see the famous engraver William Home Lizars, who was then at work on the plates for P. J. Selby's *Illustrations of British Ornithology,* a book of elephant folio plates depicting British birds life-size.

Lizars was so impressed by Audubon's beautiful paintings that he offered to engrave five plates for him, but the work was to be done at Audubon's financial risk. These five plates set the pattern for the issue of *The Birds of America,* for each part henceforth had five plates. The first part depicted the male turkey (*Meleagris gallopavo*), the yellow-billed cuckoo (*Coccyzus americanus*), the prothonotary warbler (*Protonotaria citrea*), the purple finch (*Carpodacus purpureus*), and the Canada warbler (*Wilsonia canadensis*). These drawings were chosen to demonstrate the different treatments of the large and small birds and to show how the backgrounds were to be treated.

With his drawings and the five engravings, Audubon set out to tour the country in an attempt to obtain subscriptions. He was his own publisher and had to find the money to repay Lizars. Subscribers were asked to sign for the complete work and to pay two guineas for each of the eighty-seven parts. This meant an outlay of £183, then about $1,000. On the tour he lectured and did various jobs to earn sufficient money to pay his way. In Cambridge and Edinburgh he

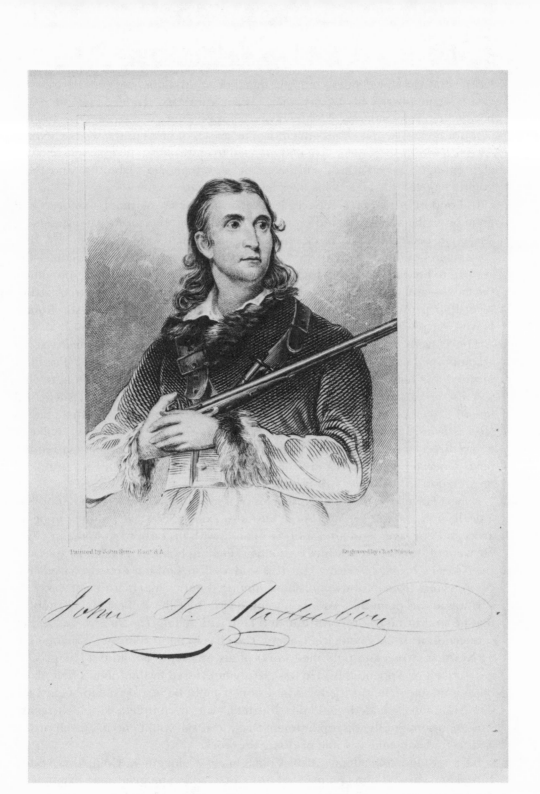

Painted by John Syme Esq^r S.A. Engraved by Cha^s Wands

73 / This portrait of Audubon in his wolfskin coat and armed with a gun was painted in Edinburgh by John Syme, a member of the Scottish Academy. It was engraved by Charles Wands for the frontispiece to *The Book of Parrots,* vol. 1 of Miscellany of Natural History, issued in 1834 by Sir Thomas Lauder and Captain Thomas Brown. Audubon described himself as "five feet ten and a half inches, . . . of fair mien, and quite a handsome figure; large, dark, and rather sunken eyes, light-coloured eye-brows, aquiline nose and fine set of teeth; hair, fine texture and luxuriant, divided and passing down behind each ear in luxuriant ringlets as far as the shoulders."

lectured at the universities, and one member of an audience, Charles Darwin, clearly remembered his lecture many years afterward. Indeed, people could hardly help remembering Audubon, for his appearance was so singular and the account he had to give of his adventures in search of birds in the wilds of North America was unforgettable. He had no need to embroider; the epic was remarkable enough. Nevertheless, Audubon the showman did elaborate, and thoroughly enjoyed the effects his tales had on people.

In London, Audubon received a letter from Lizars saying that his colorers had gone on strike and work on the prints of *The Birds of America* was at a standstill; Audubon could take the black-and-white prints that were available and find colorers in London, if he wished. Audubon suffered one of his depressions—life seemed to hold the extremes for him, elation one minute and deep despondency the next—and spent the following three days looking for colorists. Another printshop proprietor came to his rescue and suggested he go to see Robert Havell, an aquatint and line engraver.

The Havells were a remarkable artistic family. The father, Daniel, was an accomplished engraver, and several of his eight sons followed the arts. The most talented was William, a landscape painter in watercolors; then came Robert, who was also an engraver. Daniel and Robert inaugurated the long, very successful line of Havell publications in 1812 with *Views of the River Thames,* with aquatints after drawings by William. Their success was due in part to William's habit of going direct to nature for his effects. This characteristic was to show up in the next generation of Havells and be of great importance to the successful interpretation of Audubon's drawings.

Robert Havell was determined that his own son, another Robert, should follow a profession and not succeed to the business. Robert, however, wanted to be an artist and engraver, and after a fierce quarrel with his father left home in 1825. He went off to Monmouthshire on a long sketching holiday. The landscapes and river scenes he made during this trip sold well in London and procured him commissions from various publishers, among them Colnaghi and Company.

It was at this point that Audubon went to visit the elder Robert Havell, hoping that he could find colorers for him and help with selling *The Birds of America.* In connection with the Zoological Gallery, Havell sold natural history specimens at 79 Newman Street and published works of art, mainly in aquatint. (The process is described in Appendix B.) He was greatly impressed by Audubon's first plates but felt unable to help, largely because at fifty-eight he felt too old to begin a job that Audubon estimated would take fourteen years to complete. Hoping to spare Audubon some of the disappointment that a refusal would entail, Havell promised to find someone capable of doing the work.

By a strange coincidence, Paul Colnaghi, of Colnaghi & Company, visited Havell and showed him an unsigned proof of a landscape plate as an example of the work of one of his promising young engravers. With Audubon in mind, Havell exclaimed, "That's just the man for me!" Colnaghi told Havell, "Send for

your own son."[1] The two Roberts were reconciled and entered on a partnership known thereafter as Robert Havell & Son.

The next step was to send for Audubon. They decided that since Audubon was so angry with Lizars over the coloring episode, Robert, Jr., would try his hand at one of Audubon's plates. He did the plate depicting the prothonotary warbler (*Protonotaria citrea*) as a trial. Havell finished the enormous plate, double elephant folio size, in a fortnight. When Audubon came, he looked at the proof for so long that the suspense became unsupportable, and then he snatched it up and danced around the workshop crying, in his slight French accent, "Ze jig is up, ze jig is up."[2] The Havells could make no sense of this, but assumed that Audubon was displeased. The matter was quickly resolved when Audubon suddenly threw his arms around young Robert and embraced him with great enthusiasm.

After this initial reaction they all sobered up quickly. Twelve years of work and an outlay of $100,000 lay ahead of them, and they needed faith, determination, and endless patience to persevere to the end. Young Robert Havell was a cool, calm person and never wavered or lost heart. He had a stabilizing influence on the volatile Audubon, and gave him support when they ran out of funds, as they frequently did throughout the years of the book's production.

The Havells decided that they could not only do the engraving but undercut Lizars' price for the coloring. Audubon's relationship with Lizars had soured. Despite all Lizars' business advice and guidance and his personal kindness and good work up to that point, both of them began to have doubts about one another's good intentions. Lizars seemed no longer to be so keen on doing the work, though he offered to share it with the Havells, and Audubon was quite happy to let the Havells take over, to retouch Lizars' plates, obliterate Lizars' name from them, and substitute their own. Between them the Havells were to complete the rest of the 435 plates.

With this arrangement concluded, Audubon turned his attention to doing more drawings and soliciting subscribers in Great Britain, Paris, and the United States. As his own publisher he had to supervise all the work, making sure the aquatinter drew what he wanted and that the colorers faithfully copied the originals. As he drew new birds he made oil copies of some of his watercolors in order to sell them to finance the publishing. He was quite used to working a seventeen-hour day and was now a shrewd businessman, keeping track of and supplying his subscribers with the parts as they were issued and collecting the subscriptions.

Audubon returned to the United States on three occasions during the printing of the plates—in 1829, 1831–34, and 1836–37—in order to obtain further species for drawing and reproducing. Not content with some of the early drawings, he redrew many of them. On these trips he also tried to obtain the male bird of a species if he had depicted only the female on a previous occasion, and vice versa. When he wanted to combine two drawings on a single plate, he

usually cut round the birds' outlines and pasted them onto a single sheet. Sometimes he had already drawn both sexes but failed to recognize them as a pair, for many of his birds had not previously been described. In a few cases, he never realized that two birds were the same species in different plumage, and made two species of them.

Many of Audubon's drawings are still in existence. The very earliest drawings of birds, done when he visited France in 1805, were executed in pencil and pastel and are stiff profiles, just like those of his contemporaries. After 1806 his work improved, largely because he also used watercolors to color the feet, bill, and eyes. He developed a method of working from recently killed specimens so that he could portray them in more natural attitudes, reproducing the features and outlines in exactly the same size as the originals. He wired the specimens in the stance or attitude in which he wished to show them, and set them up against a background of graph paper. He then used a piece of sketching paper, with small squares exactly like those of the background paper, and faithfully reproduced all the features of the bird. To render details more exactly, Audubon experimented with various paints and substances. He combined pencil, watercolor, pastel, crayon, ink, oil, and egg white in his efforts to reproduce the sheen on the feathers and simulate the texture of the plumage. After 1824 Audubon was using watercolors basically, with the other media added for specific effects. Whether his birds were flying, running, resting, or preening, all of them were depicted as seen from eye level, a convention usually followed by bird artists. About 430 original paintings for *The Birds of America* are preserved in the library of the New York Historical Society, which purchased them from Lucy through public subscription in 1863.

When it came to reproducing those drawings as a series of prints, Audubon dearly wanted them to be large enough to show all of his birds life-size. This had always been his dream, and now there was a further reason. Alexander Wilson's *American Ornithology* was being reissued in New York and Philadelphia, and some copies were being sold in Britain. If Audubon were to face this competition, he must have something more to offer than a few additional species. His talent must be displayed to full advantage, and only life-size portraits on very large plates would produce the effect he wanted. He chose the same size of paper as that on which his drawings had been done, measuring 29-1/2″ by 39-1/2″ untrimmed, known in the trade as double elephant folio. Trimmed, the measurements were 25-3/4″ by 38″. Some of the largest species, such as swans and cranes, were still cramped, but for medium-sized birds, such as ducks, there was space for both sexes to be portrayed. The large size created a problem with tiny birds, of course, but Audubon solved it either by not using the full area of the page, by filling it with elaborate backgrounds and foregrounds, by picturing a colony or group of the same species, or by depicting more than one species on the same plate. Audubon chose the first five plates, executed by Lizars, to show his varied treatment, and the remaining plates gained much in interest from this variety.

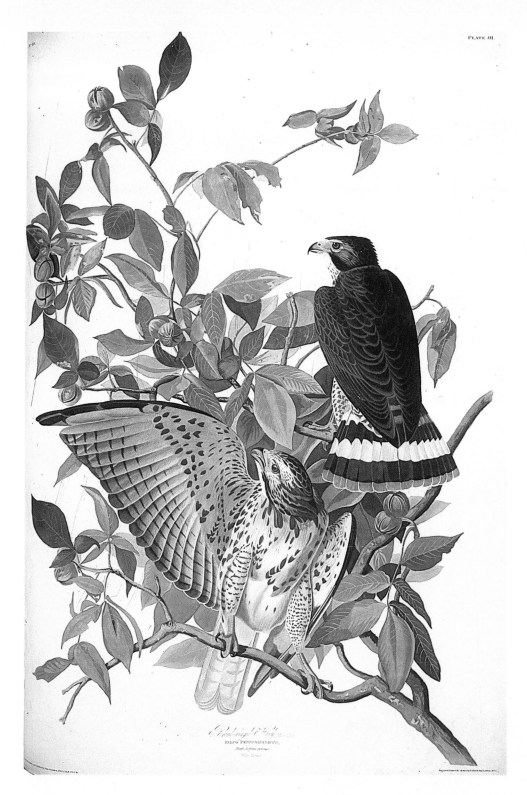

PLATE 4 / John James Audubon's broad-winged hawk (*Buteo platypterus*), Plate 91 of *The Birds of America*.

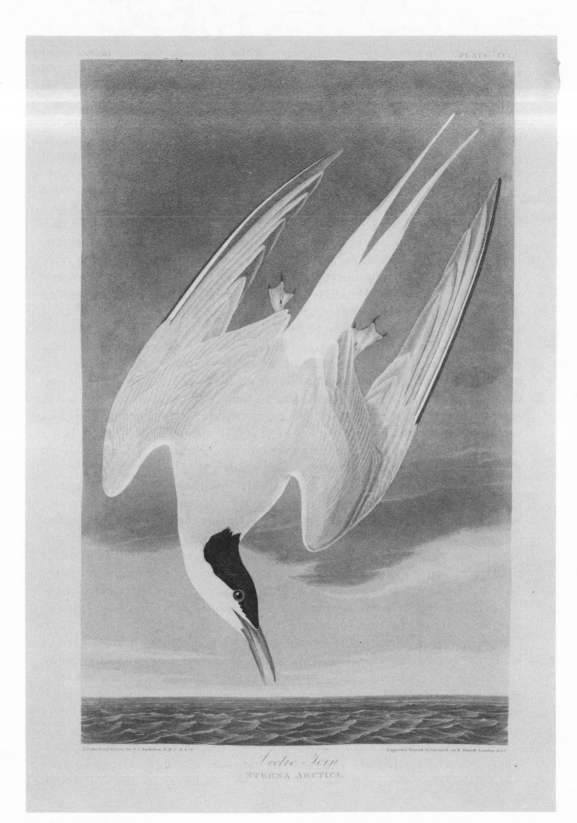

Arctic Tern
STERNA ARCTICA.

74 / Audubon drew the Arctic tern (*Sterna paradisaea*) in June 1833, on Magdalen Island, off the coast of Nova Scotia. Robert Havell, Jr., aquatinted it against a blue sky for vol. 3 of *The Birds of America*, Plate 250. It is one of Audubon's simplest plates in composition.

Whatever the size of the bird, the area of the plate was so great that a good artist was required for the habitat scenes and the foreground detail of plants and terrain. Audubon was perfectly capable of providing superb backgrounds of his own. On the plate showing the greater prairie chicken (*Tympanuchus cupido*), Audubon demonstrated his powers as an artist and designer by drawing the landscape and plants as well as the bird. But as the work progressed and the printing and the oversight of the work increasingly occupied his time, he enlisted the help of assistants. While doing the drawings, Audubon had frequently made notes as to the kind of terrain he wanted. He sometimes merely outlined a branch or plant in pencil, indicated the position of the leaves in India ink, and left the rest for Havell to copy from a specimen of the plant; the plate of the blue jay (*Cyanocitta cristata*), for example, was completed in this manner. Fortunately, Havell was an excellent artist, and toward the end of the work Audubon came increasingly to rely on his interpretation of his own notes and pencil sketches.

Audubon held Robert Havell, Jr., in great esteem and gave him a loving cup inscribed "To Robert Havell from his friend J. J. A. 1834."[3] Audubon wrote of Havell's work in 1830, "I . . . am perfectly confident that no birds were ever so beautifully and softly represented on copper."[4] Two years later he compared the softness of Havell's plates with that of lithographed plates. Havell sometimes produced the soft gradations by feathering on the bare copper plate, allowing the acid to bite its own granular surface. To balance the softness thus achieved, he ensured well-defined lines by both engraving and etching them. The chief limitation of the aquatint process is the great difficulty of getting more than a few shades, as the ground collapses rather rapidly under repeated biting. Havell was very skilled at producing intermediary shades.

Audubon had five assistants in addition to Havell. Joseph Mason, who accompanied Audubon during the first two years of his travels, provided watercolor backgrounds for about fifty-five bird subjects. During the two years after Mason left him, Audubon did fewer drawings. Then he made a new effort and produced some more excellent work before embarking for England in 1826 with a portfolio of 240 drawings. After three years in England he returned home to see Lucy and his boys and to search for more specimens to draw. In five months of travel he completed forty-two drawings of ninety-five birds and sixty kinds of egg. He employed George Lehmann, a German-Swiss landscape painter from Lancaster, Pennsylvania, to depict appropriate habitat scenes for at least ten of his birds. Lehmann helped Audubon again on a trip to Florida and South Carolina in 1831, when Audubon made about thirty drawings. Lehmann's work was so good that Audubon also allowed him to complete some watercolors of the birds themselves. Lehmann and Mason both used more opaque watercolors than Audubon.

In Charleston, South Carolina, Audubon met the Reverend John Bachman. They became firm friends, and their relationship was further strengthened when Audubon's son John married Bachman's daughter in 1837. Through

Bachman, Audubon found a third helper, Maria Martin, Bachman's sister-in-law. She painted a few plants and insects in about twenty of Audubon's drawings.

The other two assistants were Audubon's sons. Their father credited John with ten drawings of birds, while Victor seems to have supplied some backgrounds painted in oils for another ten plates. Victor went to England in October 1832 to oversee the printing of the plates, while Audubon remained in the United States to find and draw new birds.

Critics have quarreled with Audubon over the unnatural attitudes, even contortions, that a few of his birds assume. His birds are so full of life and movement that their vivacity sometimes seems excessive. Yet there were often valid reasons for the positions in which the birds are delineated. Audubon deliberately contrived their attitudes in order to show distinctive marks on the plumage. He was thus able to show the back, the underplumage, the underwing, and a view of the bird in flight. In the plate of the caracara (*Caracara cheriway*), for example, both ventral and dorsal views permit the colors of all of the feathers to be seen. The Hudsonian godwit (*Limosa haemastica*) has its wings raised so that Audubon could show the difference between this species and the black-tailed godwit (*Limosa limosa*) of Europe by the black color of the inner wing coverts. There are many other instances of this kind of treatment.

Taking the engraver's point of view, Havell considered that the plate of the mountain mockingbird (now the sage thrasher [*Oreoscoptes montanus*]; Figure 75) was one of his best in its fine rendering of the feathers. He cherished the proof of the very first plate he did, of the prothonotary warbler (*Protonotaria citrea*), which had gained Audubon's approval, and would compare it with later plates, saying, "What an improvement!"[5]

As one turns the pages of *The Birds of America,* the sheer size and color of the plates make a tremendous impact. The coloring is breathtaking. All of it was painted by hand by some fifty or so men and women working with watercolors. The basic black outlines were printed, and then the sheets went to another department for coloring. This stage was closely supervised by either Havell or Audubon or one of Audubon's sons. Any faulty work was washed off and the coloring redone. It was inevitable that with so many hands at work, the coloring would vary. Not only are the plates not uniformly colored, but the amount of care expended by the colorers was not consistent. Within these limitations, however, the coloring was very good, and accurate.

The early plates were variously signed "Engraved, Printed and Coloured by R. Havell and Son" or "Printed and Coloured by R. Havell and Son" or just "R. Havell, Junior." The brief partnership between father and son was dissolved in 1828 and Robert, Jr., moved to 77 Oxford Street. The elder Havell continued to print from the plates and to color them, but he soon found it too much to do this work and carry on the business of the Zoological Gallery. He decided to retire, his health failed, and he died in 1832. While the father had controlled the coloring, there had been a number of complaints from subscribers. The elder

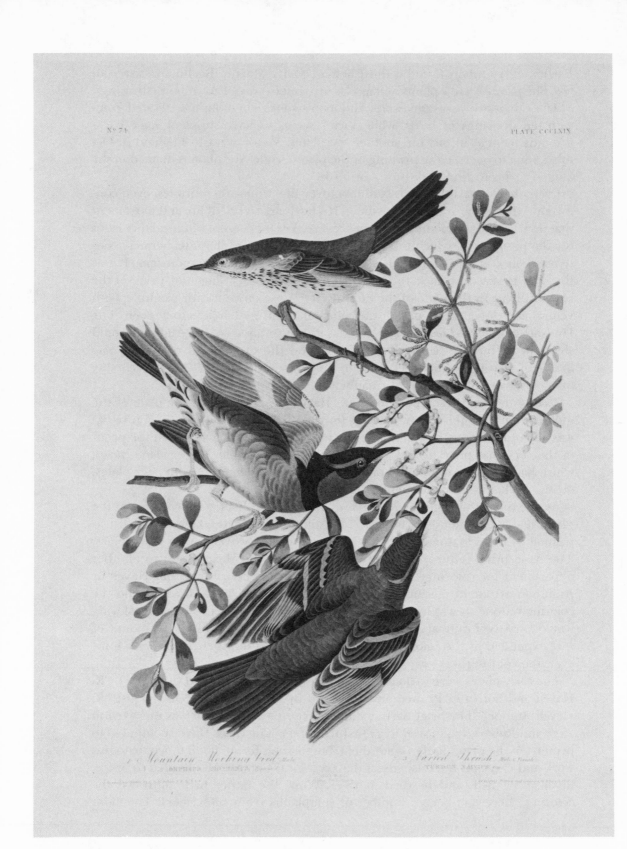

75 / Audubon's mountain mockingbird, now sage thrasher (*Oreoscoptes montanus*), and varied thrush (*Ixoreus naevius*) on one of Havell's best plates (no. 369); note the fine rendering of the feathers. Audubon never saw the sage thrasher in the wild, but drew it from a specimen sent to him by John Kirk Townsend. The American mistletoe was painted by Maria Martin.

Havell had applied the salient tones and more delicate tints after the colorers had painted in the crude washes. After Robert Havell, Jr., took over the whole production of the plates, signing them "Engraved by R. Havell," there were fewer complaints.

During the final phase, before the last of the eighty-seven parts was issued on 20 June 1838, Audubon had felt pressure from all quarters to finish the work quickly. Aside from his trips across the Atlantic, the continuing hours at his easel for the painting of 1,065 figures of some 490 species, and the business details of the project, Audubon had to contend with an economic slump in 1837 which made his subscribers restive. They were constantly dropping out, complaining about the coloring and quality of the prints, and getting behind in the payment of the subscriptions. Audubon had to go and see them, persuade and cajole them, or try to replace lost subscriptions with new ones. He had originally estimated that 400 species would be depicted. Consequently toward the end, if he were to portray all the additional birds he had collected or had sent to him, he knew he would have to crowd a number of species onto one plate.

The pressure of work led to a few errors. Some of the birds were anatomically incorrect because he was obliged to use specimens sent by friends without ever having seen the live counterparts. Audubon also mistook the sandhill crane (*Grus canadensis*) for the young of the whooping crane (*Grus americana*). Lesser sins of commission included the mistake of showing a spider that leaps on its prey busily spinning a web that it does not weave in real life. Inasmuch as so many of his bird species were entirely new to science, however, his achievements far outweigh the few errors he committed.

Not content just to publish illustrations of the birds, Audubon issued a separate text designed to complement *The Birds of America*. The five volumes of *Ornithological Biography* were published in Edinburgh by Adam Black between 1831 and 1839. Lizars had advised Audubon in 1826 not to publish a text alongside the pictures in *The Birds of America* because if he included a text he would have to deposit eleven copies, free of charge, at the Stationer's Office in order to secure British copyright and so ensure against pirated editions.

In the autumn of 1826 Audubon commenced writing the account of his birds from his journals. *Ornithological Biography* not only gave an account of the behavior, food, and habitats of the birds, but also included comments as to where and when Audubon had seen them and some details of his travels and escapades. Audubon's prose was a long continuous narrative, poured out excitedly as he relived the days he had spent tramping across North America discovering exquisite birds and listening to their songs. His friend William MacGillivray, the Scottish ornithologist, corrected his English, supplied scientific facts, and helped with nomenclature. It was a happy and successful partnership, for the account is still Audubon's in style and content and is very readable.

With the completion of the publication of *The Birds of America* and the *Ornithological Biography*, Audubon returned to the United States in the autumn of

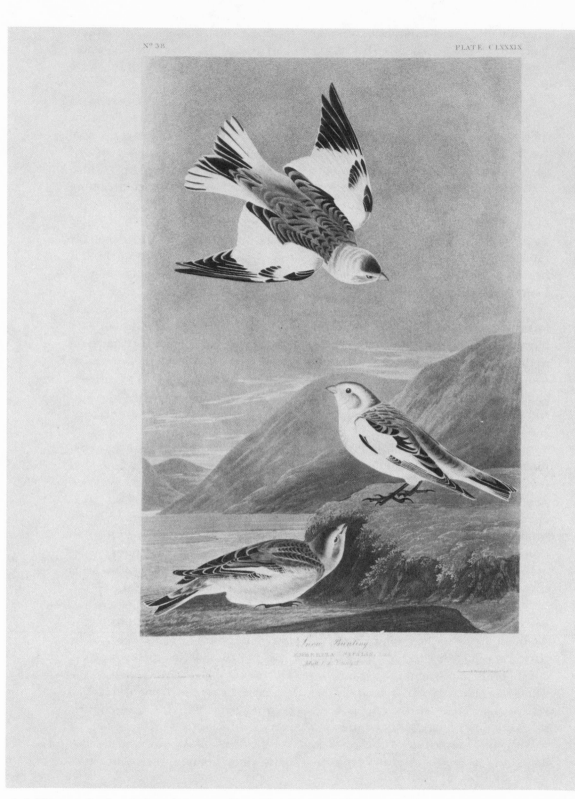

Snow Bunting
EMBERIZA NIVALIS
Male & Young

76 / This restrained and charming composition, Plate 189 of Audubon's *Birds of America*, shows snow buntings (*Plectrophenax nivalis*) in their autumn/winter plumage.

1839. He took with him the copper plates that Havell had aquatinted and stored them in a warehouse in New York City, where some of them were destroyed by fire in 1845. Then Audubon took them to a fireproof vault in his own house in the Hudson Valley village of Sing Sing (now Ossining), New York. After his death they were offered to a Boston publisher, who refused them. Since copper was then extremely valuable and the plates weighed several tons, Lucy sold them for scrap. A few were rescued and are now in private collections and some public museums in the United States.

It is difficult to discover how many complete sets of the eighty-seven original parts were bound by their owners. It is equally difficult to ascertain how many impressions were taken from each plate. As few as two hundred complete copies and perhaps three hundred prints may have been taken from any one plate. Many would-be subscribers held back from purchasing the parts as they were issued, thinking that the price of the book would drop when all parts were complete. They found out, too late, that their chance to purchase them had passed. Because of the few complete volumes and the size and magnificence of the work, any copies that come onto the market today fetch astronomical sums. A copy sold by Sotheby's in London in 1984 fetched £1 million, or about $1.4 million.

Havell sold off his business interests and took his wife and daughter to the United States in September 1839. When they arrived in New York they stayed with the Audubons, who were then living on White Street. A trip up the Hudson River so excited Havell with prospects for landscape painting that after a short stay in Brooklyn he purchased a house in Sing Sing. He was highly regarded there and had a street named after him. In 1857 he moved again, this time to Tarrytown, also on the Hudson, and built a large house and studio, where he worked in oils and occasionally did some engraving. He died in November 1878.

Back home in the States, no longer poor, Audubon could enjoy his own specially built house and the comfort of knowing that he had at last proved himself to be a more than adequate provider for his family. He was not content to sit back, however; in 1843 he set off on yet another great journey across the continent, this time to collect animals for a projected work on mammals. Three years after returning home to New York City, he found he could not see sufficiently well to keep his work in focus. Reluctantly he abandoned his easel and let his sons take over his work on mammals. When Audubon was no longer able to draw and paint, he lost all interest in the world around him. He died on 27 January 1851.

Audubon left behind him the successful realization of a dream, a work that would never be surpassed or equaled. In size alone it is outstanding; it is the largest collection of plates of birds ever published. The life-sized figures in dramatic attitudes broke new ground in ornithological illustration. The use of the appropriate plants was not new—Catesby had shown the way there—but the landscape painting in the background added a new dimension to the art of

portraying birds in their typical habitats and surroundings. When Audubon worked from freshly killed specimens, his detail was more accurate. Ornithologically he made history with the inclusion in *The Birds of America* of so many species new to science. Not only could Audubon produce a lively, faithful portrait, but his artistic abilities in the composition of the whole picture and attention to detail place him in the front rank of bird illustrators and bird artists.

The measure of Audubon's achievement is that all bird portrayal since the publication of his *Birds of America* is judged by his criteria. From his contemporaries onward, a bird artist or illustrator's ability to draw correctly, to capture the living spirit of the bird, and to create a harmonious and accurate setting became basic elements in bird art.

Book Illustrated by John James Laforest Audubon

Audubon, John James Laforest. *The Birds of America; from Original Drawings Made during a Residence of 25 Years in the United States.* 4 vols. London, 1827–38. 435 aquatints with 1,065 bird figures.
> Artists: J. J. L. Audubon; Lucy Audubon, 1 (Plate 64); John Woodhouse Audubon, 10; Victor Gifford Audubon; and assistants.
> Engravers: William Home Lizars, Plates 1-5,10; Lizars retouched by Robert Havell, Jr., Plates 8 and 9; Robert Havell, Sr., and Robert Havell, Jr., Plates 11–107; Robert Havell, Jr., Plates 108–435.
> Colorers: W. H. Lizars; Robert Havell, Sr.; Robert Havell, Jr.; Havell employees.

Appendix A

Continental Illustrated Bird Books Published to 1660

1475 Magenberg, Conrad von. *Buch der Natur.* Augsburg.
Woodcuts and text printed together. One full-page woodcut depicted 13 figures of birds.

1478 Albertus Magnus. *Summa de Creaturis.* Rome.
The second part of this work on animals, written in the thirteenth century but first printed in 1478, contained some 50 woodcuts of birds.

1555 Gesner, Conrad. *Historica animalium* Zurich.
Vol. 3 dealt with birds and also had 222 woodcuts, a portrait of Gesner, and an index of 196 British birds, drawn from the unillustrated first book exclusively on birds to be published in England: William Turner's *Avium praecipuarum quarum apud Plinium et Aristotelem,* published in 1544. Many of Gesner's illustrations were from earlier books, but he also collected a large number of specimens and original drawings to supplement them. The initials F. O. on the plates are believed to signify Franz Oberreiter, a famous woodcutter. Lukas Schan was the artist for some plates.

1555 Belon, Pierre. *L'Histoire de la nature des oyseaux.* Paris.
This first illustrated book on zoology that has survived to the present contains 144 woodcuts from drawings by Pierre Gourdelle from specimens acquired by Belon on visits to markets throughout Europe.

1557 Belon, Pierre. *Pourtraicts d'oyseaux, animaux, . . .* Paris.

Included 174 woodcuts of birds, many of which were from Belon's own drawings.

1599–1603 Aldrovandi, Ulisse. *Ornithologiae hoc est de avibus historiae.* 3 vols. Bologna.

These volumes of an encyclopedia of natural history, illustrated with 685 woodcuts from original colored drawings, included some new species and illustrations of birds. The paintings and woodcuts are still preserved at Bologna. The artists were the court painter Jacob Ligotius (Giacomo Ligozzi), the animal painter Lorenzo Bennini of Florence, and Cornelius Svintus (Swint) of Frankfurt. The woodcutter of the blocks of pearwood was Aldrovandi's nephew Cristoforo Coriolano of Nuremberg.

1605 Clusius, Carolus (Charles de l'Ecluse). *Exoticorum libri decem.* Leiden.

Figures of about 15 birds, included a dodo, a great auk, a solan goose (gannet), and a penguin.

1622 Olina, Giovanni Pietro. *Uccelliera, overo discorso della natura e proprieta di diversi uccelli e in particolare di que' cha cantano, con il modo di prendergli, conoscergli, alleuargli e mantenergli, e con le figure cavate dal vero e diligentemente intagliate in rame.* Rome.

The 66 copper engravings were drawn by Antonio Tempesta and engraved by Francesco Villamena.

1648 Marcgraf, Georg, and Willem Piso. *Historia naturalis Brasiliae, sive Guil. Pisonis de medicina Brasiliae et G. Marcgravii de Liebstadt historiae rerum naturalium Brasiliae . . .*

Included about 120 woodcuts of birds. 2d ed. (printed by Elzevir, Amsterdam, 1658) included G. Pisonis, *De Indiae utruisque re naturalis et medica.*

1650 Jonston, John. *Historiae naturalis avibus . . .* Frankfurt: Matthaeus Merian.

The figures of the 62 hand-colored plates were said to have been engraved on copper by Kaspar and Matthaeus de J. Merian, sons of the publisher.

1658 Bontius, Jacobus. *Historiae naturalis et medicae indiae orientalis . . .* Amsterdam.

Figures of 8 birds and swifts' edible nests.

John Ray stated in the preface to his and Francis Willughby's *Ornithologia* that "we culled out [from Olina's *Uccelliera,* 1622] those we thought most natural, and resembling the life, for the Gravers to imitate, adding also all but one or two of Marggravius's [Marcgraf, 1648] and some out of Clusius [1605] his Exotics, Piso his Natural History of the West Indies [see Marcgraf, 1648] and Bontius [1658] his of the East." Piso was being circulated among members of the Royal Society in 1676. Robert Hooke, curator of the Royal Society Repository, noted in his

diary (now in Guildhall Library, London) on 12 April 1676, "Took home book from [John] Martin [Royal Society printer] and returned [Henry] Oldenburg [publisher of the Royal Society's *Philosophical Transactions*] Piso I had of him last week. *Ornithologia* Willoughbis for 24s." Ray probably also used this copy of Piso.

Among the sources used by Ray was a 159-page manuscript in German by Fischer Leonard Baldner including text and hand-colored illustrations of forty fishes, fifty-six birds, and fifty-two other aquatic creatures. This manuscript, dated 31 December 1653, is now in the British Museum (MS 6485), along with an English translation prepared for Willughby by Frederick Slare (MS 6486). Willughby bought colored pictures of birds representing more than eighty species in Nuremberg.

Appendix B

The Use of Metal for Bird Illustrations

Artists' drawings of birds were reproduced to illustrate books by the processes of engraving, etching, stipple, aquatint, and a mixed process called anastatic printing or papyrography.

ENGRAVING

Engraving is an intaglio process. An intaglio print is taken from a metal plate in which the design is cut so that the ink within the sunken lines is transferred onto paper under pressure.

Engraving was first used in an English book in 1521, and by 1580 copper engraving was overtaking woodcutting as a method for illustrating books. It was used to a great extent by Dutch immigrants in England in the second half of the seventeenth century. Among them was Frederick Hendrick van Hove, of The Hague, who in 1676 engraved some of the bird illustrations for Francis Willughby and John Ray's *Ornithologia*. The first known book on etching and engraving, by Abraham Bosse, was translated by another of Ray's engravers, William Faithorne, under the title *The Art of Graveing and Etching, Wherein Is Exprest the True Way of Graveing in Copper*, published in 1662. This book popularized the method in England, and from that time illustrations engraved on copper appeared in many British books until the mid-nineteenth century.

Copper, zinc, and steel have been the metals most favored for engraving,

though others may be used. The design for the print was sketched on a sheet of paper after the back of the paper had been rubbed with chalk. The paper was then laid on a polished sheet of copper 1 to 1-1/2 mm thick, chalk side down, and the lines of the design were transferred to the plate with a sharp point. After removing the paper, the engraver selected a graver or burin (a steel pen whose tip had been sharpened to form a forward-sloping lozenge-shaped facet) and incised the lines of the design to a depth of 0.25 mm or less. The graver was pushed in the same direction at all times; when it was necessary to make a curve, the plate itself was turned. A stiff ink was worked into the furrows of the heated plate and the surface wiped clean. Paper was then pressed against the plate and passed through a roller press so that the ink was transferred onto the paper from the recesses of the plate.

The crisp image that results is the chief characteristic of copper engraving. The tones of the lines vary from black to gray; tones may be produced by the use of close lines or dots and cross-hatching. The line is freer than that produced by wood engraving. Large areas of solid color are not possible, as only narrow lines can be engraved. (A thick line would hold so much ink that it would spread out during the printing process and produce a blurred effect, so that the quality of crispness would be lost.) Frequently the shape of the printing plate remains impressed on the paper bearing the print; this plate line is another indication of the method by which the illustration has been reproduced.

About 1820 William Say introduced steel plates for mezzotint work, and steel was also used for engraving after that date. The much harder surface of steel and its finer texture allowed finer lines to be engraved. William Home Lizars used steel for the engraving and etching of the plates in the small pocket books that formed the Naturalist's Library, edited by Sir William Jardine from 1833 to 1848. These small engravings have an elegance and precision and a certain brittle quality characteristic of steel engravings.

ETCHING

The etching of copper plates was introduced to England about 1640 from the Netherlands (*etch* is from the Dutch word *etsen*, "to bite away").

No tool is used to cut the copper or zinc plate; the lines to be produced are dissolved by acid. The design is drawn with a steel point on an acid-resisting ground covering the plate so that parts of the plate below are exposed. In the early years, after a sheet of metal had been covered by an acid-resisting film of wax and asphaltum, it was blackened with a lighted taper. The design was traced in reverse on the ground. When the design was cut through the ground with a needle, the light lines of the design stood out against the dark background. The plate was placed in a bath of nitric acid until the finest lines in the exposed metal were satisfactorily "bitten." These lines were then "stopped out"; that is, they were covered with an acid-resisting varnish before the plate was again exposed to

the acid. This process was repeated until the lines that would print darkest were bitten to a sufficient depth. The ground and varnish were then cleaned off the plate. The method of printing from the etched plate was the same as that followed with an engraved plate.

The results are characterized by an easy, flowing line, lightly drawn. The foreground was often filled in with scribblings. The sketchy lines are somewhat blunt, not tapering to a fine point, as in an engraving, so that the normal etched line is the same width along its whole length. The general effect of freehand drawing with a needle is of fine black pencil or pen lines, as in a sketch; the soft ground permits depth of shadows to be reproduced.

If the artist dispensed with the ground and drew directly on the copper with an etching needle, the process was called drypoint. This method was sometimes combined with engraving but was more often used to reinforce etching.

The earliest etchings of birds in Britain appeared in the following books:

1655 Barlow, Francis. *Multae et diversae avium species.* 12 prints. 2d printing, 1658; 18 plates. 3d printing, c. 1694.

 Some prints are signed "Barlow inv. Hollar fec." Plates include "Fesonts; Patriges; Pegions; Peacockes; Gease; Wilde dookes; Hearnshaes; Woodecockes; Turkeys; Lapwinkes; Rauens, crowes, magpyes; Swan; Eagle, hawke and owles."

1660 _____. *Various Birds and Beasts Drawn from the Life.* 1660. Reissued several times.

 A number of plates are signed by Barlow; by Wenceslaus Hollar; by Francis Place as etcher; by Jan Griffier, a Dutch etcher; and by P. Tempest.

1666 _____. *Aesop's Fables.*

 Contained some birds. Barlow etched his own plates.

1671 _____. *Severall Wayes of Hunting Hawking and Fishing.*

 Wenceslaus Hollar etched the entire book, rhymes as well as illustrations.

1686 Blome, Richard. *The Gentleman's Recreation.* 5 plates on "hawking and fauconry"; 6 plates with birds under the heading "The compleat art of fowling."

 Francis Barlow's illustrations in Part II were etched by Arthur Soly ("hawking for pheasants") and Simon Gribelin ("Shooting flying").

1668 Charleton, Walter. *Onomasticon zoicon.* 6 plates; "Loxia Crossbill; Alchata Pigeon; Ficedula (Benefico); Grosbeak; Merops; Upupa."

 The text is a list of animals and birds, in alphabetical order, with English, Latin, and Greek names of all known species.

1677 _____. *Exertationes de differentiis et nominibus animalium.*

 Included the same plates as *Onomasticon zoicon* plus two extra plates depicting the "Shoveller" and the "Barbaric crane."

1684 Sibbald, Sir Robert. *Scotia illustrata sive prodromus historiae naturalis.* Edinburgh.

> Mainly a catalogue of Scottish birds, pp. 13–22, with ten plates bearing illustrations of birds. A black-winged stilt (the first recorded in Britain) and a female capercaillie with a great skua are the only two plates signed: "Geo. Main fecit."

STIPPLE

Stipple, sometimes called crayon etching, is a form of etching that was very popular for reproducing crayon drawings. Most prints done in this manner date from the 1770s; aquatint and lithography made it less popular in the 1820s and finally superseded it about 1830.

As in etching, a copper plate was covered with an acid-resistant ground. Instead of drawing lines with an etching needle, the craftsman pricked small dots through the ground, exposing the copper in a series of dots or flecks. To speed up the process, a roulette was often used. Shade was achieved by close placement of dots; fewer, more widely spaced dots produced a lighter effect. All of the dots were more or less the same size. The plate was corroded in an acid bath and the hollows thus formed retained the ink during the printing process.

Some bird artists used stipple as a supplement to etching. Charles and William Hayes, Edward Donovan, William Lewin, and others made judicious use of it, and so did John Hunt, who was his own artist, engraver, and colorer (with the exception of one plate by his son S. V. Hunt) of *British Ornithology, Containing Portraits of All the British Birds, Including Those of Foreign Origin,* published in three volumes from 1815 to 1822. He used a roulette occasionally for the light outline of a bird in stipple. His figures were well proportioned but he ended in mid-sentence on page 138 of the third volume and never completed the book. Copies vary in the number of plates, usually 192.

The only book I have found in which a large proportion of the work was done by stippling was a book by George Brookshaw called *Six Birds, Accurately Drawn and Coloured after Nature with Full Instructions for the Young Artist,* published in 1817. It was a thin folio volume with a single page of text describing how to paint each of the six birds, followed by two facing plates, one colored and one monochrome, depicting a "Bullfinch, bramble-finch, goldfinch, pie-finch, tom-tit with red-pole," and a redstart. The flowers, twigs, and leaves of the flower spray accompanying each bird are entirely in stipple. The bird figures are a mixture of stipple and engraving. The shading is all done by stipple.

AQUATINT

Aquatint was a method of tone etching often used in conjunction with etching. In an etching the gray tones were produced by a series of very fine, closely

spaced lines; in aquatint, the gray areas were produced by scores of tiny dots and rings etched in the copper plate. A polished copper or zinc plate was covered with minute grains of resin, then gently heated to make the resin adhere to the surface. The artist then either drew the design directly on the resin with a soft pencil or traced it through carbon paper. The plate was then etched in the usual way. The acid bit around the grains of resin, and the resulting islands and dots printed tones of varying intensity according to the length of time the areas were exposed to the acid. The lines drawn by the artist were broken up by the islands and dots. When the ground was cleared off, the plate was ready for printing.

Aquatints are recognized by the basic patterns of the tone's pitted effect. In a pure aquatint there are no clear-cut lines. The resulting print, after being hand-painted, looked exactly like a watercolor painting. This method of reproducing artists' drawings flourished during the period when watercolor painting was most popular in England.

The method was first used successfully, perhaps also invented, by Jean-Baptiste Le Prince, whose earliest aquatints are dated 1769. The artist Paul Sandby was introduced to the process and gave it its name when he issued twelve prints, *Views in Aquatinta from Drawings in South Wales,* in 1775. At that date, watercolor painting was done either with India ink, sepia, or some other neutral tint, and the aquatint process was used initially for the purpose of reproducing watercolor paintings in these tints. The natural history aquatints designed by William Daniell were of this type. Later, aquatints were printed in other colors, sometimes two or three tints in a single print, but very few of the plates in books were completely color-printed aquatints. It was more usual for the illustrations to be either wholly or partly hand-colored with watercolor paints. Some of the prints were so highly finished in watercolors that they were, to all intents and purposes, actual watercolor paintings. Audubon's *Birds of America,* the most magnificent example of aquatint printing in any book, fall into this category.

Aquatint could not stand the competition from the less expensive and speedier lithography. The two processes were in use concurrently in the 1830s, but though Audubon's *Birds of America* was not completed until 1838, most aquatint firms had gone out of business before then. Having completed this work, the aquatinter Robert Havell closed his shop and departed for the United States.

About 1804, William Weston Young issued a prospectus leaf and one aquatinted plate of a bullfinch for a proposed book to be called "British Ornithology or History of Birds." No further parts were issued.

The following books contain aquatint bird illustrations:

1807 Wood, William. *Zoography.* 10 sepia aquatints designed by William Daniell. Birds in vol. 1: penguins, Numidian crane, ostrich, kingfisher, cockatoo, great eared owl, goshawk, golden eagle, heron, stork.

1809 Daniell, William. *Interesting Selections from Animated Nature with Illustrative Scenery.* 12 monochrome aquatints of birds.

1813 Forbes, James. *Oriental Memoirs*. 4 bird plates: "hummingbirds of the
 Brasils, the Baya or Bottle nested sparrow of Indie, Taylor birds, Bulbul
 or Indian nightingale."

 One of the illustrations, copied "on stone" and published in 1811, must
 be one of the first lithographic plates of birds ever published in a book.
 The plates were hand-painted.

1835 Perrott, Charlotte Louisa Emily. *A Selection of British Birds from Drawings by
 C. L. E. Perrott* . . . 5 hand-colored aquatints.

 One plate bears the inscription "Engraved Printed & Coloured by R.
 Havell."

ANASTATIC PRINTING OR PAPYROGRAPHY

Anastatic printing was a mongrel process that enabled a printer to print from
an engraving published in another book, or from an artist's sketch, without
redrawing the figure on a new plate. It was based on the same principle that
made lithography effective: the antipathy of grease to water. The resulting print
looked like a lithograph, but the actual plate from which the new print was
pulled was a sheet of metal rather than a stone.

The printed engraving to be copied was moistened with a weak solution of
acid in gum water and pressed onto a zinc sheet. As most printing inks contain
some fatty substance, an oily impression was left behind in reverse. The zinc
sheet was then moistened. When an inked roller was passed over it, the ink
adhered to the oily lines. An impression was then taken from the inked plate.

This method was explained by the ornithologist Hugh Strickland in *The Athe-
naeum* in 1848. He used it for five plates in a book written with A. G. Melville in
1848, *The Dodo and Its Kindred; or the History, Affinities and Osteology of the Dodo,
Solitaire and Other Extinct Birds of the Islands of Mauritius, Rodrigues and Bourbon*.
Three other plates in this book demonstrated a variation on the application of
anastatic printing, which Strickland called papyrography. In this system the
artist sketched on paper with lithographic (i.e., greasy) chalk. The printer then
took an impression directly from the sketch.

The second book in which these processes were used to produce bird plates
was Sir William Jardine's *Contributions to Ornithology*, 1848–52. The printer was
Philip Henry de La Motte, the author of *On the Various Applications of Anastatic
Printing and Papyrography*, published in 1849 and printed anastatically.

The volumes of *Contributions to Ornithology* had a few etched and engraved
plates, some papyrographic plates, and many lithographic plates. A more perfect
example of the transition between the old method of engraving and the new one
of lithography as a means to illustrate books could not be found. Lithography
was the only one of these processes to be used again in a new major bird book.

Appendix C

The Main Periodicals with Engraved/Etched Bird Illustrations

1790–1813 Shaw, George. *Naturalist's Miscellany; or Coloured Figures of Natural Objects.* 24 vols. London. 1,064 hand-colored copper plates; 282 birds.

 The printer, Frederick Polydore Nodder, was the father of the *Miscellany*'s artist and engraver, Richard Polydore Nodder ("Botanical Painter to Her Majesty").

1804–1806 Sowerby, James. *British Miscellany; or Coloured Figures of New, Rare, or Little Known Animal Subjects; Many Not Before Ascertained to Be Inhabitants of the British Isles; and Chiefly in the Possession of the Author.* Issued in 12 parts, bound into 2 vols. Vol. 1, 4 colored plates of birds; vol. 2, 3 colored plates of birds.

 Artist, engraver, and colorer: James Sowerby.

1814–1817 Leach, William Elford. *The Zoological Miscellany; Being Descriptions of New or Interesting Animals.* 3 vols. Printed London: E. Nodder & Sons. 150 hand-colored copper plates; 29 birds.

 Artist and engraver: Richard P. Nodder.

1829–1836 *Loudon's Magazine of Natural History & Journal of Zoology, Botany, Mineralogy, Geology & Meteorology.* Ed. John Claudius Loudon. Ser. 1. Small engraved text figures and 18 figures of birds.

1835–1840 *Edinburgh Journal of Natural History and the Physical Sciences.* Ed.

William MacGillivray, assisted by several scientific and literary men. 2 vols. 130 hand-colored plates, of which 63 plates showed 379 species of birds. Vol. 1, 48 plates of bird portraits, with physiological details on other plates.

Engraver: S. Milne.

1848–1853 *Contributions to Ornithology.* Ed. Sir William Jardine. Annual volumes with 103 plates, including portraits of birds, physiological details, nests, and eggs. A few plates were etched and engraved, but most were produced by either papyrography or lithography, then colored by hand.

Appendix D

Editions, Impressions, and Special Issues

In the context of bird books brought out in parts, the terms "editions" and "issues" cannot be used in the sense in which the modern book trade uses them. Today a new edition should be revised and reset, while an issue or reissue is a printing from the same plates used for an earlier edition.

Since the publication of a book during the time under review was frequently a family concern and was carried out over a period of years, there was no clear-cut structure of production of an edition of a title. As orders were received throughout the time required to complete the printing and distribution of the parts, some early plates were retouched, re-etched or -engraved, or, if damaged, completely replaced for new subscribers. As a result, a late subscriber would receive some plates of the first printing and some from a later printing, distinguishable only by the paper's watermarks if a fresh supply of paper had been bought in the interval. If the author decided a second edition was warranted, he would not waste any surplus plates from the first edition, but incorporate them in some copies of the second. Sometimes the dates printed at the foot of the first-edition plate were scratched out, along with the initials or signature of the artist if he had died. William Lewin's sons obliterated lettering at the base of some etched plates issued after his death.

The effects of a large number of artists at work in one family is most evident in the case of the Hayes family. Few copies of their works show identical plates by the same artists throughout. William Hayes also used some plates from one work

to supply illustrations in an entirely different work; this, too, was common practice.

The standard of plates varies within the same edition or printing. Copies to be supplied to members of the aristocracy and other wealthy patrons probably received greater attention than copies intended for general sale. Such carefully painted copies still owned by the families whose ancestors originally acquired them show evidence of the varying standard of painting at the time the plates were produced. When teams of watercolorists were employed, as by Audubon and Havell, the standard was bound to vary. The girl who painted all the blue parts, for example, may have been more meticulous than the woman allotted the yellow pigments, and the young trainee given the grass to paint would have been more proficient by the two hundredth copy than at the start of the job.

The care with which the books have since been preserved is a factor now in the quality of the prints. Copies that have had little handling and have not been subjected to damp and dirt can be in mint condition, the paint colors as fresh and glowing as the day they were applied. Much-used copies are often faded and the pages foxed, and give but a poor indication of the quality of the book when it was new.

The practice of producing plates on paper of various sizes and qualities also produced variations in editions and impressions. All of these factors make judgment of the artists' and craftsmen's skills a very difficult task. I have taken every opportunity to see as many copies of each title as possible, in many libraries. The reader may well find additional signatures and variations in other copies, and some may throw new light on the artists and etchers.

Notes

1. THE BACKGROUND

1. Pennant, *British Zoology,* 4th ed., 1:482.
2. Bewick, *Thomas Bewick,* ed. Bain, p. 5.
3. Edwards, *Natural History of Uncommon Birds,* 4:230.
4. "Samuel Johnson," in *Dictionary of National Biography,* 15:787, noting James Boswell, *Life of Johnson,* 12 April 1778.
5. Mea Allan, *The Hookers of Kew* (London: Michael Joseph, 1979), p. 113.

2. FRANCIS WILLUGHBY AND JOHN RAY

1. Willughby and Ray, *Ornithology,* Preface.
2. Raven, *John Ray,* p. 312.
3. Scott, *Memorials of Ray,* p. 33.
4. Willughby and Ray, *Ornithology,* Preface.
5. MacGillivray, *Lives of Eminent Zoologists,* p. 151.
6. John Ray to Martin Lister, 29 November 1673, in Ray, *Correspondence of John Ray,* ed. Lankester, p. 105.
7. Peter Dent to Wray, 15 February 1674, in ibid. pp. 15–16.
8. Francis Jessop to Wray, 25 November 1668, in ibid. p. 33.
9. Ralph Johnson to Ray, 29 March 1672, in ibid. p. 108.
10. Willughby and Ray, *Ornithology,* Preface.
11. Thomas Browne to Christopher Merrett, 9th letter [c. 1668–69], in Browne, *Notes and Letters on the Natural History of Norfolk,* p. 84.
12. Ray to Dr. Martin Lister, 19 December 1674, in *Correspondence of John Ray,* ed. Lankester, p. 112–13.

13. MacGillivray, *Lives of Eminent Zoologists*, p. 152.
14. Willughby and Ray, *Ornithology*, Preface.
15. Ibid.
16. William Faithorne, *Art of Graveing and Etching*, title page.
17. Willughby and Ray, *Ornithology*, Preface.

3. ELEAZAR ALBIN

1. Bristowe, "Life and Work of the Great English Naturalist Joseph Dandridge," p. 82.
2. Sloane Manuscripts, British Museum, no. 4003, ff. 17–24.
3. Ibid., f. 17.
4. Ibid., 4065, f. 15.
5. Albin, *Proposals for Printing by Subscription A Natural History of English Insects*, Preface.
6. Albin, *A Natural History of Birds*, 3:46.
7. Frick and Stearns, *Mark Catesby, the Colonial Audubon*, p. 18, citing Nichols, *Literary Anecdotes of the Eighteenth Century*, vol. 1 (London, 1812), p. 370.
8. Sloane Manuscripts, no. 3338.
9. William Hayes, *Portraits of Rare and Curious Birds from Species in the Menagery of Child the Banker at Osterley Park near London* (London, 1799), 2:78.
10. John Bernard Burke, *A Genealogical and Heraldic History of the Extinct and Dormant Baronetcies of England, Ireland and Scotland*, 2d ed. (London, 1844), p. 1.
11. Swainson, *Taxidermy*, p. 105.
12. Wilkinson, "Evidence Concerning the Death of Eleazar Albin."

4. MARK CATESBY

1. Frick and Stearns, *Mark Catesby, the Colonial Audubon*, p. 9.
2. Nichols, *Illustrations of the Literary History of the Eighteenth Century*, 1:371.
3. Sherard to Richardson, 12 November 1720, in ibid. 1:371–72.
4. Sherard to Richardson, 28 March 1721, in ibid., p. 373.
5. Sherard to Richardson, 7 December 1721, in ibid., p. 377.
6. Sherard to Richardson, 27 January 1721–22, ibid.
7. Sherard to Richardson, 13 October 1722, in ibid., p. 381.
8. Sloane Manuscripts, no. 4047, f. 90.
9. Catesby to Sloane, 12 March 1723, in ibid., f. 147.
10. Catesby to Sloane, 15 August 1724, in ibid., f. 213.
11. Catesby to Sloane, 10 May 1723, in ibid., no. 4046, ff. 352–53.
12. Catesby to Sloane, 5 January 1725, in ibid., no. 4347, f. 307.
13. Catesby, *Natural History of Carolina*, 1:xi.
14. Ibid., p. xii.
15. Ibid.
16. Mendes da Costa, "Notes on Literati," p. 206.

5. GEORGE EDWARDS

1. Edwards, *Natural History of Uncommon Birds*, 2:120–21.
2. Ibid., 1:xvi.
3. Ibid., xix.
4. Ibid., xx.
5. Ibid., xix.
6. Ibid.

7. Ibid., 4:230.
8. Ibid., 3:107.
9. Edwards, *Gleanings of Natural History*, 1:146.
10. Ibid., 2:192.
11. Ibid., 2:ii.
12. Ibid., 2:v.
13. Ibid., 1:xxx.
14. Edwards to Linnaeus, August 1760, in Linnean Society Archives, Linnaeus Correspondence, vol. 3, no. 383.
15. Humphreys, "Edwards's Drawings of Birds," p. 190.

6. THOMAS PENNANT

1. Pennant, *Literary Life*, p. 8–9.
2. Ibid., p. 7.
3. Ibid., p. 38.
4. Ibid., p. 40.
5. Gilbert White, *Journals*, 3 November 1775, p. 114.
6. Pennant, *Literary Life*, p. 3.
7. Gilbert White to Daines Barrington, 12 April 1770, in Gilbert White, *The Natural History and Antiquities of Selborne*, ed. Richard Bowdler Sharpe (London, 1900), p. 17.
8. Pennant, *Literary Life*, p. 4.
9. White to Rev. John White, 5 March 1776, in *Life and Letters*, 1:311.
10. White to Rev. John White, 30 January 1776, in ibid., p. 302.
11. Pennant, *Literary Life*, p. 25.
12. White to Rev. John White, 27 February 1776, in *Life and Letters*, 1:308–9.
13. Pennant, *British Zoology*, p. 197.
14. Nichols, *Literary Anecdotes of the Eighteenth Century*, 8:752.
15. Pennant to Thomas Bewick, in Fox, *Synopsis of the Newcastle Museum*, p. 25.
16. Bewick, *Thomas Bewick*, ed. Bain, p. 117.
17. Wood, *Introduction to the Literature of Vertebrate Zoology*, p. 516.
18. Pennant, *Arctic Zoology*, advertisement to vol. 1.
19. Graham, *Andrew Graham's Observations*, ed. Williams, p. 389.
20. Horace Walpole to Rev. Mr. Coles, 4 May 1774, *Private Correspondence of Horace Walpole, Earl of Orford*, 4 vols. (London, 1820), 3:437.
21. Pennant to Thomas Bewick, 13 February 1798, in Fox, *Synopsis of the Newcastle Museum*, p. 25.
22. *Dictionary of National Biography*, 15:767, quoting James Boswell, *Life of Johnson*, 12 April 1778.
23. Sir William Jardine, *Hummingbirds*, Naturalist's Library, vol. 2 (Edinburgh, 1837), p. 39.

7. WILLIAM HAYES

1. Mary Delaney, *The Autobiography and Correspondence of Mary Granville, Mrs Delaney, Previously Pendarves*, ed. Lady Llanover, 2 sers., 3 vols. each (London, 1861–62), 2d ser., 1:158.
2. Walpole to Horace Mann, in *Osterley Park* (London: Victoria and Albert Museum, 1972), p. 52.
3. Nichols, *Literary Anecdotes of the Eighteenth Century*, 9:228–29.
4. Ann Hayes to Royal Literary Fund, 6 January 1804, in Archives of the Royal Literary Fund, London.
5. Post Master General's Minutes, no. 610c, 1802.

8. John Latham

1. Mathews, "John Latham, 1740–1837," p. 475.
2. Ibid., p. 467.
3. Swainson, *Taxidermy*, pp. 222–23.
4. Mathews, "John Latham, 1740–1837," p. 472.
5. *Dictionary of National Biography*, 11:606.

9. John Walcott

1. Penteycross, *A Sermon at the Funeral of Mrs Ann Walcott*, p. 3.
2. Ibid., p. 2.
3. Walcott, *British Birds*, 1:49.
4. Wood, *Introduction to the Literature of Vertebrate Zoology*, p. 617.

10. William Lewin

1. Parish Register, St. Dunstan, Stepney, baptisms, 1783.
2. Lewin's application form is in the archives of the Linnean Society:

 Mr William Lewin of Darenth in Kent, author of a work on the Birds of Great Britain with their Eggs, being desirous of becoming a Fellow of the Linnean Society; we the underwritten knowing him to be a practical naturalist, recommend him to be elected accordingly. [Signed] John Latham Thomas Marsham John Beckwith July 19 1791 [crossed out] Oct^r 18 1791 Elected Dec. 20, 1791.

3. The will of William Lewin of Hoxton, natural history painter, 12 November 1795, proved 30 December 1795 (Public Record Office, London).
4. Swainson, *Taxidermy*, p. 247.
5. Matthew Prior, "A Letter to Lady Margaret Cavendish Holles-Harley When a Child," in *The Oxford Book of English Verse* (Oxford: Clarendon Press, 1953), p. 500.
6. Swainson, *Taxidermy*, p. 247.
7. Wood, *Introduction to the Literature of Vertebrate Zoology*, p. 435.
8. Duke of Portland to Governor John Hunter, 6 February 1798, quoted in Jones, "John William Lewin," p. 37.
9. Jones, "John William Lewin," p. 38.
10. New South Wales Colonial Secretary, Returns of the Colony, 1852 (AO N. S. W. 4/285).

11. James Bolton

1. James Bolton to John Ingham, 10 February 1792, quoted in Crossland, *Eighteenth Century Naturalist*, p. 17.
2. Bolton, *Harmonia Ruralis*, 1:v.
3. Ibid., 2:"Note."
4. Bolton to Ingham, 10 February 1792, in Crossland, *Eighteenth Century Naturalist*, p. 17.
5. Edwards, *Gleanings of Natural History*, 1:46.
6. Ibid.
7. Bolton, *Harmonia Ruralis*, p. 40.
8. Delaney, *Autobiography and Correspondence*, 2d ser., 3:171.
9. Lightfoot to Bolton, October 13, 1785, in Crossland, *Eighteenth Century Naturalist*, pp. 7, 22.
10. Lightfoot, comp., *Catalogue of the Portland Museum Sale*, Day 25.
11. Catalogue of Sotheby's sale, 19 October 1954:

Bolton, James. The More Rare British Birds, with short notes and observations made from Nature chiefly regarding their food, actions, nests, eggs, etc. etc. A manuscript of some 18 pp accompanied by a series of 21 water colour drawings on vellum of Woodpeckers, Butcher Birds, Thrushes, Starlings, Robins, Titmice, Larks, Flycatchers, Wagtails, Snipe and Buntings mostly signed and dated 1782. Drawings measure 13" × 10" mounted in a folio album. £220.

According to the *Yorkshire Observer* of 20 October 1954, "Mr Traylen, of Guildford, gave £220 for a volume of drawings of rare British birds by James Bolton of Halifax at Sotheby's London, yesterday." Item 575 of C. W. Traylen's 1955 catalogue is described in terms similar to those in Sotheby's and priced at £320.

12. James Bolton, *Filices Britannicae: An History of the British Proper Ferns* (Leeds, 1785), p. xv–xvi.
13. Gilbert White to John White, 27 February 1777, in *Life and Letters of Gilbert White of Selborne*, ed. Rashleigh Holt-White, 2 vols. (London, 1901), 2:7.
14. George Caley to Sir Joseph Banks, 5 January 1798, in British Museum (Natural History) Library.
15. *Dictionary of National Biography*, 36:300.
16. J. Horsfall Turner, *Halifax Books and Authors: A Series of Articles on the Books Written by the Natives and Residents, Ancient and Modern, of the Parish of Halifax with Notices of Their Authors and the Local Printers* (Brighouse, 1906), p. 262.
17. James Bolton to Thomas Bolton, n.d., in Crossland, *Eighteenth Century Naturalist*, p. 24.

12. EDWARD DONOVAN

1. Swainson, *Taxidermy*, p. 169.
2. Donovan, *Prospectus for the Sale of Mr Donovan's Collection*, p. 15.
3. Ibid., pp. 5–6.
4. Donovan, *Natural History of British Birds*, 1:Advertisement, 7.
5. Donovan, *Naturalist's Repository*, subtitle.
6. Parkinson, "Letter", pp. 346–47.

13. GEORGE GRAVES

1. William Curtis, "George Graves, F.L.S., 1784–1839," pp. 43–44.
2. Register of births, 1720–1837, of the Southwark Monthly Meeting, Society of Friends, London.
3. Selby to Jardine, 22 July 1829, Jardine/Selby Correspondence, Balfour Library, Downing College, University of Cambridge.
4. George Graves to William Swainson, 23 November 1820, Swainson Correspondence, vol. 2., MS 271, Linnean Society Archives, London.
5. Selby to Jardine, 8 January 1829, Jardine/Selby Correspondence, Balfour Library.
6. George Graves to William Jackson Hooker, 4 March 1831, Hooker Correspondence, Royal Botanic Gardens, Kew.
7. Graves to Hooker, 10 March 1831, ibid.

14. PRIDEAUX JOHN SELBY

1. Swainson, *Taxidermy*, pp. 323–24.
2. Selby to Sir William Jardine, 13 January 1830, Jardine/Selby Correspondence, Balfour Library, Downing College, University of Cambridge.
3. Selby to Jardine, 27 February 1827, ibid.
4. Selby to Jardine, 2 September 1829, ibid.

5. Selby to Jardine, 18 January 1833, ibid.
6. Jardine to Selby, 9 March 1824, ibid.
7. Selby to Jardine, 14 December 1824, ibid.
8. Jardine to Selby, 2 May 1834, ibid.
9. Strickland, *British Association Report,* p. 202.

15. SIR WILLIAM JARDINE

1. Jardine to Selby, 15 August 1836, Jardine/Selby Correspondence, Balfour Library, Downing College, University of Cambridge.
2. John Gould to Jardine, 1 September 1830, Sir William Jardine Correspondence, Zoology Library, British Museum (Natural History).
3. Gould to Jardine, 20 December 1830, ibid.
4. Jardine to Selby, 28 August 1836, Jardine/Selby Correspondence, Balfour Library.
5. Jardine to Selby, 25 September 1827, ibid.
6. Jardine to Selby, 15 January 1834, ibid.
7. Jardine to Selby, 28 December 1831, ibid.
8. William Yarrell to Jardine, 5 August 1837, Sir William Jardine Correspondence, Zoology Library, British Museum (Natural History).
9. Hugh Edwin Strickland, *The Dodo and Its Kindred* (London, 1848), p. 135.
10. British Museum (Natural History), *The History of the Collections,* vol. 2, Appendix, p. 70.

16. JOHN JAMES AUDUBON

1. Williams, "Robert Havell, Junior, Engraver," p. 236.
2. Ibid., p. 240.
3. Ibid., p. 244.
4. Ibid.
5. Ibid., p. 241.

Selected Bibliography and Chapter Sources

BIBLIOGRAPHY

Agassiz, Louis, and Strickland, H. E. *Biographia Zoologicae et Geologiae*. 4 vols. London: Ray Society, 1848–54.

Albin, Eleazar. *A Natural History of Birds*. 3 vols. London: Innys, 1731–38.

———. *A Natural History of English Song-Birds*. London: Bettesworth & Hitch, 1737.

Alexander, W. B. "Ornithological Illustration." *Endeavour* 12 (1953): 144–53.

Anker, Jean. *Bird Books and Bird Art*. Copenhagen: Copenhagen University, 1938.

Audubon, J. J. L. *The Birds of America; from Original Drawings Made During a Residence of 25 Years in the United States*. 4 vols. London, 1827–38.

———. *Ornithological Biography, or An Account of the Habits of the Birds of the United States of America*. 5 vols. Edinburgh: Adam & Charles Black, 1831–39.

Bewick, Thomas. *Thomas Bewick: A Memoir*. Ed. Iain Bain. London: Oxford University Press, 1975.

Bland, David. *A History of Book Illustration*. London: Faber & Faber, 1958.

Boase, Frederic. *Modern English Biography*. Reprinted in 6 vols. London: Cass, 1965.

Bolton, James. *Harmonia Ruralis; or An Essay Towards a Natural History of British Song Birds*. 2 vols. Stannary near Halifax and London, 1794–96.

British Museum. *The History of the Collections in the Natural History Departments of the British Museum*. 2 vols. London, 1904–12.

Bryan, Michael. *A Biographical Dictionary of Painters and Engravers*. Ed. G. C. Williams. 5 vols. London, 1903–5.

Catesby, Mark. *The Natural History of Carolina, Florida and the Bahama Islands, Containing the*

Figures of Birds, Beasts, Fishes, Serpents, Insects and Plants. 2 vols. London: Benjamin White, 1731–43.

Desmond, Ray. *Dictionary of British and Irish Botanists and Horticulturalists Including Plant Collectors and Botanical Artists.* London: Taylor & Francis, 1977.

Dictionary of National Biography. Ed. Sir Leslie Stephens and Sir Sidney Lee. 66 vols. London: Oxford University Press, 1882–1902. Reprinted in 22 vols. London: Oxford University Press, 1908–9.

Dictionary of Welsh Biography down to 1940. London: Society of Cymmrodorion, 1959.

Donovan, Edward. *The Natural History of British Birds, or A Selection of the Most Rare, Beautiful and Interesting Birds Which Inhabit This Country.* 10 vols. London, 1794–1819.

_____. *The Naturalist's Repository, or Miscellany of Exotic Natural History Exhibiting Rare and Beautiful Specimens of Foreign Birds, Insects, Shells, Quadrupeds, Fishes and Marine Productions.* 5 vols. London, 1822–27.

_____. *The Natural History of the Nests and Eggs of the British Birds.* London, 1826.

Edwards, George. *A Natural History of Uncommon Birds and Some Other Rare and Undescribed Animals.* 4 vols. London, 1743–51.

_____. *Gleanings of Natural History, Exhibiting Figures of Quadrupeds, Birds, Insects, Plants.* 3 vols. London, 1758–64.

Fisher, S. W. *English Watercolours.* London: Ward Lock, 1970.

Frankau, Julia. *Eighteenth-Century Colour Printers: Stipple Engravings.* London: Macmillan, 1900.

Gage, A. T. *A History of the Linnean Society of London.* London: Linnean Society, 1938.

Gordon, Esme. *The Royal Scottish Academy of Painting, Sculpture and Architecture, 1826–1976.* Edinburgh: Charles Skilton, 1979.

Grant, M. H. *Dictionary of Bird Etchers.* London: Rockliff, 1952.

Graves, Algernon. *The British Institution, 1806–1867: A Complete Dictionary of Contributors and Their Work from the Foundation of the Institution.* London, 1875.

_____. *A Dictionary of Artists Who Have Exhibited Works in the Principal London Exhibitions, 1760–1893.* London, 1895.

_____. *Royal Academy of Arts: A Complete Dictionary of Contributors and Their Work, 1769–1904.* 8 vols. London, 1905–6.

Graves, George. *British Ornithology, Being the History of British Birds with an Accurately Coloured Representation of Every Known Species of British Birds.* 3 vols. London, 1811–21.

_____. *Ovarium Britannicum; Being a Correct Delineation of the Eggs of Such Birds as Are Native of, or Domesticated in Great Britain.* London, 1816.

Hardie, Martin. *Water-Colour Painting in Britain.* 3 vols. 2d ed. London: Batsford, 1962–69.

Hayes, Charles. *The Portraits of British Birds, Including Domestic Poultry and Water Fowl.* London, 1808–16.

Hayes, William. *A Natural History of British Birds, with Their Portraits, Accurately Drawn and Beautifully Coloured from Nature.* London, 1775.

_____. *Portraits of Rare and Curious Birds with Their Descriptions.* 2 vols. London, 1794–99.

_____. *Figures of Rare and Curious Birds, Accurately Drawn from Living Specimens and Faithfully Coloured.* London, 1822.

Hughes, Therle. *Prints for the Collector: British Prints from 1500 to 1900.* London: Lutterworth, 1971.

Jackson, B. D. *Guide to the Literature of Botany*. London, 1881.

Jardine, Sir William. *Hummingbirds*. 2 vols. Edinburgh: W. H. Lizars, 1833–34.

_____. *Gallinaceous Birds*. 2 vols. Edinburgh: W. H. Lizars, 1834.

_____. *Birds of Great Britain*. 4 vols. Edinburgh: W. H. Lizars, 1838–43.

_____. *Illustrations of the Duck Tribe*. Lockerby, Dumfries: Printed privately, 1839.

_____. *Leaves from the Book of Nature*. Edinburgh: W. H. Lizars, 1846.

_____. *Contributions to Ornithology for 1848–1852*. 5 vols. Edinburgh: W. H. Lizars, 1848–55.

_____ and Prideaux John Selby. *Illustrations of Ornithology*. 4 vols. Edinburgh: W. H. Lizars, 1826–43.

Johnson, Jane. *Works Exhibited at the Royal Society of British Artists, 1824–1893*. 2 vols. London: Antique Collectors' Club, 1975.

Knight, D. M. *Natural Science Books in English, 1600–1900*. London: Batsford, 1972.

Latham, John. *A General Synopsis of Birds*. 3 vols. London: Benjamin White and Leigh & Sotheby, 1781–85. 2 supplements, 1787, 1802.

_____. *A General History of Birds*. 10 vols. Winchester and London: 1821–28.

Lewin, John William. *Birds of New Holland, with Their Natural History*. London, 1808.

Lewin, William. *The Birds of Great Britain, with Their Eggs, Accurately Figured*. 7 vols. London, 1789–94.

Lightfoot, John, comp. *Catalogue of the Portland Museum Lately the Property of the Dowager Duchess of Portland, Deceased; Which Will Be Sold by Auction on Monday 24 April 1786 and 37 Days Following*. London, 1786.

MacGillivray, William. *Lives of Eminent Zoologists from Aristotle to Linnaeus*. Edinburgh Cabinet Library, vol. 16. Edinburgh, 1830.

Mitchell, Sir Peter C. *Centenary History of the Zoological Society of London*. London: Zoological Society, 1929.

Mullens, W. H., and H. K. Swann. *A Bibliography of British Ornithology from the Earliest Times to the End of 1912, Including Bibliographical Accounts of the Principal Writers and Bibliographies of Their Published Works*. London: Macmillan, 1917.

Nicholson, E. M. *Birds of England: An Account of the State of Our Bird Life and a Criticism of Bird Protection*. London: Chapman & Hall, 1926.

Nissen, Claus. *Die Illustrierten Vogelbücher: Ihre Geschichte und Bibliographie*. Stuttgart: Hiersemann, 1953.

_____. *Die Zoologische Buchillustration: Ihre Bibliographie und Geschichte*. 2 vols. Stuttgart: Hiersemann Verlag, 1966–78.

Parish Registers. Greater London Record Office, London.

Pennant, Thomas. *The British Zoology*. London: Cymmrodorion Society, 1766.

_____. *Indian Zoology*. London, 1769.

_____. *Arctic Zoology*. 2 vols. London, 1784–87.

Pepys, Samuel. *Diaries of Samuel Pepys, 1660–1669*. Ed. Robert Latham and William Matthews. 11 vols. London: Bell & Hyman, 1971–83.

Prideaux, S. T. *Aquatint Engraving*. London, 1909.

Redgrave, Samuel. *National Collection of Paintings in the South Kensington Museum*. London, 1877.

Rendle, A. B. *A Bibliographical Index of Deceased British and Irish Botanists*. Comp. James

Britten and George S. Boulger. 2d ed., comp. A. B. Rendle. London: Taylor & Francis, 1931.

Ronsil, René. *Bibliographie Ornithologique Française.* 2 vols. Paris: Lechevalier, 1948–49.

Sawyer, F. C. *A Short History of the Libraries and List of Manuscripts and Original Drawings in the British Museum (Natural History).* Bulletin of the British Museum (Natural History), Historical vol. 4, no. 2 (1971).

Selby, P. J. *Illustrations of British Ornithology, or Figures of British Birds in Their Full Natural Size.* 2 vols. Edinburgh: W. H. Lizars, 1819–34.

_____. *Pigeons.* Edinburgh: W. H. Lizars, 1835.

_____. *Parrots.* Edinburgh: W. H. Lizars, 1836.

Slater, J. H. *Engravings and Their Value.* 6th ed. London: Exchange & Mart, 1933.

Sloane Manuscripts, British Museum, London.

Swainson, William. *Taxidermy, with the Biographical Zoologists and Notices of Their Works.* London, 1840.

Taylor, Basil. *Animal Painting in England from Barlow to Landseer.* London: Penguin, 1955.

Wheatley, H. B. *The Early History of the Royal Society.* London, 1905.

Williams, T. I. *A Biographical Dictionary of Scientists.* London: Bell & Hyman, 1969.

Willughby, Francis, and John Ray. *Ornithologia Libri Tres.* London: J. Martyn, 1676.

_____ and _____. *The Ornithology of Francis Willughby.* London, 1678.

Wilson, Alexander. *American Ornithology; or the Natural History of the Birds of the United States. The Illustrative Notes and Life of Wilson by William Jardine.* Edinburgh: W. H. Lizars, 1832.

Wood, Casey A. *An Introduction to the Literature of Vertebrate Zoology Based Chiefly on the Titles in the Blacker Library of Zoology, the Emma Shearer Wood Library of Ornithology, the Bibliotheca Osleriana, and Other Libraries of the McGill University, Montreal.* Montreal, 1931.

Zimmer, J. T. *Catalogue of the Edward E. Ayer Ornithological Library, Field Museum, Chicago.* 2 vols. Chicago, 1926.

CHAPTER SOURCES

1. The Background

Barlow, Francis. *Aesop's Fables.* London, 1665.

_____. *Multae et Diversae Avium Species Multifariis Formis et Pernaturalibus Figuris.* London, 1671.

_____. *Several Ways of Hunting, Hawking and Fishing According to the English Manner.* London, 1671.

_____. *Various Birds and Beasts Drawn from the Life.* London, 1690.

Bewick, Thomas. *Thomas Bewick: A Memoir.* Ed. Iain Bain. London: Oxford University Press, 1975.

Blome, Richard. *The Gentleman's Recreation.* London, 1686.

Carew, Richard. *The Survey of Cornwall.* London, 1602.

Charleton, Walter. *Onomasticon Zoicon.* London, 1668.

Coombs, David. *Sport and the Countryside in English Painting, Watercolours and Prints.* London: Phaidon, 1978.

Cotton, John. *The Resident Song Birds of Great Britain.* 2 vols. London, 1835–38.

Dampier, William. *A New Voyage Round the World Describing Particularly the Isthmus of America.* London, 1697.

Hardie, Martin. *Water-Colour Painting in Britain.* 3 vols. London: Batsford, 1966–69.

Hunt, John. *British Ornithology, Containing Portraits of All the British Birds, Including Those of Foreign Origin, Drawn, Engraved and Coloured.* 3 vols. Norwich, 1815–22.

Martyn, W. F. *A New Dictionary of Natural History.* London, 1785.

Montagu, George. *Ornithological Dictionary, or Alphabetical Synopsis of British Birds.* London, 1802.

Pennant, Thomas. *The British Zoology.* 4th ed. 4 vols. London, 1776–77.

Perrott, Charlotte Louisa Emily. *A Selection of British Birds from Drawings by C. L. E. Perrott.* London: Robert Havell, 1835.

Plot, Robert. *The Natural History of Oxfordshire.* Oxford, 1677.

———. *The Natural History of Staffordshire.* Oxford, 1686.

Ray, John. *Synopsis Methodica Avium et Piscium; Opus Posthumum.* Ed. William Derham. London, 1713.

Richardson, Sir John. *Fauna Boreali-Americana, or the Zoology of the Northern Parts of British America, Containing Descriptions of the Objects of Natural History Collected on the Late Northern Land Expeditions under Command of Captain Sir John Franklin.* London: Murray, 1829–37.

Shield, George. *Ornithologia Britannica.* London, 1840–41.

Sweet, Robert. *The British Warblers: An Account of the Genus Sylvia.* London, 1823–32.

Syme, Patrick. *A Treatise on British Song-birds.* Edinburgh: Anderson, 1823.

Tradescant, John. *Musaeum Tradescantianum, or a Collection of Rarities Preserved at South Lambeth.* London, 1656.

Tucker, Andrew. *Ornithologia Danmonensis.* London, 1809.

Turner, William. *Avium Praecipuarum quarum apud Plinium et Aristotelem Mentio est Brevis et Succincta Historia.* Cologne, 1544.

Whiteley, H. *Natural History of British Tits.* London, 1846.

———. *Natural History of British Finches.* London, 1847.

Wilson, James. *Illustrations of Zoology.* Edinburgh, 1831.

Yarrell, William. *A History of British Birds.* 3 vols. London: Van Voorst, 1837–43.

Young, William Weston. *Prospectus for British Ornithology, or History of Birds.* London, [1804].

2. John Ray and Francis Willughby

Boulanger, G. S. "Unpublished Material Relating to John Ray." *Essex Review,* 1917, pp. 57–129.

Browne, Sir Thomas. *Notes and Letters on the Natural History of Norfolk, More Especially on the Birds and Fishes, and Letters to Christopher Merrett, from the Manuscripts of Sir Thomas Browne MD 1605–1683 in the Sloane Collection in the Library of the British Museum and the Bodleian Library, Oxford.* With notes by Thomas Southwell. London: Jarrolds, 1902.

———. *Works.* Ed. Simon Wilkins. 4 vols. London, 1835–36. 1:337.



Derham, William. *Philosophical Letters Between the Late Mr Ray and Several of His Ingenious Correspondents.* London, 1718.

Gadow, Hans. "F. L. Baldner of Strasbourg." *The Field,* 26 October 1907, p. 765.

Grew, Nehemiah. *Catalogue of Rarities Belonging to the Royal Society.* London, 1685.

Gurney, J. H. *Early Annals of Ornithology.* London, 1921.

Hooke, Robert. *The Diary of Robert Hooke, 1672–1680.* Transcribed from original in possession of corporation of City of London (Guildhall Library). Ed. Henry W. Robinson and Walter Adams. London: Taylor & Francis, 1935.

Jardine, Sir William. Naturalist's Library. Biographies, vols. 8 (Ray) and 36 (Willughby).

MacGillivray, William. *Lives of Eminent Zoologists from Aristotle to Linnaeus.* Edinburgh, 1830. Pp. 136–182.

Merrett, Christopher. *London Royal College of Physicians Catalogus Librorum.* London, 1660.

———. *Pinax Rerum Naturalium Britannicarum.* London, 1667.

Nottingham Museums and Library Committee. *The Story of Wollaton Hall.* 4th ed. Nottingham, 1972.

Pepys, Samuel. *The Diary of Samuel Pepys, 1660–1669.* Ed. Robert Latham and William Matthew. 11 vols. London: Bell & Hyman, 1971–83.

Petiver, James. *Musei Petiveriania.* London, 1695–1703.

Raven, C. E. *John Ray, Naturalist: His Life and Works.* Cambridge: Cambridge University Press, 1942.

Ray, John. *Travels Through the Low Countries, Germany, Italy, and France.* London, 1673.

———. *Original Letters of Eminent Literary Men.* London: Camden Society, 1843. Pp. 194–210.

———*Correspondence of John Ray: Consisting of Selections of the Philosophical Letters Published by Dr Derham and Original Letters of John Ray in the Collection of the British Museum.* Ed. Edwin Lankester. London: Ray Society, 1848.

———. *Further Correspondence of John Ray.* Ed. R. W. T. Gunther. London, 1928.

Scott, George. *Select Remains of the Learned John Ray.* London, 1760. Reprinted as *Memorials of John Ray.* London: Ray Society, 1846.

Tradescant, John. *Musaeum Tradescantianum, or a Collection of Rarities Preserved at South Lambeth.* London, 1656.

Wheatley, H. B. *The Early History of the Royal Society.* London, 1905.

Williams, T. I. *A Biographical Dictionary of Scientists.* London: Bell & Hyman, 1969.

3. Eleazar Albin

Albin, Eleazar. *Proposals for Printing by Subscription A Natural History of English Insects.* London, 1714.

Bristow, W. S. "The Life and Work of the Great English Naturalist Joseph Dandridge, 1664–1746." *Entomologists Gazette* 18 (1967): 73–89.

———. "More about Joseph Dandridge and His Friends James Petiver and Eleazar Albin." *Entomologists Gazette* 18 (1967): 197–201.

Fox, G. T. *Synopsis of the Newcastle Museum, Late the Allen, Formerly the Tunstall or Wycliff Museum, to which are Prefixed Memoirs of Mr Tunstall, the Founder, and of Mr Allen, the Proprietor, of the Collection.* Newcastle, 1827.

Frick, G. F., and R. P. Stearns. *Mark Catesby, the Colonial Audubon.* Urbana: University of Illinois Press, 1961. Albin references: pp. 18, 60, 62.

Lightfoot, John, comp. *Catalogue of the Portland Museum, Lately the Property of the Dowager Duchess of Portland, Deceased; Which will be Sold by Auction on Monday 24 April and 37 Days Following.* London, 1786. Lot 2809.

Sclater, W. L. *Notes on the Early Sources of Our Knowledge of African Ornithology.* London, 1929.

Sloane Manuscripts, British Museum, London, MSS 3338, 4003, 4065, 4066.

Swainson, William. *Taxidermy, with the Biographies of Zoologists and Notices of Their Works.* London, 1840.

Warren, C. H. "A Countryman's Journal." *The Field,* 25 May 1946, p. 586.

Weiss, H. B. "Two Entomologists of the Eighteenth Century: Eleazar Albin and Moses Harris." *Scientific Monthly* 2 (1926): 558–64.

Wilkinson, Ronald S. "Evidence Concerning the Death of Eleazar Albin." *Entomologists' Record* 89 (1977): 220–21.

4. Mark Catesby

Baker, C. H. C., and M. I. Baker. *The Life and Circumstances of James Brydges, First Duke of Chandos, Patron of the Liberal Arts.* London: Oxford University Press, 1949.

Beer, Gavin de. *Sir Hans Sloane and the British Museum.* London: Oxford University Press, 1953.

Coats, Alice M. *Quest for Plants: A History of the Horticultural Explorers.* London: Black, 1969.

Dillenius, J. J. *Hortus Elthamensis.* London, 1732.

Frick, G. F., and R. P. Stearns. *Mark Catesby, the Colonial Audubon.* Urbana: University of Illinois Press, 1961.

"List of Deaths for the Year, A." *Gentleman's Magazine* 19 (1749): 573.

McAtee, W. L. "The North American Birds of Mark Catesby and E. Albin." *Journal of the Society for the Bibliography of Natural History* 3 (1957): 177–94.

Mendes da Costa, Emmanuel. "Notes on Literati." *Gentleman's Magazine* 1 (1812): 206.

Nichols, John. *Literary Anecdotes of the Eighteenth Century.* 9 vols. London, 1812–15. 6:78.

———. *Illustrations of the Literary History of the Eighteenth Century.* 8 vols. London, 1817–58. 1:371–92.

Petersen, C. G. "The Elusive Mr Catesby." *Frontiers* 10 (1946): 71–73.

Pulteney, Richard. *Historical and Biographical Sketches of the Progress of Botany in England from Its Origin to the Introduction to the Linnean System.* 2 vols. London, 1790.

Sloane Manuscripts, British Museum, MSS 4046, 4047.

Stone, Witmer. "Some Early American Ornithologists. I. Mark Catesby." *Bird Lore* 7 (1905): 126–29.

5. George Edwards

Frick, G. F., and R. P. Stearns. *Mark Catesby, the Colonial Audubon.* Urbana: University of Illinois Press, 1961.

Gardner, H. Bellamy. "Chelsea Porcelain—the Chelsea Birds." *Transactions of the English Porcelain Circle* 111 (1931): 55–64.

Humphreys, A. L. "Edwards's Drawings of Birds: Sir Hans Sloane." *Notes and Queries* 11, ser. 4 (2 September 1911): 190–93.

James, T. E. "George Edwards, F.R.S. (1694–1773): An Eighteenth Century Naturalist." *Science Progress* 27 (1932–33): 486–93.

McAtee, W. L. "A Linnean Paper Needing Further Attention." *Journal of the Society for the Bibliography of Natural History* 2 (October 1950): 216.

————. "The North American Birds of George Edwards." *Journal of the Society for the Bibliography of Natural History* 2 (October 1950): 194.

"Memoir of George Edwards." *Annual Register* 5 (1776): 55–59.

Nichols, John. *Literary Anecdotes of the Eighteenth Century.* 9 vols. London, 1812–15. 5:317–26.

Robson, James. *Some Memoirs of the Life and Works of George Edwards.* London, 1776.

6. Thomas Pennant

"Apprentices of Great Britain, 1710–62." Manuscript in archives of Society of Genealogists, London. "1724 Peter Paillou."

Brown, Peter. *New Illustrations of Zoology; Containing 50 Coloured Plates of New, Curious and Non-descript Birds, with a Few Quadrupeds, Reptiles, and Insects, with Descriptive Letterpress in English and French* (by Thomas Pennant). 1776. Ornithology on pp. 1–104.

Collins, Charles. *Icones Avium cum Nominibus Anglicis.* 1736.

Dawson, W. R., ed. *The Banks Letters: A Calendar of the Manuscript Correspondence of Sir Joseph Banks Preserved in the British Museum (Natural History) and other Collections in Great Britain.* London: British Museum, 1958.

Dictionary of Welsh Biography down to 1940. London: Society of Cymmrodorion, 1959.

Foster, Sir William. *John Company.* London: John Lane, 1926.

Fox, G. T. *Synopsis of the Newcastle Museum, Late the Allen, Formerly the Tunstall or Wycliffe Museum, to which are Prefixed Memoirs of Mr Tunstall, the Founder, and of Mr Allen, the Proprietor, of the Collection.* Newcastle, 1827.

Graham, Andrew. *Andrew Graham's Observations on Hudson's Bay, 1767–1791.* With an Introduction by Richard Glover. Hudson's Bay Record Society Publications, vol. 37. London, 1969.

Graves, Algernon. *A Dictionary of the Artists who Exhibited in the Principal Exhibitions, 1760–1893.* London, 1895. Lists pictures by Peter Brown, Moses Griffith, and Peter Mazell.

Hardie, Martin. *Water-Colour Painting in Britain,* vol. 1, *Eighteenth Century.* London: Batsford, 1966.

Isham, James. *Observations on Hudson's Bay (1743–49).* Includes biography of James Isham; introduction by E. E. Rich. Hudson's Bay Record Society Publications, vol. 12. London, 1949.

Jardine, Sir William. *The Natural History of Hummingbirds.* 2 vols. Naturalist's Library, vol. 3. Edinburgh, 1834. Pp. 1–65.

Lightfoot, John. *Flora Scotica.* 1777. 66-page section on Caledonian zoology, by Thomas Pennant.

Lysaght, Averil. "Some Eighteenth Century Bird Paintings in the Library of Sir Joseph Banks." *Bulletin of the British Museum (Natural History)* 1, Historical Series no. 6 (April 1959): 253–366.

Mullens, W. H. "Thomas Pennant, 1726–1798." *British Birds* 2 (1908–9): 259–66.

Parkins, W. T. "Memoirs of Thomas Pennant." In Thomas Pennant, *A Tour in Wales.* ed. Sir John Rhys, 3 vols. London, 1883.

Pennant, Thomas. *The Literary Life of the Late Thomas Pennant, Esq., by Himself.* London, 1793.

———. *Tour on the Continent.* Ed. G. R. De Beer. London: Ray Society, 1948.

Rees, Eiluned, and G. Walter. "The Library of Thomas Pennant." *Library,* 5th ser., 26 (June 1970): 56–58.

Smith, Edward. *The Life of Joseph Banks.* London, 1911.

Sparrow, W. S. *British Sporting Painters.* London: John Lane; New York: Scribner's, 1931.

Taylor, Basil. *Animal Painting in England from Barlow to Landseer.* London: Penguin, 1955.

"Thomas Pennant." *Gentleman's Magazine* 2 (1798): 1090. Obituary.

Vertue, George. *Notebooks,* no. 3. Walpole Society, vol. 22. London, 1933–34.

White, Gilbert. *Life and Letters of Gilbert White of Selborne.* Ed. Rashleigh Holt-White. 2 vols. London, 1901.

———. *Gilbert White's Journals.* Ed. Walter Johnson. Newton Abbott: David & Charles, 1970. Original manuscript in British Museum, London.

Williams, I. A. *Early English Watercolours.* London: Connoisseur, 1952.

7. *William Hayes*

Canterbury Cathedral Archives. Treasurer's Account Book, 1798–99; 18 November 1799.

Census of England and Wales, 1841, 1851, 1861, 1871. Returns for Southall (Norwood).

Child family papers. Middlesex County Record Office. Acc. 180/533, Survey and Rental, 1778.

Farington, Joseph. *The Farington Diary, 1793–1821.* Ed. James Grieg. 6 vols. London: Hutchinson, 1922–28.

Graves, Algernon. *Royal Academy Exhibitions: A Complete Dictionary, 1769–1904.* London, 1907.

Nichols, John. *Literary Anecdotes of the Eighteenth Century.* 9 vols. London, 1812–15. 9:228–29.

Parish register: St. Luke, Chelsea. Baptisms, 1735–85; Burials, 1767–86.

———. St. Mary Norwood, Middlesex. Baptisms, 1760–99; Burials, 1759–1952.

Post Office Archives. Postmaster General's Minutes. No. 610c, 1802; no. 273, 31 March 1829; no. 274, 8 April 1829.

Royal Literary Fund, Archives. Letters from Ann Hayes, 6 January 1804 and 23 January 1804; from George Henry Glasse on behalf of William Hayes, 10 December 1799. Minutes, 21 November 1799.

8. *John Latham*

Isham, James. *Observations on Hudson's Bay (1743–49).* Includes biography of James Isham; introduction by E. E. Rich. Hudson's Bay Record Society Publications, vol. 12. London, 1949.

"John Latham." *Annual Register,* 1837, p. 178. Obituary.

"John Latham." *Gentleman's Magazine,* July 1837, pp. 92–93. Obituary.

"John Latham." *Magazine of Zoology and Botany* 2 (1838): 385. Obituary.

Mathews, Gregory Macalister. "John Latham, 1740–1837, an Early English Ornithologist." *Ibis*, 1931, pp. 466–75.

Rienits, Rex, and Thea Rienits. *Early Artists in Australia*. Sydney: Angus & Robertson, 1963.

Sawyer, F. C. "Notes on Some Original Drawings Used by Dr John Latham." *Journal of the Society for the Bibliography of Natural History* 2 (5 September 1949): 173–80.

9. John Walcott

Aveling, T. W. B. *Memorials of the Clayton Family*. London, 1867.

"Dorothy Walcott." *Gentleman's Magazine* 102, no. 2 (1832): 189. Obituary.

"John Walcott." *Gentleman's Magazine* 101, no. 1 (1831): 283. Obituary.

"Notes on Walcott Family." *Notes and Queries*, 16 May 1896, p. 383.

Pentycross, Thomas. *A Sermon at the Funeral of Mrs Ann Walcott Wife of John Walcott Esq. and Daughter of John Lloyd Esq of Bath, Delivered in the Countess of Huntingdon's Chapel at That Place on Sunday the 24th March 1782*. Bath, 1782.

Quaritch, Bernard, Ltd. Catalogue no. 796. London, 1959. Item 134.

Sotheby, Parke, and Bernet. Catalogue for sale Monday, 22 July 1974. London. Lot 176.

Walcott, E. C. M. "Walcott Family Pedigree." Additional MS 29743, British Museum. An inaccurate family tree.

Walcott, John. *A Catalogue of a Curious and Valuable Collection of English Books Being the Library of John Walcott [Walcott's father] Which will be Selling on Wednesday Oct. 16, 1776 at His House the Corner of Upper-Charles-street, 1675 items*. MS 824b 17(6), British Museum.

10. William Lewin

Graves, Algernon. *Dictionary of Exhibitors at the Society of Artists of Great Britain, 1760–91, and the Free Society of Artists, 1761–83*. London: Kingsmead, 1969.

Jones, Phyllis Mander. "John William Lewin: A Memoir." *Biblionews* 6 (November 1953): 36–45.

Lewin, William. "Observations of Some Rare English Insects." *Transactions of the Linnean Society* 3 (1797): 1–4.

Lightfoot, John, comp. *A Catalogue of the Portland Museum Lately the Property of the Dowager Duchess of Portland, Deceased; Which Will be Sold by Auction on Monday 24 April 1786 and 37 Days Following*. London, 1786.

Parish register: St Dunstan, Stepney. Baptisms, 1740–98; Marriages, 1754–1814.

————. All Saints, Edmonton. Burials, 1795.

Registrar of Births, Deaths, and Marriages. St. Catherine's House, London. Index of Deaths, 1850.

Rienits, Rex, and Thea Rienits. *Early Artists in Australia*. Sydney: Angus & Robertson, 1963.

Smith, Bernard. *European Vision and the South Pacific, 1768–1850: A Study in the History of Art and Ideas*. London: Oxford University Press, 1960.

11. James Bolton

Crossland, Charles. *An Eighteenth Century Naturalist: James Bolton, Halifax*. Halifax, Yorkshire, 1910.

————. "Halifax Biography and Authors. Part 3. Natural History." *Transactions of the Halifax Antiquarian Society*, 1911, pp. 253–78.

Delaney, Mary. *The Autobiography and Correspondence of Mary Granville, Mrs Delaney, Previously Pendarves.* Ed. Lady Llanover. 2 sers., 3 vols. each. London, 1861–62. Ser. 2, 3:171 (10 December 1783).

Leeds Mercury, 19 January 1799.

Lightfoot, John, comp. *A Catalogue of the Portland Museum Lately the Property of the Dowager Duchess of Portland, Deceased; Which Will be Sold by Auction on Monday 24 April 1786 and 37 Days Following.* London, 1786.

Moorhouse, Sydney. "The Boltons of Halifax." *Journal of Botany* (London) 79 (1941): 156–58.

12. Edward Donovan

Allingham, E. G. *A Romance of the Rostrum.* London, 1904.

Donovan, Edward. *Prospectus for the Sale of Mr Donovan's Collection of the Natural Productions of the British Isles; Known Heretofore under the General Appellation of the London Museum and Institute of Natural History.* London, 1817.

————. *To the Patrons of Science, Literature and the Fine Arts. E. D. Solicits Permission to Submit a Memorial of His Case with Certain Booksellers.* London, 1833.

————, comp. *Catalogue of the Leverian Museum.* London, 1806.

"Edward Donovan." *Annual Register,* 1837, p. 174. Obituary.

"Edward Donovan." *Gentleman's Magazine* 2 (1837): 96. Obituary.

"Edward Donovan." *Magazine of Zoology and Botany* 2 (1838): 292. Obituary.

Feltham, John. "Exhibition of Natural Curiosities. The London Museum." In Feltham, *Pictures of London,* pp. 285–87. London, 1808.

Mullens, W. H. "Some Museums of Old London, 1. The Leverian Museum." *Museums Journal* 15 (1915–16): 123–29, 162–72.

Parkinson, James. "Letter Relative to Mr Donovan's Museum." *Philosophical Magazine* 38 (1807): 346–47.

Reynell, A. "Notes on Donovan's 'The Naturalist's Repository.'" *Proceedings of the Malacological Society* (London) 12 (1917): 309–11.

Smith, W. J. "A Museum for a Guinea." *Country Life* 127 (10 March 1960): 494–95.

Swainson, William. *A Preliminary Discourse on the Study of Natural History.* London, 1830.

————. *Taxidermy, with the Biographies of Zoologists and Notices of Their Works.* London, 1840.

13. George Graves

Bullock, William. *A Companion to Mr Bullock's London Museum and Pantherion.* 17th ed. London, 1816.

Curtis, William. "George Graves, F.L.S., 1784–1839." *Watsonia* 2 (1951): 93–99.

————. *William Curtis: Botanist.* London, 1941.

Gray's Annual Directory of Edinburgh, 1834–35.

Hooker, William Jackson. Correspondence. Royal Botanic Gardens, Kew.

Jackson, B. D. *Guide to the Literature of Botany.* London, 1881.

Jerdon, William. *Men I Have Known.* London, 1866. Bullock references: pp. 67–82.

Pritzel, G. A. *Thesaurus Literaturae Botanica*. London, 1851.

Rendle, A. B., ed. *A Biographical Index of Deceased British and Irish Botanists*, compiled by James Britten and George S. Boulger. 2d ed. rev. London, 1931.

Smith, Joseph. *A Descriptive Catalogue of Friends' Books, or Books Written by Members of the Society of Friends from Their First to Their Present Times*. 2 vols. London: Joseph Smith, 1893.

Swainson, William. Correspondence. Linnean Society. London.

14. Prideaux John Selby

Embleton, R. C. "Memoir of P. J. Selby." *History of Berwickshire Naturalists' Club* 5 (1863–68): 336–38.

Gordon, Esme. *The Royal Scottish Academy of Painting, Sculpture and Architecture, 1826–1976*. Edinburgh: Charles Skilton, 1976.

Jardine, Sir William/P. J. Selby. Correspondence. Balfour Library, Downing College, University of Cambridge.

Jenyns, Leonard. *Reminiscences of Prideaux John Selby and Twizell House, also Brief Notices of Other North Country Naturalists*. Bath: Privately printed, 1885.

"P. J. Selby." *Gentleman's Magazine* 2 (1867): 685. Obituary.

Strickland, Hugh E. *British Association Report*. London, 1844.

15. Sir William Jardine

British Museum. *The History of the Collections in the Natural History Departments of the British Museum*. 2 vols. London: British Museum, 1904–12. Richard Bowdler Sharpe, "Account of the British Museum Natural History Collections: Birds," 2: 79–505. "Sir William Jardine," 2, Appendix: 70.

Gadow, Hans. "The Ornithological Collection of the University of Cambridge." *Ibis*, 1910, pp. 47–53.

Horsfield, Thomas, and Frederick Moore. *Catalogue of the Birds in the Museum of the East India Company*. 2 vols. London, 1853–58.

Jardine, Sir William. Correspondence. Zoology Library, British Museum (Natural History), London.

——/P. J. Selby. Correspondence. Balfour Library, Downing College, University of Cambridge.

Pitman, Joy. *Manuscripts in the Royal Scottish Museum, Edinburgh*. Pt. 1, "William Jardine papers." Edinburgh, 1981.

"Sale of Sir William Jardine's Birds." *Nature* (1886): 199.

"Sir William Jardine." *Nature*, November 26, 1874, p. 74. Obituary.

"Sir William Jardine." *Proceedings of the Royal Society of Edinburgh* 9 (1874): 20. Obituary.

Strickland, Hugh E. "Anastatic Printing." *Athenaeum*, 1848: 172–276.

16. John James Audubon

Adams, A. B. *John James Audubon: A Biography*. New York: Putnam, 1967.

Audubon, John James. *Ornithological Biography, or an Account of the Habits of the Birds of the United States of America; Accompanied by Descriptions of the Objects Represented in the Work*

Entitled "Birds of America" and Interspersed with Delineations of American Scenery and Manners. 5 vols. Edinburgh, 1831–39.

_____. *Letters of John James Audubon, 1826–40.* Ed. Howard Corning. Boston: Club of Odd Volumes, 1930.

_____. *The Original Watercolor Paintings by John James Audubon for "The Birds of America."* Introduction by M. B. Davidson. 2 vols. New York: New-York Historical Society, 1966.

Fries, W. H. *The Double Elephant Folio: The Story of Audubon's "Birds of America."* Chicago: American Library Association, 1973.

Herrick, Francis. H. *Audubon the Naturalist.* 2 vols. New York, 1917.

Williams, G. A. "Robert Havell, Junior, Engraver of Audubon's *The Birds of America.*" *Print Collector's Quarterly* 6 (1916): 227–57.

Name Index

Abdy, Sir Robert, 3d bart. (d. 1748), 67, 69
Adam, Robert (architect; 1728–92), 127
Adams, Dr. A. Leith (1826–82), 219
Albemarle, Ann, Duchess of (d. 1754), 67
Albemarle, Christopher, 2d duke of (governor of Jamaica; 1653–88), 78
Albertus Magnus (1206–80), 247
Albin, Ann (b. 1717), 70
Albin, Augustus Innys (b. 1712), 69
Albin, Caesar (b. 1716), 69
Albin, Eleazar (fl. 1708–41/42), 14, 25, 27–29, 34, 37, 40, 43, 62–75, 92, 106, 170
Albin, Elizabeth (wife of Eleazar), 62
Albin, Elizabeth (daughter of Eleazar; 1708–41?), 40, 62, 65, 68–71, 74
Albin, Fortinalus (b. 1719), 69
Albin, James (1722–23), 65, 70
Albin, Jane (b. 1721), 70
Albin, John (1714–39), 70
Albin, Judith (b. 1725), 65, 70
Albin, Roberta (b. 1709), 69
Aldrovandi, Ulisse (1522–1605), 53, 248
Allan, George (1736–1800), 112
Anglesey Abbey, Cambridgeshire, 108
Anstruther, Sir John (1753–1811), 145
Archibishop Marsh's Library, Dublin, 74
Arden, Lady Margaret Elizabeth (wife of Charles George, 2d baron Arden; d. 1851), 166, 168
Ashmolean Museum, Oxford, 44
Audubon, John James L. (1785–1851), 13, 25, 27, 29, 32, 39, 43, 47, 204, 206, 212, 214, 220, 222, 230–46, 254, 259
Audubon, John Woodhouse (1812–62), 231, 241
Audubon, Lucy (née Bakewell; 1788–1874), 231, 232, 238, 245
Audubon, Victor Gifford (1809–57), 231, 241
Ayer Library, Chicago, 74, 93

Bachman, Rev. Dr. John (of Charleston; 1790–1874), 240–41

Bacon, Nathaniel (fl. 1663), 49
Bakewell, Lucy Green. See Audubon, Lucy
Baldner, Fischer Leonhard (of Strasbourg; 1612–94), 53, 249
Balfour Library, University of Cambridge, 99
Baltimore, Cecilius Calvert, 2d baron (1605–75), 86
Banks, Sir Joseph (1743–1820), 36, 41, 103, 104, 111, 117, 118, 127, 137, 139, 143, 145, 166, 177, 185, 195
Barlow, Francis (c. 1626–1704), 23, 24, 25, 28, 29, 30, 38, 43, 57, 108, 252
Barnard, Emma. See Willughby, Emma
Barnard, Sir Henry, 53
Barrington, Daines (1727–1800), 104, 108, 111, 117
Bartram, John (1699–1777), 86, 97
Bartram, William (1739–1823), 86, 97
Bath and West of England Society, 149
Beaufort, Mary Somerset, Duchess of (wife of Henry Somerset, m. 1657; 1630?–1714), 63, 65
Beckwith, John (entomologist; fl. 1791), 159
Beechey, Capt. Frederick William (1796–1856), 41
Belon, Pierre (c. 1517–64), 247–48
Bennini, Lorenzo (of Florence; c. 1594), 248
Berwickshire Naturalists' Field Club (1831–), 201
Bevere, Pieter Cornelis de (c. 1722–81), 94, 119
Bewick, Thomas (1753–1828), 23, 28, 42, 112, 115, 120, 204, 208, 220
Bladon, Charles (on Delaware river 1777–86; 1748–1820), 117
Blome, Richard (d. 1705), 23, 38, 252
Blyth, Edward (curator of Asiatic Museum, Calcutta, 1842–64; 1810–73), 223
Bolton, James (d. 1799), 29, 34, 42, 45, 112, 163, 169–80
Bolton, Thomas (d. 1778), 163, 169, 174–75
Bontius, Jacobus (fl. mid-17th century), 248

Bowie, James (botanist, South Africa, 1817–23 and 1827; d. 1853), 219
Boyle, Hon. Robert (director, East India Company; 1627–91), 37, 53
Boys, Dr. William (of Sandwich, Kent; 1735–1803), 161
Brisson, Mathurin Jacques (1723–1806), 155
British Association for the Advancement of Science (1831–), 206
British Museum (1753–), 41, 59, 97, 108, 117, 139, 198, 215
British Museum (Natural History), 78, 97, 99, 128, 129, 131, 193, 215, 220, 227
Brookshaw, George (fl. 1804–19), 253
Brown, Peter (fl. 1760–91), 42, 110, 111, 115, 116
Brown, Robert (botanist, British Museum, 1827–57; 1773–1858), 41
Brown, Captain Thomas (curator, Manchester Natural History Museum, 1838–62; 1785–1862), 45
Browne, A. H., 212
Browne, Joseph (fl. 1677–86), 44
Browne, Sir Thomas (1605–82), 52, 53, 55, 59, 67
Brydges, Duke of. See Chandos, James
Buchoz, Pierre Joseph (1731–1807), 111
Buckley, Edward (surgeon, Madras, 1682–1714; c. 1660–1714), 59
Buffon, George Louis Leclerc, comte de (1707–88), 143
Bullock, William (museum owner; 1775–c. 1840), 41, 142, 144, 146, 195, 198
Bulwer, Rev. James (chaplain, Madeira, 1828; 1794–1879), 219
Burghers, Michael (of Amsterdam; to Oxford 1673; 1653?–1727), 44
Bute, John Stewart, 3d earl of (1713–92), 97
Byrd, William (of Virginia, in England 1696–1704; 1674–1744), 86

Caley, George (collector for Banks; 1770–1829), 177
Carew, Richard (of Antony, Cornwall; 1555–1620), 44
Caroline (queen of George II; 1683–1737), 72, 86
Catesby, Mark (1683–1749), 13, 25, 27, 29, 36, 37, 41, 43, 65, 76–87, 92, 97, 98, 106, 115, 174, 245
Cecil Higgins Museum, Bedford, 108
Chandos, Cassandra, Duchess of (née Willughby, c. 1670–1735), 53, 71
Chandos, James Brydges, 1st duke of (1674–1744), 72, 77
Charles II (r. 1660–85), 43
Charleton, Walter (1619–1707), 25, 26, 57, 252
Chenu, Jean-Charles (1808–79), 225
Child, Robert (1739–82), 127, 131

Child, Sarah (daughter of Gilbert Jodrell, m. Robert Child 1763, m. 3d baron Ducie 1791; d. 1793), 127, 129, 130
Clark, William Brown (of Belford Hall; 1807–42), 206
Clowes, Butler (d. 1782), 171
Clusius, Carolus (c. 1605), 248
College of Physicians, 54, 63, 65, 72, 89, 91, 93, 97, 99, 102
Collins, Charles (1680–1744), 10, 108, 109
Collinson, Peter (botanist; 1693–1768), 83, 86
Colnaghi, Paul (1751–1833), 236
Cook, Captain James (navigator; 1728–79), 41, 110, 137, 140, 143, 145, 195
Copley, Sir Godfrey (founder of Copley medal, Royal Society, 1709), 94
Coriolano, Cristoforo (c. 1600), 248
Cotton, John (1802–49), 45
Countess of Huntingdon's Connection, 148
Curtis, Mary. See Graves, Mary
Curtis, Thomas (1749–c. 1806), 190
Curtis, William (1746–99), 190, 191, 193

Dale, Samuel (physician and botanist of Braintree, Essex; c. 1659–1739), 59
Dampier, William (navigator; 1652–1739), 39, 41
Dandridge, Joseph (1665–1747), 63, 72
Daniell, William (1769–1837), 254
Darwin, Charles Robert (1809–82), 236
David, Jacques Louis (1748–1825), 231
Dent, Peter (physician, Cambridge; d. 1689), 54
Derby, Edward Stanley, 13th earl of (1775–1851), 135
Derham, William (1657–1735), 57, 59, 69
Desmoulins, F. A. (fl. 1770–85), 111
Desmoulins, J. B. S. F. (fl. 1760–80), 111
Dickie, Mrs. (of Edinburgh, fl. 1826–36), 234
Dixon, Captain George (d. 1800), 158
Dixon, Samuel (d. 1769), 131
Dod, John, 88, 89
Donovan, Edward (1768–1837), 29, 34, 36, 42, 155, 181–89, 198, 253
Dorville, Eliza (fl. 1800–1813), 44
Drury, Dru (1725–1803), 164, 166, 185
Ducie, Lady Sarah. See Child, Sarah

East India Company, 41, 43, 118, 145, 215
Edinburgh University, Museum, 43, 215, 227
Edwards, George (1694–1773), 14, 28, 29, 31, 37, 42, 43, 55, 72, 74, 76, 84, 86, 88–102, 106, 110, 111, 131, 145, 174
Edwards, Sydenham Teak (1768–1819), 193
Ehret, Georg Dionysius (flower painter; 1708–70), 86
Elder, William (fl. 1670–80), 59
Evelyn, John (1620–1706), 49
Eyton, Thomas Campbell (of Eyton, Shropshire; 1809–80), 43, 168, 223

Fairchild, Thomas (fl. 1710), 76, 81
Faithorne, William (1616–91), 56, 59, 250
Falconer, Elizabeth. *See* Pennant, Elizabeth
Falconer, James, 104
Fawcett, Benjamin (1808–93), 28
Fell, John (bishop of Oxford; 1625–86), 57
Ferrers, Washington Shirley, 5th earl (1722–78), 94, 97
Fletcher, Henry (fl. 1710–50), 70, 108
Flinders, Matthew (Australian explorer; 1774–1814), 41
Folkes, Martin (1690–1754), 94, 98
Forbes, James (1748–1819), 255
Forster, Johann Georg A. (artist, H.M.S. *Resolution,* 1772–75; 1754–94), 110
Forster, Johann Reinhold (German, to England 1776; artist, H.M.S. *Resolution,* 1772–75; 1729–98), 84, 110, 111, 118, 143
Fox, George Townshend (d. 1847), 215, 217
Free Society of Artists (1761–83), 108, 158

Gainsborough, Henry Noel, 6th earl of (1743–98), 175
Gainsborough, Thomas (Royal Academician; 1728–88), 105, 120
Gesner, Conrad (1516–65), 247
Glasse, Rev. George Henry (1761–1809), 131–33
Gmelin, Johann Friedrich (1748–1804), 140
Gould, Elizabeth (1804–41), 217
Gould, John (1804–81), 28, 43, 166, 206, 212, 217, 219, 222, 223
Goupy, Joseph (b. Nevers, France; to England c. 1734; d. 1763), 81
Gourdelle, Pierre (Parisian artist; c. 1530), 247
Graham, Andrew (174?–1815), 117
Graham, Dr. Robert (1786–1845), 206
Graham Watson Library, Emmanuel College, Cambridge, 130, 222
Graves, George (b. 1784), 14, 29, 32, 34, 35, 42, 43, 189, 190–200
Graves, George, Jr. (b. 1812), 191
Graves, Mary (née Curtis, b. 1784), 190, 191
Graves, Mary Ann (b. 1807), 190
Graves, William (1755–183?), 190
Graves, William Curtis (b. 1809), 191
Gray, John Edward (1800–1875), 135
Green (museum owner of Westminster, collection sold 1805), 182
Greville, Dr. Robert Kaye (1794–1866), 191, 192, 206
Grew, Nehemiah (1641–1712), 37
Gribelin, Simon (engraver, to England c. 1680; 1661–1733), 252
Griffier, Jan (engraver; d. 1718), 252
Griffith, Moses (1749–1819), 111–15, 117

Hardwicke, Major General (naturalist, Indian army; 1756–1835), 118, 145, 215

Harrison, Arthur (animal dealer, London, 1810), 195, 197
Hartlaub, Carl Johann Gustav (1814–1900), 223
Havell, Daniel (d. 1826), 236
Havell, Robert (1769–1832), 236, 237, 241, 243
Havell, Robert, Jr. (1793–1878), 29, 47, 233, 236, 237, 239–43, 245, 254, 255, 259
Havell, William (artist; 1782–1857), 187, 236
Hayes, Ann (2d wife of William; 1745–1817), 125, 126, 128, 129, 131–33
Hayes, Annette Inskip (1783–1863), 128
Hayes, Charles (d. 1753), 122
Hayes, Charles (1772–1826), 29, 125, 128, 129, 133–35, 253
Hayes, Elizabeth (fl. 1735–55), 122
Hayes, Emily (1774/75–1830), 128, 133
Hayes, Maria (b. 1782), 128
Hayes, Mary (née Pitts, 1st wife of William; c. 1734–176?), 122
Hayes, Matilda (1776–1827), 128–30, 133
Hayes, William (1735–1802), 14, 29, 32, 34, 35, 37, 67, 122–35, 253, 258
Hayes, William, Jr. (1778–1850), 128, 130
Hayes, William Graves (grandson of William; 1805–83), 133
Hodgson, Edward (drawing master; 1719–94), 158
Hollar, Wenceslaus (born Prague, to England 1636; 1607–77), 23, 29, 30, 252
Hooke, Robert (1635–1703), 248
Hooker, Joseph Dalton (1817–1911), 41
Hooker, Sir William Jackson (1785–1865), 191, 192
Hove, Frederick Hendrick van (fl. 1628–98), 52, 56, 59, 250
Howe, Dr. George (1655–1710), 63, 166
Howe, Letitia (née Foley, m. 1693), 63
Howitt, William Samuel (watercolor artist; 1765–1822), 195, 197
Hudson's Bay Company (1670–), 42, 97, 117
Hunt, John (of Norwich, engraver, bookseller, taxidermist; 1777–1842?), 253
Hunt, S. V. (son of John), 253
Hunter, Dr. John (anatomist; 1728–93), 139
Hunter, John (governor of New South Wales, 1795–1801; 1738–1821), 164
Hunter, Dr. William (anatomist; 1718–83), 137, 139
Huntingdon, Selina Hastings, Countess of (1707–91), 148
Hutchins, Thomas (surgeon, Hudson's Bay Company, 1775–90; 1730–90), 117

Impey, Sir Elijah (1732–1809), 145
Impey, Lady Mary (wife of Elijah), 145
Ingham, John (schoolmaster, Halifax, 1790s), 170, 174

Salmon, Ned (d. 1768), 125
Salt, Henry (1780–1827), 147
Sandby, Paul (1725–1809), 254
Sandwich, John Montague, 4th earl of (1718–92), 127
Say, William (1768–1834), 251
Schan, Lukas (fl. 1538–50), 247
Sclater, Philip Lutley (secretary, Zoological Society, 1889–1913; 1829–1913), 223
Scotin, J. (engraver; fl. 1730s), 62, 64
Scott, Robert (1771–1841), 45
Scott, Sir Walter (1771–1832), 234
Scottish Academy. *See* Royal Scottish Academy
Seaforth, Francis Mackenzie Humberston, Earl of (1754–1815), 147
Selby, Lewis Marianne (1811–90), 206
Selby, Lewis Tabitha (née Mitford, c. 1782–1859), 202, 206, 209
Selby, Prideaux John (1788–1867), 14, 29, 31, 32, 34, 35, 37, 42, 43, 44, 47, 129, 185, 191, 192, 201–13, 214, 215, 219, 220, 222, 225, 234
Seymer, Henry (natural history collector; 1745–1800), 93
Seymer, Major Vivean, 93
Sharpe, Richard Bowdler (Bird Room, British Museum, 1872–1909; 1847–1909), 227
Shaw, George (1751–1813), 84, 256
Sherard, James (1666–1737), 77
Sherard, William (1659–1728), 65, 77, 84
Sherwin, William (fl. 1670–1714), 56, 59
Shield, George (1804–80), 27, 45
Shirley, Captain. *See* Ferrers, Washington Shirley, 5th earl
Sibbald, Sir Robert (1641–1722), 253
Skippon, Sir Philip (1641–91), 49, 55
Sloane, Sir Hans (1660–1753), 36, 42, 55, 63, 65, 70, 72, 77–79, 81, 86, 89, 91, 97–99, 139
Smith, Sir Andrew (1797–1872), 212, 219
Smith, Edwin Dalton (b. 1800), 45
Smith, Gabriel (1724–83), 123, 124
Smith, James Edward (1759–1828), 137, 139
Society of Antiquaries of London (1707–), 94, 104
Society of Apothecaries, 59
Society of Artists of Great Britain (1760–91), 31, 108, 115
Society of Friends, 34, 190, 191
Society of Painters in Water Colour, 23
Solander, Daniel Charles (1736–82), 143
Soly, Arthur (engraver; fl. 1686), 252
Sonnerat, Pierre (1749–1814), 111
Sowerby, James (1757–1822), 256
Spalding Society, 98
Stewart, James (fl. 1826–43), 217, 220, 221
Stone, Sarah (fl. 1777–1802), 147
Strickland, Catherine Dorcas Maule (née Jardine; 1825–88), 208, 215, 225, 226
Strickland, Hugh Edwin (1811–53), 206, 212, 215, 225, 255
Svintus, Cornelius (c. 1600), 248

Swainson, William (1789–1855), 41, 46, 69, 99, 118, 140, 159, 163, 181, 192, 202, 220
Sweet, Robert (nurseryman; 1783–1835), 45
Syme, John (1795–1861), 235
Syme, Patrick (1774–1845), 45, 220

Tempest, Pierce (engraver; fl. 1670–1717), 252
Tempesta, Antonio (artist and engraver, b. Florence, d. Rome; 1555–1630), 248
Theobald, James (fl. 1720), 89
Thompson, John (wood engraver; 1785–1866), 217
Thornton, G. (fl. 1730), 70
Toppin (fl. 1785), 175
Townsend, John Kirk (ornithologist, Rockies; 1809–51), 242
Tradescant, John (museum owner; died c. 1637), 42
Tradescant, John, Jr. (1608–62), 42, 55
Tribble, Jacob (artist of Westminster, 1724), 108
Trustees' Academy, Edinburgh, 32, 204
Tucker, Dr. Andrew G. C. (fl. 1809), 44, 193
Tunstall, Marmaduke (museum owner; 1743–90), 42, 110, 111, 112, 139, 161, 185
Turner, Dr. William (1500–68), 22, 247

Vertue, George (1684–1756), 59
Victoria and Albert Museum, London, 98, 131, 193
Vigors, Nicholas Aylward (secretary, Zoological Society, 1826–32; 1785–1840), 41, 217
Villamena, Francesco (artist and engraver, Assisi; d. Rome; 1566–1624), 248

Walcott, Ann (née Lloyd, m. 1777; 1756–82), 148, 149
Walcott, Dorothy Mary (née Lyons, m. 1783; 1759–1832), 149
Walcott, Edmund Scopoli (1785–1864), 149
Walcott, John (c. 1730–76), 148
Walcott, John (1754/5–1831), 29, 31, 32, 34, 42, 148–56
Walcott, Susanna. *See* Young, Susanna
Walcott, William Henry Linnaeus (1790–1869), 149
Walpole, Horace (1717–97), 118, 127
Warner, I. (engraver; fl. 1809–13), 44, 193, 196
Watson, John, 169
Weddell (engraver; fl. 1821), 193
Wernerian Natural History Society, Edinburgh (1808–38), 202, 234
Western Museum, Cincinnati, 231
Wharton, Dr. George (1688–1739), 72
Whatman, Messrs. (paper manufacturers, c. 1750–), 27
White, Benjamin (1725–94), 36, 111, 155
White, Gilbert (1720–93), 69, 104, 106, 108, 110, 111, 120, 177, 180

White, Rev. John (fl. 1730–80), 110, 111
White, Taylor (treasurer, Foundling Hospital, 1745–72; 1701–c. 1782), 108, 111
Whiteley, H. (fl. 1846), 45
Wickam, Mrs. William N., 143
Wilkins, John (bishop; 1614–72), 54
Wilkinson, Ronald S., 74
Williams, Rev. David (founder of [Royal] Literary Fund; 1738–1816), 132
Willughby, Cassandra. *See* Chandos, Cassandra
Willughby, Emma (née Barnard; wife of Francis, 1668–72; m. Sir Josiah Child, 1676), 49, 53, 56
Willughby, Francis (of Middleton Hall; 1635–72), 22, 25, 27, 31, 34, 43–45, 48–61, 145, 249
Willughby, Sir Francis (1668–88), 53, 59
Willughby, Sir Thomas (d. 1729), 53, 59
Wilson, Alexander (1766–1813), 227, 238
Wilson, James (1795–1856), 32, 191

Winsor, William, and H. C. Newton (artists' suppliers, 1832–), 23
Wood, Casey Albert (1856–1942), 115, 164
Wood, William (fl. 1807), 254
Woodford, Emperor John Alexander (c. 1761–1825), 195
Wren, Sir Christopher (1632–1723), 49

Yale University, Library, 151
Yarrell, William (1784–1856), 44, 45, 149, 151, 206, 217, 223
Young, Susanna (née Walcott; m. 1800), 148
Young, Rev. Thomas, 148
Young, William Weston (fl. 1804), 45, 254

Zeitter, John Christian (1796/97–1862), 41
Zoological Library, South Kensington. *See* British Museum (Natural History)
Zoological Society of London (1826–), 41
Zoological Society of London, Museum (1826–55), 43, 217

Index of Avifaunal Species

In the text, North American or Nearctic species are listed under the names found in the American Ornithologists' Union's *Check-list of North American Birds*, 5th edition (1957), and British species under the names designated in the British Ornithologists' Union's *Status of Birds in Britain and Ireland* (1971). When the two overlap and the scientific names differ in the use of genus names, cross-references are supplied from British to American names. The curlew sandpiper, for example, is *Erolia ferruginea* in the American list, *Calidris ferruginea* in the British. In the index, therefore, I have referred from *Calidris ferruginea* to *Erolia ferruginea*. Names not included in these two lists are taken from Edward S. Gruson's *Checklist of the Birds of the World* (London: Collins, 1976).

Page numbers in italics indicate illustrations.

Carduelis spinus, 74, 158
Carpodacus purpureus, 234
Casmerodius albus, 206
Catharacta skua, 67
Celeus flavescens flavescens, 111
Centurus carolinus, 79
Chlamydera cerviniventris, 223
Chlamydera nuchalis, 219
Chlidonias niger, 54
Chlidonias niger surinamensis, 111
Chrysolophus pictus, 67, 125, 126, 128
Ciccaba virgata, 115
Ciconia ciconia, 55, 58, 72, 104, 129, 206
Ciconia nigra, 52, 58
Cinclodes antarcticus(?), 158
Circus aeruginosus, 125
Circus cyaneus, 44, 123
Circus melanoleucos, 118
Coccothraustes coccothraustes, 52
Coccyzus americanus, 234
Cochlearius cochlearius, 111
Colaptes auratus, 83, Plate 1
Colinus virginianus, 72
Columba livia, 57
Columba nicobarica. See Caloenas nicobarica
Columba palumbus, 123
Copsychus saularis, 72
Coracias garrulus, 185, 186
Corvus corone, 112
Corvus corone cornix, 57
Corvus frugilegus, 151, 153
Corvus monedula, 112
Coturnix coturnix, 71
Crax globulosa, 129
Crax pauxi, 96
Crax rubra, 96
Crex crex, 151
Cuculus bengalensis, 111
Cuculus canorus, 123, 125
Ciculus pyrrhocephalus, 118
Cursorius cursor, 183
Cyanocitta cristata, 79, 80, 240
Cygnus atratus, 143

Dendrocopos major, 57
Dendrocopos pubescens, 79
Dendrocopos villosus, 79
Dendroica coronata, 97
Dolichonyx oryzivorus, 81, 82, 83
Domicella domicella, 129
Dryocopus martius, 52, 104
Dryocopus palliatus, 79
Dryoscopus sabinii, 217

Egretta alba. See Casmerodius albus
Egretta garzetta, 52, 111, 195
Emberiza cirlus, 44, 185
Emberiza hortulana, 161
Erolia ferruginea, 161
Erolia maritima, 112
Estrilda amandava, 129
Eudromias morinellus, 57

Falco peregrinus, 161, 183, 227
Falco rusticolus, 207
Falco tinnunculus, 70, 123, 125
Ficedula hypoleuca, 175, 176, 193
Fratercula arctica, 49
Fringilla montifringilla, 52, 93, 125

Galerida cristata, 52
Gallinago spp., 198
Gallinago gallinago. See Capella gallinago
Galloperdix bicalcarata, 118
Garrulus glandarius, 123, 124
Gennaeus nycthemerus, 129
Glareola pratincola, 195
Goura cristata, 129, 130
Gracula religiosa, 72, 95
Grus americana, 117, 243
Grus canadensis, 243
Grus grus, 111
Guiraca caerulea, 81

Haematopus palliatus, 79
Halcyon sancta, 143, 144
Haliaeetus albicilla, 52, 112, 131
Harpactes fasciatus, 118
Himantopus himantopus, 110, 195
Hirundo rustica, 57, 134, 198
Histrionicus histrionicus, 99

Ibis leucocephalus, 118
Icterus galbula, 86, 115
Ixoreus naevius, 242

Jynx torquilla, Plate 2

Lagopus lagopus, 108, 110
Lagopus lagopus scoticus, 54, 155, 209
Lagopus mutus, 98, 104, 115, 195, 209
Lanius collurio, 44
Lanius cristatus, 99
Larus glaucoides, 208
Larus ridibundus, 193, 195
Larus sabini, 217
Limnodromus griseus, 112
Limosa spp., 110
Limosa haemastica, 241
Limosa limosa, 39, 161, 241
Lobipes lobatus, 97
Locustella naevia, 55
Lophostrix cristata, 226
Lorius chlorocercus, 40
Loxia curvirostra, 129, 158
Loxia leucoptera, 158
Lullula arborea, 44
Luscinia megarhynchos, 45
Lymnocryptes minima, 112
Lyrurus tetrix, 104, 129, 198, 209

Melanerpes erythrocephalus, 79, 81
Melanitta nigra. See Oidemia nigra
Meleagris gallopavo, 234
Mergus albellus, 54

Library of Congress Cataloging in Publication Data

Jackson, Christine E. (Christine Elisabeth), 1936–
 Bird etchings.

 Bibliography: p.
 Includes indexes.
 1. Etching, British. 2. Birds in art. I. Title.
NE2043.J33 1985 598′.022′2 84-27438
ISBN 0–8014–1695–7 (alk. paper)